the cinema of TERRY GILLIAM

DIRECTORS' CUTS

Other select titles in the Directors' Cuts series:

the cinema of TAKESHI KITANO: *flowering blood*
SEAN REDMOND

the cinema of THE DARDENNE BROTHERS: *responsible realism*
PHILIP MOSLEY

the cinema of MICHAEL HANEKE: *europe utopia*
edited by BEN McCANN & DAVID SORFA

the cinema of SALLY POTTER: *a politics of love*
SOPHIE MAYER

the cinema of JOHN SAYLES: *a lone star*
MARK BOULD

the cinema of DAVID CRONENBERG: *from baron of blood to cultural hero*
ERNEST MATHIJS

the cinema of JAN SVANKMAJER: *dark alchemy*
edited by PETER HAMES

the cinema of NEIL JORDAN: *dark carnival*
CAROLE ZUCKER

the cinema of LARS VON TRIER: *authenticity and artifice*
CAROLINE BAINBRIDGE

the cinema of WERNER HERZOG: *aesthetic ecstasy and truth*
BRAD PRAGER

the cinema of TERRENCE MALICK: *poetic visions of america (second edition)*
edited by HANNAH PATTERSON

the cinema of ANG LEE: *the other side of the screen*
WHITNEY CROTHERS DILLEY

the cinema of STEVEN SPIELBERG: *empire of light*
NIGEL MORRIS

the cinema of TODD HAYNES: *all that heaven allows*
edited by JAMES MORRISON

the cinema of ROMAN POLANSKI: *dark spaces of the world*
edited by JOHN ORR & ELZBIETA OSTROWSKA

the cinema of JOHN CARPENTER: *the technique of terror*
edited by IAN CONRICH & DAVID WOODS

the cinema of MIKE LEIGH: *a sense of the real*
GARRY WATSON

the cinema of NANNI MORETTI: *dreams and diaries*
EWA MAZIERSKA & LAURA RASCAROLI

the cinema of DAVID LYNCH: *american dreams, nightmare visions*
edited by ERICA SHEEN & ANNETTE DAVISON

the cinema of KRZYSZTOF KIESLOWSKI: *variations on destiny and chance*
MAREK HALTOF

the cinema of GEORGE A. ROMERO: *knight of the living dead*
TONY WILLIAMS

the cinema of KATHRYN BIGELOW: *hollywood transgressor*
edited by DEBORAH JERMYN & SEAN REDMOND

the cinema of WIM WENDERS *the celluloid highway*
ALEXANDER GRAF

the cinema of KEN LOACH: *art in the service of the people*
JACOB LEIGH

the cinema of EMIR KUSTURICA: *notes from the underground*
GORAN GOCIC

the cinema of
TERRY GILLIAM

it's a mad world

edited by Jeff Birkenstein, Anna Froula
& Karen Randell

WALLFLOWER PRESS LONDON & NEW YORK

A Wallflower Press Book
Published by
Columbia University Press
Publishers Since 1893
New York • Chichester, West Sussex
cup.columbia.edu

Copyright © Jeff Birkenstein, Anna Froula & Karen Randell 2013
All rights reserved.
Wallflower Press® is a registered trademark of Columbia University Press

A complete CIP record is available from the Library of Congress

ISBN 978-0-231-16534-1 (cloth : alk. paper)
ISBN 978-0-231-16535-8 (pbk. : alk. paper)
ISBN 978-0-231-85038-4 (e-book)

Series design by Rob Bowden Design

Cover image of the Terry Gilliam courtesy of The Kobal Collection

Columbia University Press books are printed on permanent
and durable acid-free paper.
This book is printed on paper with recycled content.
Printed in the United States of America

c 10 9 8 7 6 5 4 3 2 1
p 10 9 8 7 6 5 4 3 2 1

CONTENTS

Acknowledgements vi
Notes on Contributors x

Introduction *Jeff Birkenstein, Anna Froula & Karen Randell* 1
Terry Gilliam Interview: *Karen Randell* 9

1 Steampunked: The Animated Aesthetics of Terry Gilliam in *Jabberwocky* and Beyond *Anna Froula* 16

2 Grail Tales: The Preoccupations of Terry Gilliam *Tony Hood* 32

3 'And Now for Something Completely Different': Pythonic Arthuriana and the Matter of Britain *Jim Holte* 42

4 The Baron, the King and Terry Gilliam's Approach to 'the Fantastic' *Keith James Hamel* 54

5 The Subversion of Happy Endings in Terry Gilliam's *Brazil* *Jeffrey Melton and Eric Sterling* 66

6 The Fissure King: Terry Gilliam's Psychotic Fantasy Worlds *Jacqueline Furby* 79

7 'You can't change anything': Freedom and Control in *Twelve Monkeys* *Gerry Canavan* 92

8 'It shall be a nation': Terry Gilliam's Exploration of National Identity, Between Rationalism and Imagination *Ofir Haivry* 104

9 'Won't somebody please think of the children?': The Case for Terry Gilliam's *Tidelands* *Kathryn A. Laity* 118

10 Divorced from Reality: *Time Bandits* in Search of Fulfilment *Jeff Birkenstein* 130

11 Celebrity Trauma: The Death of Heath Ledger and *The Imaginarium of Doctor Parnassus* *Karen Randell* 145

Filmography 158
Bibliography 163
Index 173

ACKNOWLEDGEMENTS

JB: My Dad had no idea this would happen. When he signed us up for HBO, somewhere back in the prehistory of the early 1980s, he had no idea I would discover Terry Gilliam's *Time Bandits*, watch it a couple of dozen times or more, and, one day, co-edit a book on the director. Well, it did and it has. But beyond that happenstance, I would like to thank my father, Robert Birkenstein, for all his love, support and enthusiasm. I would also like to thank my entire extended family, some of whom are related to me and some of whom are not, especially my siblings, in descending age: Brian Birkenstein, Jennifer Fiduccia, Kara Lucca, Beth Stillwell and Jonathan Michaels. Ashley E. Reis and my mom, Diana Michaels, have for many years been my proofreaders and so much more. My step-dad, Richard Michaels, taught me lots of computer tricks along the way, including screen grabs. I am grateful to all my wonderful colleagues at Saint Martin's University for their love and support over the years, especially David Price (a longtime Gilliam fan) and everyone in the English Department: Olivia Archibald, Nathalie Kuroiwa-Lewis, Fr. Kilian Malvey, O.S.B., Gloria Martin, Stephen Mead and Jamie Olson. There is one name missing from that English Department list, of course, that of Les Bailey, who passed away on 24 December 2010. I don't know if the phrase 'like a father' explains it, but something like that. I only have room now to mention two more people, for whom I do not have enough room to express my true feelings: Anna Froula and Karen Randell, my dear, dear friends and co-editors. I could say more, but what would be the point? They know.

AF: First thanks go to my brother Matt, who introduced me to the subversively outrageous hilarity of *Monty Python and the Holy Grail* decades ago, and to Sally Sain, who watched it with me almost incessantly and always let me replay my favorite scenes (the absurdity of that tortured prisoner clapping along to the beat of 'Knights of the Round Table' and the rabbit that was not so very 'ordinary'). I also deeply appreciate the indulgence of my colleagues at East Carolina University, who have engaged my Gilliam enthusiasm both in conversing about and watching his films, whose helpful comments on my chapter were invaluable, and whose continued support continue to sustain me in my ongoing academic labours. Thank you Jeffrey Johnson, Lee Johnson, Don Palumbo, Michelle Eble, Rick Taylor, Will Banks, Jim Holte, Tom Shields, Donna Kain, David Wilson-Okamura and especially my beloved femidemics – Marame Gueye, Andrea Kitta, Amanda Ann Klein and Marianne Montgomery – who kept me focused on the importance of *jouissance* in Gilliam's art. As always, the support of my parents and extended family has bolstered me emotionally and intellectually

throughout my work. For continuing to travel to North Carolina and London to meet with me, collaborate, and make this book possible, thanks to both Karen and Jeff, who first proposed, 'hey, we should do a book on Gilliam' while we watched *Brazil* together. Finally, I reserve my deepest appreciation and gratitude to my husband, Sean Morris, who nourished us with stores of fine food and finer wit during our writing retreats, re-viewed all of Gilliam's films with me, and provided incisive commentary out loud and in prose along the way, and whose unconditional love and enduring buoyancy help keep me on a productive tack and even keel.

KR: I thank the film folk of the Screen Research Cluster in the School of Media at Southampton Solent University, UK, for their continued enthusiastic support, friendship and inspiration; Mark Aldridge, Sarah Arnold, Claire Hines, Darren Kerr, Mark de Valk, Donna Peberdy and Tony Steyger; extra special thanks go to Jackie Furby for *just loving* Terry Gilliam's work and inspiring years and years of our students to love him too. We got our passion for his work from a great teacher, Professor Linda Ruth Williams; Linda, thank you for this and everything else. Work for this volume carried out at the Margaret Herrick Library, Academy of Motion Picture Arts & Sciences Library, Beverley Hills, CA, was funded by the Southampton Solent University Research & Enterprise fund for which I am very grateful; thank you to Professor Maurice Owen & Professor Jane Longmore for this opportunity. Thank you family: Jason Lucas, Victoria Brant, Will Brant, Alex Brant and Jessie Rae Randell Lucas, you always 'get me', it's important. Anna and Jeff made this project happen, over pizza and beer, as all the best ideas are made... the best idea I ever had was working with you guys. And Sean Morris (Mr. Anna) what can I say? You make me want to have a writing retreat every weekend ... please make me a Carolina coffee again sometime soon. Finally, I would like to thank the Monty Python team for adding a little bit of hilarity and subversion to my school days; to recite the parrot sketch in double English felt like pure anarchy.

The editors would collectively like to thank: Yoram Allon of Wallflower Press who believed in this project and saw it through to the end, and Jason Lucas for final image editing – you made us look like pros! Finally, Sean Morris for being a bigger part of this book than one can notice... but we notice.

JB – with love to all of my extended family,
wherever and whenever you may be…

AF – to Sean for always synchronising the anachronistic

KR – for my son William, with love, for sharing with me
the weird and wondrous world of boys

NOTES ON CONTRIBUTORS

Jeff Birkenstein is Associate Professor of English at Saint Martin's University in Lacey, WA. He is co-editor of *Reframing 9/11: Film, Pop Culture, and the 'War on Terror'* (Continuum, 2010) with Anna Froula and Karen Randell. His research interests lie in the short story, post-9/11 culture, and 'Significant Food' in fiction and culture.

Gerry Canavan is Assistant Professor in the Department of English at Marquette University, teaching twentieth- and twenty-first-century literature. He is a co-editor of recent special issues of *Polygraph* and *American Literature*, as well as two edited collections: *Green Planets: Ecology and Science Fiction* (Wesleyan University Press, 2013) and *The Cambridge Companion to American Science Fiction* (Cambridge University Press, 2013).

Anna Froula is Assistant Professor of Film Studies at East Carolina University in Greenville, NC, and Associate Editor of *Cinema Journal*. She has published on war trauma and gender in publications including *Changing English*, *Cinema Journal*, *The Journal of War and Culture Studies* and *Iraq War Cultures* (Peter Lang, 2011), and is working on a manuscript about representations of American military women.

Jacqueline Furby is a Senior Lecturer and Course Leader for Film at Southampton Solent University, UK. She has published on film theory, film fantasy and time in film and television, including *Screen Methods: Comparative Readings in Film Studies*, which she co-edited with Karen Randell (Wallflower Press, 2005), and the Routledge Film Guidebook on *Fantasy*, co-authored with Claire Hines (2012).

Ofir Haivry is Senior Fellow at the Institute for Advanced Studies in Jerusalem, and is founding editor of the journal *Azure*. His recent publications include the introduction to the first complete Hebrew translation of Tocqueville's *Democracy in America*, as well as 'John Selden and the early modern debate over the foundations of political order' in *Annuaire de l'Institut Michel Villey*.

Keith James Hamel received his doctorate from the Department of Communication and Culture at Indiana University. He has taught at Marist College in Poughkeepsie, NY; Boston University; and Suffolk University in Boston, MA. His research interests include the history and aesthetics of film trailers, film acting and fantasy films. His work has appeared in the *Quarterly Review of Film and Video*, *Journal of Film and Video* and *Scope: An Online Journal of Film Studies*.

Jim Holte is Professor of English and Film Studies at East Carolina University in Greenville, NC. He is the author of *Dracula in the Dark: The Dracula Film Adaptations* (Praeger, 1997) and is currently working an examination of *Abraham Lincoln: Vampire Hunter*.

Tony Hood is a writer and academic based in Melbourne. His doctorate was awarded in 2003 for his dissertation *Far from Equilibrium: The Film Art of Terry Gilliam* from Deakin University, Victoria. His research interests are literary and philosophical influences in film and expressions of 'the fantastic'.

Kathryn A. Laity is Associate Professor of English at the College of Saint Rose, NY. She was a Fulbright Scholar in Digital Humanities at the National University of Ireland Galway (2011–12) and is a novelist, playwright and humorist. Her areas of research include writers in the digital age, medieval literature and culture, film, comics, feminism and classic British comedy.

Jeffrey Melton is Associate Professor of American Studies at the University of Alabama in Tuscaloosa. He is author of *Mark Twain, Travel Books, and Tourism: The Tide of a Great Popular Movement* (University of Alabama Press, 2002) and co-editor of *Mark Twain on the Move: A Travel Reader* (University of Alabama Press, 2009) with Alan Gribben. He has published essays on tourism, humor, and satire in various journals including *South Atlantic Review*, *Studies in American Humor* and *Papers on Language and Literature*.

Karen Randell is Professor of Film and Culture at Southampton Solent University, UK. She is co-editor of five books including *The War Body on Screen* (Continuum. 2008) and *Screening the Dark Side of Love: From Euro-Horror to American Cinema* (Palgrave Macmillan, 2012). She has also been published in *Screen* and *Cinema Journal*.

Eric J. Sterling is Distinguished Research Professor of English at Auburn University, Montgomery, where he has taught since 1994. He has published two articles on *Schindler's List* and essays on popular culture, and has authored four books, including an essay collection on *Death of a Salesman* (Rodopi, 2008).

INTRODUCTION

Fear and Loathing in Hollywood: Looking at Terry Gilliam through a Wide-angle Lens

Jeff Birkenstein, Anna Froula & Karen Randell

> My work is not realistic in any way, it's more like cartoons. Distorted. Hyper-real. I don't think I can ever see the world in a banal way. I am always inventing stuff to highlight reality.
>
> Terry Gilliam (Tapper 2006: 64)

Watching a Gilliam film tends to leave the audience in joyful wonderment, dazed and confused, and out of breath, if not utterly baffled or even angry about what has transpired on screen. Gilliam fills every frame with minute detail, much of it impossible to see in one viewing without the aid of a remote control and a thumb on the pause button. This volume takes a snapshot of the still very-much-in-progress career of Terry Gilliam as we seek to turn a wide-angle lens, now known industry-wide as 'The Gilliam', on this original and influential director (see Cullen 2000). For five decades he has been a cartoonist, animator, comic, film auteur, social critic and, most recently, opera director. While he has never wholly departed from his Monty Python roots, he has forged his own distinct vision. Gilliam creates worlds that are at once familiar and uncanny and he always triumphs the mundane and the ridiculous. His anachronistic and off-kilter vision, his exploration of space – both enormous and claustrophobic – and his particular sense of cluttered *mise-en-scène* consistently evades our ability to find a stable or common foundation on which to ground a single approach to his films. But Gilliam's *ouvre* is more than mere stylised nonsense: his genius is clearly defined by his visual style as it expresses a political and social critique of the world he sees.

When Gilliam makes a movie, he goes to war: against Hollywood caution and convention, against hyper-consumerism and imperial militarism, against narrative

vapidity and spoon-fed mediocrity, and against the brutalising notion and cruel vision of the American Dream. His critics have accused him of making elaborate inside jokes, but, while he does want his viewers to 'work the meanings out for themselves' and to 'fill in the gaps', he makes movies that end in questions and that are 'messages in bottles for America' (Christie & Gilliam 2000: 246). These messages are national allegories – dark and daring, colourful and complex – that challenge viewers to reconsider the experience of watching films. From his black-toothed villagers in *Jabberwocky* (1977) to his Dalí-inspired landscapes in *The Imaginarium of Doctor Parnassus* (2009), Gilliam's *mise-en-scène* confronts audiences with darkness and filth that is alternatively gleefully scatological and profoundly abject. In Gilliam's eyes, 'the darkness is what makes the light more beautiful', and, he says, 'a problem I see now in the modern world – particularly in America – is the perception of a world without struggle, a world were [*sic*] all our needs are taken care of' (Tapper 2006: 65). Perhaps his most scathing expression of his vision of 'America as the Rome of the twentieth century' is *Fear and Loathing in Las Vegas* (1998) (McCabe 1999: 183).

Arguably, his political distance as an expatriate 'gonzo' filmmaker made possible his biting translation of Hunter S. Thompson's psychedelic account of the 1971 Mint 400 race into cinematic language.[1] While Thompson praised the adaptation as 'a masterpiece … an eerie trumpet call over a lost battlefield', critics writing at the end of the *Pax Americana* frequently missed what the fight was all about in the first place (Smith 1998: 79). Some booed the film at Cannes, some sneered at what they saw as its (and the book's, presumably) lack of a narrative centre, some giggled and grimaced through the visual rendition of the pharmaceutical adventures of Duke Raoul (Johnny Depp) and Dr. Gonzo (Benicio Del Toro), but few read Gilliam's 'secondary language embedded in the film that people either grasp or don't' (Christie & Gilliam 2000: 256). *Fear and Loathing in Las Vegas* crystallises this tragic past, as gleaned through the lens of a traumatic (or traumatised) present in which the lessons of jingoism, dehumanisation and expenditure on weapons of mass destruction have yet to be learned.[2]

All of Gilliam's movies render time as the director sees it, as one elongated moment of overlapping histories and *Fear and Loathing in Las Vegas* is his distillation of late twentieth-century American warfare. The grotesque images that bulge through Gilliam's satiric lens are of politicians adorned in red, white and blue; a tank, Vietcong guerrillas in black pyjamas, Vietnam-era military fatigues, and a small girl firing an M-16: 'apocalyptic images from everywhere, from the seventies to the present' (Christie & Gilliam 2000: 252). Yet, as in all of his films, Gilliam refuses the easy moral message and leaves it to us to solve the puzzles, to see the 'candid reality' of our imperial muck and a better way to move forward from the 'worst of our hells' (McCabe 1999: 253). And if we're willing, he will show us a way to laugh through our collective pain.

This volume, then, offers critical readings of Gilliam's films to highlight the authorial style of a director that we unashamedly believe to be a genius, but it is not a work of biography. Three excellent collections of interviews, which many of our contributors have drawn on for this volume – Ian Christie's *Gilliam on Gilliam* (2000), David Sterritt and Lucille Rhodes' *Terry Gilliam: Interviews* (2004) and Bob McCabe's *Dark Knights and Holy Fools: The Art and Films of Terry Gilliam* (1999) – have charted

Gilliam's work and captured some of his own opinions on his life and career. To help us all understand the man behind the lens, these interviews include discussions about his early influences (artistic, cultural, religious and familial), from his animation days with *Monty Python* (1969) to his later independently- and Hollywood-produced financial successes (*Time Bandits* [1981] and *Twelve Monkeys* [1995]), financial disasters (*The Adventures of Baron Munchausen* [1988], *Brothers Grimm* [2005], and the as-yet unfinished *Don Quixote*) as well as critically acclaimed films, such as *Brazil* (1985) and *The Fisher King* (1991) and social commentaries such as *Fear and Loathing in Las Vegas*.

What emanates from these interviews is Gilliam's undeniable passion for his work, his sense of incorrigible humour and his much misunderstood, absolute discipline for his art. Asked by Gregory Solman if he would rather be known as 'the madman or Merchant-Ivory', Gilliam replies, 'I'm happy to be the lunatic' and notes that it is 'the film that confuses people' (Solman 2004: 188). Because of his affinity for narrative confusion, his chaotic screen worlds are often mistaken as the work of a director who must surely also work in such chaos, and, says Gilliam, people mistake his madness on screen for his method behind it (ibid.).

Numerous volumes on the Monty Python television series also include discussion of Gilliam's animation.[3] Books on single films tend to focus on the drama of Gilliam's various spats with Hollywood, such as Jack Mathews' *The Battle of Brazil: Terry Gilliam v. Universal Studios* (1998), or Gilliam's production dilemmas, such as Andrew Yule's *Losing the Light: Terry Gilliam & The Munchausen Saga* (1991) and Bob McCabe's *Dreams and Nightmares: Terry Gilliam, The Brothers Grimm & Other Cautionary Tales of Hollywood* (2006). Gilliam is quite familiar with such problems as the film *Lost in La Mancha: The Unmaking of Don Quixote* (Keith Fulton & Louis Pepe 2002) documents well. Peter Marks' *Terry Gilliam* (2010) offers an illuminating critical and textual analysis of Gilliam's work up to 2005 and highlights his peculiar geographical position in film history.

As an American – who now also carries a British passport and has, since 1967, lived in the UK – working ostensibly as a British filmmaker, Gilliam, not surprisingly, defies categorisation even in terms of his national status. However, notable sources such as Marks and Manchester University Press consider Gilliam as British, as does the British Film Institute, which placed *Monty Python's Life of Brian* (1979) and *Brazil* in their '100 Favourite British Films of the 20th Century' (see Marks 2010: 2). Marks also highlights the difficulty of reading Gilliam as an auteur, noting that the director sees the process of filmmaking as a 'learning process' for himself and that the team effort is as important as the director's single vision. However, Gilliam understands that he operates as a 'filter that lets certain ideas through and stops others. That's my function', though he generously notes that 'half the things that end up in the film I would never have thought of myself' (Marks 2010: 7). We problematise this notion in our book, too, as scholars grapple with the hybridisation of Gilliam as auteur and collaborator.

Such hybridity can be seen as recently as his May 2011 venture with the English National Opera which gave him the opportunity to direct Hector Berlioz's *The Damnation of Faust* at the London Coliseum. 'I suppose an opera is a sweep', remarks the director, 'an arc of character and ideas, and in that case, half of my films have been

operas' (Christiansen 2011). Gilliam's breathtaking embellishment of Berlioz's opera ricochets the audience through the first half of Germany's twentieth century from the rise of fascism after Versailles: via projected animation and distorted film images from *Triumph of the Will* (Leni Riefenstahl, 1935), newsreel from the 1936 Berlin Olympics and the Nuremberg rallies, and live-action portrayals of the execution of the pogroms and the mass graves of the concentration camps. Gilliam observes in the programme notes that theatre staging does not allow the creative control of the close-up to direct the eye of the viewer; nevertheless, the set design of the opera matches its composer's refusal to 'play by the rules' (Christiansen 2011). Gilliam's incarnation starts with a moment of waiting as a bald man, seemingly dressing for dinner, talks to the audience – immediately breaking the artifice of theatre – and asks whether the image of the ideal man can ever be reached. He is of course, the devil, Mephistopheles, his elegant suit complete with bowler hat reminiscent of the devil, Mr. Nick (Tom Waits), in *The Imaginarium of Doctor Parnasuss*, another of Gilliam's narratives exploring the question of the morality of man. The bowler-hatted baddie is an iconic trope of Gilliam, found in *Brazil* and 'The Crimson Permanent Assurance' in *Monty Python's The Meaning of Life* (1983) and many Monty Python sketches including 'The Ministry of Silly Walks'. The bowler hat represents Gilliam's frustration with all things bureaucratic and stifling.

Like Faust, philosopher Dr. Parnassus has sold his soul for the promise of immortality, only to see his loved ones suffer for this hubris. This philosophical question in *Faust* is prompted by the projected image of Leonardo da Vinci's 'Vitruvian Man' (c. 1487), an image whose proportions enable a perfect relationship to geometrical space and whose image is in turn made bawdy and then bastardised by the finale of the opera where a straight-jacketed Faust is crucified upside down upon a Nazi swastika placed within a circle on a square board and lowered into the depths of hell. Does the audience have their answer at this point? Can there be an ideal man? The spectacle, clearly influenced by German Expressionism and Riefenstahl's visual style, follows the aesthetic principles that originated in Gilliam's comics and Monty Python animation: pastiche, collage and the 'squaring of the circle', here that is literally imposing the rigidity of the swastika over the 'beautiful and round forms' of German Romanticism (Seckerson 2011: 8).

In true Gilliam style, the audience is left perplexed and not a little shocked by the final scenes of his first opera, which challenges audience expectations of what opera is and does. Ghosts of World War I soldiers arise from their battleground, reminiscent of Abel Gance's *J'Accuse* (1919) and tapping in, again, to a much-returned-to theme for Gilliam. The full horrors of the Holocaust are impossible to fully represent of course, but the brilliantly lit, glowing white body of Marguerite laying in the centre of a pile of exterminated bodies, while the ash falls like snow around her, is a shocking way in which to 'save' her from hell. The black curtain falls on the last impossible visual – the glowing corpse of redemption – and the audience sits in silence, unsure of what happens next, until the first tentative clap begins. Left with Gilliam's typical cinematic finale, which evades simple interpretation, the audience bursts into sustained applause.

When Edward Seckerson interviewed Gilliam for the opera programme, he asked about Faust as a character. Gilliam replied, 'he is somebody who is trying to create

order out of chaos' (ibid.). In one sense this is where Gilliam positions himself as a filmmaker. He creates chaotic worlds for his characters to make sense of, and, though they rarely do, the audience can find some sense of their own world by sharing the chaos of the characters for their screen time and unravelling the complexities of the realities found there. Similarly, with *The Damnation of Faust*, the chaos caused by powerful men is impossible to tame and is writ large and fantastical for the audience by the director.

Like the bricolage formation of his latest artistic piece, Gilliam's first project mixed the reactionary and the revolutionary to announce his emergence as a director of a particular style, as Anna Froula argues in chapter one of this volume, 'Steampunked: The Animated Aesthetics of Terry Gilliam in *Jabberwocky* and Beyond'. Here Froula examines Gilliam's influence on and adoption of the steampunk aesthetic by examining his animation and his live-action film, especially his first solo-directed film, *Jabberwocky*. In chapter two, 'Grail Tales: The Preoccupations of Terry Gilliam', Tony Hood provides a detailed overview of Gilliam's artistic quest to create myriad worlds and his bid to try to have power over them. He argues that it is a full exploitation of this creative licence to control that characterises the fantastic and diverse territories that Gilliam constructs. In chapter three, '"And Now For Something Completely Different": Pythonic Arthuriana and the Matter of Britain', Jim Holte charts the romantic and mythical legends that are taken up in *Monty Python and the Holy Grail* (1975) and later in the Python team's *Spamalot* (2005). He explores how the fascination with Britain's mythical and historical past is made mad – yet strangely comprehensible – by the Python team.

Keith James Hamel in chapter four, 'The Baron, the King, and Terry Gilliam's Approach to "the Fantastic"', explores the narrative of fantasy through an engagement with Todorov and his theorisation of the concept. Using *The Adventures of Baron Munchausen* and *The Fisher King* as key texts, Hamel interrogates the notion of fantasy and suggests ways in which Gilliam frustrates the formula with his particular auteurist twist. In chapter five, 'The Subversion of Happy Endings in Terry Gilliam's *Brazil*', Jeffrey Melton and Eric Sterling discuss Gilliam's focus on dreams and their ability to enable characters to escape from the tedium and/or trauma of their modern lives. The characters battle, they state, with 'both inner demons and the outer world in troubled efforts to save (or find) their humanity'. In *Brazil* the dream is the ultimate escape from the horrific circumstances in which Sam Lowry finds himself.

Such dreams or nightmares are also explored by Jacqueline Furby in chapter six, 'The Fissure King: Terry Gilliam's Psychotic Fantasy Worlds'. Here Furby examines the 'film's central concern with fantasy storytelling and the mental condition of psychosis' to explore Gilliam's construction of narrative around Parry as he comes to terms with the traumatic loss of his wife. Trauma in *Twelve Monkeys* is also discussed by Gerry Canavan in chapter seven: '"You can't change anything": Freedom and Control in *Twelve Monkeys*' employs the notion of the biopolitical to understand the central themes of regulation, imprisonment and control. *Twelve Monkeys* exemplifies Gilliam's anger at outrageous bureaucracy and oppression, to which he often returns in his films. In chapter eight, '"It shall be a nation": Terry Gilliam's Exploration of

National Identity, Between Rationalism and Imagination', Ofir Haivry discusses *The Brothers Grimm* and its play with national and cultural identity. Haivry suggests that fantasy – such as that of the Grimm Brothers, and indeed, Gilliam – is adept at exploring the excesses of the political dimensions of nationalism in terms of both images and ideas and address the significance and the consequences of conflict, as they relate to national identity.

Kathryn A. Laity tackles one of Gilliam's least critically successful films, *Tideland*, and considers some of the reasons for its unpopularity. In chapter nine, '"Won't somebody please think of the children?": The Case for Terry Gilliam's *Tideland*', Laity discusses the film's narrative focus on the notion of the monstrousness that can surround a child but that many instead read as engaging with a child that is monstrous. Its horror genre style takes the director away from his more quirky fantasy approach to the dark side of life, even as in true Gilliam style there are still moments of absurdity and humour that undercut the difficult subject matter of the narrative. In chapter ten, 'Divorced from Reality: *Time Bandits* in Search of Fulfillment', Jeff Birkenstein approaches his analysis of *Time Bandits* from an autobiographical stance and discusses the ways in which Gilliam treats the child in his films with a respect and tolerance that he very often does not give to adults. Birkenstein argues that in *Time Bandits* Kevin's quest to understand what family really is takes him to fantastical places that Gilliam skillfully negotiates for both child and adult audience; experiencing the film from both perspectives has enabled Birkenstein to understand some of his own ghosts and fantasies from the past.

Finally, in chapter eleven, 'Celebrity Trauma: The Death of Heath Ledger and *The Imaginarium of Doctor Parnassus*', Karen Randell explores Gilliam's last major film to date and its traumatic journey to screen following the death of Heath Ledger during production. She suggests that the narrative structure of the film contains a significant gap caused by the loss of the star that is not fully recuperated through the performances of the three 'behind the mirror' actors: Johnny Depp, Jude Law and Colin Farrell. Ledger's spectre is writ large throughout the film and adds a melancholic air to the tone of what is already a dark and deeply philosophical film.

In an exclusive interview for this volume, Gilliam admits, he is 'just a prisoner of my own limitations … There's obviously some little creature inside of me that only wants to do what it wants to do … I don't have a choice.' With typical modesty Gilliam describes his fantasy visions as something beyond his artistic control, beyond his conscious construction but to which he must adhere, even as it has meant a lifetime of frustration, fighting the Hollywood machine.

There is a growing body of work on 'Terry Gilliam Cinema', and we join a collective of scholars, industry practitioners and film critics who admire his complexity and vision. *The Cinema of Terry Gilliam: It's a Mad World* enters this discussion by offering a collection of critical essays that engage in multiple approaches to reading his films. In *Dark Knights and Holy Fools*, Gilliam comments, 'you can write about them all you want but movies are basically there to be seen' (McCabe 1999: 5) and reminds us that very soon, maybe now, we need to put down the pen, turn off the computer, and go watch a Terry Gilliam film… or opera… or animation, or…

Notes

1 See *Where Buffalo Roam* (Art Linson, 1980) for another approach to the life of journalist Hunter S. Thompson.
2 See, for example, Ebert (1998); Gleiberman (1998); Holden (1998); McCarthy (1998); Tobias (2011).
3 See, for example, Monty Python (1999, 2006, 2007); Monty Python and McCabe (2005).

Works Cited

Christiansen, Rupert (2011) 'The Damnation of Faust, ENO, London Coliseum–Review', *The Telegraph*, 9 May. Online. Available at: http://www.telegraph.co.uk/culture/music/opera/8502174/The-Damnation-of-Faust-ENO-Coliseum-review.html (accessed 28 May 2011).
Christie, Ian and Terry Gilliam (2000) *Gilliam on Gilliam*. London: Faber.
Cullen, Mitch (2000) 'The Metaphorical Sperm Donor Masturbates', *Dreams: The Terry Gilliam Fanzine*. Online. Available at: http://www.smart.co.uk/dreams/tidecul2.htm (accessed 27 May 2011).
Ebert, Roger (1998) '*Fear and Loathing in Las Vegas*', *Chicago Sun-Times*, 22 May. Online. Available at: http://rogerebert.suntimes.com/apps/pbcs.dll/article?AID=/19980522/REVIEWS/805220303 (accessed 17 May 2011).
Gleiberman, Owen (1998) 'Fear and Loathing in Las Vegas,' *EW*, 29 May. Online. Available at: http://www.ew.com/ew/article/0,,283406,00.html (accessed 17 May 2011).
Holden, Stephen (1998) 'A Devotedly Drug-Addled Rampage Through a 1971 Vision of Las Vegas', *The New York Times*, 22 May. Online. Available at: http://movies.nytimes.com/movie/review?res=9800E7DF1039F931A15756C0A96E958260&scp=3&sq=fear%20and%20loathing%20in%20las%20vegas&st=cse (accessed 17 May 2011).
Marks, Peter (2010) *Terry Gilliam*. Manchester: Manchester University Press.
Mathews, Jack (1998) *The Battle of Brazil: Terry Gilliam v Universal Studies*. New York: Applause.
McCabe, Bob (1999) *Dark Knights and Holy Fools: The Art and Films of Terry Gilliam*. New York: Universe.
____ (2006) *Dreams and Nightmares: Terry Gilliam, The Brothers Grimm & Other Cautionary Tales of Hollywood*. London: HarperCollins.
McCarthy, Todd (1998) '*Fear and Loathing in Las Vegas*', *Variety*, May 16. Online. Available at: http://www.variety.com/review/VE1117477489?refcatid=31 (accessed 17 May 2011).
Monty Python (1999) *Monty Python's Big Red Book*. London: Meuthen.
____ (2006) *The Very Best of Monty Python*. London: Meuthen
____ (2007) *The Brand New 'Monty Python' Papperbok*. London: Meuthen.
Monty Python and Bob McCabe (2005) *The Python's Autobiography*. London: Orien.

Seckerson, Edward (2011) 'A Mischievous Showman', *The Damnation of Faust* [programme]. London: English National Opera, 8–13.

Smith, Giles (1998) 'War Games: Terry Gilliam Goes Gonzo With *Fear and Loathing in Las Vegas*', *The New Yorker*, 74, 74–9.

Solman, Gregory (2004) 'Fear and Loathing in America: Gilliam on the Artist's Fight or Flight Instinct', in David Sterritt and Lucille Rhodes (eds) *Terry Gilliam: Interviews*. Jackson, MS: University Press of Mississippi, 184–207.

Sterritt, David and Lucille Rhodes (2004) *Terry Gilliam: Interviews*. Jackson, MS: University of Mississippi Press.

Tapper, Michael (2006) 'Beyond the Banal Surface of Reality: Terry Gilliam Interview', *Film International*, 4, 1, 60–9.

Tobias, Scott (2011) 'The New Cult Canon: *Fear and Loathing in Las Vegas*', *The A.V. Club*, February 24. Online. Available at: http://www.avclub.com/articles/fear-and-loathing-in-las-vegas,52308/ (accessed 17 May 2011).

Yule, Andrew (1991) *Losing the Light: Terry Gilliam & The Munchausen Saga*. New York: Applause.

TERRY GILLIAM INTERVIEW

with Karen Randell – 3 May 2012

KR: Do you know anything about the project that we're doing?
TG: Well, it seems to be a book about somebody called me.
KR: Yes, that's exactly right. This will be called *The Cinema of Terry Gilliam: It's a Mad World*. We hope you like the word 'mad' in there. We thought it was appropriate somehow.
TG: [Laughs]
KR: It came about … I've edited this with two of my colleagues from the US, Jeff Birkenstein and Anna Froula. We were editing a book about 9/11, actually, about post-9/11 culture…
TG: And you thought of me.
KR: What happened was that one of the abstracts was on *Brazil*, and we thought, well, that was made in 1985, and we hadn't seen it for a while. So we all sat and watched *Brazil* and realized that the guy was quite right. It was an incredibly prophetic film about our post-9/11 culture, so we included it in our 9/11 book. And when we were watching the movie and drinking beer and eating pizza, Jeff said, 'Hey! Somebody should write a book about this guy.' So, here we are. A couple of years later, we now have eleven essays on most of your major films, actually, right up to *Doctor Parnassus*.
TG: Fantastic.
KR: We asked all of our contributors that if they met you, what would they want to ask you, so we've got a few questions … Jeff wrote about *Time Bandits*, and it was an incredibly important film for him when he was growing up, and he wanted to know, in all your movies about children, are the children really the adults? And also, when you make a movie with only adults, are they about children anyway?
TG: I suppose they're all about children and holy fools. I think it comes down to a very simple thing. It's the Hans Christian Andersen fairy tale, 'The Emperor's New Clothes'. Of all the people watching the king process, only one, a child, sees the truth, and that's the fact the king is naked, and it's all been a con. And I always

IT'S A MAD WORLD 9

thought children just seem to see the world with unfiltered eyes. As we get older, we put filters on everything. We seem to think that we have the standard. We put things in boxes, just a more controlled set of experiments, I suppose, and I just think kids don't. They can put their finger on the truth much more accurately than all of our wise men. I think that way even in films with just adults in them, there's usually somebody in there who is the childlike one, or the holy fool, one of the two.

KR: *The Fisher King* would be a really good example of that. We thought you might say something like that.

TG: That's probably one of the essays already.

KR: No, not really, but thank you.

TG: Basically what I don't do is change my attitude towards life very often.

KR: We were wondering about that, actually. Only because two of us write about post-war films, and we're very interested in post-9/11 culture and wondered whether that had affected your thinking and your filmmaking, that great terrible moment, or whether you have just kept the same kind of themes going. It seemed *Parnassus* had a kind of edge to it around politics.

TG: *Parnassus* is a little bit more about me – well, *Parnassus* links to *Munchausen*. It's really about getting older and thinking that the things I want to say nobody wants to listen to. It's about that really in a more general sense. It's about how the world seems to pay little attention to wonder, the wonders that are around them, they're so fixated on what I think are banal things and such immediate things, things that have just to do with the moment, as opposed to experiencing the moment. You can't exactly experience the moment 'cause you've got to tweet about the moment. It's a frenzy going on out there. I think to really enjoy the world and to really look at it you've got to isolate yourself. I'm pushing aloneness these days. Loneliness, aloneness. People break the social contract. I've got into the anti-social contract where you pull away from all the noise. Have you ever read Don DeLillo's book *White Noise*?

KR: No, I haven't.

TG: It's a great one. It's honest. It's about the tsunami of pointless information that just fills the head all the time and how it just dominates everything. And it's stopping people from really standing back and looking, and I suppose I always want to encourage people to do that or to allow themselves to be surprised and shaken out of their worldview.

KR: I understand. I've always thought that nowadays everyone's got a soundtrack to their life, 'cause wherever you go there's music playing, right?

TG: I know! It's terrifying.

KR: It's not necessarily the soundtrack you've got going on in your head either.

TG: I left New York actually for England eventually, because in New York it was like being on a Roman warship where all the rowers are rowing to the beat of his drum. And the drum was the beat of the city being tamed and I wanted to work to a different beat, a different rhythm, and I couldn't while I lived in New York. It was overpowering, the beat of the city, so I left.

KR: I can understand that. On a different note, though everything's always connected, I think for you and your work. What do you think about steampunk?

TG: I never thought about steampunk until I started seeing stuff on the web about steampunk, and it always related to my films. So I was poking around in some of the steampunk websites, and I seemed to be one of the patron saints of it.

KR: Absolutely. Anna certainly thinks so. She's written an essay for the book about the way you use steampunk.

TG: That was invented after we started playing around. I've always had a fascination with older technology because I can understand it. I can actually do something about it. When a computer goes down you have to buy a new one. I don't know how to fix those things, but an old mechanical steam-driven thing, you understand exactly how it works and the possibility of fixing it.

KR: So you didn't read Gibson, then?

TG: That is interesting. Is that where it comes from?

KR: Yeah.

TG: *Neuromancer*'s the only book of his that I've ever read. I don't think steampunk is mentioned in there.

KR: Well, I tell you what. When it's finished we'll send your agent a copy of the book, and if you have a moment…

TG: I'll read all about myself and what I seem to do.

KR: And what you've created. Isn't that funny? That's really ironic, isn't it?

TG: To be honest, I do find it very interesting that I read what people write about the stuff I've done, and I find it amazing that they're really writing about their interpretations and their impressions about what I was doing, what I was thinking. I find intriguing that the films, well, they do exactly what I want them to do, they encourage other people's imaginations to take flight and so the films become their films and not mine.

KR: Well, I think that's a real strength in the films, though. I think that is why they've got legs. Now, thinking about your audiences, do you want them to get political or think about oppression? I'm thinking about *Brazil*, *Twelve Monkeys* – the films that really think about the establishment. Are you interested in thinking about politicizing your audience? Or is it just your vision again?

TG: Again, I graduated university in political science, so I've read a lot of books, so they're stuck in my head and it comes out, yes. I do rail against the system all the time. Sometimes I'm right even; sometimes I'm wrong. It's political in a broader sense and more about getting people to think and to look at the world around them and try to understand it and not just be trapped by buzzwords and knee-jerk reactions to things. It's the connections that intrigue me, and, always inevitably, it's either escape from society or one is part of society and, for me, that's always a difficult choice. And if you're part of society I think you should really understand how it works and the things that are wrong, try to do something about it. It doesn't always mean you'll succeed. But there's a line I'm always pleased we left in, when the Supreme Being is taking the Time Bandits back to heaven, and one of them, Fidget, says, well, can't Kevin the boy come with us? He says, no, he's got to stay

here and carry on the fight. It's that, it's just carrying on the fight. It's not that you win the fight or that one side is necessarily good and the other evil, it's just that there has to be a balance maintained and the intelligent person, hopefully, can help right the balance. Let's put it that way: it's swung too far the wrong way.

KR: Right, right, well certainly, those films create a lot of discussion in the classroom, so, hopefully you're pleased to know that.

TG: Well, that's great, I couldn't be happier, people talking about them, arguing about them, fighting about them. That's good, if I've made something interesting happening.

KR: You have and those two films in particular, *Twelve Monkeys* and *Brazil*, are still the two films that really speak to the students. Certainly, David Price, who wrote about *Brazil* for us for *Reframing 9/11*, thinks that *Brazil* is prophetic. Did you think about it again after, well you must go through airports a lot, do you think about *Brazil* when you're being searched, and going through all the security?

TG: [Laughs] Well, when I was in America promoting *Tideland*, I was considering suing George W. Bush and Dick Cheney for the illegal and unauthorised remake of *Brazil* ... *Brazil* was, to me, commenting on the times we were in. It was very much a documentary, I think. Everything in there was happening at that point. It's just now it's become bigger and more in your face and more intrusive, and that's all. There was much more terrorism going on then, in the 80s than there is now, so this is the joke of it. But what is interesting is, really, there's no past anymore. People just don't seem to pay attention to what happened before, and there was a much more violent time. The IRA was busy bombing London, the Baader-Meinhof gang was rampaging around Germany, the Red Brigade in Italy. In Argentina and places in South America, you had to pay for your incarceration and even your torture. So all of these things were going on and they are going on now. I don't know, there's probably less terrorism now. There's certainly a more heavy-handed State, and, certainly, the Homeland Security is the Ministry of Information, and if there aren't terrorists we will make terrorists.

There is a piece I've just read recently, about whatever is happening with all the arrests or even convictions in America, or lack of convictions, for terrorist acts. And the majority of them, or maybe not the majority – let's not over-state it – half of them, were all initiated by the FBI encouraging people to do certain things. And as soon as they did they were arrested. That's very different than people going out on their own and doing something. So, that's the Ministry creating terrorists when nothing else is out there to blow things up.

KR: Well thank you. That's really helpful. My students make those kinds of points really, about the torture, of course, the explicit use of torture in *Brazil*, when we're *not* torturing anymore.

TG: Really? Oh, really, that's good to hear. That's the one thing I was wrong about in *Brazil*: we don't torture anymore. I think *Brazil* stopped torturing going on.

KR: [Laughs] Apparently.

TG: People will always torture.

KR: Yes.

TG: I mean that's the horrible fact of it. It's about how much you can limit and how much you can remove the hypocrisy of governments, but it's not going to stop. Because it's fun for some people who don't get proper jobs. [Laughs] I never got into torture but I haven't got proper jobs either.

KR: Just thinking about war again, we used *Fear and Loathing in Las Vegas* as a focus for the introduction of the book, and it seems that you were definitely creating a visual relationship between Vietnam in *Fear and Loathing* and possibly the first Gulf War. Now is that us over-reading your text?

TG: It wasn't the Gulf War, but it was dealing with the Vietnam War. I mean, there are funny things in there, if you look carefully. We've got people in there with Vietcong uniforms, and all sorts of little references. If you're very, very crazy and want to waste your time looking for them you can find them.

KR: We did that! We kept stopping the DVD. We are those people. That's exactly what Anna and I did.

TG: [Laughs] That's why I don't like film courses [laughs], because they waste people's time with things like that.

KR: It was in the evening, we were drinking beer, it was fine.

TG: Well, as long as you were drinking, that's fine.

KR: You mentioned before, and obviously we've looked at all your books (with Ian Christie, for instance), that the spark for *Brazil* came from a seventeenth-century document that you stumbled across. How much do you poke around researching your films, or are you just reading for your own joy and then things happen for your films?

TG: Well, both. I read constantly, and basically what I do with it is forget it. I couldn't tell you what I read last week, but it's obviously going in there, and what I hope is that it comes out in some form. So I read a lot and I get intrigued by things. Things spark me off, and then I start doing a lot of research. I read as much around the subject as I can to discover things; that's how it works. I think I am desperate to maintain a sense of serendipity. It's what I do. It's one of the things that bothers me about the web. Even though it works wonderfully, I find when I use a dictionary on the web it makes me crazy when I don't spell the word right or I only find that one word. If I go to my Oxford Dictionary and open it up, I bump into a lot of things along the way when I hunt for the word I'm after.

KR: I'm going to quote you when I talk about research to my students – that's perfect! They might listen to you.

TG: I mean, Wikipedia's great for other things, 'cause when I did this opera last year at the English National Opera, *The Damnation of Faust*, I found extraordinary things on Wikipedia by just hunting in a funny little way, that worked, but it's online dictionaries that make me crazy. I like the book.

KR: I don't want to be rude, but I'm 50 and I'm thinking back on my life already. You're 71, is that right?

TG: That's not rude, that's just pathetic.

KR: Yeah, oh, I'm sorry. [Laughs] Do you look back and think, 'Could I have done something else or more or less or…?'

TG: Yeah, I could have done much more if I hadn't been so pig-headed about wanting to do just what I wanted to do, that's the price you pay to do what you want to do and control the stuff. You do less, I suppose, because it's film. It's very funny, at the moment; my daughter has become an archivist around the house here, going through all my work. She has everything I've ever done put in boxes.

KR: Right. Well, some film student will love that one day.

TG: Well, hopefully, because I'm just discovering all this stuff I've done, and I don't linger in the past. It doesn't interest me. It's done. It's finished. It's what happened. The future is, well, actually, the future is getting shorter. That's the good thing, so I don't have to worry as much about the future as I used to. And mainly, it's just what's happening right now. How is a day going? How is this week going to be? And it gets very frustrating if I'm not doing what I want to do, which is making films. And I find, it's the money at the moment that is very difficult. The film business, unless you're spending 100 million or 200 million or under 10 million, the middle ground is really difficult. It's just like the world in that one sense … film budgets reflect society perfectly. The rich, a very small number, have huge amounts of money to play with and the poor are always the poor. But the middle ground is the one that's squeezed. So, here we are.

KR: So, have you got a new project running?

TG: Well, no. For the last eight months I've been trying to resuscitate *Quixote*.

KR: Oh, you have!

TG: Yeah.

KR: Well, we did hear that, but … wow.

TG: I don't know, eight months gone with nothing to show for it.

KR: So, you're not out on the street begging again.

TG: Yeah. I mean, that's exactly how it works. The money may happen, but it may not. I think it isn't going to happen. Too many things are running against us at the moment. But it's just the way it is. I watch other people, good friends, people like Stephen Frears. He's not as obsessed as I am. He likes making movies. I like getting my ideas onto film. There's a big difference.

KR: Is that because you are an artist?

TG: Listen, there's nothing great about being an artist, if that's indeed what I am. I'm just a prisoner of my own limitations, is what it is. I'm trapped. There's obviously some little creature inside of me that only wants to do what it wants to do. Me, I'd rather keep busy doing anything, but this other guy won't let me. I don't have a choice.

KR: That's an interesting idea, if you think about it like that.

TG: It's why whenever I talk to film students, I say, 'You've got a choice. Either you can go out and be a film director, or a director, or you can be what I think is a film-maker. And they're different.' Last night, I went to see *Avengers Assemble*, because I wanted to see what it was like. And I go down to Finchley Road. I get in there with all the kids. It must look pretty odd, this old guy in the middle of all these teenagers. But I was curious, and it's an incredibly well-made object. There's no question about it. It's very smart at times. It's got some wonderful actors in it. It's

technically extraordinary. And, there it is. BUT it's not the individual voice I try to listen to or try to be. And, therefore, I like reading books, because it's a single voice writing them. Obviously not your book about me, because that's obviously a lot of people babbling. [Laughs]

KR: [Laughs] We are babbling, too. That is what we do.

TG: I know, books babbling.

KR: We get paid to babble, too, which is just marvellous.

TG: I love brooks and streams, they babble.

KR: Yeah, that's us.

KR: I met Alan Parker last week and he did this fantastic impression of you, actually, because he was talking about having been asked to potentially direct *Harry Potter*, and that you were also asked to do it. And he was saying that you told the studio, 'Let's make it dark! Let's scare the shit out of the children!'

TG: Well, exactly. I remember, when Warner Brothers was talking to him, he said, 'Why are you talking to me? The guy that should be doing this is Gilliam.'

KR: And then you scared them to death.

TG: Well, that's the thing. We know what we're good at. We know what we're capable of. We know what our skills are. But the Hollywood system doesn't know what people's skills or talents are. They just know who's been successful last week. And it gets worse. [A successful director] used to be good for three films, before you had to go and beg on the streets. Now, if the last one didn't work, you're begging again. It's simple now.

KR: OK, Terry, that's been absolutely fantastic. Thank you so much.

TG: I hope you publish this.

KR: We will. It's going to come out next year. Like films, there's more time in post-production than there is in production.

TG: Yes.

KR: So, when it's out, I will obviously send [you] a copy. If you like, we'll sign it for you, how 'bout that?

TG: [Laughs]

KR: That's different, huh?

TG: Alrighty…

CHAPTER ONE

Steampunked: The Animated Aesthetics of Terry Gilliam in Jabberwocky and Beyond

Anna Froula

> Whatever works best is what I do. I don't have any aesthetic thing about one or the other.
>
> Terry Gilliam (Adams 2010)

Terry Gilliam made the transition from illustrator to movie-maker when he made his first animation for *We Have Ways of Making You Laugh* (1968). With a £400 budget and a two-week deadline, he volunteered to translate the potentially funny but seemingly unusable 'tapes of terrible punning links between records made by disk jockey Jimmy Young' into visual language (Marks 2010: 18). Inspired by the technique of avant-garde filmmaker Stan Van Der Beek, Gilliam explains, 'I could do what I do – cut-outs. So I got pictures of Jimmy Young, cut his head out and drew other bits and pieces and started moving the mouth around' (Monty Python and McCabe 2005: 113). Gilliam's ability to make such visual spectacles on the cheap using found material has become one of the director's trademarks. From his *Monty Python's Flying Circus* (1969–74) animations to his live-action films and computer-generated art, he has forged his own distinct aesthetic of cinematically dense, textured worlds that are mundane yet absurd, hallucinogenic yet barren, and bursting with gadgetry and grotesquerie. His rich aesthetic sensibility reflects such influences as German Expressionism, Ray Harryhausen, Hieronymus Bosch, Alfred Hitchcock, Lewis Carroll, *Mad* magazine, and a Chevrolet assembly line.[1] These influences and experiences coalesce in his animation and live-action production design to satirise modern dehumanisation and apocalyptic dystopia via neo-Victorian design, absurdist medievalism, intestinal

ducts and anachronistic technologies. By examining his animation and his live-action film, especially his first solo-directed film, *Jabberwocky* (1977), this chapter traces the ways in which Gilliam's aesthetic has influenced and incorporated the visual style and movement known as 'steampunk', a postmodern aesthetic and rebellious movement mixing Victorian imagery and steam-powered technology.

Gilliam's aesthetic is immediately recognisable yet difficult to define. Peter Marks underscores the difficulty of categorising the filmmaker at all because of the hybridity that he and his films embody (2010: 2–6). This is partly geographical, for the native Minnesotan has lived in England since the late 1960s. As Marks details, Gilliam's filmography fits within a range of 'UK Film Categories', some of which combine American and British finance and some US productions that incorporate British finance, 'creative involvement', or 'cultural content' (2010: 45). The director's films also blend genre categories, such as the 'previously undemographed medieval comedy market' with *Monty Python and the Holy Grail* (1975), which he co-directed with Terry Jones, and *Jabberwocky*, his solo directorial debut (Marks 2010: 10; McCabe 1999: 63). Gilliam describes his work as 'reactive' – an 'alternative' to 'the way the world sees itself, or the way the world is being portrayed' (Adams 2010). Both reactionary and revolutionary, Gilliam's approach to filmmaking manifests both the process and aesthetic we now describe as steampunk.

Like Terry Gilliam as filmmaker, steampunk is difficult to define because it is, as Rachel Bowser and Brian Coxall write, 'part of this, part of that' (2010: 1). Steampunk's suffix denotes its status as an artistic movement distinguished by countercultural themes that focus on 'underground movements, marginalised groups and anti-establishment tendencies' (Remy 2007). Whereas cyberpunk is concerned with a data-powered world, steampunk focuses on the material and industrial world. By convention, steampunk deploys intertextuality, pastiche, bricolage and anachronism (see Pagliassotti 2009). Gilliam's aesthetic – and the kind of anarchist, rebel ideology it embodies – both exemplify and inspire the slippery tenets of steampunk, in particular historical anachronism, claustrophobia, pastiche, some 'invocation of Victorianism' and machinery: wires, gears, cogs and ducts – lots of ducts (Bowser and Coxall 2010: 1).

Bowser and Coxall explain elsewhere: 'steampunk is about things – especially technological – and our relationship to things' (2009). In contrast with the slick contemporary design of surfaces that the consumer can only stroke and tap but not open and/or repair (such as the recent generation of Apple devices), steampunk exposes the innards of things and society by making them visible. Bowser and Coxall identify one defining element of steampunk as 'the invocation of Victorianism', for example, stories set in London or 'in a future world that retains or reverts to the aesthetic hallmarks of the Victorian period … or a text that incorporates anachronistic versions of nineteenth-century technologies' (2010: 1). Steampunk's appearance is characterised by the Victorian industrial: 'dirigibles, steam engines, and difference engines built out of brass rods and cogs, cogs, cogs' (2010: 16). The cogs are particularly significant because steampunk's insistence on the visibility of labour makes it more than an aesthetic. Gilliam's development as an artist coincided with the historical period in which the elements that would become steampunk emerged. Cory Gross describes this

moment in history – that is, the My Lai massacre, the Summer of Love, Woodstock, the Stonewall riots, the moon landing, the avant-garde cinema of Stan VanDerBeek and Kenneth Anger – as a time in which 'the romance of the Victorian Era' and other 'threads were fermenting that would, by the late 70s, mark the rebirth and eventual solidification of what would come to be known as Steampunk' (2008).[2]

As a movement, steampunk also performs 'a kind of cultural memory work, wherein our projections of fantasies about the Victorian era meet the tropes and techniques of science fiction, to produce a genre that revels in anachronism while exposing history's overlapping layers' (Bowser and Coxall 2010: 1). By interweaving different time periods and by making visible the inner workings of an object or system, steampunk criticises capitalism's historic 'lack of mercy' in its treatment of 'both the haves and have nots' (Nevins 2008: 10). In its insistence that we confront labour in visible, material forms, steampunk teaches us 'to read all that is folded into any particular created thing – that is, learning to connect the source materials to particular cultural, technical and environmental practices, skills, histories and economies of meaning and value' (Forlini 2010: 73). As Dru Pagliassotti suggests, 'by recycling and rethinking history's lost dreams and obsolete technologies within the context of contemporary historical awareness, steampunk is poised to offer the world, with an ironic wink and a shiny brass-and-wood carrying case, a vision of the future that offers cautious hope instead of dystopian despair' (2009). However, both hope and despair characterise Gilliam's movies, which embody the optimism of the Victorian period's exciting possibilities and emerging technologies, as well as the dystopian result of these same technologies: the unspeakable slaughter of World War I. In particular, his narratives that are told from a child's perspective – *Time Bandits* (1981), *The Adventures of Baron Munchausen* (1988) and *Tideland* (2005) – open up fantastic visions of endless possibilities and reflect his sense that children are as intelligent as adults (if not more so), albeit less experienced: 'Their minds are just as active – more so, in fact, because they haven't been limited and defined yet. To them, wonderful things can happen' (Sterritt and Rhodes 2004: 17). The child's subjective point of view, however, stands in stark contrast to Gilliam's adult worlds of hyperconsumerism (*Time Bandits*), war-mongering (*Baron Munchausen*) and neglect (*Tideland*) and serves also to underscore the 'scathing indictment of modern culture' that characterises his films and steampunk itself (Jones 2010: 103).

Steampunk as Aesthetic and Process

Gilliam's aesthetic also evokes the artistic influences listed above, and he has yet to describe his production design as steampunk, *per se*. Nevertheless, its distinctive look, ideology and themes permeate much of his production design and approach to filmmaking and have done so since before the term 'steampunk' was coined in 1987 in a letter written by K. W. Jeter in *Locus* magazine (see Di Filippo 2010). Bruce Sterling and William Gibson's *The Difference Engine* (1990) is credited as the literary progenitor of modern steampunk, and Jules Verne and H. G. Wells are cited as steampunk's aesthetic inspiration, but, as Paul Di Filippo points out, 'the ex-Python gets too little credit as an outlier of the steampunk movement' (ibid.). However, Gilliam's steampunk vision

has inspired a new generation of artists, such as 'Datamancer' (Rich Nagy), who credits *Brazil* as part of the inspiration for his innovative brass and wood laptop computer embellished by shiny gears and an ornate crank power switch (see Frucci 2007).

Yet Gilliamesque steampunk does more than expose labour and celebrate Neo-Victorian craftsmanship. Two of *Brazil*'s initial working titles, *Brazil, or How I Learned to Live With the System SO FAR* and *1984½*, explicitly invoke, respectively, Stanley Kubrick's critique of nationalist militarism and George Orwell's critique of nationalist totalitarianism, thus anticipating what Pagliassotti conceives of as steampunk's ideology. Pagliassotti argues that its Neo-Victorianism ironically challenges Victorianism's affection for nationalism and 'the propagation of cultural imperialism' by not 'adopting all of the Bad Old Ideas of Victorianism … not its sexism, racism, classism, poverty and other ills' (2009). Similar to the Victorian images that populate Gilliam's early animation for *Monty Python's Flying Circus*, the Pythons play a squad of Tommies in *Monty Python's Meaning of Life* (1983) in 'Part III, Fighting Each Other' and give Captain Biggs (Terry Jones) several timepieces, including an ornate Victorian clock, for his birthday.

The delicate craftsmanship of the glass-encased clock with exposed ornate gears and its absurd appearance in a desolate, muddy trench highlight its contrast with the senseless and brutal war machine of World War I, particularly when Blackitt (Eric Idle) takes a bullet in the chest before the rest of the troops are killed, one by one. This satire of oppressive totalitarianism that treats humans as utilitarian automatons frequently appears in Gilliam's production design, from his medieval tales to his science fiction and opera, via motifs of Neo-Victorian gears and dials fused with cogs, clock faces, keyboards and the ubiquitous ducts.

Such an industrial *leitmotif* characterises the interrogation room in *Twelve Monkeys* (1995) where scientists in the future evaluate Cole (Bruce Willis) as a 'volunteer' for time travel. In the introductory scene, after Cole's visit to the desolate winterscape above the underground shelter, figures in elaborate rubber suits and protective masks scrub him with mops and hoses from a distance. Clean and naked, he draws blood from his own arm with a Victorian syringe in an exam room observatory populated by

Celebrating the Captain's birthday in the trenches in *Monty Python's Meaning of Life*

Dystopian steampunk in *Twelve Monkeys*

machines composed of exposed sprockets and automated pistons. Next, guards lead him into the interrogation room while an announcer's voice informs over a loudspeaker, 'there will be socialization classes in 0700'. One guard declares him 'clear from quarantine', and another scans the barcode on Cole's neck. At his captors' direction, Cole lets himself be mechanically restrained in a chair that lifts him into the air so that the scientists can communicate with him at a remove, broadcasting their faces and conversation through multiple small screens and speakers that adorn a brass-covered globe. The flywheels, dials and other guts of the scientists' computers are exposed in a series of glass-topped tables, onto which clutter brass instruments, a variety of clocks and multiple gauges.

The industrialised complex of exploitation via Neo-Victorian mechanics imprisons Cole in a dystopian future run by a totalitarian regime of 'rational' scientists. Gilliam's production design particularly embodies steampunk's 'harsh view of reality', in which, as Bruce Sterling has observed, 'anything that can be done to a rat can be done to a human being. And we can do most anything to rats' (Remy 2007). In *Twelve Monkeys*' future, the scientists experiment on people with dehumanising technology that is also faulty, such as when Cole and a fellow traveler are sent into the trenches of World War I.

The scientists' dependence on scavenging together a working laboratory out of whatever materials can be salvaged and recycled after the virus devastates the global population has less dystopian roots in Gilliam's creative process, which principally engages steampunk's deployment of bricolage. His meshing of outdated and updated technological fashions both anticipates and reinforces steampunk's focus on historical anachronism. As a cartoonist for *Help!* magazine (1960–65), which was created by *Mad* magazine founding editor Harvey Kurtzman, Gilliam became skilled in creating '*fumetti* – photo comic strips that essentially played like a movie storyboard with characters speaking in word bubbles, with Gilliam often writing, casting, and photographing them himself' with a '16mm Bolex camera and a tape recorder (McCabe 1999: 16, 18).[3] As Gilliam remembers, 'We were always stealing film from trash cans and drawing on it. We'd animate right on the clear film' (McCabe 1999: 18). When he began working as an animator in London on the children's television show *Do Not Adjust Your Set* (1967–69, with Michael Palin, Eric Idle and Terry Jones) and on *We Have Ways of Making You Laugh* (1968), he honed this approach to his innovative 'cut-animation' that flourished on *Monty Python's Flying Circus*. To create his cut-outs, he spent time at the British Museum looking for free materials from 'a lot of dead painters

and a lot of dead engravers' to draw and cut into moveable parts that he would place in a setting and photograph two frames at a time, making the filmmaker, in his own words, the 'premier cut-out animator of the era' (McCabe 1999: 24; Gilliam 2006).

The opening credit sequence of the first episode of *Monty Python's Flying Circus* revels in the anachronisms created through Gilliam's bricolage process. As Bowser and Croxall observe, 'anachronism is not anomalous but becomes the norm' in steampunk (2010: 3). Marks writes that Agnolo Bronzino's *Venus, Cupid, Folly, and Time* (circa 1545) provides the giant foot that crushes many an unsuspecting angry old man, television set, or 'fat balding gent' (2010: 22). In Gilliam's animations, this motif reverses the *deus ex machina* of the Renaissance, creating machinery out of God. Philippe de Champaign's Cardinal de Richelieu (1633–40) lasciviously pursues a woman lying naked on a steam-powered train. Rembrandt's allegorical painting of his wife as the Roman goddess of Spring (1635) hides her face before cherubs from Nicolas Poussin's *Adoration of the Shepherds* (1633–34) frolic overhead. In turn, the cherubs bat around a disembodied head until, like a fighter jet, one dive-bombs Richelieu and a cartoon figure inflating the black and white photographed head of a man from a nineteenth-century portrait. Sixteenth- and seventeenth-century images romp with the characters from Edison's early film *The Kiss* (1896) and other such 'photographs, airbrushed figures and images that might have been taken from Victorian magazines or posters' (ibid.). The pastiche of fine art and grotesque created via bricolage defines one element of Gilliam's aesthetic and creates a 'cultivated but irreverent stream of consciousness, one that is witty, risqué and subversive' and an introduction to the 'world that would become known as "pythonesque"' (Marks 2010: 23). Yet it is the Gilliamesque 'watcherly' world, *pace* Roland Barthes (1975), of Eisensteinian montage that exposes its own mechanical workings even as it demands that the viewers translate the meaning of the juxtaposition of images.

Gilliam's animation relishes embellishments of Victorian imagery and the proliferation of tubes in steampunk as process and aesthetic. In the introduction to *Monty Python's Flying Circus: Terry Gilliam's Personal Best* DVD (2006), which features many of his most popular animations for the television series, the director tells the viewer that he is trapped in a dungeon to protect the 'truth' about the comedy troupe. In his tongue-in-cheek revisionist history, he explains, 'In the sixties ... before *South Park* [1997–]', the BBC had approached this 'world-famous' cartoonist to make his own 'glorious' all-animated show. This project, however, was destroyed by the introduction of live-action sketches developed by 'some college boys that I found rather down on their luck in Piccadilly Circus selling their well-educated bodies for drugs'. When the implied viewer flips a switch, an explosion transforms Gilliam into a cut-animation version of himself in a steampunked basement studio. As the filmmaker cut-out bounces around the room in wide-eyed panic, two television monitors stacked together play a *Monty Python* skit and an excerpt of Gilliam's animation. The studio is powered by the amputated hand of God from Michelangelo's Sistine Chapel, shooting electricity into a cog hooked to the editing board, a *machina ex deo*. Large ducts curve from the foreground and stretch across the ceiling, one supporting a radioactive warning-sign over a doorway that emits a glowing green light. The Gilliam cut-out cartwheels away

as a spotlight searches the room from above. He cowers as a robot disguised as a camera lowers into the room and seizes the animated artist, squeezing him into blood spatter before curtains fall triumphantly on the grisly scene. The gleeful moment of violence in which creation destroys its creator is emblematic both of the dystopian themes that Gilliam's filmography explores and of the steampunk aesthetic that influences (and is considerably influenced by) his work (see Di Filippo 2010).

The aesthetic elements at work in his *Personal Best* introduction cultivate explicit steampunk animation. In one featured introductory credit sequence, the roses that blossom into the series' title reveal, as the camera tracks back, that they grow from the bald head of a man who is submerged in what appears to be a puddle of urine. Bronzino's giant foot stomps on this bizarre image, and then the scene cuts to a factory that mockingly anticipates the dehumanizing mechanical systems of entrapment seen in both *Brazil* and *Twelve Monkeys*. Surrounded by an ornate system of pulleys, prongs, flywheels and cylinders, a tripod raises a short, mustachioed man into the centre of the frame. An amputated hand hanging from pistons reaches to pluck his head from his neck, then another piston on the right side of the frame shoots out and punches his torso from his body before a third piston attached to an amputated foot kicks a torso onto his legs.

When the manufacture of the Frankensteinian creature is complete, the head is reattached to the feathered torso, and a leg emerges from the piston, kicking it from the tripod stool. The figure tumbles onto a conveyer belt emerging from a coiled duct. In the background, cogs and gears continue to grind, and the hand, now holding a box, collects the hybrid man-chicken from the belt and sets him into another frame with an indistinguishable landscape. A cut-out of a grinning male face wearing Victorian-era glasses initiates more odd events, which result in the chicken man hatching from the egg before flying a *Monty Python Flying Circus* banner across the sky. These factory images comically evoke the grim, inhuman hypercapitalist nightmare of Fritz Lang's German Expressionist masterpiece, *Metropolis* (1925), especially its introductory scene, which portrays human workers as mechanical parts that manufacture the urban industrialisation and traps them in an unending capitalist system dependent on cruel exploitation of labour.

The pastiche creature absurdly undergoes creation and re-creation for mass production that recalls Orwell's Fordist themes as well as Gilliam's early job on a Chevrolet assembly line, which he describes as his 'ultimate nightmare' (Christie & Gilliam 2000: 19). This Gilliamesque steampunk factory also appears in the introductory sequence of *The Meaning of Life*, this time mass-producing identical versions of pudgy families adorned in Mickey Mouse ears from a richly-detailed system of gears, cogs and pulleys.

Such a critique embodies steampunk's anti-establishment tendencies as well as Gilliam's own distaste for Disneyland, which originated when the amusement park conglomerate, suspicious of his long hair, refused to let him enter. While at the park to review new rides for *LA Magazine*, he 'noticed the barbed wire along the top of the fence – Disneyland had become a kind of concentration camp. Truth, justice, and the American/Disney way were getting confused' (McCabe 1999: 31). Jason B. Jones

German Expressionist labour in *Monty Python's Meaning of Life*

argues that such an indictment of modern culture 'is one of the pleasures of steampunk ... and that indictment somehow becomes simultaneously both more damning and more acceptable by being voiced from the [mechanical] moment of that culture's birth' (2010: 103). Eric Idle's song lyrics about humans being 'self-replicating coils of DNA' play over these images, further augmenting this animation's industrial anticipation of steampunk.

Gilliamesque steampunk synthesises the economising practice of reusing found material with a critique of exploitative economic policies, which he develops thematically in *Jabberwocky* and *Brazil*, although this concept also appears elsewhere in his films. When the Pythons made *Monty Python's Holy Grail*, his idea to use coconut shells to mimic horses clopping solved the financial problem of horses being too expensive to employ for the knights. *The Crimson Permanent Assurance* (1983), a short live-action mini-movie Gilliam created for *The Meaning of Life*, also predicates its critique of Reagan/Thatcher economic policies on bricolage. It opens in the 'bleak days of 1983' when insurance agents who struggle 'under the yoke of their oppressive new [American] corporate management' transform their Victorian building into a pirate ship that sails 'the wide accountancy' to fight The Very Big Corporation of America. The ageing agents-*cum*-pirates battle their oppressive executive leadership with fan blades that become swords, create daggers out of stamps and letter holders, and trim sails made of Acme Construction cloths hanging from construction scaffolding. A similar collaboration that combines Gilliam's thrift with contemporary social satire also created the computers that automate bureaucratic kidnapping and torture in *Brazil* in an organic moment of bricolage. George Gibbs, the production effects supervisor, found cheap teletype machines, which motivated Gilliam to remove the housing and replace it with 'the smallest screen we could find: it was like sculpture. Pretty much the whole film was done that way. And you end up with a look that you could never design because you can't think of it' (McCabe 1999: 118). That Gilliam practices such thrift to create props, which manufacture a totalitarian system that automates the torture of citizens without due process, engages the irony implicit in steampunk's bricolage.

Intertextually conjoining the archaic with the contemporary, Gilliamesque steampunk crams frames with anachronistic, ornate structures that expose human exploitation in industrial systems of economic and nationalist domination. In one *Flying Circus* animated sequence, World War I-era Tommy hats converge as a fleet of flying saucers that travel past a monk who has paused from chanting Latin for lunch and

then past a British officer whose duct-like neck snakes from his collar. The hat-saucers spawn World War I British soldiers into a waiting trench, raising the spectre of the Great War while Gilliam was avoiding being sent to the war in Vietnam (a war he opposed). Decades later, these cut-outs culminate in filmic and live-action expression in Gilliam's 2011 production of *The Damnation of Faust*. Cinematic footage of soldiers projects over the titular character in the depths of his despair before Mephistopheles leads him to serve in a makeshift army field hospital. In the opera's overlapping of media, the lightness of Pythonic humor takes on the darkness of the rise of fascism amidst Berlioz's lyrics from 1846. In *The Damnation of Faust* Gilliam's German Expressionist influences saturate his darkly satiric and tragic pastiche of the Holocaust, yet the production – glorying in the merging of the nineteenth and twentieth centuries – somehow retains the spark of humour so pervasive in his early *Monty Python* animations and his computer-generated imagery in *The Imaginarium of Doctor Parnassus* (2009).

In another introductory sequence from *Monty Python's Flying Circus*, Bronzino's foot hops by a tiny house, its ankle propping up a woman in Victorian dress. The British Pythons emerge from the house and slide into a black hole that becomes a human oesophagus, landing in the stomach and gurgling through the intestinal plumbing, depicted as interlocking pipes set in motion by a series of pistons, before a primate burps them out of the system. These industrial signatures of Gilliam's style reflect his fascination with 'the innards of everything, whether it's people or machines. The inner workings of things have always intrigued me … I'm curious about how things work, how the guts of a system function, and the sound of plumbing is always comic' (McCabe 1999: 36). This plumbing fascination is also reflected in a moment of *Monty Python's Meaning of Life*'s introduction when a fat, TV-watching man dissolves into a liquid that seeps into a drain and enters the steampunk Disney family-producing factory described above. Its imagery not only bears Gilliam's aesthetic fingerprint of anachronism but also serves the intent to make labour visible shared by both steampunk and the auteur. The production design bursting with ducts in *Brazil*, he says, 'was a result of looking at beautiful Regency houses, Nash terrace houses, where, smashing through the cornices, is the wastepipe from the loo' (McCabe 1999: 141). This is but one visible manifestation of his conception of time: 'all these times exist right now and people don't notice them. They're all there' (ibid.). Time, for Gilliam, is not anachronistic but synchronic, making industrialisation and imperialism trans-historical.

While promoting *Brazil* in Chicago, Gilliam responded to questions about the ducts by pointing out the typical invisibility of the labour that produces the energy and materials we often unthinkingly consume: '"Well, don't you realize what's behind the walls and the suspended ceiling and under the floor in this room we're sitting in?" It seemed these kids had no idea of the connections needed for all these things, and of the price to pay. I said there was this balance I was dealing with – what is the price? – and they were stunned by that' (Christie & Gilliam 2000: 130–1). Similar to the black clouds of pollutants that trail behind contraptions in Gilliam's collaboration with his long-time creative partner Tim Ollive, the explicitly steampunk trailer for *1884: Yesterday's Future*,[4] and Gilliam's *Metropolis*-like renditions of factories, the retrofitted ducts

expose the guts of society and the labour and price of privilege, both Victorian and contemporary.[5] As the director explains, the initial idea for *Brazil* emerged when he was doing research on the Renaissance period and came across a text from the 1600s at the apex of the witch-hunts: 'This was a chart of the costs of the different tortures and you had to pay for those inflicted on you; if you were found guilty and sentenced to death, you had to pay for every bundle of faggots that burned you. I started thinking about the guy who was a clerk in the court and had to be present while the tortures were going on, to take down testimonies' (Christie & Gilliam 2000: 130). The use of anachronism to highlight contemporary social issues via centuries-old imagery is one of the director's aesthetic and thematic trademarks, for, as he says, 'constantly shifting perception is really important to me' (Wardle 1996).

Frequently, such perceptual shifts and anachronistic juxtaposition, such as the Vulcan's factory in *The Adventures of Baron Munchausen* building 'intercontinental ballistic missiles', as Marks explains, serve both a steampunk agenda and 'a satirical purpose' (2010: 119). The single scene that Gilliam directed in *Monty Python's Life of Brian* (1979) features the sudden appearance of a spaceship, which abducts Brian (Graham Chapman) and engages in intergalactic warfare before crashing back into Jerusalem. The scene playfully interweaves one mythology into another, though without discrediting the need for mythology and fantasy.[6] Rather, it reflects Gilliam's fascination with the medieval worldview 'where reality and fantasy were so blended' (Gilliam 1999). This sequence, with its invocation of alternative history, is also characteristic of steampunk pastiche. The movie's tale of Brian (a marginalised figure who ends up crucified with several other outcasts after he is heralded as a prophet along with Jesus Christ) is reminiscent of what Mike Perschon describes as steampunk's 'post-colonial anti-Empire sentiment' (2009), which informs Monty Python's satire of the Roman Empire in particular and of empire in general.

The Steampunking of Lewis Carroll: From Pythonesque to Gilliamesque

Though seemingly anachronistic, this last section analyses the ways in which the director's aesthetic and approach to filmmaking has always already been steampunk by comparing his first solo project with the trailer for *1884*. For his first almost completely live-action movie, Gilliam brought the nightmarish creature from Lewis Carroll's nonsense poem 'Jabberwocky' (1872) to life to explore what the director characterises as 'the idea of a world where the terror created by a monster is good for business' through 'a collision of fairy tales'.[7] Though three Pythons appear in the cast, as Michael Palin notes in the DVD commentary, the movie is a significant departure from a Monty Python comedy, in part, because 'the entire British comedy establishment is in this film' (Gilliam and Palin 2001). *Jabberwocky* follows the tale of Dennis Cooper (Palin), who dreams of taking stock and marrying the scornful girl next door, Griselda Fishfinger (Annette Badland). With his aspirations of mediocrity, remarks Gilliam, Dennis anticipates *Brazil*'s 'clerk-bureaucrat' Sam Lowry (Jonathan Pryce): 'his father is a craftsman, a barrel-maker, but Dennis is more interested in accounting. He's like a guy somewhere in the Midwest who aspires to own a used car lot' (Christie

& Gilliam 2000: 66). After his disappointed father (Paul Curran) disowns him from his deathbed in a scene resembling Caravaggio's chiaroscuro in *The Death of the Virgin* (1605–6), Dennis strikes out to 'make good' in the city and return to marry Griselda. Instead, through a series of misadventures, this counter-epic hero winds up accidentally killing the Jabberwocky that terrorises the Kingdom of Bruno the Questionable (Max Wall), thus earning him the fairy tale ending that, says Gilliam, 'we're all told we want', but that he does not seek: one-half of the kingdom and the hand of the Princess [Deborah Fallender]' (McCabe 1999: 70). Though only one scene bears the steampunk aesthetic, the director's filmmaking philosophy and process bear steampunk's anarchist ideology.

While the film was not well received by reviewers expecting a Monty Python movie or viewers disappointed by the scatological and bloodily violent realism of Gilliam's anti-heroic fairy tale world, *New York Times* critic Vincent Canby described it favourably, noting its use of pastiche as 'a wickedly literate spoof of everything from *Jaws* through *Ivanhoe* to *The Faerie Queen*' (1977). Canby noticed its mock epic aim and lauded *Jabberwocky* as 'a comedy with more blood and gore than Sam Peckinpah would dare use to dramatize the decline and fall of the entire West. The world through which Dennis stumbles ever upward is an unending landscape of misery, torture, filth, slop buckets, sudden death, and all-round decay … showing us the past as it supposedly really was' (ibid.). Gilliam's medieval pastiche combines the grim and grimy realism of a crumbling castle and the medieval sewer system with the grotesquely beautiful canvases of Peiter Bruegel and Hieronymus Bosch. The dust that coats King Bruno and his helpmate Passelewe (John Le Mesurier) – and that cleaners futilely and endlessly attempt to sweep – composes the failing architecture that Gilliam characterises in his commentary as symptomatic of 'the whole regime'. He uses actual paintings as 'historical shorthand', creating a canvas montage on which the camera tracks to reveal pertinent details, while the narrator explains the story and then reconfigures the visual elements in the paintings into the *mise-en-scène*.[8] The movie is a visually stunning work of art that comically confronts the viewer with the filth and excrement of both the human system and a bureaucratic system of commerce based on members-only employment and dependent upon fear to subjugate citizens to that system.

Satirising that system in *Jabberwocky*'s city market, a man sells fast-food rats on a stick, and merchants whip human beasts of burden to speed them through rush hour to meet with King Bruno. As Marks explains,

Steampunk 'oil change' for *Jabberwocky*'s knights

> A key target of this satire are the merchants who first appear on their way to see Bruno, riding in sedan chairs that correspond to modern limousines. Held aloft by their bearers, they discuss market fluctuations and economic predictions. But underlying antagonisms and competitiveness force them to 'accelerate' their sedan chairs in a ludicrous race that mercilessly exploits their bearers while exposing their mutual hatreds and fundamental duplicity. Under-cranking the film briefly at this point recreates the frenetic pace of a silent movie car chase. (2010: 51)

Gilliam subtly emphasises this satire of economic exploitation in King Bruno's castle, in which he foregrounds servants working. They sweep and clean the dust constantly falling from the royal interiors while merchants beg the king to stop the tournament of knights jousting for the privilege of fighting the monster, an argument the bishop supports since the monster keeps church attendance at record highs.

Gilliam's DVD commentary typically reveals the intricate labour behind every scene. For *Jabberwocky*, he explains that he hated Rock Hudson's perfect teeth in the 1950s, so the characters' blackened ones offered 'the most anti-American statement I could make' (Gilliam and Palin 2001). The director's long-running resistance to the US military empire, then so recently embroiled in the quagmire of Vietnam, as well as his appreciation and practice of creative craftsmanship over mediocre repetition, emerge in *Jabberwocky*'s script and illustrate steampunk's rebellious, anarchic ideology. Gross argues that steampunk's ideology 'mythologizes the self-reliant, DIY [Do-It-Yourself] tinkerer or artist', which describes Gilliam's bricolage on *Jabberwocky*. In the DVD commentary, Gilliam expresses frustration with the wires being visible in the joust scenes, but such mechanical slippages in special effects actually exemplify steampunk's aesthetic, slippages that would re-appear in the staging of his 2011 opera, reminding the audience of the machinery required to create the live-action magic. As he explains in the commentary, the film's shoestring budget frequently allowed only one take, producing such accidental anachronisms as a truck in the background of a battle scene. But his movie-making and live-action labour proves often consciously, and even anarchically, steampunk.

To create the medieval set that would inspire John Boorman to order his crew on *Excalibur* (1981) to watch the film fourteen times, Gilliam and his staff recycled sets from both *Oliver!* (Carol Reed, 1968) and *The Marriage of Figaro* (Jean-Pierre Ponnelle, 1976) (see Gilliam and Palin 2001). Moreover, while Blake Edwards was making one of the *Pink Panther* movies, Gilliam would 'borrow' from the castle set: 'We were guerilla film-makers out there, stealing and scavenging what we could' (Christie & Gilliam 2000: 67). In the penultimate scene when Dennis accidentally vanquishes the monster, Gilliam literally recycles found objects by burning tyres for smoke effects and draping actual animal carcasses around the quarry, all of which Palin describes as going 'beyond the rules of filmmaking' (Gilliam and Palin 2001). In a simultaneously post-apocalyptic/meta-industrial revolution process, while filming *Jabberwocky*, Gilliam developed a bricolage strategy still in use on his sets. He would have the crew 'assemble a kit of bits and pieces that we could carry around with us everywhere so that we could always get a shot: things like a piece of foreground, the edge of a building,

a little Lego kit of parts', which he would film at different angles to make them look different (Christie & Gilliam 2000: 79). Essentially his cogs of movie production, this kit made possible his chiaroscuro *mise-en-scène*, particularly when he would use black velvet drapes instead of building higher sets to achieve lighting.

Because the production was running out of money when the factory scene was shot, the crew played extras and reused pieces of sets from other scenes in the armourer's workshop. Thus the flagellates' wheel becomes a gear in the scene, anticipating steampunk's aesthetic. Pulleys hoist knights like cars so mechanics can work on their armour and give them 'oil changes' from underneath. Humans move in automated rhythms, pump air to power the steam, grind on millstones, labour hamster-like in wheels, and form a crude production line. Gilliam states that this scene anticipates *Brazil*'s depiction of dehumanising production: 'The cogs are always human. I think people use machinery as a way of avoiding machinery, but still somebody either is the machine, or is in control of the machine or has bought the machine. It's always intrigued me how people are the system, and not the technologies' (McCabe 1999: 72). The oil change visuals particularly emphasise this sense of bodily technology and Gilliam's sense of bricolage, as the oil is derived from dinosaur fossils and pumped into human bodies, or at least their technological carapaces. When Dennis takes stock of the scene and interrupts the chain of human labour to suggest a more efficient method, his misplacement of but just one cog sets off a comical chain of destruction.[9] Labourers scream as they drop from the works; gears pick up the fallen and roll out of the shop. Like the suffocating dust that coats the royalty in its crumbling castle, levers and pulleys smash the humans beneath them, victims of the economic dependence on automation – and of Dennis, the efficiency expert.

So begins Gilliam's steampunk, and, if *1884: Yesterday's Future* emerges from post-production, we shall see its full embodiment. In December 2010, *Variety* announced that Gilliam was working with Ollive on *1884,* an explicitly steampunk, tongue-in-cheek parody of George Orwell's *1984* (1948) as voiced by former Pythons. According to an executive producer, *1884* 'imagines a film made in 1848 with steam power, narrating a tale of laughable imperialist derring-do and espionage set in a futuristic 1884 when Europe is at war' (Woerner 2010; Hopewell & Keslassy 2010). Though Gilliam's role is listed as a 'consulting producer', and is thus more supportive than directive, this development appears to be the culmination of elements that have become recognisable as 'Gilliamesque' throughout his career. The movie's official website features a mock-up of a newspaper that buttresses its title 'The Daily Empire' with warring dirigibles.

One of Steam Driven Films' trailers explains that *1884* will 'explore the murky world of Victorian foreign policy' and ends with a battalion of US Marines riding balloons kept afloat by steam-powered riverboat wheels. In another, a Master of Ceremonies appears onstage in London's Old Red Lion Theatre to announce 'the miracle of the steam motion image projection system', a steampunk projector into which an operator shovels coal. The projector plays a movie 'made with steam power' that features a brass spaceship whirling past the moon and trailing an anchor. In the London of 1884, steam-powered dirigibles and dangling double-decker buses exhale black clouds of

pollution as they soar past Londoners pedalling flying bicycles through noxious smog while a paperboy hawks news of the lunar landing. A scientist squints into an ornate brass telescope to see firecrackers launched from the moon that announce 'WE'RE HERE!' claiming the moon as a colony of the British Empire. Mockingly, the trailers' imagery affirms Gilliam's and steampunk's anti-Empire ideology and celebrates what Gilliam always does best: strip away the sheen of nostalgia for some fictitious past in which life was somehow better and render in exquisite detail the historical processes that recycle humans into expendable objects, assembling the crude and cruel empires that eventually crumble under the self-indulgence of the powerful and exploitation of the cogs.

Notes

1. Inspired by Harvey Kurtzman's *Mad* magazine, Gilliam cites Kurtzman as his 'hero' and worked as an assistant editor on *Help!*, which was also created by Kurtzman (Adams 2010).
2. Coincidentally, Michael Garrison's television series *The Wild, Wild West* (1965–69), which infused the western genre with science fiction and the aesthetic that would become known as steampunk, was broadcast at the same time Monty Python was forming.
3. Though Gilliam did not design it during his tenure at *Help!* John Cleese appeared in the *fumetti*, 'Christopher's Punctured Romance', about a man who develops an obsessive 'relationship' with his daughter's Barbie doll (see Crossley 1965; Wardle 1996).
4. Whereas this film was initially slated for a 2012 release, the Internet Movie Database lists it as still being in post-production at the time of writing.
5. Tim Ollive and Terry Gilliam have collaborated on *Monty Python's Life of Brian, Time Bandits, Brazil, The Adventures of Baron Munchausen, The Fisher King* (1991), *Twelve Monkeys, Fear and Loathing in Las Vegas* (1998), and *The Imaginarium of Doctor Parnassus* (2009).
6. George Lucas praised this scene, which Gilliam had done 'just to show' directors such as Lucas and Steven Spielberg 'that you could do it for a couple [*sic*] fivers instead of millions' (Marks 2010: 60; Christie & Gilliam 2000: 98–9).
7. *Jabberwocky* uses existing paintings to illustrate bits of the story and a cartoon background, in which an animated iris slams shut on the 'fairy tale' ending but the rest is live-action. In Carroll's *Through the Looking Glass* (1865), Alice finds the 'Jabberwocky' nonsense text in a book and says it is 'all in some language I don't know' (Christie & Gilliam 2000: 65).
8. As Marks describes, 'sections of the panel "Hell" from Bosch's *The Garden of Earthly Delights,* depicting horrendous human suffering, are spliced with Bruegel's similarly unsettling *The Triumph of Death*' (2010: 48). As the narration continues to explain the darkness of the Middle Ages, Gilliam also juxtaposes Bruegel's *Tower of Babel* to envision the horror of the monster with serene pastoral scenes in his ironically titled *The Merry Way to the Gallows* (ibid.).

9 Ironically, Gilliam notes in the commentary, the first visible injury happens to a worker whose finger kept getting smashed by another extra during filming.

Works Cited

Adams, Sam (2010) 'Interview: Terry Gilliam'. Online. Available at: http://www.avclub.com/articles/terry-gilliam,37194 (accessed 14 May 2011).
Barthes, Roland (1975) *S/Z: An Essay*, trans. Richard Miller. New York: Hill and Wang.
Bowser, Rachel and Brian Coxall (2009) 'Material History: The Textures, Timing and Things of Steampunk'. Paper presented at the annual convention of the South Atlantic Modern Language Association, Atlanta, GA, 6 November.
____ (2010) 'Introduction: Industrial Evolution', *Neo-Victorian Studies*, 3, 1, 1–45.
Canby, Vincent (1977) '*Jabberwocky:* Monster Film with Heart', *New York Times*, 16 April. Online. Available at: http://movies.nytimes.com/movie/review?res=9D03EFDE1E3BE334BC4E52DFB266838C669EDE (accessed 15 May 2011).
Christie, Ian and Terry Gilliam (2000) *Gilliam on Gilliam*. London: Faber.
Crossley, Dave (1965) 'Christopher's Punctured Romance', *Help!*, May, 15–21.
Di Filippo, Paul (2010) 'The Remarkable Resilience of Steampunk'. Online. Available at: http://www.salon.com/books/feature/2010/04/22/steampunk_appeal (accessed 14 May 2011).
Forlini, Stephania (2010) 'Technology and Morality: The Stuff of Steampunk', *Neo-Victorian Studies*, 3, 1, 72–98.
Frucci, Adam (2007) 'Exclusive Interview: Steampunk Virtuoso Datamancer, aka Rich Nagy, Shows Us His "Tesla Cane"'. Online. Available at: http://gizmodo.com/#!322687/exclusive-interview-steampunk-virtuoso-datamancer-aka-rich-nagy-shows-us-his-tesla-cane (accessed 22 April 2011).
Gilliam, Terry (1999) 'Director's Commentary', *Monty Python and the Holy Grail* (1975). Directed by Terry Jones and Terry Gilliam. Culver City: Sony Pictures.
____ (2006) 'Special Features: Terry Gilliam's Featurette: Episode Four', *Monty Python's Flying Circus: Terry Gilliam's Personal Best*. DVD. Directed by Terry Gilliam. New York: A&E Home Video.
Gilliam, Terry and Michael Palin (2001) 'Special Commentary', *Jabberwocky* (1977). DVD. Directed by Terry Gilliam. Culver City: Sony Pictures.
Gross, Cory (2008) 'A History of Steampunk: Part III: The Birth of Steampunk', *Voyages Extraordinaires*, 28 August. Online. Available at: http://voyagesextraordinaires.blogspot.com/2008/08/history-of-steampunk.html (accessed 25 October 2009).
Hopewell, John and Elsa Keslassy (2010) 'Gilliam to Godfather *1884*', *Variety*, 16 December. Available at: http://www.variety.com/article/VR1118029166?refCatId=13 (accessed 29 April 2011).
Jones, Jason B. (2010) 'Betrayed by Time: Steampunk & the Neo-Victorian in Alan Moore's *Lost Girls* and *The League of Extraordinary Gentlemen*', *Neo-Victorian Studies*, 3, 1, 99–126.
Marks, Peter (2010) *Terry Gilliam*. Manchester: Manchester University Press.

McCabe, Bob (1999) *Dark Knights and Holy Fools: The Art and Films of Terry Gilliam.* New York: Universe.

Monty Python and Bob McCabe (2005) *The Python's Autobiography.* London: Orien.

Nevins, Jess (2008) 'Introduction: The 19th-Century Roots of Steampunk', in Ann VanderMeer and Jeff VanderMeer (eds) *Steampunk.* San Francisco: Tachyon, 3–11.

Pagliassotti, Dru (2009) 'Does Steampunk Have Politics?', *The Mark of Ashen Wings.* 11 February. Online. Available at: http://ashenwings.com/marks/2009/02/11/does-steampunk-have-politics (accessed 25 October 2009).

Perschon, Mike (2009) 'Steampunk as Pastiche', *Steampunk Scholar.* 15 June. Online. Available at: http://steampunkscholar.blogspot.com/2009/06/steampunk-as-pastiche.html (accessed 15 May 2011).

Remy, J. E. (2007) 'The "Punk" Subgenre', *Die Wachen.* 26 July. Online. Available at: http://diewachen.com/2007/07/punk-subgenre.html (accessed 25 October 2009).

Sterritt, David and Lucille Rhodes (2004) *Terry Gilliam: Interviews.* Jackson: University of Mississippi Press.

Wardle, Paul (1996) 'Terry Gilliam', *The Comics Journal*, 182. 15 November. Online. Available at: http://archives.tcj.com/index.php?option=com_content&task=view&id=36&Itemid=48 (accessed 15 May 2011).

Woerner, Meredith (2010) 'Terry Gilliam's Next Project Takes You Into the Steampunk Britain of 1884'. *io9.* 21 December. Online. Available at: http://io9.com/#!5715735/terry-gilliams-next-project-takes-you-into-the-steampunk-britain-of-1884 (accessed 29 April 2011).

CHAPTER TWO

Grail Tales: The Preoccupations of Terry Gilliam

Tony Hood

Terry Gilliam begins the film *Time Bandits* (1981) with an image of Earth spinning in space. As the camera tracks slowly towards the planet, this celestial perspective evokes a timeless quietude yet curiously, at the same time, an over-abundance of historical description by which humanity has sought to appraise it: metaphysical, scientific, philosophical and mythological. It invites contemplation of the vast project to understand the operations of our world and elicit meaning for our experiences, and announces something of the order that the filmmaker – no less than the scientist, historian, theologian or philosopher – constructs a model of the world. This chapter charts Gilliam's artistic quest to create worlds and his insistence on 'trying to control them' (Dening 1998). This statement suggests that there is an invitation to megalomania implicit in the filmmakers' craft. I argue here that it is with both an exploitation of this creative licence and a concomitant gravitas that characterises the fantastic and diverse territories that Gilliam builds.

The celestial perspective at the beginning of *Time Bandits* perhaps most readily connotes an ultimate creator or supreme architect for such a world. For the time-travelling child protagonist Kevin (Craig Warnock) in *Time Bandits*, it is indeed the Supreme Being that he is contrived to meet. There is a detectable self-reflexivity on Gilliam's part of his own status as filmmaker in his superintendence over a cinematic world of his design. In his ambitious visions for the cinema, Gilliam is pre-eminent among time bandits, plundering the troves of history and myth to construct surprising, unsettling and gloriously incongruous domains: the baroque fantasy of *The Adventures of Baron Munchausen* (1988); the hallucinatory probing of the near-present in *The Fisher King* (1991), *Fear and Loathing in Las Vegas* (1998) or *Tideland* (2005); the retro-futuristic compositions of *Brazil* (1985) and *Twelve Monkeys* (1996); or the fantastic theatre of *The Imaginarium of Doctor Parnassus* (2009).

A Terry Gilliam film is a site of a particular imaginative combustion of ideas and forms disturbed from their original historical contexts and set in collision, challenging conventional cinematic expectations of continuity and temporal cohesion. Scouring these worlds for clues to the personality of their maker – or supreme architect – conjures something akin to a cartoonist-animator as God, with a propensity towards exaggeration, distortion, shock and a delight in the absurd. The seeds for this were planted in Gilliam's early career as animator for the television series *Monty Python's Flying Circus* (1969–74). Unbound to mimetic representation of 'the real', the animator is not beholden to crafting worlds with fidelity to natural laws and temporal cohesion; instead, such limits are more frequently used as points of departure, the art being one of disturbing the familiar, combining the incompatible and confounding expectations.

The craft of deconstruction and reconstitution of elements of 'the real' is neatly summarised in a description by Gilliam of his working processes for Monty Python. He tells of a cabinet in which he built up the imagery for his animations, saying, 'backgrounds would be in one drawer, skies in another, and buildings over there. It was a kit of parts that I could reassemble over and over again in different combinations, adding new things to it' (Christie & Gilliam 2000: 50–1). The 'kit of parts' can be extended as metaphor to Gilliam's subsequent forays into the cinema: his art emerging from a vast *Wunderkammer*, its heterogeneous contents sourced in the stories and symbolic vocabularies of time past, their visual motifs and narrative tropes reassembled into strange and fantastical worlds. Yet, for all the play and chaos that this liberation of form implies, Gilliam has a countervailing drive in his reluctance to abandon the tasks of narrative construction and meaning-making in the cinema. Given the complex, de-familiarised worlds he builds, it is no surprise that his narrative formulations so frequently take their cue from the ancient tale of 'The Quest'.

Ian Christie, in his introduction to *Gilliam on Gilliam* (2000), recognises the critical anchorage of Gilliam's expression in stories of 'The Quest'. He describes Gilliam's characters as the 'latter-day descendants of the Grail Legend' whose quests 'lead them into perilous worlds of illusion, poetry and nonsense' (Christie & Gilliam 2000: viii). There is rich appeal for a filmmaker of Gilliam's historical and mythopoeic sensibilities in the tales of King Arthur and his knights and their search for the chalice used by Christ at the Last Supper. While the tapestry of interpretations and appropriations of the Grail legend throughout history serves as genealogy for such a vision, a more contemporary parentage exists in Gilliam's own early directorial venture with the Monty Python team in *Monty Python and the Holy Grail* (1975). The film is effectively a redeployment of the 'kit of parts' of Arthurian mythology (as discussed by Jim Holte in chapter three of this volume) lampooning all the allegorical high-seriousness of the Grail quest. But beyond the parodic intent of the excursion, Gilliam seems to have distilled a thematic template from it: the heroic pursuit of the Grail object, and the faith invested in it, coming to be explored with greater seriousness and more complex expression in subsequent films. In *Time Bandits* and *The Fisher King*, the quest for the Grail is enacted in literal form. Kevin and the bandits exploit time holes in the universe to search past history for 'the Most Fabulous Object in the World'. And, as

Jacqueline Furby discusses in chapter five, Parry (Robin Williams), believing he is a medieval knight, recruits Jack (Jeff Bridges) in the cause to retrieve the Holy Grail in the metropolis of New York. In other films, the Grail object is given a stand-in, either material or ideological, but always ascribed with the same importance. In *Twelve Monkeys*, the time-travelling Cole (Bruce Willis) believes his quest to find the source of a viral outbreak will save the world from a catastrophic future. For all the drug-fuelled mayhem in *Fear and Loathing in Las Vegas*, Duke (Johnny Depp) is on an urgent, self-appointed mission to locate the source of the rot in capitalistic America and to re-find the American Dream. However the 'Grail' is represented, it is signified as no less hidden and elusive as the holy object of archaic myth; similarly, the quest to find it is no less imperative nor less epic in its undertaking, with mortal dangers to be confronted and adversaries to overcome.

From its beginnings in oral storytelling and the emergence of its written heritage in the twelfth century, and in its reinterpretations across time, the Grail legend has held as its central premise the vision of a land that has become blighted: the kingdom is ailing, its prosperity is gone, where once order prevailed, now only chaos and confusion reigns. In Christian formulations, it is a world to which God is no longer tending, diminished of spirit, without comfort or shelter, where humankind has set upon itself in conflict and war. Regardless of their temporal locale, Gilliam's films incorporate versions of such a conflicted and blighted land. In *The Adventures of Baron Munchausen*, the townsfolk are struggling to save themselves in their war with the Turks. *Brazil* is racked with bombings as 'terrorists' battle the State. Televisual imagery of the Vietnam War pervades *Fear and Loathing in Las Vegas*. Science is at war with the natural world in the themes of animal (and human) experimentation in *Twelve Monkeys*. In *The Fisher King*, random street violence and shooting massacres characterise 1980s Manhattan, the bewildered Jack trying to comprehend a world 'where people get gunned down in Dairy Queens'. The consistent application of the metaphor of the blighted land across Gilliam's films points to more than play with the tropes of the Grail quest; detectable throughout these films is a didactic intent concerned with articulating the conditions of the 'historical now'. Despite their frequent temporal infidelities, his films are all presented as costumed dramatisations of the social and cultural conditions of late twentieth-century and millennial (post-)modernity.

Interpretations of the Grail Legend – historically – have been both constituted of and enjoyed renewed popularity during periods of cultural uncertainty: Thomas Malory's *Le Morte d'Arthur* (1485) emerged in the upheaval that was the fifteenth-century Wars of the Roses; renewed interest in the myth coincided with anxieties during the encroachment of industrialisation in nineteenth-century Victorian society. Gilliam imaginatively reconstitutes the tale to express the anxieties and tensions of our own epochal moment, more pertinently, those that surround the supposed 'shelter' we have installed in the form of the structures and operations of modernity. Peter Wollen describes Gilliam's films as an urban vision, expressing the 'horror of standardisation, regimentation, (and) instrumental reason' (1996: 61). Even when not specifically referencing the urban experience, such as in *Tideland* or *The Adventures of Baron Munchausen*, the theme of the modern dystopia exists as a shadow presence

that inflects the story regardless. Indeed, Gilliam locates the latter film in the opening titles at the wellspring of its source in the 'Late Eighteenth Century' and the dawning of 'The Age of Reason', effectively flagging his cinematic manifesto – evident in all his films – of opposition to the perceived dominance of rational thought. Gilliam's antipathy is directed at the vast apparatus of contemporary modernity constructed on the Enlightenment faith of progressive liberation from the capriciousness of fate through technology, science and systems – social, political and economic – to the detriment of other stories that once explained experience of the world. It is in the technological pastiches of *Brazil* and *Twelve Monkeys* that Gilliam gives full expression to the invidious and stultifying hegemony of these forces, using all the tools of exaggeration and distortion at a cartoonist's disposal. They are environments in which our technology and systems have turned malignant, producing their own brutality, terror and chaos. Disorientation is the *leitmotif* of the Gilliam film, the root of which is a world overburdened with complexity, such that it is irrational.

This portrayal of the experience of contemporary modernity is exaggerated by Gilliam to the point of grotesquery. The filmmaker's conjuring tricks and mastery of illusion meets a socio-cultural environment engaging in the same. Nancy Steffen-Fluhr notes that *Brazil* is filled with 'interconnected visual puns and mirror images', which represent how 'the whole force of industrial technology is turned to creating masks and screens to cover the incompetence and rot at the core of consumer capitalism' (1994: 18). The individual must navigate the multiple instrumental forces of commercial culture that seek to eviscerate the imagination and coerce the dreaming mind towards the corrupted fantasies of their own projection. It is an all-pervasive presence that Gilliam depicts satirically: in the television-game-show-addicted parents in *Time Bandits*; the fashion fetishes and shopping 'muzak' that play throughout *Brazil*; the plagiarised and distorted titles of pornographic videos in *The Fisher King* (*Ordinary Peep-holes*, *Creamer vs. Creamer*); the frenetic spewing of cartoons and advertisements from the television in *Twelve Monkeys* ('The future can be yours … last chance!'). Gilliam states of *Fear and Loathing in Las Vegas*: 'It's trying to get visual nightmares going where it's not extreme psychedelia or distortion, it's real' (Anon. 1998). Duke and Gonzo (Benicio del Toro) are mired in a hallucinatory universe generated by their drug consumption, but the horror lies in how benign it is in comparison to the cynical derangement of the senses promoted by Las Vegas and its casinos.

In Gilliam's formulations, contemporary modernity presents a labyrinthine world of phantasms, threats and false Grails that is no less bewildering than the tangled woods and or dangerous wastelands of lore. For humankind, it is an estrangement from a world of its own making: a conflicted state that Gilliam dramatises in his depictions of the city. The modern metropolis, as constructed by Gilliam, is frequently a schizophrenic site: a bastion of architectural triumph with towers of stone, concrete, steel and glass, and simultaneously an entropic wasteland of abandoned infrastructure, slums and ruins. As Fred Glass articulates effectively, Gilliam's worlds can be generalised as ones of 'historical regression', where progress is but a 'mask for actual decay' (1986: 24). More pointedly, Gilliam uses the multiple spaces of the city to expose the operations of progress in the oppression of the human and displacement

of those that will not meet its prescriptions to its most marginal domains. Gilliam's characters occupy tiny apartments, slum tenements, shacks, basements, wagons, or have no home and are seeking refuge where they can in the derelict infrastructure of the 'wastelands'. The territories of the homeless in *The Fisher King* and *Twelve Monkeys* are imbued with a distinctly medieval squalor as their inhabitants attempt to improvise shelter in the blighted kingdom. For characters who have been complicit with machinic modernity, like Sam (Jonathan Pryce) and Jack, their fate is to be suddenly cast-out into the margins and the flux and uncertainty of a world of precarious shelter. In the post-apocalyptic-underground world of *Twelve Monkeys*, humankind, through its own operations, has managed to displace itself entirely from the sanctuary of its constructions.

It is an existential horror that Gilliam so effectively renders of the (post-)modern experience in his films, his characters seeking redemption from their alienating, fragmented and discontinuous worlds. A lamenting Jack expresses the yearning for a simpler, more cogent order, and a higher authority to provide it, when he states, 'I wish there was some way I could … just … pay the fine and go home'. Yet, wherever Gilliam's protagonists probe their temporal reality for explanation for their circumstance, they meet only incomprehensibility. Trying to find the source of their persecution only reveals others caught in the operations of the machine. What they believe to be malignant reveals itself as benign, and vice-versa. There is no higher authority to which to make such an appeal. John Orr, discussing modernity in the cinema, states that the 'mature industrial age' cannot 'be idealized as the age of heroic resistance or noble transcendence', rather, 'it is fragmented, uncertain, painful and at times formless' (1993: 15). The loss, as experienced by Gilliam's protagonists, is the authority of any narrative that can bind their experiences, providing coherence of meaning and a guide for action. The compensatory psychological reflex in all of Gilliam's films is the seeking of such a narrative from time past and the symbolic paradise it offers of a more accommodating world – of the world re-enchanted.

Whether it is the Baron's (John Neville) 'memories' of his old crew and their fantastical adventures, the nostalgia of Parnassus (Christopher Plummer) for the height of his magical and romantic powers, Parry's delusions of himself as a medieval knight, Cole's desire for a permanent return to the pre-apocalyptic twentieth century, Sam's myth-inflected romantic dreams, Kevin's time-travelled meetings with his historical heroes, or Jeliza-Rose's (Jodelle Ferland) fantasies of womanhood – they are all fantasies of a richer, more meaningful world than the dysfunctional material circumstance in which they are embedded. Each is a rebellion, a psychological flight from reality and investment of faith in the dreaming mind. In this, they are kindred with the ancient seekers of the Holy Grail whose quests, too, were sustained by an imagining of time past and the dream of a more coherent realm. As the inheritance of the Grail tale promotes, the quest, no matter the form it takes, has 'a spiritual goal representing inner wholeness, union with the divine, [and] self-fulfillment' (Matthews 1985: 5). The hope invested in the story of the Grail – the lost object of the past – is that its finding will restore the grace and benevolence of its mythological origins, old orders will be reinstalled, the flux and indeterminacy of material reality will be transcended. The psychological

lure of the past story is the romanticised offer of reparation, of a means for integrating experience in the simple stratification it makes of the world.

This attraction to a romanticised, mythologised past is something that Gilliam recognises in himself: 'Knights, castles, princesses, dragons, things that have to be slain, quests to go on ... Nothing changes, I've always liked that' (McCabe 1999: 64). For the Baron and Doctor Parnassus, the stories they keep of the past invoke a simple mythological world of heroic action and tangible adversaries – where one can negotiate directly with the Devil. The 'medieval knight' Parry has found in archaic myth is a bulwark against the trauma of the death of his wife, the disorientating loss supplanted in his fantasy with the codes of medieval lore – duty, chivalry and honour – by which he is able to survive. Sam's fantasy obsession with Jill (Kim Greist), anchored in romantic Hollywood films and mythic tales of fated love, inures him to the complex bureaucratic forces that are contriving his fate – and to which he will ultimately sacrifice himself rather than abandon the dream. Cole sustains himself in the dystopian future through his dream of the flawed, but relatively paradisiacal twentieth-century world: 'That's why they chose me. I remember things.' For Gilliam's child protagonists too, their simple imaginative conceptions of the world enable them to transcend the dysfunction of their material circumstances. For Kevin, it is the stultifying life of his parents; for Jeliza-Rose, the horror of the putrefying corpse of her father (Jeff Bridges).

It is in the connection that Gilliam makes between the proclivity to fantasy and the survival of his characters that his cinema articulates much more than a Romantic idealism of escape from the temporal world or a valorisation of the nourishment available in the dreaming or unconscious mind. It is also more than nostalgia. There is an active assertion of the imagination on the part of these characters to reconfigure the chaos of reality in order to endure. But the dream of a transcendent realm is not, as Gilliam knows, to be mistaken for the quest. The elusive Grail relic is foremost evidence; only when it is found will faith be finally rewarded. Until that time, belief is under assault because its negotiations with reality bring multiple challenges and false Grails.

The complexity of Gilliam's fantasy constructions come to the fore in his depiction of the burden of occupying multiple temporal realms and the faltering of faith it entails. Past stories, past structures, old orders re-imagined in absentia of the worlds that produced them, have no ultimate ground for their veracity. In rationalistic modernity, with its demand for facts, they are particularly vulnerable. The Baron and Doctor Parnassus have kept faith in their fantasies, but they are also old, tired and worn down by a sceptical world that has marginalised them, to the point that they are ready to take their leave. Assaults, however, also come from within. As those who venture behind the curtain of Doctor Parnassus discover, the dreaming mind is a dangerous terrain with its own irrational terrors. In his attraction to Lydia (Amanda Plummer), Parry is tempted to rejoin the real world, a desire that unleashes the full terror in his psyche of the Red Knight. Gilliam creates a world where imagination and reality are in a state of unstable tension, the shelter to be found in either but crushingly provisional.

Twelve Monkeys, particularly, encompasses Gilliam's preoccupations with the fractious interplay of the psychological construct with reality. The time-traveller Cole

arrives from the future, sent by scientists to find the source of the viral outbreak that has wrought the apocalypse; in the present, he finds himself institutionalised as a paranoid schizophrenic. Unable to sustain the brutal wrenching of his mind back and forth between two temporal locales, he applies his rationality to try and determine where the self-deception lies. But there is no stable ground for assessing which is his madness. He is enmeshed in a perpetual scanning for clues, his faith oscillating with the constant reappraisal he has to make of his cognitive structures. In Gilliam's world, no matter how robust and hermetic a character's dream world may seem, there is, in the swirl of new information, the ever-present threat of collapse. Our imaginative constructions are subject to a double-guessing, the multiple avenues for self-deception as insidious as a world that will not cohere: as Duke decries of the overlay of his hallucinogenic mind with the hallucinatory reality of Las Vegas: 'Madness! It made no sense at all! I desperately needed the facts.'

All of Gilliam's protagonists occupy this liminal overlap of dream and reality, where the yearned-for structures of past time – inscribed in myth, legend, poetry, literature, art and stories of history – must confront the indeterminacy, flux and change of the material present. The clash of the past with the present, the mythical with the modern, of dream with reality, and the irrational with the rational, lends itself to the sort of cinematic spectacle that brings glee to an animator. Gilliam's nefarious 'kit of parts' is re-evoked by Steffen-Fluhr's comment on *Brazil* that 'all versions of security are devastated repeatedly – their fragments reconnected, each time in a new and more powerful form – only to be shattered again' (1994: 187). This is the case, but the impulse is not as nihilistic as this suggests. Gilliam's cinematic vision, I propose, is orientated towards *how* those fragments are reconnected and recomposed, founded in the pragmatic utility in composing meaning from experience.

This vision has fermentation in Gilliam's own methodological processes: as the supreme architect of his cinematic domains, charged with hammering out a dramatic structure. On *Fear and Loathing in Las Vegas*, he describes how Dante's *Divine Comedy* (c. 1320) provided a structure for interpreting Hunter S. Thompson's novel. As incompatible as Thompson's novel may seem with Dante's fourteenth-century Christian allegorising may appear, the overlay of its conceptual universe distills a framework: 'Nobody understands most of this stuff', Gilliam says, but 'there's a structure there, with biblical overtones. You keep hoping that some people will spot things and make connections' (Christie & Gilliam 2000: 252). Discussing the making of *Twelve Monkeys*, Gilliam describes the increasing influence of Alfred Hitchcock's *Vertigo* (1958) in the development of the film, and the ultimate incorporation of it: 'You begin to think there must be Platonic scenes already in existence, which just have to be remade' (2000: 233–4). Whether consciously or unconsciously applied, Gilliam recognises the role of past narrative constructs, genre patterns and symbolic vocabularies in structuring and eliciting meaning from the material at hand.

At work in a Gilliam film is the awareness that the imagination does not conjure things up out of thin air. The sub-strata of imagination comprise both memories of past individual experience and a vast trove of received cultural memory. It is an amplification of a cognitive reality that Gilliam dramatises with his characters; that is, how

reality is perceived and the meaning that is derived from it is dependent upon the narratives that we carry. We are always overlaying our conceptual maps upon the chaos of experience – our stories of what the world is – and we look for connections, symmetries and patterns that can create islands of coherence and meaning. We are engaged in the dynamic application of our own 'kit of parts' in composing experience, adding new understandings to the kit and remodelling our maps as we go. The veracity of 'lived memory' is unimportant in the enactment of this process.

In the imagination, personal memory is porous with all the tales we have learned of the world: of science, history, myth, art and literature. Inscribed in them are the past human strivings to construct models for the world and maps for navigating experience. Whether fact or fiction, archaic or modern, they are all products of the human imagination seeking to wrestle meaning from the world and are all available for appropriation: the obsolescence of gods and monsters is of no consequence if the imagination finds pragmatic utility in them. It does not matter whether the Baron or Doctor Parnassus are giving truthful accounts of their past lives, for the crucial gift they bestow in their fabulist tales is the opening up of imaginative possibilities and cultivation of the awareness that the world's 'parts' can be assembled in different ways.

Gilliam gives expression to this idea in his films through a recurring fascination with junk objects. Parry speaks on behalf of the filmmaker when he declares in *The Fisher King*, 'There are some pretty wonderful things you can find in the trash.' In his medieval reconfiguration of the world, Parry has recycled an old car hubcap as a shield and a hood ornament as a sword. In *Tideland*, the mentally-impaired Dickens (Brendan Fletcher) has built a 'submarine' out of salvaged objects to hunt the Monster-Shark. Similarly, Jeliza-Rose has constructed her coming-of-age fantasy by reusing the vintage clothes, wigs, make-up and jewellery of her Grandmother's estate. In *Twelve Monkeys*, the technologies of the 'future world' are assemblages of found objects scavenged from the historical detritus of multiple eras: 'including the Renaissance, the Victorian Age, World War I and II, and the Fifties and Seventies' (Pizzello 1996: 38). The ability to rummage in the trash of the past and to appraise objects not for their lost utility, but for the creative potential in a recasting of their function or the construction of something new in combination with other (frequently incompatible) objects, is at the foundation of Gilliam's narrative, aesthetic and philosophical preoccupations. It is a valorisation of the power of the imagination's will to find form: the creative possibilities extended and enhanced by drawing the perceived 'obsolete' into its range. Importantly too, it is an assertion of presentness: of the pragmatic necessities of dealing with 'the now'.

The junk object is a rude reminder of the passing of time. The structures in which it had functionality have faded. It invites an eddy of nostalgia for the world of its origins, nevertheless, its materiality as a fragment of that world accentuates awareness that the past is lost and cannot be resurrected. Gilliam's junk aesthetics operate to remind us that we are embedded in the processes of time and a universe of changing conditions in which forms arise and disappear. Functionality for an old object can be reanimated, but never restored as per its origins; changed conditions dictate that it is activated anew, its utility extending only so far as that which present circumstance chooses to

imbue it and imagines building from it. The junk assemblages in Gilliam's films are expressions of an evolutionary sensibility: the past affords us building blocks, but their value resides in how they are rearranged and redeployed to meet the conditions of 'the now'. For the underground citizens of the future in *Twelve Monkeys*, evolution has proceeded very badly. Yet, evident in their makeshift, jury-rigged machinery, is an ingenuity applied in improvisation with the materials at hand, and it has enabled them to survive, albeit precariously. The fantasy projections of Parry, Dickens and Jeliza-Rose onto the world of objects are no less expressions of the pragmatic utility of the imagination in adapting to a world of flux and change: to be able to creatively rearrange the building blocks and – psychologically – survive it.

As totems of past worlds, junk objects and old stories are synonymous. Gilliam is aware that the making of meaning in the present takes place in a field of possibility established by the stories of the past. Dante's *Divine Comedy* and Hitchcock's *Vertigo* cannot be remade, but they can provide building blocks for something new: the imaginative appropriation of them is a process that is epiphenomenal. As with the junk object assemblage, Gilliam's cinematic allusions, citations and overlays of tales past – mythic and modern – are not just a reprisal of function, but are ventures to create new structures of meaning: the dramatisation of a quest to find metaphorical shelter that will meet the pragmatic demands of the now. On *Brazil*, Salman Rushdie writes: 'We are being told something very strange about the world of the imagination – that it is, in fact, at war with the "real" world, the world in which things inevitably get worse and in which centers cannot hold' (1985: 52). Rather than 'war', however, the strangeness lies more perhaps with the enactment that Gilliam makes of the reciprocity of imagination with the real world: a correspondence that emerges from the interplay of the evolutionary processes of each. There is no war that can be won. Deep evolutionary time shows that 'centers' do not hold in either the natural world or the human constructed world, and nor does it necessarily proceed in an orderly or benign fashion: volcanoes erupt, animal populations suddenly drop into extinction, civilisations collapse. At the same time, however, the real world rearranges its building blocks to evolve new structures and new orders: a countervailing drive that is a will to form. Rather than an inevitable 'getting worse', the world is marked by chaos and order, discontinuity and continuity, unpredictability and stability, but with all states relentlessly subject to change. The imagination tasked with adapting to this fluxional reality cannot hold its centres either: its constructions are necessarily contingent and provisional. The temporal world – always on the boundary of the emergent – mandates that the quest of the imagination to wrestle meaning from the universe is a perpetual and unceasing one. The shelters we construct, literally and symbolically, are always precarious.

The world that we see spinning as the frontispiece to *Time Bandits* is not one of timeless quietude. Gilliam's films rally our imaginations to engage with the full complexity and experience of it, with all its monstrosities and enchantments. It is a world that can appear to reward, in symmetry and pattern, human faith in an inherent design and purpose. In the Nevada Desert, Duke has a temporary epiphany: 'Well! This is how the world works. All energy flows according to the whims of the great magnet. What

a fool I was to defy him.' But just as the Grail and the promise of transcendence may seem to be near, the world and its operations can again become opaque, arbitrary and seemingly governed only by happenstance. In trying to apprehend it, we are all, as the dispirited Duke laments, 'permanent cripples' misled by the 'old mystic fallacy [that] something or some force is tending the light at the end of the tunnel'. No matter how complex and extravagant his cinematic bricolage is, Terry Gilliam's strident, maverick vision is the amplification of a simple truth: our familiar structures can be lost to us, without compensation, at any time. Even the comic exploding of Kevin's parents at *Time Bandits*' conclusion has the pathos of this existential truth. The blight suddenly upon us, the burden of the quest to find shelter anew will be ours. The tracks we make, however, join the tracks of all those who have searched before, and it is from the vast historical detritus left behind of their journeys that the imagination can summon a 'kit of parts' that may temper fluctuating faith and hold the world momentarily still enough such that we can adapt to its demands.

Works Cited

Anon. (1998) 'Summer movies; On Filming a Gonzo Vision: A Gonzo Dialogue', *New York Times*, 3 May. Online. Available at: http://www.nytimes.com/1998/05/03/movies/summer-movies-on-filming-a-gonzo-vision-a-gonzo-dialogue.html?pagewanted=6&src=pm (accessed 17 May 2011).

Christie, Ian and Terry Gilliam (2000) *Gilliam on Gilliam*. London: Faber.

Dening, Penelope (1998) 'Devious Devices', *Dreams: The Terry Gilliam Fanzine: Devious Devices*, 25 January. Online. Available at: <http://www.smart.co.uk/dreams/automata.htm> (accessed 10 May 2011).

Glass, Fred (1986) 'Brazil', *Film Quarterly*, 39, 4, 22–8.

Matthews, John (1985) *The Grail: Quest for the Eternal*. London: Thames & Hudson.

McCabe, Bob (1999) *Dark Knights and Holy Fools: The Art and Films of Terry Gilliam*. London: Orion.

Orr, John (1993) *Cinema and Modernity*. Cambridge: Polity Press.

Pizzello, Stephen (1998) '"*Twelve Monkeys*": A Dystopian Trip Through Time', *American Cinematographer*, 77, 36–44.

Rushdie, Salman (1985) 'The location of *Brazil*', *American Film*, 10, 50–3.

Steffen-Fluhr, Nancy (1994) 'Terry Gilliam', in Gary Crowdus (ed.) *A Political Companion to American Film*. Chicago: Lakeview Press, 185–9.

Wollen, Peter (1996) 'Terry Gilliam', in Philip Dodd and Ian Christie (eds) *Spellbound: Art and Film*. London: British Film Institute and Hayward Gallery, 61–6.

CHAPTER THREE

'And Now for Something Completely Different':
Pythonic Arthuriana and the Matter of Britain

Jim Holte

> There are but three literary cycles that no man should be without:
> the matter of France, the matter of Britain, and the matter of great Rome.
> Jean Bodel, *La Chaison de Saisnes*

Monty Python and the Holy Grail (1975) consists of a series of comedic sketches based, loosely of course, on the Quest for the Holy Grail, one of the central and perhaps the best known and most popular elements of the Matter of Britain. Other significant elements of the Arthurian narrative – Arthur's mysterious birth, pulling the sword Excalibur from the stone, the romantic triangle of Arthur, Lancelot and Guinevere, the conflict between Arthur and Mordred – are ignored. What the film presents is the essential Quest – the call to action, testings and trials and, of course, the search for the Holy Grail. *Monty Python and the Holy Grail* is a complex text, and the complexity begins prior to the narrative itself; it begins with the titles.

The main titles present viewers with an example of the cinematic deconstruction that will follow: they begin in a high epic mode, with neo-gothic script and *faux*-Wagnerian music describing the state of Britain in the Middle Ages. Suddenly the titles are interspersed with comments in Swedish extolling the virtues of the moose, among other Scandinavian wonders. An announcement follows, informing viewers that those responsible for the titles have been sacked and replaced. Stereotypical South American pan pipe music plays as the description of medieval Britain continues until the description is interspersed with comments on the wonders of the llama. The titles abruptly end. This is not the stuff of ordinary cinema, nor is it the usual treatment of Arthur

and his Knights; something completely different is going on. This chapter argues that *Monty Python and the Holy Grail* is not only a successful film but also a satiric narrative that is part of and comments upon the Matter of Britain, or the story of King Arthur, his Knights and the Quest.

The twelfth-century poet Jean Bodels' assertion that the complete literary education for any man (person) would be an understanding of, or at least the awareness of, the Matter of France – Charlemagne, his paladins and the wars against the Moors; the Matter of Britain – King Arthur and the Knights of the Round Table; and the Matter of Rome – the founding of Rome, Aeneas and the mythological legends of antiquity, as well as associated nobles, lovers, adversaries and battles – reads as a prime example of the sexist, Eurocentric, elitist and authoritarian assumptions that provide the foundation for the idea of the Western Literary Canon. However, Bodel may have written more wisely than he knew. While many of the narratives that were part of the standard curriculum are no longer taught in school, almost everyone it seems knows about King Arthur, Excalibur, Guinevere, Merlin, Lancelot and the Quest for the Holy Grail.

Despite the awareness of King Arthur and much of the Matter of Britain in the popular imagination, scholars continue to debate whether Arthur ever existed. During the last century critical opinion shifted. Earlier critics, influenced by the work of Carl Jung, Jessie Weston and Joseph Campbell, believed that Arthur was a mythic figure, perhaps a semi-divine figure, possibly created out of earlier Welsh and Celtic legends. Later scholars, drawing on recent archeological research in Britain, suggest that Arthur was an actual historical figure, possibly a post-colonial Roman war leader (*dux romanum*) who fought against the Saxon incursion into Britain. Contemporary critics have reached the consensus that we will never know if Arthur was a real person or not: so much for progress (see Charles-Edwards 1991).

Although there is no record of an actual Arthur, Camelot or the Round Table, there is a clear lineage of the sources for the Matter of Britain from early Celtic legends to contemporary films and novels that influence *Monty Python and the Holy Grail*. Although vague reference to Artorius or Arturus exist in Welsh and suggest a bear or bear-man – or perhaps a reference to the star Arcturus in the constellation Boötes, located near the Great Bear (Ursa Major) – the earliest written references to Arthur appear in Nennius's ninth-century *Historia Brittonium* (*History of the Britons*) and the tenth century *Annales Cambriae* (*Welsh Annals*). Both refer to Arthur as a noble warrior and leader who led the British against invaders. His status grew in Geoffrey of Monmouth's influential *Historia Regnum Britanniae* (*History of the Kings of Britain*), completed about 1138. In his history Geoffrey places Arthur as King of the Britains in a post-Roman world, but more importantly he creatively fills in the blanks of his life and reign. Appearing for the first time are the magician Merlin, the Knights Bedivere, Kay, Gawain, Queen Guinevere and the traitorous Mordred. The popularity of Geoffrey's work is demonstrated by the numerous copies that still exist.

The next development in the story of Arthur occurred on the continent with the development of a series of Arthurian romances, five of which were written by Chretien de Troys. Chretien's romances – *Eric and Enide*; *Cliges*; *Yvain, the Knight of the Lion*; *Lancelot, the Knight of the Cart*; and *Perceval, The Story of the Grail* – emphasise the

courtly aspects of the Arthurian material, foregrounding the love triangle of Lancelot, Guinevere and Arthur and the Quest for the Holy Grail. The final, and perhaps most influential, medieval compilation of Arthurian matter was Thomas Malory's fifteenth-century *Le Morte D'Arthur* (*The Death of Arthur*), an English prose retelling of the story of Arthur that was one of the first printed books in England, which served as the main source of characters and actions for later adapters, including the members of the Monty Python writing and directing teams, who make specific references to a number of elements foregrounded in Malory, such as Camelot and the Round Table and the Quest for the Holy Grail.[1]

After Malory, the popularity of the Arthurian legends faded, as Arthurian references became the substance of children's stories rather than that of high literature. This all changed dramatically in 1859, when Alfred Lord Tennyson, reflecting the growing cultural influence of Romanticism, Medievalism and the Gothic Revival, began to publish the multi-volume *The Idylls of the King*, which became an immediate bestseller that established Arthur and the Knights of the Round Table as models of noble human behaviour. Tennyson's depiction of Arthur and his court, with its ordered rationality and elite culture as the epitome of human society, reflected Victorian cultural ideals and provided an image of a lost perfect time that would come again. 'Camelot' would be echoed in most of the adaptations of the Arthurian matter throughout most of the twentieth century and which the Pythons would undercut in much of their film. On the other hand, and on the other side of the Atlantic, Mark Twain adapted, or transformed, the Arthurian material in his *A Connecticut Yankee in King Arthur's Court* (1889), which satirises the high seriousness, decorum and reverence of Tennyson's *The Idylls of the King* in a comic dream narrative in which a Connecticut machinist finds himself in a superstitious, violent and barbaric court of King Arthur, which is surprisingly much like the world created in *Monty Python and the Holy Grail*.[2]

In the twentieth century (and beyond) adaptations and interpretations of the Matter of Britain have appeared in a variety of media: books, operas, television, comic books and film. Arthur and his Knights are everywhere. Perhaps the most influential modern adaptation is T. H. White's *The Once and Future King* (1958). White's successful novel is a composite of three of his earlier works – *The Sword in the Stone* (1938), *The Queen of Air and Darkness* (1939) and *The Ill-Made Knight* (1940) – that rely primarily on Malory's *Le Morte D'Arthur* but also on Tennyson's *The Idylls of the King*. White creates an Arthur and a Camelot modern in complexity and motivation. His novel and the Disney film adapted from it were very popular and introduced, or reintroduced, readers and viewers in the middle of the twentieth century to the Matter of Britain in familiar formats. Numerous other modern authors have re-imagined this; among the most interesting and influential re-imaginings are Marion Bradley's *The Mists of Avalon* (1983), Bernard Cornwall's *The Warlord Chronicles* and the Merlin novels of Mary Stewart. Arthurian matter has also appeared in a variety of theatrical formats, from opera – with Richard Wagner's *Lohengrin* (1848), *Tristan and Isolde* (1865) and *Parsifal* (1882), being the most famous – to musical theatre, Lerner and Lowe's *Camelot* (1960) being the most well known and influential. These linked music and the Matter of Britain, a combination essential to the success of both *Monty Python*

and the Holy Grail and the play *Spamalot* (2005), and, throughout the twentieth century (and beyond) where drama and fiction lead, film follows.[3]

The Matter of Britain has prospered on the screen, appearing in a variety of forms: comedy, tragedy, musical and horror; all genres referenced in *Monty Python and the Holy Grail*, which draws on this long tradition.[4] The traditional adaptation of the material, heroic drama can be seen in *Knights of the Round Table* (1953) directed by Richard Thorpe and starring Robert Taylor as Lancelot, Mel Ferrer as Arthur and Ava Gardner as Guinevere. In this version, acclaimed for its elaborate sets and costumes (cinematic elements deliberately downplayed in *Monty Python and the Holy Grail*), Taylor plays a loyal Lancelot who does not betray his king, and virtue is ultimately rewarded in a classic Hollywood epilogue. A completely different take on the material is the 1963 Disney animated *Sword in the Stone*, based on T. H. White's 1939 novel, which emphasises a youthful Arthur and a bumbling and befuddled Merlin. In its depiction of attractive and brave youth and incompetent adults, this film is like many other Disney projects and aimed at a youthful audience. An equally comic version is an adaptation of Twain's *A Connecticut Yankee in King Arthur's Court* from 1949, starring Bing Crosby as the traveller and Cedric Hardwicke as Arthur. This adaptation, in which Crosby croons, does not have the bite of Twain's novel, but is mildly amusing. These films establish a cinematic tradition of using the Matter of Britain for comedic purposes, something that the Pythons push to its illogical extremes.

The most ambitious film adaptation is John Boorman's *Excalibur* (1981) which, as Anna Froula notes in chapter one of this volume, was significantly influenced by Gilliam's *Jabberwocky* (1977), and stars Helen Mirren as Morgan le Fay, Nicol Williamson as Merlin and Nigel Terry as Arthur. This version dramatises the mythic and tragic aspects of the Arthurian legends and is a visually stunning celebration of high seriousness that seems at times almost Wagnerian. Filmed on location in Ireland, the sets are lush, the costumes extravagant and the acting serious. Boorman's *Excalibur* is part fantasy, part tragedy, but never dull. Unlike most films about the Matter of Britain, this adaptation demands to be taken seriously, and, for the most part, succeeds. The best-known and most popular Arthurian film, other than *Monty Python and the Holy Grail*, is, of course, *Camelot* (1967) adapted from the successful Broadway musical that was itself an adaption of White's *The Once and Future King*. Directed by Joshua Logan and starring Richard Harris as Arthur, Vanessa Redgrave as Guenevere and Franco Nero as Lancelot, the film follows the form of the classic Broadway musical. *Camelot* focuses on the love triangle of Arthur, Guenevere and Lancelot. The plot is simple and the musical numbers express character and emotion, and advance the action. *Camelot*, on stage and screen, made the Matter of Britain musical. The Pythons would make it musically comedic.

'Get on with it!'

In the early 1970s the Monty Python team was planning to make a movie. A British comedy troupe of five members – Eric Idle, Terry Jones, Michael Palin, John Cleese, and Graham Chapman – they had had considerable success on television in both

Britain and the United States and had released a previous film, *And Now for Something Completely Different* (1971), a compilation of several of their television sketches, produced to introduce the troupe to a wider American audience. For their first original film they settled on an irreverent take on the Matter of Britain. The five members began writing scenes based on popular elements of the Arthurian material and began scouting locations in Scotland, settling on Doune Castle (where most of the film, including all the interior scenes was shot), Glen Coe (the location of the Bridge of Death and the Cave of Arrghhh) and Castle Stalker (the location of the Grail Castle and the final non-climactic battle).

Monty Python's Flying Circus was a successful television series that violated the rules of the traditional comedy review, especially that of the integrity of the comic sketch, which demanded that each sketch have a discrete beginning, middle and end. The series attracted a large and enthusiastic audience in the United States, appearing first on PBS and then network television after attaining cult status in Britain. Each episode of *Monty Python's Flying Circus* consisted of a number of sketches, often with references to classical literature, medieval art and history, religion, and classical and modern philosophy. It was unlike anything else on television. For example, nowhere else would the Spanish Inquisition suddenly break into a contemporary narrative or Socrates, Plato and Aristotle appear as members of the Greek soccer team. The individual sketches seldom followed the standard narrative conventions of beginning, middle and end. At times characters from one sketch would suddenly appear in another, and the tone swung from satire to farce. Animation – created by Terry Gilliam – was used as commentary and transition. *Monty Python's Flying Circus* worked at subverting and satirising its own form. The same structure, tone, and attitude permeate *Monty Python and the Holy Grail*.[5]

In his *Diaries 1969–1979: The Python Years* (2006), Michael Palin recalls that in March 1973 the members of the group were writing sketches for an Arthurian film and were pleased with their progress. With a budget of under $500,000 and a shooting schedule of a few weeks, the Pythons set out to recreate, redefine and reconstruct (and perhaps deconstruct) the Matter of Britain. The result is, of course, *Monty Python and the Holy Grail*, and the small film went on to both financial and critical success. The scene titles themselves (not in the original release but available on the Special Edition DVD) suggest the approach co-directors Gilliam and Jones have taken to the Arthurian material. Scenes such as 'Plague Village', 'Knights of the Round Table', 'The Tale of Sir Galahad', 'The Tale of Sir Lancelot' and 'The Holy Grail' are easily recognised as part of the traditional Matter of Britain. However, such scenes as 'Coconuts', 'Constitutional Peasants', 'The Trojan Rabbit' and 'The Holy Hand Grenade' seem somewhat out of place, or rather they suggest a dialectical movement between the sublime and the ridiculous, the serious and the silly, that is the foundation of much Pythonic humor. Throughout the film the heroic Arthurian tradition is continually undercut, creating a deconstructive text that provides a parody of itself as the narrative moves forward. The individual scenes follow the same structural pattern. Each begins with a familiar, potential heroic situation, and then through the introduction of a variety of extraneous material – inappropriate language, puns, songs, dances, exaggeration, farce,

nonsense, animation – that undercuts, parodies or comments upon the traditional narrative.

As mentioned above, the narrative disruptions begin with the 'Titles', but they continue with the first scene, 'Coconuts'. The scene begins with two figures, dressed in medieval costumes, moving through a misty landscape, reminiscent of the opening of *The Seventh Seal* (Ingmar Bergman, 1957). The soundtrack suggests the sound of galloping horses, but as the characters emerge they are banging coconuts together, providing their own special effects and establishing Gilliam and Jones' lack of concern with verisimilitude. The next scene also references *The Seventh Seal*. The opening of 'Plague Village' could be inserted into Bergman's famous flagellation sequence in which robed penitents whip themselves in an attempt to placate God and avoid the scourge of the plague. However, instead of depicting religious fervour as a response to the plague, Gilliam and Jones present an argument between an old man (John Young) who argues he is not quite dead yet and a collector of the dead (John Cleese) who is willing to help speed up the process at the behest of the old man's son (Eric Idle). The scene ends with the old man on a cart of bodies with the collector crying 'bring out your dead' both undercutting the heroic aspect of the Arthurian legend and also signalling to the audience the filmmakers' irreverence for tragic moments of history.

'Constitutional Peasants' opens with King Arthur (Graham Chapman) and his faithful squire Patsy (Terry Gilliam) meeting a peasant (Michael Palin) working in a muddy field. Arthur announces, with full romantic music in the background, that he is 'King of all the Britons' because he has been given the sword Excalibur by the Lady of the Lake. The peasant responds that he is a member of an anarchist collective and has no need of a king who claims power because he has been given a sword from 'some aquatic tart'. When Arthur grabs him on the shoulder the peasant announces loudly that he is being 'oppressed by the system': Arthur and Patsy ride ('coconut') off disgusted by the 'silly democracy thing'. In this scene Gilliam and Jones introduce temporal discontinuity as a means of parody, and they will continue to employ it as they introduce scenes of a twentieth-century historian commenting in documentary fashion on the narrative taking place simultaneously, thus breaking the fourth wall of the cinema and calling attention to the lack of temporal, spatial and narrative unity.

Even the scenes that would appear to be part of the traditional Matter of Britain, 'The Black Knight', 'Knights of the Round Table' and 'The Tale of Sir Galahad', become vehicles for parody, farce and Pythonic self-referentiality. 'The Black Knight' scene opens with Arthur and Patsy riding (or 'coconutting') through a forest where they come across a Knight (John Cleese) dressed in black, guarding a bridge, and challenging anyone who would try to cross it. Impressed with the Black Knight's prowess in dispatching potential bridge crossers, Arthur asks him to join the Quest. The Black Knight refuses and also refuses to let Arthur cross. Arthur then engages the Black Knight in combat, cutting off arms and legs, leaving a bloody head and torso stump claiming victory and calling Arthur a coward: so much for chivalry. 'The Knights of the Round Table' provides perhaps the simplest deconstruction of the heroic matter of Britain in the film. Arthur and his chosen Knights approach Camelot, which is very clearly a deliberately bad model of a castle, constructed for budgetary reasons

but also working to undercut the awe associated with the traditional representation of Camelot. The deflation continues as the lines 'it's only a model', are heard on the soundtrack. The film cuts to a table upon which are a chorus line of chainmailed Knights singing, 'We're the Knights of the Round Table / We dance whene'er we're able / We do routines and chorus scenes / With foot work impeccable / We dine well here in Camelot / We eat ham and jam and Spam a lot'. 'Spam a lot' is a reference to the famous Monty Python 'Spam skit' and a promise of things to come. Arthur announces that 'this is a silly place', reinforcing with dialogue the visual image created by the model castle, before riding away with his Grail Knights.

'The Tale of Sir Galahad' opens with a questing Galahad (Michael Palin) struggling through the darkened wilderness and coming across a grail glowing in the sky over Castle Anthrax. Inside Anthrax, Galahad, in the traditional Matter of Britain the purest and most holy of the Knights, discovers the beautiful Zoot (Carol Cleveland), her twin sister Dingo (also Carol Cleveland), and a host of beautiful women who demand to be punished, for lighting the false grail spotlight, by being tied to their beds and spanked before having 'the oral sex'. Galahad is intrigued by this challenge but is saved by Sir Lancelot (John Cleese), who tells Galahad that he is in peril. Galahad pleads 'Oh, let me go and have a little peril', but when Lancelot refuses, Galahad comments, 'I bet you're gay', subverting both the traditional image of the Knight as hypermasculine and the legend of Lancelot as the lover of Guenevere, a central theme in the Matter of Britain.

After all of the Knights have been shown on their individual quests, Gilliam and Jones bring them together in the final quest for the Holy Grail. Arthur leads them to a confrontation with a Merlin-like figure, Tim the Enchanter (John Cleese), who directs them to the Cave of Caerbannog, which is protected by the terrible Killer Rabbit who must be dispatched by the Holy Hand Grenade of Antioch, and suitable prayer, before they can cross the Bridge of Death. Here Brave Sir Robin (Eric Idle) and Sir Galahad die by failing to answer three questions correctly, (one being 'What is your favorite colour?') and discover the Grail Castle, which unfortunately is occupied by the same French taunters who defended the castle from Arthur and his Knights and the Trojan Rabbit in chapters nine and ten. These discoveries bring the quest adventures of the narrative full circle, suggesting that a traditional resolution is about to occur. As Arthur and his remaining Knights, and a seeming horde of costumed extras (actually only about eighty, carefully arranged in the frame) prepare to storm the castle, a police car arrives, and a cop arrests Arthur, Sir Bedevere (Terry Jones) and Lancelot for the murder of the modern historian, again bridging the fourth cinematic wall. This nonconclusion defies all audience expectations: there is neither a conclusion to the quest nor a resolution to the film. The film abruptly ends, leaving everything unresolved, which is unlike the narrative structure of the Arthurian narratives but very much like the narrative structure of the *Monty Python and the Flying Circus* sketch. Here characters, setting and the structure of the traditional Matter of Britain can be recognised but it has been manically transformed and subverted.

Although the sketches for *Monty Python and the Holy Grail* were written by the five members of the group only Terry Gilliam and Terry Jones shared the direction and, as

in many artistic collaborations, there were some problems and differences of opinion during the filming. Because of his art background, Gilliam took primary responsibility for the film's *mise-en-scène*, while Jones focused more on the comic action and dialogue. In the DVD commentary, John Cleese notes that at times Gilliam appeared too concerned with the technical aspects of the film. In essence Jones was in charge of performance and Gilliam with the visual aspects. Thus the moody harsh landscape of the first three scenes, the bleak mountain settings in the later part of the film, as well as the exotic island Castle Arrghhh of the conclusion, are all Gilliam's work. In *Diaries 1969–1979* Palin writes that as early as 1972 Gilliam had begun to grow tired of his work solely as an animator and wanted to direct live-action films with Palin and Terry Jones. His dual responsibilities permitted him to engage in both crafts in *Monty Python and the Holy Grail*. Much of the direction resembles Gilliam's work as an animator, especially the use of juxtaposition and the introduction of the macabre and the satiric into the narrative. The result is both comedy and commentary.

As in *Monty Python's Flying Circus*, animation is employed in *Monty Python and the Holy Grail* to advance the action, to provide punctuation (or commentary) on the action, to exaggerate or contrast the action, or to depict something beyond the limitations of the narrative. Gilliam was credited as Python's animator before becoming a full member of the troupe, and his surreal animation in *Monty Python and the Holy Grail* is similar to that of *Monty Python's Flying Circus*. Three examples in the former illustrate Gilliam's effective use of animation. The first is his depiction of God. In manifesting the ineffable Gilliam draws the stern patriarchal crowned face of famous nineteenth-century cricketer W. G. Grace speaking from the clouds, calling Arthur and his Knights to undertake the quest. Arthur, justly awed by the Lord's presence, averts his eyes and falls to his knees, only to hear God tell him to 'stop grovelling'. The animation here establishes authority and then immediately undercuts it. A second example is the animated story, actually an animated summary of the 'Black Beast of Arrghhh', in which Gilliam depicts the conflict between Arthur and the Grail Knights and a horrible monster in a few seconds. Perhaps the most interesting use of animation is 'The Death of the Animator', in which Gilliam is seen at a drawing board creating an animated bridge between sequences when he suddenly dies. This temporal and structural intrusion again violates standard cinematic conventions of unity but also continues to undercut the idea of death, which has been a source of comedy in a number of scenes throughout the film, the most obvious being 'Plague Village', 'The Black Knight' and 'The Rescue of Prince Herbert', all of which challenge the seriousness of death.

A final element of the film deserves mention, as it points the way for the further development of the Pythonic Matter of Britain: music. The film includes two and a half songs. The most famous is the aforementioned 'Knights of the Round Table'. The second is the 'Ballad of Brave Sir Robin', song by a group of minstrels who follow Robin about as they chronicle his adventures, including how he soils himself and 'bravely runs away'. This subverts both Knightly bravery and the idea of the minstrel, or poet, as recorder of heroic deeds. The partial, or attempted song is sung by Prince Herbert (Terry Jones), kept a prisoner in a tower by his father, who is forcing him

to marry an unattractive princess against his will in order to gain her property. This is obviously a parody of the beautiful princess being held in the tower and forced to marry an evil brute, a popular motif in many fairy tales and Hollywood's medieval films. Several times he attempts to break into song, as he would be allowed to do in the musical *Camelot*, only to be silenced by his father.

Monty Python and the Holy Grail was a financial and critical success. Made for the equivalent of $350,000, which explains the decision to use coconuts rather than real horses, the film has grossed well over $1.5 million. Three DVD versions have been released (1999, 2001 and 2006), all with commentary and additional material. The film has also received a good deal of critical and popular praise. For example, the film is rated number forty on Bravo's '100 Funniest Movies', and *Total Film* magazine voted *Monty Python and the Holy Grail* the fifth greatest comedy of all time.[6] But what to make of the film: is it simply silly and pure fun? Perhaps not: Rebecca Housel writes that the film is indeed serious; she argues that in debunking the patriarchal and authoritarian attitudes imbedded in the Arthurian narratives, the film is 'as much a document of the 1970s as a satire of medieval culture' (2006: 92). There is much to be said for a serious reading of this 'silly' film. Humour in general, and satire in particular, has always tended to be subversive, mocking, sometimes gently and sometimes savagely, the pretensions of the powerful. In *Monty Python and the Holy Grail* Gilliam, Jones, and the rest of the troupe present and undercut religion, science, philosophy, nationalism, heroism and even conventional narrative structure. As in all narratives of the Matter of Britain, this film uses the story of Arthur and his companions to explore contemporary issues that call into question traditional attitudes towards politics, religion and sexuality. The Pythons do so by making us laugh at Arthur and ourselves. The Pythons would continue their subversive madness in their next film, *The Life of Brian* (1979), which would undercut the Matter of Christianity.

'We Eat Ham and Jam and Spam a lot.' Again.

Like King Arthur himself, who as 'the once and future king' never dies, the Pythonic take on the Matter of Britain did not end with *Monty Python and the Holy Grail*. During the 1990s the four surviving members of Monty Python (Graham Chapman having died in 1989) had a series of discussions about reforming the group and taking on some new projects. One idea was a sequel to *Monty Python and the Holy Grail*. All the members of the troupe had achieved post-Pythonic success, and there was little interest in the idea (see O'Connell 2006). Eventually, however, Eric Idle convinced his colleagues to give him permission to adapt *Monty Python and the Holy Grail* for the stage. The result was *Spamalot*, which opened on Broadway in 2005, thirty years after the premiere of the original film. Idle wrote the book and the lyrics and collaborated with John Du Prez on the music. In 2005 the musical was nominated for thirteen Tony Awards and won three: Best Musical, Best Performance by a Featured Actress in a Musical and Best Direction in a Musical.

The storyline of *Spamalot* generally follows that of *Monty Python and the Holy Grail*, and most of the characters from the film appear, somewhat altered for the stage, in the

play as well. Referencing the Titles of the film, the play opens with a historian providing an overview of medieval England only to have the actors sing about Finland. Following processing penitential monks, King Arthur and Patsy enter and ride ('coconut') about the stage, gathering the Knights of the Round Table. Along the way they encounter Not Dead Fred, a constitutional peasant, the Lady of the Lake with Laker Girls, God and a Trojan Rabbit. After the Intermission Arthur and Patsy encounter the Knights who say 'Ni', who demand a shrubbery and that Arthur put on a Broadway play, the Black Knight, Prince Herbert, Tim the Enchanter, the Killer Rabbit and the Holy Hand Grenade of Antioch. They eventually achieve the Grail, Arthur marries the Lady of the Lake (whose name happens to be Guinevere), Lancelot marries Herbert, and Robin decides to pursue a career in musical theatre. Idle's play rewards audience members who are aware of the form of musical theatre and the work of Monty Python. Both the lyrics and the narrative satirise the idea of the heroic quest, as did *Monty Python and the Holy Grail*, and the idea that the characters on stage will stop, sing and be conscious of the musical itself because the characters constantly remind each other and the audience that they are engaged in an act of musical theatre.

Musical theatre is not cinema, and in telling the Grail story on stage Idle and director Mike Nichols must rely on the musical numbers both to advance and subvert the action. Just as *Monty Python and the Holy Grail* is an anti-film, deconstructing the tale it tells and parodying the cinematic form, so *Spamalot* is an anti-musical, deconstructing the tale and parodying musical theatre. It is no wonder that alongside musical numbers that advance the plot – 'King Arthur's Song', 'I am Not Dead Yet', 'Knights of the Round Table', 'Run Away' (appropriately staged just before Intermission), 'Brave Sir Robin' and 'The Holy Grail' – several songs subvert and satirise the musical itself. For example, 'The Laker Girls' cheer undercuts the seriousness of the Lady of the Lake, a medieval version of the Celtic Goddess, the Morrígan, by equating her to basketball cheerleaders. Or perhaps it establishes the divinity of the Laker cheerleaders? 'The Song That Goes Like This' is generic love song staged with a large chandelier (a visual reference to Andrew Lloyd Webber's *Phantom of the Opera*), and, finally, 'You Won't Succeed on Broadway' is an elaborate production number that spoofs *Fiddler on the Roof*.

Spamalot is a popular and financial success. The show had an initial run of over 1,500 productions, has received mostly positive reviews, and, although a number of critics noted that the musical lacked the satirical power of the film, I would say that comparing the musical to the film is like comparing a coconut to a hand grenade. However, the reaction to *Spamalot* from the members of Monty Python was mixed. Terry Gilliam called the play 'Python-lite' and quipped 'it keeps the pension fund alive'; Terry Jones said he had reservations about the project but thought it was 'good fun'; Michael Palin said, 'We're all hugely delighted that *Spamalot* is doing so well. Because we're all beneficiaries'; and John Cleese observed, 'In the end I think it turned out splendidly'. For his part Idle noted, 'I'm making them money, and the ungrateful bastards never thank me. Who gave them a million dollars each for *Spamalot*?' How serious or sarcastic these comments are one will never know, but the Pythonic world is, as we have seen, a world often turned upside down.[7]

Monty Python and the Holy Grail and *Spamalot* are just two of the many contemporary adaptations of the Matter of Britain. As with all the narratives that make up the complex story of King Arthur and the Quest, these Python productions reveal as much about contemporary attitudes and ideologies as they do about the subject matter itself. They use an ironic, postmodern lens to observe and transform some of the essential narratives of Western culture. In adapting the heroic romances of King Arthur, his Knights, and the Quest for the Holy Grail as satiric cinema and musical comedy, the Pythons not only retell the legends to new audiences, they also employ the characters and situations from those legends to explore, satirise and subvert accepted notions about politics, power, religious authority, the use of violence and the role of women in society. Additionally, they satirise the narrative structure of the theatre and cinema. In their creation of self-aware characters who often mock the very actions they perform, Monty Python continues in the long tradition of interpreters of the Matter of Britain. Perhaps Bondel was correct, and sometime in the future cinema scholars will carefully study these comedies. Oh, right, we have just done that. 'Wink, wink; nudge, nudge, say no more.'

Notes

1 For further information on these tales, see Chrétien de Troys (1991).
2 For information on *The Idylls of the King, A Connecticut Yankee in King Arthur's Court*, and other contemporary adaptations of Arthur in fiction, see Taylor and Brewer (1983) and Thompson (1996).
3 For music in *King Arthur*, see Barber (2002).
4 For film adaptations of Arthur, see Hardy (1991).
5 For additional information about *Monty Python's Flying Circus*, see Landy (2002).
6 See Project Bravo (2006).
7 For the Python team's responses to *Spamalot*, see Plume (2005), O'Connell (2006), Elfman (2008) and Ganley (2009).

Works Cited

Barber, Richard (2002) *King Arthur in Music*. Woodbridge: Boyehill and Brewer.
Bradley, Marion Zimmer (1982) *The Mists of Avalon*. New York: Ballantine.
Bodel, Jean (1989 [c1200]) *La Chaison de Saisnes*, 2 vols. Annette Brasseu (ed.). Geneva: Druz.
Charles-Edwards, Thomas (1991) 'The Arthur of History', in Rachel Bromwich, A. O. H. Jarman and Brynley F. Roberts (eds) *The Arthur of the Welsh: Arthurian Legend in Mediaeval Welsh Literature*. Cardiff: University of Wales Press, 15–32.
Cornwell, Bernard (1997) *Enemy of God: A Novel of Arthur*. New York: St. Martins.
———— (1998) *Excalibur: A Novel of Arthur*. New York: St. Martins.
de Troys, Chrétien (1991 [c1180]) *Arthurian Romances*. Eds. William Kibler and Carelton Corrall. London: Penguin.

Elfman, Doug (2008) 'John Cleese Loves *Spamalot*, Doesn't Know It's Closing, Also He Declares, "It's Not a Fortune to be God"', 5 May. Online. Available at: http://www.lvrj.com/blogs/elfman/John_Cleese_Loves_Spamalot_Doesnt_Know_Its_Closing_Also_He_Declares_Its_Not_a_Fortune_to_be_God.html (accessed 6 November 2011).

Ganley, Doug (2009) 'Monty Python's 40 Years of Silliness', *CNN,* 24 October. Online. Available at: http://articles.cnn.com/2009–10–24/entertainment/monty.python.40_1_ifc-documentary-silliness-bbc?s=PM:SHOWBIZ (accessed 6 November 2011).

Geoffrey of Monmouth (1996 [c1138]) *The History of the Kings of Britain*, Lewis Thorpe (ed.) Harmondsworth: Penguin Books.

Hardy, Kevin J. (1991) *Cinema Arthuriana.* New York: Garland.

Housel, Rebecca (2006) 'Monty Python and the Holy Grail: Philosophy, Gender, and Society', in Gary Hardcastle and George A. Reisch (eds) *Monty Python and Philosophy: Nudge Nudge, Think Think!* Chicago: Open Court, 82–92.

Landy, Marcia (2002) *Monty Pythons' Flying Circus.* Detroit: Wayne State University Press.

Mallory, Thomas (2001 [1485]) *Le Morte D'Arthur,* trans. and ed. Keith Baines. New York: Penguin.

Nennius (1948 [c800]) '*Historia Brittonum*', in J. A. Giles (ed.) *Six English Chronicles.* London: Henry G. Bohn, 1–15.

O'Connell, John (2006) 'Michael Palin: Interview', *Time Out,* 31 October. Online. Available at: http://www.timeout.com./london/books/features/2202/3.html (accessed 17 December 2010).

Palin, Michael. *Diaries 1969–1979: The Python Years.* New York: Thomas Dunne, 2006.

Plume, Ken (2005) 'Interview with Terry Gilliam'. Online. Available at: http://www.asitecalledfred.com/2006/08/08/quickcast-interview-terry-gilliam-part-8/ (accessed 6 November 2011).

Project Bravo (2006) 'Bravo's List of 100 Best Movies is Laughable', 2 June. Online. Available at: http://www.projectbravo.com/?m=200606&paged=2 (accessed 27 May 2011).

Taylor, Beverly and Elizabeth Brewer (1983) *The Return of King Arthur: British and American Arthurian Literature Since 1800.* Cambridge: Brewer.

Tenneyson, Alfred (1996 [1859]) *The Idylls of the King*, ed. J. M. Gray. New York: Penguin Books.

Thompson, R. H. (1996) 'English, American Literature in (Modern)', in Norris J. Lacy (ed.) *The New Arthurian Encyclopedia.* New York: Garland.

Twain, Mark (2002 [1889]) *A Connecticut Yankee in King Arthur's Court.* Berkeley, CA: University of California Press.

White, T. H. (1986 [1958]) *The Once and Future King.* New York: Ace.

CHAPTER FOUR

The Baron, the King and Terry Gilliam's Approach to 'the Fantastic'

Keith James Hamel

'He won't get far on hot air and fantasy.' So says Jackson (Jonathan Pryce), the evil civil servant in Terry Gilliam's film *The Adventures of Baron Munchausen* (1988), as he watches the Baron (John Neville) and his nine-year-old sidekick Sally (Sarah Polley) escape an unnamed walled city in a hot-air balloon made out of women's underwear. Coincidentally, the Jackson character is rumoured to have been modelled on the studio moguls (such as Sid Sheinberg of Universal) who tried to shape and control Gilliam's wildly imaginative films to that point – namely *Brazil* (1985) (see Kael 1989: 103). But Gilliam has gone far on fantasy. If the reviews of *The Adventures of Baron Munchausen* are any indication, then Gilliam is a maker *par excellence* of fantasy films. TV film critic Joel Siegel remarked of it, 'like *Time Bandits* [1981; Gilliam's second solo directorial effort], like *Brazil*, this picture is about imagination and the power of imagination to conquer that drab place we know as reality' (Yule 1991: 233). Jim Emerson of *The Orange County Register* wrote, 'Fantasy achieves nobility in *Munchausen*', while Derek Malcolm in the *Guardian* heralded the movie as 'one of the greatest fantasies of all time' (Yule 1991: 235). Similar observations have been made about Gilliam's other movies, and by all popular accounts Gilliam is one of the foremost film directors of fantasy (see Robley and Wardle 1996). His films often have monsters or mythical characters, they are usually set in exotic or surreal realms, some of them play with notions of identity and time, and all of them contain imaginative and bizarre visuals. But while his films might generally be labelled 'fantasy', do they automatically belong to the specific realm of the 'fantastic'? Two of Gilliam's mid-career works will be analysed to test this hypothesis, the aforementioned *The Adventures of Baron Munchausen* and his subsequent film *The Fisher King* (1991). Using Tzvetan Todorov's theorisation of the concept as a guide, this chapter posits that Gilliam's fantasy films complicate Todorov's

narrow definition of the fantastic by playing with some of its conditions and stylistic features but ultimately frustrating it with an auteurist thematic agenda.

In his *The Fantastic: A Structural Approach to a Literary Genre* (1975), Todorov's criteria for a work to be categorised as fantastic can be condensed to one important passage found in his second chapter. While describing the central tenet of the fantastic, which he labels 'sustained ambiguity', he writes, either 'the person who experiences the event ... is the victim of an illusion of the senses, of a product of the imagination – and the laws of the world then remain what they are; or else the event has indeed taken place, it is an integral part of reality – but then this reality is controlled by laws unknown to us' (1975: 25). Opting for the first case places the subject in the world of the uncanny, which provides an extraordinary, shocking or disturbing, albeit rational, explanation for the events (1975: 46). Pursuing the second leads to the realm of the marvellous in which the supernatural is unquestioningly accepted as reality. The true fantastic is the limitable space between these two options, also known as the fleeting moment of uncertainty, but before reaching this uncertainty, three conditions of unequal value must be satisfied:[1]

> First, the text must oblige the reader to consider the world of the characters as a world of living persons and to hesitate between a natural and a supernatural explanation of the events described. Second, this hesitation may also be experienced by a character; thus the reader's role is so to speak entrusted to a character, and at the same time the hesitation is represented, it becomes one of the themes of the work. Third, the reader must adopt a certain attitude with regard to the text: he will reject allegorical as well as 'poetic' interpretations. (1975: 33)

Having established the pertinent aspects of this theory, the remainder of this chapter analyses how Gilliam's notions of fantasy both simulates and surmounts Todorov's concept of 'the fantastic'.

The Adventures of Baron Munchausen is set, as a title card indicates, in 'the late 18th century', which a second card labels, 'the age of reason'. The film opens as war rages between the Turks and some unnamed European state. Inside the walls of a war-torn city, Henry Salt's (Bill Patterson) theatre company is clumsily performing 'The Adventures of Baron Munchausen', which its poster describes as 'a tale of incredible truths'. As the 'Baron' (played by Salt) narrates his encounter with a monstrous fish and tells of his time in the Sultan's court, a mysterious figure from the back of the theatre screams, 'Lies! Lies!' This old man (Neville), who bears a striking resemblance to Salt's character both in terms of his costume and his exaggerated aquiline nose, pushes his way on to the stage claiming to be the real Baron Munchausen. There he notices four supporting players in the theatre's company who he believes to be his gifted lost henchmen: Berthold (Eric Idle), Albrecht (Winston Dennis), Gustavas (Jack Purvis) and Adolphos (Charles McKeown). They, however, believe the Baron to be a loon and maintain that they are just actors. When the theatre licenser and official in charge of conducting the current war, Horatio Jackson, comes backstage to investigate the disruption, the mysterious man claims that only he himself can end the war since he

began it. He then goes in front of the theatre audience to reveal how he is the true cause of the war.

As the supposedly-real Baron now narrates his meeting with the Grand Turk, the film seamlessly transitions from the shoddy stage to the regal residence of the Sultan (Peter Jeffrey) by panning, as a character moves left to right across the screen, from the theatre wings in the background to the palatial columns of a new set. Here, a younger-looking Baron bets his head that he can procure within an hour a superior bottle of Tokay from a wine cellar over a thousand miles away. The Sultan accepts the wager and puts up as much of his treasure as 'the strongest man can carry'. The Baron then sends his servant Berthold, a man who can outrun a bullet and who looks exactly like one of the theatre troupe, to Venice to retrieve the wine. Berthold makes it back just in time, and the Baron then uses his servant Albrecht, a man with enormous strength who was also onstage prior, to carry away everything in the Sultan's treasury. Recognising the folly of his figurative language, the Sultan orders the Baron stopped, but another henchman/actor from the earlier play, Gustavas, who has the power to blow down buildings, bowls over the Sultan's soldiers with his breath. The Sultan then orders cannon fire, and, as the explosions go off around the Baron outside the palace, explosions presently occur in the theatre while the *now older* Baron remarks to the audience: 'As you can see, the Sultan is still after my head.'

After an encounter with the Angel of Death during the attack, the Baron takes flight in a hot-air balloon in an effort to find his lost henchmen and save the city. Accompanying him is Henry Salt's daughter, Sally, who stowed away on the ship that is serving as the balloon's basket. Their first stop is the moon where they encounter the lunar king (Robin Williams) and queen (Valentina Cortese), both with detachable heads. They also find an aged and balding Berthold, but the three of them are forced to flee for their lives when the king discovers that the Baron, made younger by his present adventure, has a romantic past with his wife. Falling off the moon, the group lands in the volcano of Mount Etna where they meet the god Vulcan (Oliver Reed) and his wife Venus (Uma Thurman). Coincidentally, one of the god's servants is a dainty Albrecht. Once again, the Baron's amorous ways with the lady lead to spousal jealousy and expulsion. Upon being thrown out by Vulcan, the now group of four lands in the South Seas where they are swallowed by a huge monster fish. Inside its belly they find a wheezy Gustavas, and a near blind Adolphos. Using 'a modicum of snuff', a line delivered earlier in the film by Salt as the Baron, the entire group of six is sneezed out of the fish and find themselves back in the bay of the city. With the Turks preparing to storm the gates, the Baron plans a counterattack, but Sally points out that his servants are too tired and too old to help. To keep his promise to save the city, the Baron then decides to offer his head to the Sultan, hoping that this will motivate 'his troops'. His plan is a success, and his henchmen regain their lost powers and defeat the Turks. The city gives the victors a heroes' parade, but as he waves to the crowd the Baron is shot and killed by Jackson. Everyone mourns, but the Baron, suddenly on stage in the theatre, reveals to the audience that this was 'only one of the many occasions on which [he] met [his] death'. Jackson rushes into the theatre to arrest the Baron on the trumped-up charge of telling lies while the enemy is at the gates, but to counter, the Baron orders anyone

who will listen to open the gates. The two go back and forth as the Baron marches to the city's gates while Jackson promises to shoot anyone who would commit treason by listening to the Baron. The crowd nevertheless sides with the Baron who opens the gates to show everyone that the Sultan's army has indeed been defeated. He then rides off and fades into nothingness against an artificial-looking horizon.

This lengthy plot summary only touches upon the many complexities of the film's narrative. Was it all just a theatrical play, or did the Baron and Sally really go to the three exotic locales and then defeat the Turks with the help of the henchmen? If it all was play, when did it start (before or after the Baron enters the theatre)? If their journey was real, when did that start (before or after the Baron sets out to find his servants)? How can characters be both supporting players in the play and the Baron's servants in his adventures? Two female players also reappear: one as the queen of the moon and the other as the goddess Venus. How can the Baron and his henchmen appear young and vibrant in one setting and then old and frail in another? The manner in which Gilliam structures his narrative makes it impossible to answer these questions with much certainty.

So it would seem that this film has the essential element of ambiguity to qualify it as belonging to Todorov's fantastic. Or does it? First, does the viewer hesitate between a natural and a supernatural explanation of the events depicted? The film begins with the viewer vacillating as to whether or not the mysterious play crasher is the legendary Baron Munchausen (fantasy/supernatural) or just a delirious old fool (logical/natural). However, after the Angel of Death (who resembles a statue perched on one of the city's walls) visits him, the viewer is more likely to see this man as the fabled Baron. And when pressed by Sally as to who he 'really is', the Baron announces that he is the antithesis of the rational, natural world: 'It's all logic and reason now. Science. Progress. Tsk, tsk. Laws of hydraulics. Laws of social dynamics. Laws of this, that and the other. No place for three-legged Cyclops in the South Seas. No place for cucumber trees and oceans of wine. No place for me.' In his monologue the Baron tells the viewer that he sees himself as existing outside the modern world and coming from a place that the viewer understands as only existing in fairy tales. The Baron then performs a supernatural act by flying to the Turkish camp and back on a pair of cannonballs. Aiding the supernatural explanation is his wild adventure to save the city, which, Todorov would argue, puts this film outside the uncertainty required for the fantastic and into the realm of the pure marvelous, a state that justifies its supernatural elements via certain character or narrative tropes.

Todorov identifies four such categories, three of which are present in the film.[2] The first is the *hyperbolic marvellous* in which 'phenomena are superior to those that are familiar to us' (1975: 54). Running fast or being a good marksman are in themselves not remarkable feats, but being able to outrun a bullet or being able to hit something from five hundred miles away make Berthold and his cronies' abilities appear superhuman. Next, the settings for the Baron's adventures qualify as the *exotic marvellous*. Even though the viewer knows that the moon and the South Seas do exist, he or she is generally ignorant of what one might find there which makes it easier to accept lunar royalty with detachable heads or a leviathan that can swallow a boat whole. Finally,

the hot-air balloon made of women's underwear or the Vulcan's prototype weapon link the film to Todorov's categorisation of the *instrumental marvellous*. Here, 'gadgets [or] technological developments unrealized in the period described [are], after all, quite possible' (1975: 56). Even though *The Adventures of Baron Munchausen* is set in the eighteenth century, it is not hard to imagine the underwear balloon as a modern-day blimp or the weapon that 'kills the enemy … all of them gone for good' (according to Vulcan) as a nuclear warhead. Thus, most of the film provides the viewer with supernatural explanations for the phenomena presented that might cause her or him to accept this reality as valid rather than question those moments that should cause hesitation; this goes against Todorov's first condition of the fantastic.

The film fares a bit better with a character experiencing hesitation, but it is far from perfect. Gilliam typically uses a character like Sally, with whom the viewer is meant to identify, to balance out the seemingly-delusional main character whose credibility the viewer tends to doubt. These latter characters are Gilliam's 'visionaries', and their actions and/or dialogue make them seem either crazy or naïve, thus placing the viewer in a position in which it is difficult (though not impossible) to identify with them. Gilliam's solution is to include a secondary character, a 'materializer' figure, who comes to believe in the alternative reality of the visionary, in this case, the Baron. He sees, without a doubt, his special servants in the players on stage, he speaks of his implausible adventures with the utmost sincerity, and he defies all known logic and reason by his belief in and reliance on the impossible. However, it is Sally, as the visionary, who gives credibility to the action by believing in the wild things the Baron says and does.

Though her childlike innocence allows her to play along with most of the Baron's stories and plan to save the city, she does hesitate at various points in the film. First, after the Baron's tale about starting the war, she finds him backstage and asks, 'Who are you really?', which suggests that she does not totally believe that he is indeed the real Baron Munchausen. Then, as they are sailing to the moon, the Baron tells Sally about the king and queen with detachable heads and asks her, 'You do believe me don't you?' Sally demonstrates hesitation by responding: 'I am doing my best.' Finally, after the Baron has gathered all his henchmen and is planning his attack on the Turks, Sally shows doubt by telling him, 'This isn't going to work. They're [the servants] old and tired. Don't you see?' These moments of uncertainty suggest that the film's narrative ultimately depends on Sally believing in the Baron, and, given that the viewer is meant to identify with her, if she accepts the Baron's tales as true, then viewer hesitation is all but eliminated. For this condition of the fantastic, Sally does show that she believes in the Baron. First, after he flies across the battlefield on a cannonball, Sally looks at him and says, 'You really are Baron Munchausen' (paradoxically, the Baron looks dejected and shakes his head 'no'). Then, after opening the gates to show that the Turks have been defeated, Sally asks the Baron, 'It wasn't just a story, was it?' (and, with the same look as before, the Baron shakes his head 'no'). So for the majority of the film Sally has her reservations, but the fact that she ultimately decides to accept the marvellous explanation of events again moves this film from Todorov's notion of the fantastic.

Todorov's third condition for the fantastic requires the reader to reject poetic or allegorical interpretations of the text. It is possible to read this film, and most

of Gilliam's other works, as allegory, although not overly blatant. To do so requires introducing another character type: 'the technocrat'. This figure, antithetical to the visionary, wholeheartedly subscribes to the benefits of social modernity, which is an intellectual movement that began with the Enlightenment and posits that the source of all human misery is ignorance (especially superstition), and that only knowledge, reason and science can destroy this ignorance and help improve the human condition (see Hollinger 1994: 2). Although this argument is beyond the scope of this chapter, Gilliam regularly uses concepts associated with fantasy to challenge the world's dependence on the dogmas of modernity. The visionary and the technocrat are the allegorical figures that repeatedly fight this symbolic war between imagination and logic in Gilliam's films.

In *The Adventures of Baron Munchausen*, Jackson, the civil servant, plays the role of the technocrat. His first line of dialogue in the film establishes his philosophy. Looking at a treaty from the Turks he says, 'No, the Sultan's demands are still not sufficiently rational. The only lasting peace is one based on reason and scientific principle.' In the same scene he orders the execution of a heroic officer (Sting) who saved the lives of ten soldiers and claims that it is bad to have such 'emotional' (as opposed to reasonable) people running around. Towards the end of the film, during negotiations with the Sultan, Jackson proposes that they 'concentrate on reaching a rational, sensible, and civilized agreement which will guarantee a world fit for progress, science and…' At this point the Baron enters the Sultan's tent and says, 'But not for Baron Munchausen!' The Baron accuses Jackson of being 'the rational man', and asks, 'How many people have perished in your logical little war?' During the Baron's victory parade, Jackson shoots the Baron from behind the statue of the Angel of Death, which bluntly symbolises the logic of modernity, 'killing' any need for fantasy, not to mention the obvious visual connection between the man of reason and another allegorical figure, 'Death'. Beyond the symbolic figures themselves, Gilliam likely structured his narrative so that the viewer could understand it as all taking place 'on stage', the site of many medieval plays using allegorical modes of representation. So, once more, Gilliam's film thwarts a condition for the fantastic.

Yet while the film falls short of the three conditions of Todorov's fantastic, it does rather well in terms of the two stylistic devices that he claims are necessary to create ambiguity in a fantastic text. The first of these is the imperfect tense. Grammatically speaking, the imperfect tense is used to indicate that an action started in the past but is still ongoing or incomplete in the present. But Todorov is more interested in this device's effect, which he claims suggests that something 'is *possible*, but as a general rule *unlikely*' (1975: 38). When the Baron and Sally set off to find the Baron's servants, the viewer believes that she is witnessing the narrative events in the present tense. However, when the story returns to the stage, the Baron announces: 'And that was only one of the many occasions on which I met my death.' 'Was' and 'met' are verbs in the past tense, which might indicate that what the viewer just witnessed was not happening in the present as watched, but rather could have been an event from a long time ago. The Baron's adventures seem to fuse the past and the present into a new concept of time. In fact, Todorov sees, in the imperfect tense, the fantastic text as able to keep the reader

in both the realm of reality and the world of the marvellous at the same time (ibid.). The fact that the Baron's appearance shifts from old to young to old again reinforces this notion. It is as if Gilliam is telling a story that is presently happening, but while it is happening it is narrated in the past tense with the future known at certain intervals (the viewer knows, for example, that the Baron will use snuff to escape the monster fish because he or she witnessed this event in Salt's performance earlier in the film). This film, along with several others by Gilliam, challenges the viewer's understanding of narrative time as strictly chronological – chronological often becomes 'chrono-*illogical*' to Gilliam.

Todorov's second literary device is 'modalization [sic]', which, he maintains, refers to certain words or expressions that indicate uncertainty concerning the accuracy of an utterance. But how does one recognise concepts such as 'seems', or 'perhaps', or 'it is doubtful' in cinematic terms? To do so, viewers must look for clues in the film that suggest that things might not be as they seem. One example occurs right after cannon fire interrupts the Baron's story about his wager with the Sultan. The Baron is trying to stop the players on stage from fleeing, but when he calls to the one he believes to be Berthold, the actor says to him, 'The name's Desmond, mate. We're actors, not figures of your imagination. Now get a grip.' Yet, as he delivers the last line, he jumps twice before running off stage. On the surface it looks like he is just stomping to make a point, but in fact this act is the same one that Berthold performs as he 'winds' himself up like a cartoon character by running in place to build up speed in his legs before exploding off to his destination. So while this character claims to be Desmond, his actions make him *seem* to be Berthold. Gilliam also uses cinematic elements, such as *mise-en-scène*, cinematography and sound, to suggest the uncertainty inherent in modalisation. During the moon sequence, Gilliam presents a gala ceremony in which the Baron and Sally 'sail' (on sand) into the King of the Moon's domain. Even though no people are present at this parade, Gilliam includes a cheering crowd and festive music on the soundtrack to simulate a big to-do surrounding their arrival. Furthermore, as the two wave to the unseen crowd, Gilliam shows them passing two-dimensional, pastel-coloured structures (or rather these structures, some on different planes, passing them) to make it *seem* as if their boat is moving forward. In fact, when Gilliam changes from the shot/reverse-shot pattern to an overhead shot of the boat, it is evident that the Baron and Sally didn't sail anywhere. Instead they are confined within a rectangle composed of two-dimensional buildings. What looked like an extravagant march up main street turned out to be nothing but an illusion.

If Todorov's conditions rule it out, but his stylistic devices qualify it, where does this leave *The Adventures of Baron Munchausen* as a film of the fantastic? The most appropriate place seems to be slightly right of Todorov's imaginary frontier for the fantastic, or in the sub-genre known as the fantastic-marvellous. However, Gilliam's film reverses the terms for Todorov's conception of this case. Typically, in the fantastic-marvellous, the story's events create the required ambiguity for the fantastic until the last moment when the narrative clearly adopts the existence of the supernatural. This film tips to the side of the supernatural early on with regard to the first condition for the fantastic with its superhuman characters, exotic locales and imaginary tools.

However, the ending of the film, notably when the Baron vanishes in the final shot, tilts the film away from the pure marvellous and back toward the fantastic. It questions whether there really ever was a Baron and his adventures, or whether this is all the product of Sally's imagination as she watched her father perform the role of the Baron. Does the ending of the film occur in the same reality as the beginning? The Baron's disappearance, as well as the artificiality of the horizon against which he disappears, causes the viewer to hesitate and to ponder the Baron's true existence as well as the validity of the tale just seen. By including such an ending, Gilliam places his film in the realm of the fantastic-marvellous.

Gilliam's next film is not as imaginatively complex as this one, perhaps with good reason. Given the troubled production history of *The Adventures of Baron Munchausen*, it is likely that the film took a psychological toll and after it; Gilliam 'announced that he was tired of defending his own ideas and was ready to direct someone else's work' (Drucker 1991: 50).[3] The resulting project is *The Fisher King*, which is set in present-day Manhattan, has reality-based main characters, and seems to be outside the bounds of Gilliam's typical fantasy fare. Yet, as Gilliam acknowledged in an interview with Bob McCabe, he approached the film 'like a fairy tale', and, as Elizabeth Drucker concludes in her review, 'Even with its many contributors, *The Fisher King* is very much a "Terry Gilliam Film"' (ie, a fantasy) (1991: 51).

The film tells the story of two broken individuals who end up helping each other find redemption. Jack (Jeff Bridges) is a former shock deejay whose rants against society inspire a man to gun down patrons in a trendy bar, while Parry (Robin Williams) is a potentially delusional, homeless history professor who is obsessed with finding the Holy Grail. When Jack learns that Parry's wife was a victim of the aforementioned shooting, he attempts to help Parry overcome his repressed demons (manifested in the form of an ominous Red Knight surrounded by fire) in order to win the love of a mousy girl named Lydia (Amanda Plummer). After Jack and his on-again/off-again girlfriend Anne (Mercedes Ruehl) arrange a date between him and Lydia, Parry is 'wounded' by the Red Knight and ends up in a catatonic state brought on by a flashback to the night his wife was shot. When Parry doesn't wake up, Jack attempts to retrieve the object to which Parry devoted his life, which he believed was kept in a millionaire's library on Fifth Avenue. Jack breaks in and steals 'the Grail', which turns out to be a trophy from 1932, and puts it in Parry's hands. That night, Parry magically awakens and comes to terms with his wife's murder.

The Fisher King contains sustained ambiguity, but unlike *The Adventures of Baron Munchausen*, the hesitation concerns character and not narrative events. Commenting on the characters, Gilliam has said: 'I love the fact that there is this ambivalence. All myths, if they are dealt with properly, are never as clean-cut as we tend to see them. One side, if you twist it enough, becomes the other' (Drucker 1991: 50). The particular myth in this film is the tale of the Fisher King, which Parry narrates to Jack halfway through the film (paraphrased below):

> It begins with the king as a boy, who had to spend the night in the forest to prove his courage. While there he had a vision of the Holy Grail surrounded by fire. A voice told

the boy that he was to be keeper of the Grail, so that it might heal the hearts of men. But the boy was blinded by a life of power and glory. Feeling like God, he reached for the Grail, but it vanished, burning the boy's hand. As he grew older, the wound on his hand grew deeper and even life lost its reason. He couldn't love or be loved, and he began to die. One day a fool wandered into the castle and saw this man in pain; being simple-minded he didn't see that it was the king. He asked the king, 'What ails you, friend?' The king replied, 'I am thirsty. I need some water to cool my throat.' The fool reached down beside the king's bed and picked up a cup and filled it with water. As the king drank, he felt his wound heal and realized that the cup was the Grail. He asked the fool, 'How could you find that which my brightest and bravest could not?' The fool replied, 'I don't know. I only knew that you were thirsty.'

This story informs the film's larger narrative, but which character is the king and which the fool? Paradoxically, the answer is 'both'. Both Jack and Parry fulfill the role of king because they both need healing. Jack is haunted by the feeling that his radio tirade led to the nightclub massacre (ironically, the viewer keeps hearing the words, 'Well forgive me!' coming from a TV sitcom in which Jack was supposed to star before the tragedy). Conversely, Parry needs to put his wife's death behind him and learn to love again. Each time he recalls his past love, a vision of the menacing Red Knight appears. Similarly, they also both play the fool helping the other overcome his wound. Jack fulfills Parry's quest for the Grail (even if it is only an award that looks like the Grail), and helps him woo Lydia. Meanwhile, Parry teaches Jack about the goodness inside himself, which frees him from his guilt. However, character ambiguity is not synonymous with the ambiguity to which Todorov referred as essential for the fantastic text. That ambiguity is caused when one is forced to explain a phenomenal event in the story as either an illusion of the senses or as the product of reality controlled by unknown laws. *The Fisher King*'s character ambiguity is not that problematic. The narrative events of the film remain the same (ie, they do not waver between a natural or supernatural explanation), regardless of whether or not one views Jack or Parry as the king and the other as the fool or each as both.

Nearly all of the phenomenal events of the film can be explained by the psychological trauma that Parry experienced when his wife was shot. Right after Jack hears about the 'little people' (imaginary fat fairies who told Parry to embark on his Grail quest), Gilliam includes a scene between Jack and the superintendent of the building in which Parry once lived. The superintendent tells Jack about the 'accident', which allows the viewer to understand Parry's visions of pixies as the result of some repressed psychosis. Also, Gilliam suggests that the Red Knight is a product of Parry's unconscious mind when the viewer at last sees the threatening foe at the end of Parry's date with Lydia. Here, Gilliam uses parallel editing to clearly link the Red Knight to the man who shot Parry's wife. However, Jack sees a representation of the Red Knight in a stained-glass window of the 'castle' he 'storms' or breaches to find the 'Grail', thus troubling the idea that the Knight exists only in Parry's unconscious, even if only as a picture come-to-life. Both of these examples more or less provide a rational explanation for the supernatural elements, namely 'madness' or 'strange coincidence',

which Todorov would argue places the film in the realm of the uncanny and not the fantastic.

Yet the fact that Parry emerges from his catatonia shortly after Jack brings him the 'Grail' does provide the film with a degree of the fantastic. Is the timing of Parry's awakening mere coincidence or is it tied to Jack's chivalrous act? Furthermore, if it is the latter case, is it just simple belief in the Grail that made Parry better, or does the Cup indeed have magical powers? By not providing answers to these questions in its final scenes, Gilliam allows the film to tread the waters of the fantastic-uncanny; although, like *The Adventures of Baron Munchausen*, *The Fisher King* reverses Todorov's definition of this sub-genre. As characterised, the supernatural events of the fantastic-uncanny receive a rational explanation at the end (1975: 44). In this case, Parry's supernatural recovery complicates the uncanny, but nonetheless rational, elements of the film. However, this ending is far from the purely fantastic. For one thing, neither character ponders the cause of Parry's extraordinary recovery, which complicates Todorov's second condition of the fantastic (character hesitation fostering reader/viewer hesitation).

Todorov's third condition (rejecting allegorical interpretations) also problematises *The Fisher King*'s candidacy as a fantastic text. While not as symbolic as the earlier film, it's take on the homeless could be read allegorically as another critique of social modernity. During the Grand Central Station sequence, Gilliam diverts from Parry inconspicuously following Lydia in order to focus on a homeless man in a wheelchair (Tom Waits). This man tells Jack that the homeless are society's 'moral traffic lights'. Allowing such an inconsequential character (in terms of the film's narrative) to offer such a profound political statement is significant. It is as if Gilliam is directly challenging the viewer to ask in this instance, 'How can this indeed be an "Enlightened" world when people are left to live in such a decrepit state just to remind the rest of the population of how lucky they are?' Such a philosophy mocks the reasoning and logic of social modernity. Given all its instances of, and references to, the homeless – from the bum knocking on the window of Jack's limo in the second scene of the film, to the proposed sitcom titled 'Home Free' about 'happy homeless people' that is pitched to Jack and his agent – it is hard to imagine that Gilliam intends his representation of homelessness to remain purely literal. Instead, as in *The Adventures of Baron Munchausen*, Gilliam seems to be using the concept of 'homelessness' to once again challenge a world dominated by reason, logic, science and technology.

As these two films demonstrate, Gilliam begins in the marvellous or the uncanny and ends near the line of the fantastic; but, ultimately, it is this critique of social modernity that keeps his fantasy films from truly being Todorovian fantastic texts. From *Time Bandits* through *Twelve Monkeys* (1996) to *The Imaginarium of Doctor Parnassus* (2009), Gilliam's films toe the line of sustained ambiguity well enough to be considered part of the fantastic (are the events real or are they merely illusion?), but ultimately Gilliam uses this ambiguity to challenge the world's dependence on logic and reason. Furthermore, the ambiguity is typically secondary to his film's visuals. As Gilliam himself once said in an interview, 'In the end I always sort of … just go for visual spectacle and the things that excite me' (Behar 1995). In this respect, his work

follows Jochen Schulte-Sasse's splitting of fantasy into the duel concepts of 'imagination' and 'fancy'. According to Schulte-Sasse, fantasy can be used to compensate for the shortcomings of existing realities or to produce new ones (1987: 29). This first instance comprises 'imagination', which Gilliam's films demonstrate through their attack on reason and logic (ie, 'existing reality'), while the latter encompasses 'fancy', which is the escapism factor associated with Gilliam's visuals (ie, 'producing a new reality'). Gilliam's signature themes thus resemble the words of Marcel Schneider who wrote in his *La Littérature Fantastique en France* (1964), 'The fantastic explores inner space; it sides with the imagination, the anxiety of existence, and the hope of salvation' (Todorov 1975: 36). Coincidentally, as if expecting a case to be made for Gilliam as a director of the fantastic, Todorov rejects this definition by saying that this is a theme that could be applied to texts which are not fantastic at all (ibid.). But Gilliam obviously does not need Todorov's approval to make it as a fantasy auteur: with his perfect blend of imagination (themes deconstructing the dogmas of modernity) and fancy (proposing a new way to see and understand the world), Terry Gilliam has indeed gotten far on 'hot air and fantasy'.

Notes

1. Todorov represents the relationship between these terms in the following sketch with 'fantasy in its pure state represented here by the median line separating the fantastic-uncanny from the fantastic-marvelous … a frontier line between two adjacent realms' (1975: 44). Uncanny > Fantastic-uncanny > Fantastic-marvellous > Marvellous.
2. Seemingly missing is the 'Scientific Marvellous,' which Todorov also calls 'science fiction' (1975: 56), but David Morgan has labelled Munchausen an 'eighteenth-century sci-fi' (1988: 240).
3. For the troubled production history, see Bob McCabe's chapter, 'The Adventures of Baron Munchausen' (1999: 130–43).

Works Cited

Behar, Henri (1995) 'A Chat with Terry Gilliam on (or around) *Twelve Monkeys*', *Film Scouts*. Online. Available at: http://www.filmscouts.com/scripts/interview.cfm?File=ter-gil (accessed 15 May 2011).
Drucker, Elizabeth (1991) '*The Fisher King*: Terry Gilliam Melds the Modern and the Mythical', *American Film*, 16, 50–1.
Hollinger, Robert (1994) *Postmodernism and the Social Sciences: A Thematic Approach*. Thousand Oaks, CA: Sage.
Kael, Pauline (1989) 'Too Hip by Half', *The New Yorker*, 3 April, 103–5.
McCabe, Bob (1999) *Dark Knights and Holy Fools: The Art and Films of Terry Gilliam*. New York: Universe Publishing.

Morgan, David (1988) 'The Mad Adventures of Terry Gilliam', *Sight and Sound*, 57, 4, 238–42.
Robley, Les Paul and Paul Wardle (1996) 'Hollywood Maverick: Terry Gilliam, A Career Profile of One of the Cinema's Premier Fantasists', *Cinefantastique*, 27, 6, 24–37.
Schulte-Sasse, Jochen (1987) 'Imagination and Modernity: Or the Taming of the Human Mind', *Cultural Critique*, 5, 23–48.
Todorov, Tzvetan (1975) *The Fantastic: A Structural Approach to a Literary Genre*. Ithaca, NY: Cornell University Press.
Yule, Andrew (1991) *Losing the Light: Terry Gilliam & The Munchausen Saga*. New York: Applause.

CHAPTER FIVE

The Subversion of Happy Endings in Terry Gilliam's Brazil

Jeffrey Melton & Eric Sterling

Terry Gilliam's directorial career is defined by persistent explorations of the dreams of overwhelmed or even delusional characters. They battle with both inner demons and the outer world in troubled efforts to save (or find) their humanity. It is a trademark of his directorial vision and has secured his rightful place within the pantheon of substantive filmmakers as well as appreciative, if selective, audiences throughout his career. His work often focuses on the struggle within the main characters to find some solace in perilous worlds bent on crushing the spirit, where the key to salvation, however tempered by horrific circumstances, resides in the individual imagination because it does not exist in the real world. Gilliam presents this salvation often in terms of an escape, however brief, from a mindless state-sponsored bureaucracy that threatens creativity, innovation and original thought. It is with *Brazil* (1985) that Gilliam presents for many viewers his most compelling exploration of this theme.

The film almost never made it into the theatres, however, and the battle for its release in many ways reflected an ironic interplay of these same issues. The impasse between Gilliam and Universal Studios over the release of the film has been well documented by Jack Mathews.[1] In brief, studio executives considered the film overly depressing, especially its ending, which they determined to be completely unacceptable (read: unmarketable). Perhaps they responded to the standard assumption that films with overtly happy endings are more appreciated at the box office than movies with depressing conclusions. That is not complicated or surprising. However, their effort to piecemeal a version of the film that would achieve their financial expectations is instructive, since it also unwittingly reveals overarching societal beliefs regarding romantic love and (un-)happiness. Universal Studios President Sid Sheinberg claimed that his studio 'wasn't so much interested in a happy ending as a "satisfying ending"'

and that, because of Gilliam's ending, its commercial potential was 'something close to zero' (Lyman 2004: 28).

Universal created different conclusions to the film, but Gilliam did not like any of them because a 'satisfying ending', as implicitly defined by Sheinberg, was simply incongruous with the rest of the film. Gilliam lamented that studio executives such as Sheinberg are 'businessmen who have risen to the top because they are very good businessmen, but when they find themselves running a movie studio, they suddenly want to be filmmakers. They think they *are* filmmakers. But you know what? They're not' (Lyman 2004: 29). From the legal battle came a bowdlerised film *Brazil* (what has been deemed the 'Love Conquers All' version) that provides a clear and happy ending which follows conventional Hollywood patterns. Our heroes survive, a happy couple, with a happy future implied. Love, indeed, conquers all, even totalitarian societies.[2] Fortunately, this version survives only as a curiosity for avid fans of Gilliam's art. Although no one needs to argue against this silly insult to Gilliam's work, since its invalidity is self-evident, the cultural desire for the triumph of romantic love that the version represents, however, can provide a springboard from which to view *Brazil* proper. Gilliam's masterpiece is a different kind of love story, one tied not so much to romance but to humanism.

The desire of studio executives to conform to the notion that successful films must have happy endings, however unrealistic and unaesthetic that may be, correlates well with Gilliam's conception of office administrators who adhere blindly to bureaucratic regulations. In a 1995 interview with Paul Wardle, Gilliam expressed concern over the inconsistency in the studio executives' proposed alternative endings to *Brazil*: their 'ending was appalling! You create an android, and tell the viewer that they all have limited life spans, and then at the end, it's, "Oh, but this is one that doesn't." That's the kind of thing that drives me crazy. Let's at least be consistent or true to the piece' (2004: 91). Gilliam, in stark contrast to studio executives, offers an ending that is indeed 'true to the piece', and its validity resides in the mind of our reluctant hero.

Sam Lowry (Jonathan Pryce), a highly competent though complacent bureaucrat, sheds his waking identity to become the heroic saviour of a damsel in distress. The excitement of his dreams provides sharp contrast to the mediocrity of his daily life: 'In his fantasy world, he is a heroic figure who rescues his dream girl from nightmarish creatures, derivative of and corresponding to the intrusive social system in which he lives' (Rosen 2008: 78). Lowry's imagination in the beginning resides wholly in a chivalric dreamscape wherein he is a knight errant battling with an ever-present dragon – or, as he creates it, a giant metallic samurai warrior. As opposed to being evidence of an active imagination, Lowry's dream woman, more accurately, is simply evidence of his self-absorption born of loneliness, boredom and apathy. Viewers should note that his dreams are not harmless escapism; rather, they allow him to remain guilty of disengagement from the workaday world and to ignore his complicity with its horrors.

Lowry's flights of fancy, while seemingly metaphorical moments of escape and lightness, actually weigh him down by continuing his delusion of meaningful participation in the human race. The totalitarian system dehumanises him by denying him aspirations for autonomy or self-determination; his dreams ironically perform a similar

function and equally deny Lowry his humanity. He seems to be under the impression that his dreams are his own (though he does deny to his mother that he has any at all). He clearly sees his flight fancies as separate from the drudgery of 'Brazilian life'; he is wrong, for they serve as part of the mechanism that keeps him passive and submissive. On their surface, Lowry's daydreams, defined first via heroic flights through the clouds, would seem to be clear evocations of his true self, a man driven to a sublimated rebellion against the overbearing and tedious weight of life in a totalitarian society. While these can be regarded as metaphorical moments of lightness, these dreams perhaps more accurately should be viewed as self-defeating in that they appease his psyche's need for such escape while doing nothing to challenge the complacency of his waking self.

In the opening minutes of the film, audiences witness a bumbling everyman who nonetheless has dramatic subconscious delusions of himself as capable of soaring above his mundane world. The waking Lowry, however, indicates no real capacity or inclination to rebel. His dreams do not intrude upon his waking life, or the real world of *Brazil*, beyond making him somewhat distracted. He remains a functional cog in the machine. His flights are more romantic versions of the old films, like *Casablanca* (1942) that his co-workers watch at every possible moment, enjoying their own brief moments of escape. They all, however, simply fulfill the ultimate goal of the state. In one of the many propaganda posters that litter the city, an image of a storm trooper is complemented with a simple message: 'They work so we may dream.'[3] In this sense, Lowry's romantic dreams, quite simply, serve the state, which encourages dreams of a passive nature as an opiate and thereby benefits from the lie that such dreams promote happiness and general well-being.

More importantly for his salvation, however, is that his waking life begins to intrude upon his dreams. As we hope to show, both his growing sense of guilt and his growing selflessness gain influence over his subconscious. It is this transformation that is crucial to assessing fully the conclusion of the film and Lowry's final utopian dream. Fredric Jameson has argued that the modern difficulty of envisioning, much less achieving a utopian world derives not from any 'individual failure of imagination'; rather, the failure comes from the 'systematic, cultural, and ideological closure' of industrial society that imprisons us all (1982: 153).[4] With this context in mind, we should consider that the awakening of Sam Lowry is an extraordinary act of human will, but it is an act made possible by his altruistic interactions with Jill Layton (Kim

'They work so we may dream.'

Greist) – encounters that enable him to rebel against the totalitarian society that attempts to dehumanise them both.

The process of pursuing Jill Layton offers him the opportunity to think and act in a more selfless manner, as he tries to save her life. It forces awareness of a world beyond his childish ego and outside of state-sanctioned dreaming. Of course, there are two Jill Laytons. Fred Glass observes that Lowry's 'dream woman also actually exists, as her own person, and as someone who is quite different – active, capable, thoughtful – than he has fantasized' (1986: 24). We should clarify that a *dream* woman cannot be a *real* woman, even when both are played by the same actress. The key is that Lowry makes this connection immediately and absolutely. As the childlike romantic, Lowry believes, or assumes, that she *is* his dream woman made flesh in his waking reality. This is a fortunate coincidence for Lowry's salvation. The fact that beyond her superficial appearance Layton bears no resemblance to his dream woman is vitally important, however. He seeks her merely for her beauty, and he persists despite her clear antagonism for him and for the dehumanising bureaucratic establishment he represents. His persistence, which is not necessarily a sign of strength of character but more one of desperation and self-absorption, nonetheless allows him to learn from her. The chase – Lowry's quest – provides him a picaresque tour of his world, and he learns much in the process. He is, in the end, able to incorporate her otherness into his own sense of self, or, more accurately, he joins her, which transforms his selfhood altogether into a compassionate human being. Herein rests the true potential for affirmation of human feeling revealed in *Brazil*.

Before addressing Lowry's quest, we must consider his world – an authoritarian nightmare that in every way discourages human aspiration beyond the desire for comfort and commodities. *Brazil* could represent society in any twentieth-century Western culture, or as Gilliam puts it, 'the Los Angeles/Belfast border' (Christie & Gilliam 2000: 129). The society he creates (or reflects) is awkwardly caught in a technological age in which machines and bureaucracies quash human compassion and self-identity. Gilliam asserts that there is 'a price to pay for all of these Central Services, for the world we have … By taking part in that process, the price you pay is a more complicated society, and one you're dependent on' (Gleiberman 2004: 32). The dehumanising effect of this reliance upon machines is most evident in the absence of altruism or even basic caring for others. The dearth of such human feeling becomes all the more apparent with Gilliam's choice to set the film during Christmas time. Viewers may even wonder if the world of the film is in a perpetual season of giving, wherein citizens are encouraged to perform – over and over again – the act of giving but with no capacity for, or expectation of, genuine joy that such acts of kindness could provide. One gets the impression that Christmas is a year-round opiate to allow the performance of human interaction via the exchanging of gifts, while everyone remains distant and isolated. There is no pleasure in either giving or receiving; rather, each exchange of gifts is perfunctory, a symbolic act of community rendered virtually meaningless. The sacred promise of technology – that it will make humans comfortable and happy – remains unfulfilled.

Added to this malaise is the constant threat of random violence. Daily terrorist bombings have continued for thirteen years, so no one, even those in close proximity

to the explosions, seems to care or even notice them anymore as long as they are not directly affected. Gilliam comments that because *Brazil* shows that in 'a terrorized society, and whatever that terror is, whether it's terrorists or just the complexity of a system that just blows up in your face the whole time, the best way to survive it is just staying in your own little cubby hole' (Morgan 2004: 56). Gilliam makes a vital point here in that both terrorism and governmental control work to keep citizens fearful and isolated as seemingly solitary victims of circumstances beyond their comprehension. The director suggests that governments control citizens through bureaucratic numbness and fear. As a result, even if citizens imprisoned in such a world of random violence chafe against circumstance, they lack the capacity to imagine an alternative, much less fight for one. So they conform. As Jameson asserts, 'it is practical thinking which everywhere represents a capitulation to the system itself, and stands as a testimony to the power of that system to transform even its adversaries into its own mirror image' (1971: 111). As a result, citizens reflect the will of the state and become isolated and disinterested, even cold. When bombs explode, people react apathetically, as if they are machines within the system. The lives and identities of the victims are meaningless. The silence of the survivors is the voice of complicity.

Sam Lowry acts likewise. Bob McCabe observes that Lowry is 'the guilty party' and enjoys 'all the privileges through his father and other's connections. He's bright so he should be taking responsibility in that organization, but he shuns responsibility. He lives in his little fantasy world' (1999: 126). Early in the film, when he makes a show of helping others, he does so merely in order to make himself feel good and to assuage his guilt, as in the scene involving Mrs Buttle. Indeed, his offer to deliver the refund check personally derives simply from a desire to get out of the office and to clear up some paperwork. He indicates no substantive interest in the fact that his action could be helpful to the family. In reference to this scene, Gilliam remarks, 'Sam thinks he's a good Boy Scout; it's Christmas time, so he's doing his best for everybody by taking his chance. Normally, you wouldn't do that in the system, but he thought this was a great humane gesture, without understanding what he was doing' (Christie & Gilliam 2000: 144). The intensity of Mrs Buttle's grief and the violent attack by her son stun Lowry. He has no concept of the lives of the Buttles or anyone in the city at all. His only response to her question, 'what have you done with his body!?' is to deny responsibility and to assert his magnanimity in bringing her the check in the first place.

This vital moment introduces Lowry to the 'reality' of his world while also demonstrating his disengagement from it. Even as he is knocked to the floor, he catches a glimpse of Layton in the broken mirror and takes off after her, leaving the Buttle family to its tears without further thought. After failing to catch up with her, he learns her name – Jill Layton – from a little girl who says that she is waiting for her father to come home. Walking away, he realises that the girl must be Buttle's daughter. His dream woman via Jill Layton is now inextricably tied to the Buttle tragedy. Throughout the film, Gilliam demonstrates that love and liberty are virtually impossible in this postcapitalistic existence, but he also suggests – through the intertwining of the Buttle family, Tuttle, Layton and Lowry – that human interconnectedness remains, however sublimated by the system.

Lowry's dreams begin to show a progression driven by the guilt of this connection. Obstructions or challenges increasingly appear in successive dreams, and they derive in mutated form from the events of his waking life that increasingly burdens him. The guilt is shown primarily through his imagined construction of Mrs Buttle whose repeated demand, 'what have you done with his body?' serves as a steady drumbeat in his increasingly worried mind. These images, in addition to his relationship with Jill Layton, incite him to change and become more caring, selfless and humane – hence his benevolent behaviour alongside Layton in the department store, where they tend compassionately to the victims of the bombing, a sincere act of human kindness. This essential scene is brief but compelling nonetheless. Although the action of their relationship centres on his manic and often comic attempts to win her trust, the underlying significance resides not in the romantic quest but Lowry's developing identity in response to life outside of his normal routine.

Whereas his dream woman is separated from reality, Jill Layton is wholly enmeshed with it. His chance sightings of her – in the Ministry of Information and at the Buttle home – occur only because she is demonstrating concern for her neighbours, keeping their welfare in the front of her consciousness. This impulse for human kindness intrudes itself upon Lowry's self-identity as he pursues her. The bombing scene in the department store provides a clear indication of this subtle but crucial shift. The only people who tend to the wounded are Lowry and Layton, who, because of their altruism, are subsequently accosted by stormtroopers. They are arrested even though the package she carries is still intact after the bombing and is thus obviously not the source of the explosion. Lowry's caring is genuine, though we should note that he acts in direct response to Layton's command: 'Make yourself useful.' Gilliam suggests here that those who care enough to help threaten a society that works so comprehensively to dehumanise its citizens under the guise of law and order. This is an important implication. To take any interest in the well-being of fellow citizens is at best suspicious and, by extension, inherently a form of subversion. The two become suspects simply for displaying human kindness.

Layton's troubles, however, are much deeper. Because of her efforts to help the Buttle family, she has been included on the list of dangerous terrorist subjects provided to Jack Lint (Michael Palin), the Information Retrieval specialist who tortures Buttle. By seeking formal redress about the mistreatment of the innocent man, Layton has revealed herself as compassionate and, unlike Lowry, not a passive dreamer. Viewers witness her core personality from the beginning, and her anti-establishment nature is revealed at every moment; her isolation from society seems to have preserved her identity. Even her choice of entertainment carries significance.

Her appreciation of the Marx Brothers is not incidental. Gilliam establishes a connection between Layton and the Marx Brothers when she lies in her bathtub watching *The Cocoanuts* (1929) as government foot-soldiers come to arrest Buttle. She is clearly enjoying the anarchic humour of the comedy team until she is interrupted by the capture of Buttle. The Marx Brothers were notorious for making movies that satirise all political and cultural power structures and established hierarchies. Though the images from *The Cocoanuts* appear briefly, Gilliam is clearly interested in

the Marx Brothers as a symbol of the inversion of social order, including references to the comedy team in other films, such as *Twelve Monkeys* (1995) when the members of the asylum watch *Monkey Business* (1931). Layton's taste in comedy is not incidental by any means, and it complements the reasons why Layton stands out in her society. She cares about others and complains about the bureaucracy; she is thus labeled any enemy of the state.

In the world of *Brazil*, the word of an innocent citizen means nothing compared to the black type on a white form. To the government bureaucrats, forms never lie. When Jill Layton goes to government desks, which tower above her and other citizens in a spatial display of hegemony – literally as well as metaphorically placing bureaucracy on a pedestal – she is unceremoniously dispatched from one office to another in vain, unsuccessful in her attempt to help the Buttles. She is not allowed to save the life of this innocent man because she lacks the appropriate form (or the appropriate stamp for the form), and each apathetic bureaucrat sends her to another one in her fruitless effort to secure the proper documents. Glass notes that 'Jill sees through the machinations of the state bureaucracy and the myriad ideological systems it utilizes because she cares – without becoming maudlin – about human beings and her empathy puts her into direct conflict with the worldview and practices of nearly everyone around her' (1986: 27). The totalitarian bureaucracy allows no room for caring, individualistic human beings, so for Layton these qualities prove fatal. Layton's altruism and willingness to challenge the bureaucratic hegemony renders her dangerously human, for it manifests her desire to make her own decisions; her choices give her a true individual identity, which makes her a subversive force. The moral point, though, is that her individuality exists in context with others.

Part of the lack of humanity depicted in *Brazil* derives from the lack of choice – or what Lawrence Langer refers to as 'choiceless choices, where the only alternatives are between two indignities' (1980: 55). For instance, Lowry can marry, but he is pressured to acquiesce to the woman selected by his mother, Ida, and Ida's best friend, Mrs Terrain. Naturally, they select the best friend's daughter, Shirley, even though the two 'lovebirds' are clearly incompatible. The two are thrown together by their overbearing mothers without their consent or input. Just as he must blindly obey authority in his bureaucratic world, Lowry is pressured by his mother to marry against his will. It is noteworthy, then, that when Lowry rebels against his mother, he does so by finding his own woman, Layton, ultimately consummating their relationship in Ida Lowry's bed. The sexual liaison between Lowry and Layton on his mother's bed serves as a blatant rebellion against dictatorial authority.

Furthermore, Ida Lowry secures a nepotism-based promotion to Information Retrieval for her son, even though he does not want it and it is without his permission. Likewise, Kurtzmann rejects Lowry's promotion for him, also without his permission. Gilliam, therefore, presents a society in which people lack autonomy because all decisions are made for them, as if they are too ignorant to decide anything for themselves, or perhaps more accurately, in fear that citizens may actually exercise autonomy and challenge the will of the state. Gilliam observes that the office workers in Information Retrieval are 'doing whatever the boss demands of them, they're evil in the sense that

they're not taking the responsibility for their own actions, they're just desperate to please whoever it is that is in power' (Klawans 2004: 154). Government workers and, by extension, citizens at large thus become automatons who mindlessly fill out forms, follow orders, and accept decisions made for them.

Brazil demonstrates the power of the state to stifle or blunt imagination by erasing self-identity. Those in control of the system dehumanise the citizenry through excessive use of – and obsession with – numbers and forms, all of which serve as signifiers of a bureaucracy of total control. After his promotion, Lowry becomes DZ/015. The letters and numbers replace his identity and demonstrate that he has become one of the nameless followers who desperately walk behind the boss, Mr Warrenn (Ian Richardson). The code DZ/015 substitutes for – or supplants – his identity, just as Holocaust victims in Auschwitz-Birkenau had numbers inscribed onto their arms or Americans are followed everywhere, even to their deaths, by their social security number. Lowry's new identity, DZ/015, resembles 27B/6 (the designation for a government form related to heating and cooling systems work orders): both consist of a seemingly random combination of letters and numbers. Lowry's identity is thus no different from that of a bureaucratic form. In fact, Warrenn welcomes him by saying, 'Congratulations, DZ/015. Welcome to the team.' Yet it is hardly a team because no one cares or works with each other. All workers are sequestered in small offices more similar to prisoners in cells than humans with any spirit of cooperation or commonality. Harvey Lime (Charles McKeown), who occupies the adjacent office and a similar letter/number code, struggles to seize more of the desk that he shares with Lowry, as it is wrenched through the wall by first Lowry and then Lime in an endless contest. Workers are left to engage in petty battles for extra inches of desk space, seemingly oblivious to the inherent loss of dignity and purpose. David Morgan notes, 'modern life is designed to separate us much more than it used to; it's not the village any more. We all have our little boxes we live in' (2004: 56). Lowry is being swallowed up by the bureaucratic government established initially to maintain order, yet that now exists to ensure that people live not as vibrant human beings but as lifeless automatons in a world defined by 'the commodification of all social relationships' (Glass 1986: 22).

Jill Layton and Harry Tuttle, though acting as individuals and apparently in no direct connection to others, stand apart. They are loners, but they act ultimately for a common good. Layton shows clear concern for her neighbours and acts on their behalf. Tuttle also acts for the benefit of others simply by insisting on doing quality work – a rare thing in Gilliam's 'Brazilian world.' Tuttle is a true craftsman and, according to Gilliam, is one of those rare individuals 'who make things work' (Gleiberman 2004: 32). Tuttle, an artisan, is clearly motivated by the challenge of the work itself, but his efforts nonetheless help others. Any enjoyment he garners from the work does not undermine the core altruism of his actions. He refuses to be reduced to a number and thus provides another valuable model for Lowry's awakening. Though both Layton and Tuttle are loners, they are not isolationists. Their actions move outward, not inward, and they are, as a result, intricately connected to both the Buttle tragedy and Lowry's development.

The 'Love Conquers All' version of *Brazil* is unintentionally ironic, for it implies unrealistically that love wins out over authority, the state and oppression. Implicit in this dishonest version is that love – romantic love – is the ultimate triumph of the human spirit. Therein rests the deeper horror of the version. The idea of using the 'love conquers all' conceit as a model for a revision of *Brazil* clearly distorts the struggles within the film itself, turning a 'sad' ending into a 'happy' one. But such a view of the film also undermines the more nuanced triumph of the human spirit found in Gilliam's masterpiece: the triumph of shared humanity, a different kind of love story. Gilliam's film, in its proper directorial form, demonstrates the ultimate transformative power of cooperative community spirit, and is not ultimately a celebration of the individual. Of course, interpreting the film in this manner must inevitably prove less rewarding for those viewers (and studio heads) who desire unadulterated joy. However, it provides, nonetheless, its own inspiration for those viewers who hope for some substantive resistance to totalitarianism. Cooperation among oppressed, apathetic and distrustful human beings – emotionally and morally crippled spirits created by a dysfunctional totalitarian social system – is in itself a victory for humanity. This victory becomes even more poignant when we consider that Lowry has been indoctrinated into the mind-numbing bureaucratic routine for many years.

Initially, Gilliam envisioned a young man in his early twenties, not Jonathan Pryce, a middle-aged actor, to play the role of Sam Lowry. Gilliam decided to adapt to the casting of Pryce, a fortunate decision for the moral movement of the film. The director remarked that as an older man, Lowry

> is guiltier, he deserves the final punishment far more than if he'd been a 21-year-old kid; he's somebody who has avoided responsibility, who has failed to make the most of himself in life. These things actually add to the character. (Christie & Gilliam 2000: 115)

The casting of a middle-aged man in the lead role deepens Lowry's complicity. Because he has been part of the dehumanising bureaucracy for decades, he is highly invested in the system, no matter his level of ambition professionally. He would find any awakening of moral responsibility rather challenging, to say the least. Lowry's incomplete nature, even though he is a middle-aged man, renders his tragic fall from grace as an ideal citizen of the state more stunning to the status quo. When Lowry and Layton join, as Gilliam puts it 'to make a full human being', they represent not a loving couple of misfits (typical of more standard Hollywood romances) but a shock to the system. With Lowry's struggle against the powerful state a catastrophic failure, the concept of a happy *romantic* ending is absurd and, worse, beside the point.

Lowry's tragic dive into madness is tempered by his efforts to establish bonds with those outside of his social caste structure, a decidedly unromantic narrative arc. Yes, his efforts are inept and frequently clueless – he is a man-child – but they are increasingly sincere and move beyond adolescent whimsy and self-absorption, and they develop into a legitimate human desire for interconnectedness. Lowry moves outside of his socially determined place of isolation and complacency. The initial catalyst for his movement is romantic, chivalric love, but the effort moves well beyond that rather

narrow movement. Lowry – whether intentionally or not – becomes a force for social rebellion as he becomes aware of a broader community of resistance – via Layton and Tuttle. True, his ultimate madness leaves the state intact – this point is unequivocal – but his dream vision implies the removal of oppression for all.

Lowry's final dream concludes with a pastoral vision of shared experience and is in no way a continuation of heroic flights of fancy definitive of his early dreams. Moreover, throughout the long sequence that begins in the massive torture chamber, he no longer creates a world wherein he fights to save a weak, caged, subordinate female. On the contrary, although he participates in the violence of the escape, the entire dream is defined by his increasingly desperate efforts to evade capture. Most importantly, he accepts a wholly passive role in the last stage of the escape; this is not resignation. Rather, it marks significant emotional growth. Lowry becomes a mature human being fully embracing a communal spirit. The first part of the dream is defined by male violence led by Tuttle, but the images nonetheless exhibit cooperative effort to destroy the totalitarian state. This part of the dream, albeit satisfying emotionally as the Ministry of Information is destroyed, offers no real solution. It is only when his dream returns to Layton that Lowry develops a purposeful, truly inspired narrative vision.

His dream in its concluding sequence celebrates not violence, not adventure, not ego, but life. The final dream becomes possible only within a mind transformed, a mind and heart at peace and within a cocoon of shared human desire and experience, a mind in love with the endless hope of humanity. We must understand that Lowry, as the man we see in the early parts of the film, could in no way have imagined the final sequence. At the film's conclusion, he is not the same adolescent dreamer of the earlier dreams of flight. Awakened to the needs of others, Lowry creates a willful rejection of the authority that has always separated him from Layton – not as lovers but as fellow human beings. His dream speaks from the collective unconscious and symbolically asserts that, indeed, we are all in it together. Lowry and Layton, together, have successfully thwarted a corrupt society simply by being together in their hearts and minds. Subversion need not be any more complicated than that.

However, Lowry's final dream sequence pushes the subversion further. He creates a symbolic way for the disaffected to recapture their individual and collective human spirits, and those spirits remain intact despite the horror of the core fact that at the end of the film the state remains in control of the society at large. This assertion does not ignore the terror that our hero has been put through by the Ministry of Information during his incarceration. The cruelty of the impending torture itself, as revealed by the perverse display of tools on the table next to Lowry, demonstrates both the power of the state and the void created by the utter lack of human compassion. Although Lint is Lowry's long-time friend, he is most concerned with the embarrassment caused by his relationship with Lowry, even as he prepares to use surgical instruments and power tools to torture his friend.[5] Lowry's torture – and most certainly he *is* tortured, as the wound on his hand shows – does not appear on screen. His increasing insanity is awful and heartbreaking. This awareness, however, should not blind viewers to the other part of this complex exchange: Gilliam's film ends with Lowry at peace.

He is free, not because of insanity but because of his subversive imagination. As revealed by the final image, his dream – just before Lint and Helpmann reappear – is coherent and complete and made possible by the processes of an inwardly rational mind. The image itself provides evidence for rationality. It stands in sharp relief from the manic movement and violent chaos that dominates the preceding sequences of the final dream. It is calm and complete, a still life of peace in the valley. Moreover, Lowry, when we last see him, is in no pain. The government agents of torture – Lint and Helpmann – are fully aware that they have failed to achieve their purpose. Lowry has clearly made no admission of guilt that satisfies them. In fact, Lowry's last sane words are wholly focused on asserting his innocence. His claims are desperate, indeed, as he tries to convince Lint to be merciful, but we should also consider that he now also believes in the concept of such innocence and the validity of his own assertion. And he believes this in spite of his full awareness of the subversive acts that he has committed with Layton and the perverse accuracy of the charges made against him by the Ministry. Lowry, indeed, for the first time in the film, is truly innocent of complicity with the dehumanising effects of the regime.

Lowry's final dream nullifies the entire previously displayed cultural vision of the Brazilian world. As discussed above, Jameson has provided perhaps the most sustained theoretical consideration of the utopian ideal and the difficulty of forging an alternate reality in a postmodern world. He has pointed out how in early industrial society the utopian concept diverged into 'idle wish fulfillments and imaginary satisfactions'. According to Jameson, postmodern explorations of the utopian ideal, while pretending to create a practical response to totalitarian state power, nonetheless have often fallen into lock-step with the system itself. Jameson goes on to make the crucial point that can apply to Gilliam's *Brazil*: 'The Utopian idea … keeps alive the possibility of a world qualitatively distinct from this one and takes the form of a stubborn negation of all that is' (1971: 111). Lowry's early dreams, his flights of fancy, simply encourage childlike escapism and represent no threat to the status quo with respect to both imaginative and practical thinking. Indeed, his early dreams support the state in that this harmless dreaming sustains him while he works in the real world at maintaining the status quo. His dream sequence, however, represents what Jameson calls for: 'a stubborn negation of all that is'.

Lint and Helpmann, as leading representatives of the system, see only Lowry's insanity, but they are not privy to his imagination and cannot recognise the potential of his vision that asserts a distinct world apart from theirs. Since audiences, on the other hand, are aware of that vision, we should not accept or participate in their complacency and dismiss his smile as invalid or unearned by a rational mind. They do not grasp that Lowry's happiness in the end lies within his consciousness, a powerful force that has created a subversive dream of autonomy. Lowry's vision is astounding. He jumps back into an agrarian ideal that prefigures industrial, postmodern and postcapitalist dystopias. Lowry's vision is in no way a plan or fully engaged statement of an alternative social order complete with a subsequent strategy for implementation; rather, it is a flash of awareness that an alternate world can be imagined – or remembered. This may not be a realisation that can save Lowry, but it certainly implies that

he can see it as a worldview. He can imagine freedom, and that means others can, too.

Fully aware of the controversial ending of *Brazil*, Gilliam remarked, 'I always thought the ending was chilling, but then it bursts out musically and suddenly it's wonderful – wonderful in the context of all the possibilities open to our boy – at least he's free in his mind' (Christie & Gilliam 1999: 147). Despite the tragedy, Gilliam is justified in using the term 'wonderful', because Lowry shows that hope exists for the human spirit through the interconnection of people who actively seek meaningful lives. He has developed the capacity to dream a human memory of freedom even though everything in his culture has conspired to deny him the capacity to do such an audacious thing. He imagines a life beyond the urban nightmare, beyond the billboard walls lining the highways, and beyond a blasted, apocalyptic landscape. Lowry's triumphant dream – in contrast to the ones born of flight and escapism – is a vision of life on the ground, a life in its pastoral ideal that would be tied wholly to the earth, never flying above it in egomaniacal fantasies or hidden behind the cold metal and plastic of technology, a life that would prove difficult but always shared. When the landscape/still-life image concluding the dream sequence is torn asunder by the reappearance of Lint and Helpmann, we are shocked back into the reality of *Brazil*'s totalitarian world. However, Lowry is not; he is with Jill Layton – his Eve – in a new world of their making. Lint notes: 'He's gotten away from us.' This is true, and that is a happy ending.

Notes

1 For a full accounting of the controversy, see Mathews (1998). The book also contains the full director's cut screenplay.
2 This version is available in the Criterion Collection release of *Brazil*.
3 This particular poster appears as Lowry walks away from his destroyed car after visiting the Buttle apartment.
4 Jameson's essay is built around his assessment of the character of contemporary science fiction as a medium for utopian explorations. For an excellent discussion of Jameson's utopian thinking, see Fitting (1998).
5 For a compelling discussion of how Gilliam demonstrates the power of the state and the justifications for the use of torture regarding the post-9/11 war in Iraq, see Price (2010).

Works Cited

Christie, Ian and Terry Gilliam (2000) *Gilliam on Gilliam*. London. Faber.
Fitting, Peter (1998) 'The Concept of Utopia in the Work of Fredric Jameson', *Utopian Studies*, 9, 2, 8–17.
Glass, Fred (1986) '*Brazil*', *Film Quarterly*, 39, 4, 22–8.
Gleiberman, Owen (2004) 'The Life of Terry', in David Sterritt and Lucille Rhodes (eds) *Terry Gilliam: Interviews*. Jackson: University of Mississippi Press, 30–5.

Jameson, Fredric (1971) *Marxism and Form: Twentieth Century Dialectical Theories of Literature*. Princeton, NJ: Princeton University Press.

____ (1982) 'Progress Versus Utopia; Or, Can We Imagine the Future?', *Science Fiction Studies*, 9, 2, 147–58.

Klawans, Stuart (2004) 'A Dialogue with Terry Gilliam', in David Sterritt and Lucille Rhodes (eds) *Terry Gilliam: Interviews*. Jackson: University of Mississippi Press, 141–69.

Langer, Lawrence (1980) 'The Dilemma of Choice in the Death Camps', *Centerpoint: A Journal of Interdisciplinary Studies*, 4, 1, 53–9.

Lyman, Rick (2004) 'Zany Guy Has Serious Rave Movie', in David Sterritt and Lucille Rhodes (eds) *Terry Gilliam: Interviews*. Jackson: University of Mississippi Press, 26–9.

Mathews, Jack (1998) *The Battle of Brazil: Terry Gilliam v Universal Studies*. New York: Applause.

McCabe, Bob (1999) *Dark Knights and Holy Fools: The Art and Films of Terry Gilliam*. New York: Universe.

Morgan, David (2004) 'Gilliam, Gothan, God', David Sterritt and Lucille Rhodes (eds) *Terry Gilliam: Interviews*. Jackson: University of Mississippi Press, 52–64.

Price, David (2010) 'Governing Fear in the Iron Cage of Rationalism: Terry Gilliam's *Brazil* through the 9/11 Looking Glass', in Jeff Birkenstein, Anna Froula and Karen Randell (eds) *Reframing 9/11: Film, Popular Culture, and the 'War on Terror'*. New York: Continuum, 167–82.

Rosen, Elizabeth (2008) *Apocalyptic Transformation: Apocalypse and the Postmodern Imagination*. Lanham, MD: Lexington Books.

Sterritt David and Lucille Rhodes (2004) *Terry Gilliam: Interviews*. Jackson: University of Mississippi Press.

Wardle, Paul (2004) 'Terry Gilliam', in Sterritt David and Lucille Rhodes (eds) *Terry Gilliam: Interviews*. Jackson: University of Mississippi Press, 65–105.

CHAPTER SIX

The Fissure King: Terry Gilliam's Psychotic Fantasy Worlds

Jacqueline Furby

> It's one thing to get lost in your own madness, but to become lost in somebody else's madness is weirder.
>
> Terry Gilliam (Lafrance n.d.)

This chapter considers the discourse around fantasy articulated by Terry Gilliam's *The Fisher King* (1991). In particular, it examines the film's central concern with fantasy storytelling and the mental condition of psychosis, which for Sigmund Freud involved the psychotic subject in a defensive movement away from external reality towards a newly-substituted alternative reality. Significantly, *The Fisher King* is not the first film (nor the last) where Gilliam explores the connections between fantasy storytelling and psychosis and their implications. For example, in *Brazil* (1985) Sam Lowry's (Jonathan Pryce) escape into fantasy ultimately means that he is unable to save himself from physical torture in the real world, suggesting that fantasy might be seen as a dystopian rather than a utopian space. And in *Twelve Monkeys* (1995) L. J. Washington (Frederick Strother), an asylum inmate, most explicitly expresses the link between fantasy as escape and madness. He says of his diagnosis (while dressed in a black dinner suit, bow tie and pink bunny slippers):

> I don't really come from outer space ... It's a condition of mental divergence ... I am mentally divergent in that I am escaping certain unnamed realities that plague my life here. When I stop going there, I will be well.

The Fisher King, however, sees fantasy as both an escape and as a redemptive healing space, as Parry (Robin Williams) is rescued from a life of psychotic reality divergence by Jack Lucas (Jeff Bridges) because Jack is able to enter into Parry's strange medieval fantasy. This chapter, therefore, reflects on *The Fisher King's* psychotic, fissured fantasy world and the implications that it might have for an audience lost 'in somebody else's madness'.

The Fisher King tells the story of four people – Jack, Parry, Anne (Mercedes Ruehl) and Lydia (Amanda Plummer) – all in different ways trapped in their unhappy lives. Jack is a successful but cynical, shallow and narcissistic New York shock jock who arrogantly goads an unstable caller, Edwin Malnick (Christian Clemenson), into shooting dead seven diners at 'Babbitts', a fashionable bar, and then shooting himself. One of Edwin's victims is Parry's wife, and the trauma forces Parry first into catatonic shock and then into a defensive fantasy. Having sabotaged his own career and blighted his life, Jack mooches off his long-suffering girlfriend, Anne, whom he feels unable to properly love. The fourth character, Lydia, is a mousy, unfulfilled office worker whom Parry loves from afar.

The film opens on Jack in his role as radio cult personality interviewing callers in order to abuse them and belittle their problems. Our first view of Jack is an extreme close-up of a mocking mouth that fills the frame. Peter Marks observes that while this and other similar shots 'render him both sensual and monstrous, a figure verbally dominant but visually indistinct', this first partial sight of Jack establishes him 'as a fractured or incomplete character, intellectually sharp … but malicious, superior and emotionally vacuous' (2010: 140). When the camera pulls back it reveals his small, cramped studio, which, as Keith James Hamel remarks, looks like a prison cell, 'given that the lighting provides chiaroscuro shadows that streak down the walls and resemble jail cell bars' (2004). Gilliam supports this reading by saying that 'everything [Jack's] in is a cage of one sort or another' (Morgan 1991: 169). Hamel and others also note that Gilliam commonly traps his characters within cages while granting them varying degrees of success at breaking free from them (2004).[1] Jack's cage-like cell functions, according to Marks, as both a fortress and a prison, and suggests that he is confined by his narrow, jaded view of the world; this suggestion is confirmed by his description of the diners at Babbitt's (possibly named after the materialistic, middle-class and self-satisfied eponymous hero of Sinclair Lewis' 1922 satirical novel), which he dismisses as a 'chic yuppie watering-hole' (2010: 140). He tells Edwin that 'these people … can't feel love. They can only negotiate love moments. They're evil … They're repulsed by imperfection and horrified by the banal – everything America stands for … They have to be stopped before it's too late. It's us or them.' These casually uttered words, which we come to realise perfectly sum up the nature of Jack's own emotional prison, have a devastating effect on Jack and Parry's lives.

The scenes prior to the news report that reveals the massacre at Babbitt's echo with the mantra, 'Forgive me', which Jack repeats nine times as he rehearses for a part in a TV sitcom because he is ambitious to move on from being merely a voice on the radio. The repetition foreshadows Jack's desperate need for redemption when we find him three years later, having exchanged his luxury lifestyle for a cut-price one and become 'an intolerant, paranoid, self-pitying misanthrope' (LaGravenese 1991: 14). He makes

a drunken suicide attempt after asking a wooden Pinocchio doll whether 'ya ever get the feeling sometimes … you're being punished for your sins?' Following this, as he is preparing to jump into the East River with weights strapped to his ankles, two vigilante youths who mistake him for a homeless drunk try to set him on fire. A quixotic Parry rushes to his rescue armed with an assortment of found objects refashioned to function as the accoutrements of a medieval Grail knight. Until now both Parry and Jack have been living in a form of limbo as a result of emotional trauma, and the rest of the story charts their developing relationship, mutual redemption and eventual release from their respective cages.

Parry is clearly written as a psychotic character; Freud makes the following concise distinction between neurosis and psychosis. He says, 'neurosis is the result of a conflict between the ego and its id, whereas psychosis is the analogous outcome of a similar disturbance in the relations between the ego and the external world' (1993: 213). That Parry suffers from this kind of disturbance becomes evident as the plot unfolds. While twentieth-century New York life continues around him, Parry, previously Henry Sagan, a medieval history professor, retreated into an alternative medieval reality in order to escape the emotional pain involved in acknowledging and remembering his wife's death, therefore becoming 'this Parry guy'. The historical past becomes his defence mechanism with which to disavow his personal history, and appropriately enough the verb 'to parry' means 'to ward off' with 'a countermove' to 'block' or to 'turn aside'.

Parry's defence complies with Freud's view of psychosis: 'We might expect that in a psychosis … two steps could be discerned, of which the first would drag the ego away … from reality … while the second step of the psychosis is … intended to make good the loss of reality … by the creation of a new reality which no longer raises the same objections as the old one that has been given up' (1993: 223). He is similar to many protagonists in Gilliam's films (such as Sam Lowry in *Brazil,* Hieronymus Munchausen (John Neville) in *The Adventures of Baron Munchausen* (1988), James Cole (Bruce Willis) and Jeffrey Goines (Brad Pitt) in *Twelve Monkeys* and Jeliza-Rose (Jodelle Ferland) in *Tideland* (2005)). Although Parry is a chaotic figure vibrating on the border of insanity, he nevertheless at times demonstrates total wisdom. His original surname, 'Sagan', plays with the words 'sage', a character of 'ancient history or legend traditionally regarded as the wisest of humankind', and 'saga', a 'story of heroic achievement'.[2]

Parry's 'new reality' is recreated out of fragments of his previous academic life. Freud writes:

> In a psychosis, the transforming of reality is carried out upon the psychical precipitates of former relations to it – that is, upon the memory-traces, ideas and judgements which have been previously derived from reality and by which reality was represented in the mind. But this relation was never a closed one; it was continually being enriched and altered by fresh perceptions. Thus the psychosis is also faced with the task of procuring for itself perceptions of a kind which shall correspond to the new reality; and this is most radically effected by means of hallucination. (1993: 224)

Parry lives in the basement boiler room of the apartment block that he inhabited before the tragedy and his subsequent illness. He rationalises and accounts for his new reality and his basement home by describing himself as 'the janitor of God', which coheres with his medieval Grail knight identity, which in turn is constructed out of memory fragments ('psychical precipitates') from his previous reality as a medieval history professor. His psychosis is exhibited as he hears voices, sees 'little fat people', believes himself to be on a quest for the Grail, and yearns after Lydia, whom he implicates in his medieval fantasy by writing her as a damsel in distress whose affections he must earn by performing heroic deeds. As new characters or objects arrive in his life, such as Jack or the Grail, he then also writes them a role that corresponds to his new identity. In this way Parry's turbulent fantasy existence is conducted on the margins of modern city life, and the two worlds are linked, so we can share in Parry's hallucination via Gilliam's employment of fantastic architectural styling. There are castellated mansions, monumental tower-blocks and Dante-esque streetscapes populated by the city's down-and-outs that build to an 'evocation of New York City as a magical landscape filled with medieval flourishes and hellish visions of danger' (Morgan 1991: 153).

If our first sight of Jack is fragmented, then as Marks notes, 'our first view of Parry is also visually occluded', and in the scene where he rescues Jack he 'appears magically in silhouette, speaking the words of the knight he believes himself to be, but filtered through Gilliam's particular brand of antic humour: 'Hold varlet, or feel the sting of my shaft!' (2010: 141). As we get to know Parry and his world it becomes clear that two medieval motifs are used to express his psychotic break from reality. The first is the Red Knight – a mysterious, fire-breathing, galloping spectre, half horse and rider, and half dragon – which pursues and terrifies Parry. The second is the Holy Grail. After rescuing him from the ruffians, Parry tells Jack that he has been 'chosen' to retrieve the Grail, which belongs to a Fifth Avenue billionaire.

Learning that Parry's madness is a result of his actions, Jack firstly attempts (and fails) to obtain redemption from the prison of his guilt by giving Parry money. Parry's response is an act of generosity: he gives the money away to a 'real' down-and-out. This gesture highlights the cultural and temporal differences between the two characters: Jack inhabits present-day, materialist New York where money is the signifier of status, while Parry lives, at least in his mind, in an antique world of the spirit where hard currency has no currency, and where the duty of a knight-errant is to care for the poor and helpless. It is obvious that Jack's parole cannot be purchased so easily.

The film is, after all, a fairy tale of redemption, and at its heart lies the eponymous legend of 'The Fisher King', an ancient source text adapted for many Christian-themed redemption stories including Chrétien de Troy's *Perceval, le Conte du Graal* (12th century), Wolfram von Eschenbach's *Parzival* (13th century) and Sir Thomas Malory's *Le Morte d'Arthur* (1485), all of which explore the tale of a knight of King Arthur's court and the quest for the Holy Grail, as Jim Holte notes in this volume (see also Weston 1920). Parry tells Jack his version of the 'The Fisher King' story while they lay on the grass in Central Park.

As in Parry's story, the Fisher King of many of the adaptations of the traditional tale suffers from a wound that will not heal until Perceval, a somewhat foolish knight yet

one pure of heart, enables his cure by means of the Holy Grail. Elements of both Parry and Jack's lives echo that of Perceval, and Gilliam says that 'both of them is a Fisher King and both of them is a Fool' (Morgan 1991: 156). Parry's name is clearly based on Perceval and its many versions, such as Parsifal, Parzival, Percival and Peredur. Jack himself, while his name can be read as a version of 'knave' (meaning a male servant, a young prince, or even rogue), is also a onetime 'king' of the New York airwaves, who actively sought 'a life full of power and glory and beauty', and was guilty of great arrogance. He played with fire (goading Edwin to stop the yuppies), and while it was Parry (and indeed Parry's wife) who were most obviously wounded, Jack also suffered a reversal of fortune of a type commonly depicted in the genre of tragedy (see Sternberg 1994).

The story that Parry tells reiterates many of the film's wider themes. It shows the power of fantasy and myth to act as a precipitate of and a window through which to view the struggles of the individual. Its theme suggests the folly of not recognising the value of what is being offered, and instead searching after material wealth at the expense of spiritual or psychological worth. The story is also about active denial, refusing reality. It is also a story about compassion, helping those who are in need of help, and about how the self-serving are not really alive. Finally it is about identity slippages, for example, as Jack and Parry both vie for the position of Fool and the King.

Although the tone and style of the tale of 'The Fisher King' place it in a medieval setting, its message adapts easily to modern New York. And although the King's wounds are apparently physical, Parry's version implies that the real wounds are in fact psychological: 'Life lost its reason. He couldn't love or be loved', and 'Sick with experience, he began to die.' These phrases echo Jack's words to Edwin when he says that the 'yuppies' are unable to feel love, but he might also be referring to himself because until the final scenes he is unable to love Anne. Both 'The Fisher King' story and the film are concerned with healing the human spirit, and the film attributes story itself with redemptive power.

In the medieval tale, it is an act of hubris – the Fisher King reaching into the fire after the Grail whilst believing himself 'invincible, like a god' – that causes his apparently incurable wound. In the film, Jack's inflated narcissism leads him to abuse his responsibility as broadcaster. Gilliam reminds us how far Jack has fallen when he has Jack drunkenly tell the Pinocchio doll about Friedrich Nietzsche's idea of 'higher man' from part four of *Thus Spoke Zarathustra* (1892), which features a collection of characters, two of whom are kings and one a voluntary beggar. Zarathustra, like Parry, and perhaps also like Jack, is forced into convalescence as the world of men has made him ill, 'sick still from my own redemption' (Nietzsche 2006: 176). Jack tells Pinocchio that, according to Nietzsche, 'There are two kinds of people … People destined for greatness … And then there's the rest of us … the Bungled and the Botched … the expendable masses.'

At the film's start Jack clearly believes himself to be the former kind, 'destined for greatness', but in fewer than seventeen minutes into the film he has reached the point where he feels himself to be 'one of the Bungled'. When he eventually returns to broadcasting, towards the film's end, he again refers to himself as 'Bungled', but

it is not until he realises finally that 'there is nothing special' about him, that his journey of self-discovery reaches the point where he can redeem himself by curing Parry. The cure involves bringing Parry the Grail, symbol of divine grace, of salvation, resurrection, redemption and cure. The Grail is also truth, and in the context of this film, truth means having self-knowledge, and the healing process of safely releasing repressed memory from its guarded chamber in the unconscious.

Parry's moment of self-knowledge and recovered memory is still some ways off as he finishes telling his tale of 'The Fisher King' to Jack. He says: 'I think I heard that at a lecture once.' We have already seen the typescript of the tale, kept hidden from Parry by the janitor, and we know that he authored this version of the tale himself in his previous existence as Henry Sagan. As Parry begins to consider how he knows of the story, memories of his own past threaten to break through his defence and in a classically Freudian gesture the repressed returns, in this case in the form of the Red Knight. Freud notes that 'probably in a psychosis the rejected piece of reality constantly forces itself upon the mind, just as the repressed instinct does in a neurosis' (1993: 224). A 'screen memory' may lie close to a significant (repressed) memory but not have any other obvious connection, and as such the hallucinated Red Knight is associated with Parry's rejected reality. At the same time the Knight is both a substituted symbol inserted in place of the traumatic memory and a mechanism for displacing it.

On this occasion Parry succeeds in blocking his memory and the Red Knight withdraws, but successful repression is only temporary as the trauma catches up with him in a later scene. This later scene takes place after, having failed to buy his own redemption with hard cash, Jack plays Cupid between Parry and Lydia. This second shot at salvation fails, too, because the moment when Parry seems about to attain his love object is marked with terror. Parry and Lydia exchange a kiss outside Lydia's apartment which triggers a flood of memory; the vision of the Red Knight rears up and Parry is again pursued by the (k)nightmare of his defence-symbol after Parry mistakes a neon sign outside Lydia's apartment for the sign over the door of the bar where his wife was murdered.

Parry sees the sign (and the viewer also sees the sign through Parry's eyes). He is positioned outside the apartment building, while the camera is inside, looking out at him through the glass doors. Parry moves to his left, and his image is caught in the splitting effect of the glass door's bevelled edge. We see two Parrys, side by side. The

Parry the fissured king
standing outside Lydia's apartment

84 THE CINEMA OF TERRY GILLIAM

Parry in two minds
as the repressed returns

camera pans in from the long shot to a close up of Parry's face, split into two overlapping images, clearly literalising his psychotic mind-state.

In a typically Gilliamesque reversal, the kiss that Parry and Lydia share is the switch that leads ultimately to Parry's catatonic state. Instead of the fairy tale prince kissing Sleeping Beauty awake, Gilliam gives us Parry's princess kissing him to sleep. Before he can find the solace of sleep, though, Parry's surge of love and the awakening of his sexuality undermine his defensive medieval fantasy and activate his memory of the kiss between him and his wife immediately before she is shot.

The gruesome, carnal image of the Red Knight pursues Parry as he flees through the streets of Manhattan. The sequence is intercut with scenes from his memory as he is forced to recall it. This is a moment of retroactive understanding for the viewer who is obliged to review what they know of the Red Knight, the exact identity of which has been unclear up to this point. The flashbacks reveal that the look of the Red Knight is partly composed from the grisly appearance of Parry's wife's head after she has been shot and partly from the image of Parry's own face as he is splattered with gore. The Red

The Red Knight,
the inside of Parry's defence

The image of Parry's wife
after the shooting

IT'S A MAD WORLD 85

Henry Sagan, mid-trauma

Knight also carries a strong association with the shooter, Edwin. This becomes evident as an image of the Knight blasting fire is placed either side of the image of Edwin firing his shotgun. Until this moment of revelation (for both Parry and the viewer), the death scene had been hidden behind a composite image of the sensory images Parry received immediately prior to and immediately after the traumatic moment of death. So the blast from the gun, the blood and the affect of fear and horror had metamorphosed into the Red Knight, both in Parry's mind and in our vision.

Two other images from earlier in the film link the images of the bloodied faces and the Red Knight. These linking images are found in Parry's basement home. The first is painting of a knight on the wall. The paint has run and looks like dripping blood, and there is a tiny skull stuck onto the knight's helmet. The other image is a page torn from a manuscript showing the picture of a knight, this time with the head obliterated by a starburst of red paint. The Red Knight therefore is the *inside* of Parry's defence literalised on screen. The viewer sees the knight when Parry sees him, and so is also inside Parry's mind, seeing Parry's hallucination as it threatens

Painting of a knight from Parry's wall with skull and bones

Manuscript image of a knight with an exploding head

the eruption of the repressed unconscious into his conscious mind. The Red Knight is the dangerous fissure in the fabric of Parry's (and the film's) fantasy world, just as the original moment that it resembles is the wound that caused the fissure in Parry's reality that drove him to seek refuge in fantasy. Of course it is not the Red Knight itself that Parry fears, but what it represents, which is the horrific scene of his wife's death.

Parry runs from the Red Knight through the streets of New York to the place where he first encountered the suicidal Jack and where he is now met by the same vigilante youths who severely beat him. The only recourse left open to Parry is to retreat into catatonia which keeps him unconscious in his hospital bed while a (temporarily) unaware Jack leaves Anne, and prematurely resumes his radio career, believing for a while that his debt to Parry has been paid. His conscience is not clear though as he agonises to an unresponsive, bedridden Parry about his own responsibility and role. Finally, because, as Gilliam says, 'the film is about becoming selfless and breaking down the ego', he leaves the hospital to retrieve the Grail (Christie & Gilliam 2000: 196).

Jack breaks into Langdon Carmichael's castellated mansion dressed in a Parry-esque combination of medieval-looking garments and using equipment harvested from Parry's grotto-like home. Once Jack takes Parry's delusion seriously it starts to take on a physical reality. At one point Jack (and the audience) hears the Red Knight's mount neigh, and he says: 'I'm hearing horses now, Parry would be so pleased.' Shortly after this he sees Edwin on the stairs. Morgan says that 'as Jack becomes totally drawn into Parry's world, effectively becoming Parry, the film gets more and more skewed towards that point of view, where it doesn't show New York for what it is but as Parry himself sees it' (1991: 157).

Parry's cure is finally realised when Jack brings him the cup that he believes to be the Grail. Although it is Jack who has carried the Grail to Parry and who brings about his cure, the action also results in Jack's own redemption, a major turning point in his journey being the moment when he decides to save Carmichael from accidental suicide.

There has been an exchange here. Parry and Jack are now both the King and the Fool; they have cured each other. This complicates the structure of 'The Fisher King' tale, in which Perceval hands the King the Grail (which is by his bedside all along). In the tale this gesture heals the King of his wounds, whereas in the film it heals them both. On waking, Parry says: 'I had this dream, Jack. I was married to this beautiful woman. You were there too. I really miss her Jack. Is that okay? Can I miss her now?' Having slipped back into sanity and reality, and at last freed from their respective cages, Parry's of denial, and Jack's of soul-sickness, they can start living again. Jack is reunited with Anne and Parry with Lydia.

It is typical of Gilliam to blend the ordinary and the extraordinary in a way that suggests the irredeemable entanglement of madness, fantasy and dreams, and in itself this points towards his status as a creator of troubling (psychotic) worlds on screen. Many commentators have noted the connections between cinema and the dream state, which Freud compared with the psychotic state as they both involve 'a complete

turning away from perception and the external world' (1993: 215). The dreamer and the psychotic may both turn away from the external world, but a key difference is that the psychotic carries the dream world, the divergent reality, into everyday, waking life whereas the dreamer does not. Therefore, the boundaries between fantasy and reality in psychosis are indistinct or nonexistent, as indeed they are in all of Gilliam's films. For example, in the final scenes of *Brazil* it is impossible to identify the moment when the viewer moves from objectively watching Sam being strapped into the torturer's chair, to being inside Sam's mind as he hallucinates an alternatively reality where he is rescued by Archibald Tuttle (Robert de Niro) and Jill Layton (Kim Greist). Similarly, in *The Fisher King*, the camera repeatedly moves seamlessly from an external, objective viewing position, such as one of witnessing the dialogues between Parry and Jack, to an intersubjective position also able to share Parry's distinctive point of view.

One such moment of intersubjective viewing occurs in the only scene in which Gilliam deviated significantly from LaGravenese's screenplay. This scene takes place in Grand Central Station during the evening rush hour as Parry waits for Lydia on her way home from work. As Parry sees Lydia enter the station the hurrying commuters suddenly stop rushing, pair up and start waltzing. Lydia sways gracefully through the crowd of dancers followed by Parry. Just as suddenly, the commuters resume their hectic onwards rush as Lydia passes beyond Parry's orbit. Peter Travers writes of this scene in *Rolling Stone* that 'in a breathtaking scene … Parry follows Lydia to Grand Central Station and watches her in love-struck awe, oblivious to the fact that the rest of the rush hour crowd has broken into a waltz' (1991). This reading, then, uses the dancing couples as a way of representing Parry's single-minded obsession with Lydia. We are in Gilliam's mind's eye, seeing Grand Central Station as he sees it.

An alternative way to think of this scene, though, is that we share the point of view of Gilliam's onscreen stand-in, Parry. He does not see the world as Jack does, for whom the station is just another ordinary public New York space. Parry's vision is filtered through his romantic sensibility that, like Gilliam's, finds magic, beauty and meaning lying just under the surface of the mundane. But we should remember that one of the functions of the Fool is to produce utterances that, although they might sound like nonsense, actually constitute truth and wisdom. For example, Parry loves Lydia and sees her as beautiful, graceful and transformative of any place she inhabits, and by the end of the film that is what she has become. Nevertheless, no matter which reading is accepted, the scene remains a metonymical, symbolic moment strongly suggestive of Gilliam's persistent relationship in his films with reality/fantasy, sanity/madness and rationality/romance.

It is not sufficient, though, for the viewer to be able to see the world through Gilliam/Parry's eyes because the magical transformation has also to work within the narrative between characters, as well as beyond it, between film and audience. Parry's unconscious response to Jack as 'the one' who has been sent to heal his psychic wounds by securing the Grail is answered when Jack does finally enter into Parry's fantasy, and it is Jack's participation in Parry's delusion that affects the cure. So, in *The Fisher King* fantasy not only provides an escape from reality but is also the cure for life's ills. This suggests that Gilliam shares a view of fantasy as transformative in

common with J. R. R. Tolkien, author of *The Lord of the Rings* novels (1954–5), which he saw as a particular 'gift' of fantasy, which Tolkien named 'recovery'. He used the term to express his belief in the power of fantasy to alter the way we look at our everyday world, so that we (re-)gain a clear view. Tolkien also considered fantasy to possess among its valuable gifts that of escape and consolation. Escape does not, for him, carry negative connotations. Instead, he means the word to be understood as 'departure' and 'imagination'. Tolkien says that escape is 'very practical, and may even be heroic'; this is because it enables us to gain insight, and to learn again the value of things, which we might else have forgotten (1966: 33–99). It is clear that Parry and Jack both escaped into fantasy for good reasons and it is also clear that fantasy served them both well in the end.

Finally, fantasy's third gift, for Tolkien, is consolation, which is the joy we feel at the miraculous or surprising turn of the happy ending from the possibility of tragedy. Tolkien calls this moment *Eucatastrophe,* when catastrophe is averted, and explains, 'the *eucatastrophic* tale is the true form of fairy-tale and its highest function' (1966: 85). Not to be outdone *The Fisher King* has four endings. The first is when Jack is conducting the sing-along in the mental hospital and Parry is reunited with Lydia; in the second Jack declares his love to Anne; the third sees Jack and Parry reunited, lying naked on the grass; and the fourth sees fireworks over the New York skyline. Marks writes that the ending in which 'a fireworks display ... traces out THE END in the sky, harks back to the fantasy endings of *Jabberwocky* and *Baron Munchausen,* signalling that, for all its tough take on the reality of contemporary New York, a space remains for the miraculous' (2010: 149).

In addition to possessing Tolkien's three gifts, the film also follows the ancient and universal mythic structure of the quest, which has the protagonist(s) leaving home to undergo trails and challenges, battle with the monster, journey to hell, face a real or symbolic death, and return to life renewed, often to be rewarded by marriage (see Eliade 1963). Furthermore, in *The Encyclopedia of Fantasy*, John Grant sees *The Fisher King* as an 'instauration fantasy of a very high order' (1999: 354). In turn, John Clute notes the definition of 'instauration' as 'restoration after decay, lapse or dilapidation' and as 'the action of restoring or repairing; restoration, renovation, renewal'; he identifies instauration fantasies as those 'in which the real world is transformed', often focusing on 'processes of learning' tending to 'emphasize its difficulty' (1999: 501). Grant says, 'when we see the Red Knight we are experiencing a perceptual shift that allows us access to a perfectly valid alternative reality; and the kitsch goblet does indeed restore the Fisher King to life' (1999: 354).

Like *The Fisher King,* an instauration fantasy frequently contains 'within its text a fictional book, whose title is that of the real text, and whose contents reveal ... the true story' (Clute 1999: 501). These fantasies usually begin in the mundane world and involve a slippage into the magical world (Parry's mind). Clute says that the threshold tension between worlds commonly invokes 'feelings of stress', perhaps due to a 'sense of the precariousness of the psyche' at these moments; later he remarks that there is a 'constant interrogative tonality' to such self-reflexive narratives that 'point to themselves as being "stories" which extends to the "nature of fiction itself"' (ibid.). In the

end, Clute says that the instauration fantasy 'is a story about finding out the truth, and living with the consequences', and he remarks that on the edge of the millennium it was 'the cutting edge of fantasy – the place where fantasy has no excuse not to be' (ibid.). All of this points to Gilliam as a skilled fantasist who regularly invites us over the threshold into his idiosyncratic world, and if it is 'weird' being in somebody else's madness, at least he is in there with us.

Notes

1 For example, Kevin and the dwarfs are caged in *Time Bandits* (1981); dream girl Jill is caged in *Brazil* (1985); cages in the form of the Sultan's torture organ and the King of the Moon's bird cage appear in *The Adventures of Baron Munchausen* (1988) and James Cole is imprisoned in a Panopticon-like cage in *Twelve Monkeys* (1995).
2 All definitions come from the *Oxford English Dictionary*.

Works Cited

Christie, Ian and Terry Gilliam (2000) *Gilliam on Gilliam*. London: Faber.
Clute, John (1999) 'Instauration Fantasy', in John Clute and John Grant (eds) *The Encyclopedia of Fantasy*. London: Orbit, 500–2.
Eliade, Mircea (1963) *Myth and Reality*, trans. W. R. Trask. New York: Harper and Row.
Freud, Sigmund (1993 [1924]) 'The Loss of Reality in Neurosis and Psychosis', Alan Tyson and James Strachey (eds and trans.) *On Psychopathology: Inhibitions, Symptoms, and Anxiety and Other Works, vol. 10*, Harmondsworth: Penguin, 219–6.
Grant, John (1999) 'The Fisher King', in John Clute and John Grant (eds) *The Encyclopedia of Fantasy*. London: Orbit, 354.
Hamel, Keith James (2004) 'Modernity and Mise-en-scène: Terry Gilliam and Brazil', *Images: A Journal of Film and Popular Culture*, 6. Online. Available at: http://www.imagesjournal.com/issue06/features/brazil.htm (accessed 4 November 2011).
Lafrance, J. D. (n.d.) '*Twelve Monkeys*: Dangerous Visions'. *Dreams: The Terry Gilliam Fanzine*. Online. Available at: http://www.smart.co.uk/dreams/home.htm (accessed 7 April 2011).
LaGravenese, Richard (1991) *The Fisher King: The Book of the Film*. New York: Applause.
Marks, Peter (2010) *Terry Gilliam*. Manchester: Manchester University Press.
Morgan, David (1991) 'Interviews with Terry Gilliam', in Richard LaGravenese (ed.) *The Fisher King: The Book of the Film*. New York: Applause, 153–71.
Nietzsche, Friedrich (2006 [1892]) *Thus Spoke Zarathrustra*, Adrian Del Caro and Robert Pippin (eds. and trans.). Cambridge: Cambridge University Press.

Sternberg, Doug (1994) 'Tom's a-cold: Transformation and Redemption in *King Lear* and *The Fisher King*', *Literature/Film Quarterly,* 22, 3, 160–9.
Tolkien, J. R. R. (1966) 'On Fairy-stories', in *The Tolkien Reader*. New York: Random House, 33–99.
Travers, Peter (1991) '*The Fisher King*', *Rolling Stone,* 20 September. Online. Available at: http://www.rollingstone.com/movies/reviews/the-fisher-king-19910920 (accessed 5 June 2011).
Weston, Jessie Laidlay (1920) *From Ritual to Romance: History of the Holy Grail Legend.* Cambridge: Cambridge University Press. Online. Available at: http://books.google.co.uk/books?id=bvdU05-zgF8C&dq=from+ritual+to+romance&source=gbs_navlinks_s (accessed 3 March 11).

CHAPTER SEVEN

'You can't change anything': Freedom and Control in Twelve Monkeys

Gerry Canavan

In his *Society Must Be Defended* (1977), a collection of lectures originally given at Collège de France in 1976, Michel Foucault describes a new paradigm for power relations that he calls *biopolitics*, which reflects the new strategies and technologies of control employed by contemporary governments. Power in its classic form, Foucault writes, was organised around the concept of *sovereignty*, the right of the sovereign to either make die or else let live.[1] But the new sciences of population and demography that developed over the nineteenth and twentieth centuries brought into existence a new paradigm for power, a shift away from sovereignty to what Foucault calls *biopower*, the authority to *make live* or else *let die*. In biopolitics, government becomes the guarantor of the necessities for life through the development of bureaucratic agencies ranging from food and medicine inspection to social safety net and welfare programmes and beyond. 'We are,' Foucault writes, 'in a power that has ... taken control of life in general' (1997: 253). Under a biopolitical regime it is no longer merely the individual human body that must be *disciplined*, as under sovereignty, but rather the population as a whole that must be *regulated*. If sovereignty is concerned with the life and death of individual persons, biopower governs the life and death of populations, managing such threats as unemployment, poverty, mental illness and chronic disease.

In this chapter I read Terry Gilliam's apocalyptic *Twelve Monkeys* (1995) in the context of the biopolitical turn in political theory and interpret the film as an extended allegory for the creeping reach of contemporary institutions of authority. *Twelve Monkeys*' plot centres on the efforts of a time-traveller/escaped mental patient James Cole (Bruce Willis) and his skeptic-turned-believer psychologist Dr Kathleen Railly (Madeleine Stowe) to investigate and perhaps prevent the release of an artificially created virus that will soon kill billions. The film allegorises the extent to which the

contemporary moment still hovers uneasily between sovereignty and biopower, and deconstructs the ideologies by which biopower justifies the continued use of sovereign violence. *Twelve Monkeys*, through its interrogation and complication of the relationship between discipline and regulation, renders attempts to distinguish sovereign power from biopower nearly impossible. At the same time the film offers us (beneath the surface of its apparently hopeless fatalism) a bare but palpable utopian glimpse of a world freed from either system of control.

The notion that there could be some utopian component to *Twelve Monkeys* – which concludes, we must remember, with our hero dead, billions doomed, and all hope permanently lost – may appear at first glance to be completely perverse. It would likely seem so to Gilliam himself, who in interviews frequently seems amused by the difficulty audiences (especially American) have in accepting the film's finality. '[One] of the things that intrigued me about the film', Gilliam told a reporter from *The Guardian* in 1996, 'was that it was very anti-American in that there is a sense of fatalism in it, an idea that you can't fix everything' (Fountain 2004: 112). But the approach to utopia offered by the critical work of Fredric Jameson offers us a way around (or perhaps a way out of) this pessimism, through the distinction Jameson draws between utopian *form* and utopian *content*. Though the *plot* of the film certainly suggests pessimism and hopelessness, this need not be the final word. Outside the narrative, after all, the future still has not happened yet. Jameson has argued that all utopian and dystopian imaginings – as well as all popular entertainments, more generally – are ultimately motivated by a single, unquenchable dream that the world might somehow become better than it is: what he calls 'the desire called utopia.'[2]

My approach to *Twelve Monkeys* is influenced not only by Jameson but by Darko Suvin and other similarly utopian thinkers in science fiction studies, whose approach to science fiction is organised around an aesthetics of *cognitive estrangement*: the claim that science fiction offers us a glimpse at another type of world not for the purposes of prediction or escapism but so that we can gain a new, critical perspective on our own.[3] The pleasure in such texts comes when we contrast the science fictional imagination with the 'real world' – when we appreciate not only how they are different, but also how they are metaphorically the same. Science fiction, from this perspective, is not really about the future, but about the present, and *Twelve Monkeys* is not about the bad things that *might* happen, but rather the bad things that already have. This chapter thus reads *Twelve Monkeys* as a radical critique of the failure of contemporary biopolitical institutions, one which makes all too clear the pressing need for another sort of life.

We can find the allegorical work of cognitive estrangement from the earliest moments of the film, which depict a world in which individual freedom has been completely subsumed by government authority. When we first see the adult James Cole, he is lying in his hammock in a long row of mesh cages in a huge, multilevel prison, with similar prisoners in identical cages surrounding him on all sides. The image suggests a perfect Panopticon, which, Foucault says in *Discipline and Punish*, is designed 'to induce in the inmate a state of conscious and permanent visibility that assures the automatic functioning of power' (1977: 201). In a Panopticon like

Cole's cage, one knows one is always being watched – and so one never even tries to misbehave.

Cole is just waking up from a nightmare, almost as if we are continuing from exactly the moment Gilliam's *Brazil* (1985) left off – only now the horrors of modern life haunt us even in what in the earlier film had been our only refuge, our dreams. A voice over a loudspeaker calls his name: 'Inmate #87645, Cole, James.' This is the first of Cole's many misidentifications throughout the film; no one can ever seem to get his name right. The scientist-rulers of 2025 and the psychiatrists of 1996 both call him Mr Cole; Jeffrey Goines (Brad Pitt) calls him Jim; one of the attendants calls him Jimbo; the clerk at the hotel calls him Jack; his friend and fellow prisoner Jose (Jon Seda) seems to think his name is actually Colejames; and, the sinister voice he sometimes hears in his head calls him Bob. No one recognises Cole, who is at the bottom rung of every social ladder. When Dr Railly asks if she may call him James, he does not even know how to process this small kindness; he simply and sadly replies, 'Nobody ever calls me that'. Towards the end of the film, we discover that his mother used to call him James.

Cole has been 'volunteered' for an experiment – a euphemism naturally dripping with irony – that involves duty on the abandoned surface. As we have learned from the opening titles, which describe the epidemic that killed over five billion people in 1996, the cage in which Cole resides is only one prison inside another, as the entire human race has been driven underground. Now, 'once again the animals will rule the world', and, from what we can see of life in the bunkers underground, this life is not something we would immediately recognise as human. David Lashmet points out that the film likely takes its title from the twelve monkeys used in the Silver Spring nerve-severing experiments that prompted the formation of People for the Ethical Treatment of Animals (who are themselves parodied in the film by Goines's gang of eco-pranksters), and the clearest referent for Cole's dehumanising treatment is clearly animal experimentation; like laboratory animals, Cole and his fellow inmates live in 'a giant stack of identical cages', are subject to bar-code tattoos for easy identification, and are lifted from their cages by huge harnesses (2000: 5). Later, images of animal experimentation seen on the television in the Baltimore asylum reinforce this visual metaphor.

We never see much of the world of the future outside Cole's prison, but the few glimpses we do see are of workers in heavy suits and welder´s helmets and a PA system announcing mandatory 'socialization classes' for better compliance with a sinister-sounding 'Permanent Emergency Code'. The unstated suggestion is that nearly everyone in the future has been found guilty of one infraction or another and incarcerated. The recitation of Cole's supposed crimes, left vague, quickly progresses from apparently legitimate ('violence, anti-social sex, repeated violations of the Permanent Emergency Code') to completely meaningless ('insolence, defiance, disregard of authority'). Cole is offered a pardon in exchange for his participation in often lethal time-travel experiments, with the suggestion that, once he is a hero, women (otherwise all-but-invisible in the future, with the sole and singular exception of the female scientist played by Carol Florence) will become interested in him. But the real force of his 'volunteerism'

clearly originates in threat: 'For a man in your position, not to participate would be a mistake.' Of course, like an animal in a laboratory cage, he has no real choice, no capacity for consent.

We may at first be shocked by the terrible degradation that characterises Cole's everyday life. But the scenes that follow show us that this base existence may not be so foreign from our own. The first hour of *Twelve Monkeys* follows Cole from his cage to a prophylactic, condom-like body suit for safe travel to the surface; to a delousing shower; to quarantine; to a shackled meeting with the Scientists of the Future; to the tiny enclosed space of the time machine; the asylum in 1990, where he is again deloused, chained, drugged and locked up; and on and on. Ultimately, James Cole is in some form of restraint in nearly every instant he appears on screen for the first 45 minutes of *Twelve Monkeys*, nearly half the film, as Gilliam quite deliberately bleeds the *mise-en-scène* of the post-apocalyptic future into that of the present. The same actors appear in both time periods, performing the same functions; particular incidents and visual sequences are repeated to drive the point home, most notably the delousing chamber and the interview room with the scientists/psychiatrists. Repeated lines of dialogue and mirrored layouts of rooms (particularly between the underground bunker and the Baltimore insane asylum) make clear that Cole's 'bad future' is not to come but already here. Cole is always under surveillance, watched at every turn in his present as in his future. In an interview, Gilliam himself calls attention to a shot in which Cole and Railly believe they have escaped the notice of a passing police car, only to appear by a giant bank of televisions: 'That wasn't in the script; I just wanted to do it because I loved the idea of them thinking they were hiding, yet being totally exposed by technology' (Christie & Gilliam 2000: 230). The metaphorical Panopticon of the future – at first a signifier of the *difference* between that time period and now – turns out to already exist.

Of all the many sites of surveillance and control in the film, perhaps the most salient is airport security, a pivotal location that has only further expanded in cultural importance since 9/11. It is no longer sufficient to simply run our luggage through a metal detector. Airport security now encompasses a massive and often absurd calculus of acceptable and unacceptable items – nearly all of which are in actuality perfectly safe – while at the same time forcing us to remove our hats, coats, belts and shoes and subject ourselves to ever-more-humiliating searches, x-rays and pat-downs. Real life has become more Gilliamesque than even Gilliam could have ever anticipated. The time-travel plot of *Twelve Monkeys* puts significant symbolic weight on airport security. After all, the child Cole watches his future self gunned down from the metal detectors at Philadelphia International Airport, a scene that bookends the film and appears multiple times in flashbacks. These metal detectors illustrate how difficult it can be to tell sovereign power and biopower apart, the smooth regulation of air travellers blending seamlessly with the police power of the state. Instead of Foucault's clean historical division, we find instead that these two concepts look more like two faces of a single force: *power,* which evolves and adapts to ensure its own survival. In certain circumstances – ie, managing populations – biopower is the superior tool and indeed seems to have become the dominant one in the modern context. But the violence of

sovereign power remains always at the ready, to be deployed at the precise moment it is needed. There is always the potential for a state of 'exception', a 'Permanent Emergency Code', to immediately reinscribe us as disciplinary subjects.[4]

It is helpful to recall here the distinction Giorgio Agamben draws between *bios* and *zoē* – *bios* referring to the political life of the human being as a citizen and *zoē* referring to the mere quality of biological survival that is common to all living things. (1995: 1–2). *Bios* is a full life as a human being; *zoē* is bare life, no better, more meaningful, or more secure than that of an animal. Modern political states – of which positive effects and good intentions biopolitical thinkers like Agamben, Foucault and Gilliam are deeply sceptical – use the threat of bare life to justify any and all institutions of political *bios*, no matter how violent, terrible and unjust they may seem. However bad *bios* gets, after all, it is always better than *zoē* – and everything the government does, it insists, is designed to keep the threat of bare life at bay. Various forms of state violence – which are illegitimate under biopolitics insofar as government's stated purpose is to *protect* life, to keep us safe – quickly become legitimate once they can be justified in the name of preserving life. Agamben notes the slippery slope at work here, as greater intrusions on personal liberty become 'necessary' in the name of public safety – with the result that over time life as a citizen becomes ever more like bare life.

In the meantime, biopower designates those who threaten the population as a whole not merely as a danger but as a kind of *anti-life* that must be sequestered from life at any cost, and against whom the worst sovereign violence becomes once again justified. The terrorists and drug smugglers who are the supposed target of airport security sweeps are only the most vivid example of this kind of anti-life. The inconveniences and humiliations of the airport security checkpoint pale in comparison to the background checks and drug tests, inner-city SWAT teams, mandatory sentencing guidelines, prisons, deportations, wiretaps, 'enhanced interrogations' and multiple overseas wars that have sprung up in the name of public safety during the 'War on Drugs' of the 1980s and 1990s and the 'War on Terror' of the 2000s and 2010s. Such 'emergency' powers, once instituted, never go away; rather, their scope only widens to include larger and larger segments of the population. We might imagine a straight line running from these increasingly intrusive governmental practices to the ultimate 'bare life' nightmare represented by Cole's future of universal imprisonment, when everyone is in a cage, watched at all times. *Twelve Monkeys* metaphorically suggests, too, the extent to which these efforts of the security state may be fundamentally misguided: although the Army of the Twelve Monkeys are believed throughout the film to be organised and dangerous eco-terrorists, they turn out in the end to be harmless pranksters. The *true* terrorist is a respected scientist, acting alone, who has no problem at all passing through the checkpoint, and who indeed the security forces of the US government ultimately kill Cole to protect.

Much more than violence against terrorists and drug dealers, however, *Twelve Monkeys* is preoccupied with the way this aura of 'anti-life' has infected our treatment of the mentally ill, especially with respect to their isolation and abandonment within governmental mental health systems. The 'patients' in Gilliam's mental institution

spend their stuporous days aimlessly wandering a single locked room in a run-down asylum, tranquilised by 'chemical restraints' and completely ignored by their doctors. The rhetoric of treatment is maintained but not the practice; despite the doctors' claims to help their patients, the asylum (which looks like a prison) is in reality little more than a leper colony.

Ranting and raving after Cole's request to use the telephone, the clearly unstable Jeffrey Goines describes his incarceration in starkly biopolitical terms: 'A telephone call? A telephone call? That's communication with the outside world! Doctor's discretion. No, no – if all of these nuts could just make phone calls, it could spread: insanity oozing through telephone cables, oozing into the ears of all those poor sane people, infecting them. Wackos everywhere, plague of madness.' Jeffrey's madness offers the audience another cognitively estranged viewpoint. Like the Shakespearean jester, he cannot be simply ignored; his defamiliarising pronouncements force us to reevaluate some of our most deeply-held beliefs about contemporary life. Here he suggests that the true purpose of the asylum is not to help the sick, but to protect the sane.

Jeffrey continues: 'In fact, very few of us here are actually mentally ill. I'm not saying you're not mentally ill – for all I know you're crazy as a loon. But that's not why you're here, that's not why you're here, that's not why you're here. You're here because of the *system*.' Seen from Jeffrey's perspective, biopower *itself* is what opens up the legendary 'cracks' through which so many groups of people are so often said to 'fall', precisely because state power is no longer concerned with the individual but with the population as a whole. Certain types of lives become secondary and unimportant; the social (and sometimes literal) deaths of the underprivileged are justified for the sake of everyone else. The reprehensibly shoddy disrepair of the prisons and mental institutions depicted in *Twelve Monkeys* is only one of many examples of this phenomenon in Gilliam's work; the abandonment of the homeless to their fate – so central to both *Twelve Monkeys* and Gilliam's *The Fisher King* (1991) – is another.

Jeffrey, then, despite his instability, turns out to have a keen awareness of the realities of biopolitics and his diminished, de-privileged place within it: 'And all the doors are locked, too. They're protecting the people on the outside from us. But the people outside are as crazy as us. You know what "crazy" is? "Crazy" is majority rules.' Foucault would identify the reclassification of certain portions of the population as 'crazy' and 'criminal' as a variation on biopolitical racism, which, like earlier forms of violence and segregation, identifies those persons whose removal 'will make life in general healthier: healthier and purer' and then seeks to remove them (1997: 255).[5] In the biopolitical arena, the ultimate criterion for decision-making is the good of the population as a whole, as determined by the 'experts' like the scientists who control Cole's life and whose expertise and authority leave no room for argument. The question becomes not 'what is the good?' but 'good for whom?' Who has co-opted the biopolitical rhetoric of the protection of life, to what ends are they putting it, and what sorts of power hierarchies have been established as a consequence? Are those in power really out to protect us, or to benefit themselves?

At the hyperbolic limit of this process, the expansion of the class of people characterised as 'anti-life' extends across ever larger populations, until the entire population

is more or less again inscribed within a disciplinary context. This is how the establishment of concentration camps, which Agamben says is 'now securely lodged within the city's interior', becomes the quintessential state action of the twentieth century; 'We must expect not only new camps', he writes, 'but always new and more lunatic regulative definitions of the inscription of life in the city' (1995: 176). It is in the tendency of *bios* under a biopolitical regime to slowly evacuate itself, to establish more and longer states of exception in which *bios* must continually be suspended in the name of its own preservation. In *Twelve Monkeys*, Gilliam reveals the violent endgame of this process lying in wait for us in all temporal directions, from the trenches of World War I to the universal prison of the future: the reduction of the human being to a mere animal, to be poked, prodded and controlled by those claiming to 'know best'.

Myriad invocations of a 'new God' coincide with this new biopolitical locus for power and division. Jeffrey calls his famous virologist father 'God', and also believes that Dr Railly has used an omniscient 'probability matrix' to know 'everything I'm ever going to do before I know it myself'. Railly herself notes that 'psychiatry is the latest religion, and we're the priests – we decide what's right and wrong, we decide who's crazy and who's not. I'm in trouble here. I'm losing my faith.' The rhetoric of the 'divine right of kings', the right to rule (and kill) conferred by God, gives way in modernity to science itself as a new religion, conferring a new right to rule and a new *way* to rule on those it favors: what Foucault calls 'power-knowledge' (1997: 252). This paradigm shift is perhaps best reflected by the audacious name given in the production materials to the oligarchs whose 'knowledge' gives them the right to rule Cole's post-apocalyptic reality: the Scientists of the Future. Their wisdom, their *science,* has determined who should live and who should be cast aside – and in the film they have selected only themselves to be saved. Their unfeeling callousness and out-and-out bizarre behaviour gives us good reason to be sceptical of their authority; as one of Cole's cellmates memorably puts it: 'Science ain't an exact science with these clowns.'

Above and beyond this direct depiction of a dystopian future in which political life has seemingly been stripped of all but its most bare-life characteristics, all in the name of a perpetual 'emergency' without end, Gilliam nicely articulates this 'mission creep' of biopower from life-preserving regulation into a system of total domination through the metaphor of the time-travel plot. Just as Cole has no freedom in the face of his present and future government minders, he has no freedom in the face of the mechanistic unfolding of temporal predestination. Cole, after all, has already seen himself die; he just doesn't know it. Of the variations on the time-travel theme, and the most important in *Twelve Monkeys* is clearly the story of the paradox: the disruptive reversal of causality that threatens not only logic but, in the memorable phrasing of Doc Brown from the *Back to the Future* trilogy (1985, 1989, 1990), the entire space-time continuum itself. A paradox occurs whenever an effect precedes its cause, which can happen in any number of ways but which most essentially boils down to one essential Ur-text: the man can go back in time and murder his own grandfather, the famous 'grandfather paradox'. With Freudian overtones the grandfather paradox in American popular culture often dispenses with killing the (grand)father altogether and focuses instead on the forbidden libidinal possibility of mating with one's own

mother, either directly (as in the case of the original *Back to the Future*) or through a proxy (as in the case of 1984's *Terminator*). Constance Penley (2004) writes that the autogenesis narrative of the grandfather paradox is in fact a barely sublimated extension of the primal scene fantasy, the unrealisable desire to have witnessed the scene of one's own conception.[6]

Not surprisingly, then, Penley calls *La Jetée* (1962; the acknowledged French predecessor for *Twelve Monkeys*) the time-travel film *par excellence*, and indeed suggests that its power (and even perhaps the power of all film) is linked to 'infantile sexual investigation', the playing out of unconscious anxieties and unacknowledged desires (2004: 131). The climactic scene of *La Jetée* is of course the climax of *Twelve Monkeys* as well: a shooting at an airport witnessed as a child, which turns out to be the death of the observing child as an adult. Penley's recognition of the doubled father/mother figures – the two parents who lead the child into the airport, doubled in the female love-object and the male assassin – turn out to be similarly doubled in *Twelve Monkeys* as well (2004: 133). Both Railly and Cole's mother call him 'James', and we see the haunting look of recognition Railly gives the child Cole as she is pulled away from Cole's adult corpse, a received gaze that is central to Cole's traumatic entry into a broken adulthood. The film's title also invokes the sort of nostalgic/traumatic longing for a return to childhood that characterises Cole's entire adult life in its nod to the classic children's game Barrel of Monkeys (containing, naturally, twelve monkeys per barrel), from which the Army of the Twelve Monkeys takes its signature insignia.

The primal scene's characteristic evocation of sex and death (in the form of the threat of castration/exclusion) is importantly rebalanced in *Twelve Monkeys*: the primal scene for Cole (and, perhaps Gilliam is suggesting, for all subjects of the biopolitical regimes of the late twentieth century) is the direct prefiguration of one's own death. If we read Cole's doomed life as an allegory for the prospects of the human race as a whole – which *is* doomed and *will always* be doomed to extermination – the apocalyptic disease is merely the latest iteration of the shadow of universal death under which we have all lived since at least 6 August 1945, the day the atomic bomb was dropped on Hiroshima. Apocalypse is here revealed as the ultimate endgame for biopolitics, which always propels itself forward toward the insane illogic of its ultimate extension: the atom bomb which 'protects' life by exterminating it entirely, or, in the case of *Twelve Monkeys*, a human-developed germ which wipes out 90 per cent of the human race.[7] That the bulk of *Twelve Monkeys* is set in Philadelphia expresses the time-warped logic of the primal scene: Philadelphia, the first capital of the US, is the perfect setting for a film about our 'doomed civilization' (Christie & Gilliam 2000: 227).[8] From science fictions about atomic war to schoolyard duck-and-cover drills, our collective vision of humanity's future extinction is so vivid that it seems somehow to have already happened, to already be a part of our shared collective past. As a culture, perhaps we all suffer from a version of Dr Railly's own 'Cassandra Complex': 'the agony of foreknowledge, combined with impotence to do anything about it'.

By the end of the film, we understand that the events of *Twelve Monkeys* have always been a part of Cole's personal history. In the dystopian moment of 2025, Cole will again be troubled by nightmares he doesn't understand, will again travel back in

time to meet Dr Railly in the past, and do everything again in exactly the same way, which will culminate in his death. There is nothing excessive or unaccounted for, nothing lingering that threatens to destabilise the loop. The loop is total, and it is final. The important question is whether or not the loop must *necessarily* have been closed, ie whether or not the characters might have made choices that could have prevented the release of the virus, whether it was just bad luck or the immutable laws of the universe that doomed these characters to failure. Significantly, had they done *nothing at all* the virus would never have been released. Among the many similar ironies surrounding this fact is that Dr Peters only gains unfettered access to the virus in the first place as a consequence of Cole and Railly's efforts to prevent its release.

More important, in terms of *Twelve Monkeys*' critique of biopolitics, is that the scientists of the future *never even attempt* to prevent the release of the virus, they don't try; they are not interested.[9] When they give Cole the gun, it is not to stop Dr Peters but rather to demand his loyalty and subservience, which he recognises: 'This part isn't about the virus, is it? … It's about obeying, about doing what you're told.' As viewers, we realise that at this point the virus has already been released at the security checkpoint, that humanity is already doomed. When the scientists do make their move, it is on the plane itself, as the female scientist positions herself in first class next to Dr Peters in order to retrieve a sample of the pure original virus in accordance with the scientists' stated objective to develop a vaccine that will allow humanity to regain the surface of the ruined Earth. Why not attempt to intervene at an earlier moment – stop Dr Peters before he leaves his house that morning, or, indeed, murder him years before he gets his medical degree? The scientists have any number of potential points of intervention; they choose not to intervene at all. We take the woman on the plane at her word when she says she is in 'insurance', but what kind? It is not simply to insure the future of the human race; it is also to insure the grip of the scientists on power, to insure that the virus will still be released, that the 'scientists' (whoever they are) will still take control in the ruins, and that they will control any eventual vaccine for their own purposes and on their own terms. The presence of the woman on the plane may give us hope, but it is at the same instant the last tightening of the noose – the control of the scientists is now final and complete.

What, then, can be said of *Twelve Monkeys* but that it is among the most pessimistic of films? With five-sixths of the human race eliminated in a virological disaster and the few survivors imprisoned underground trapped in the jaws of the 'Permanent Emergency Code', with Cole dead and Railly doomed, is there room left for any hope at all? There is, it must be admitted, but not much. What slim room for hope exists in the film is outside the control of biopolitical governmentality, outside its grip not just on life and death but on the totality of time itself. The only hope, that is, is to run: abdicate responsibility, abandon in that sense hope itself, and live what life you can, while you can, outside the technologies of control. The freest characters in *Twelve Monkeys* are the time-traveling 'volunteers' who have broken the doomed circle of responsibility and 'doing their duty' by pulling out their teeth; they live on the streets of our dying world, unable to be tracked, traced or retrieved by the Scientists of the Future. For Railly and Cole, this dream of freedom locates itself in a perpetually recurring television commer-

cial for a vacation in the Florida Keys, a much-glimpsed but never-reached place where the two hope they might go and live out what is left of their lives.

This is the return of what Agamben calls bare life – not as the false-choice threat of the biopolitical regime to *submit or die* but as life itself, valourised and actually lived, freed from the watchful eye of our supposed betters. This is bare life in a new register, bare life as a self-conscious renunciation of 'the greater good'. As Railly puts it: 'If we can't change anything because it's already happened, then we might as well smell the flowers.' We should *live*, in short – we should practice a self-protective selfishness that values the personal happiness of the individual and the relationships she chooses above our participation as a mere number in a faceless statistical mass. It is a pointed *rejection* of the responsibility to do one's part and submit to any biopolitical regime that promises it can stave off death – to reject in the end the necessity for staving off death and to instead just 'gather ye rosebuds while ye may'. It's a dream that in the end goes unrealised for either Cole or Railly, or their predecessor, Sam Lowry (Jonathan Pryce), the doomed, dreaming bureaucrat of *Brazil*, all of whom are scooped up by power just in the moment they had thought they had escaped. And, to be sure, it is a dream that must necessarily go unrealised, that can *only* go unrealised: all things alive, after all, are doomed to die. One can only run for so long. It is with this Sword of Damocles hanging over our heads, Gilliam insists, that we must somehow carve out a decent life for ourselves, a life that must be fashioned on our terms and not those of 'the system' if it is ever to be worthy of the name 'life' at all.

In *Twelve Monkeys*, more so than even *Brazil*, Gilliam leaves us with nothing save this last hope – a last chance for (impermanent, temporary) happiness for an otherwise completely hopeless human race. These are the moments that most excite James Cole: hearing 'the music of the twentieth century' ('Blueberry Hill' and 'What a Wonderful World'), splashing around in a shallow stream. 'Freedom, sunshine, air you can breathe', he writes in one early, childish love letter to Dr Railly – these are the things that make the world beautiful, and make him wish that his future were as unwritten as ours. It is the utopian promise of the far-off Florida Keys and their slogan, 'Take a chance, live the moment', or of the mad rant that Jeffrey uses to spring Cole from the asylum: 'The window of opportunity is opening now. Now's the time for all good men to seize the moment! The moment. Now's the time for all good men to seize the day!' An end to futurity: a return to the now.

Slim pickings, maybe, but if Gilliam is right, it's the only hope there is, the only chance we've got.

Notes

1. I am drawing most heavily from chapter 11, where the concepts of *biopower* and *biopolitics* are laid out.
2. This is the subtitle for the recent book-length elaboration of these ideas (2005). See Jameson (1992) for his application of the idea of utopia to mass culture more generally, still the classic essay on the topic.

3 See Suvin (1979) for what is still the best introduction to these ideas.
4 See Agamben (2005) for an exploration of this idea.
5 See also Foucault (1997: 258): '[B]roadly speaking, racism justifies the death-function in the economy of biopower by appealing to the principle that the death of others makes one biological stronger insofar as one is a member of a race or a population, insofar as one is an element in a unitary living plurality.'
6 See Gordon (2004) from the same volume for even more examples of this phenomenon.
7 Foucault discusses the 'paradox' of the atom bomb as the ultimate limit point for both sovereignty and biopower (1997: 253–4). Moreover, when Dr Goines' assistant, Dr Peters – the deliberate architect of the release of the virus – meets Katherine Railly, he frames his doomsday vision in explicitly biopolitical terms: 'I think, Dr Railly, you've given your virus a bad name. Surely there is very real and very convincing data that the planet cannot survive the excesses of the human race: proliferation of atomic devices, uncontrolled breeding habits, the pollution of land, sea and air, the rape of the environment. In this context, isn't it obvious that "Chicken Little" represents the sane vision and that *Homo sapiens*' motto, "Let's go shopping!" is the cry of the true lunatic?' If this is not genocide as humanitarianism, exactly, then it is at the very least genocide as environmental policy: global death in the name of preserving life.
8 See also McCabe (2004: 136).
9 Of course, they claim it is impossible – but since we never see them try, we just have to take their word for it.

Works Cited

Agamben, Giorgio (1995) *Homo Sacer*, trans. Daniel Heller-Roazen. Stanford: Stanford University Press.
____ (2005) *State of Exception*, trans. Kevin Attell. Chicago: University of Chicago Press.
Foucault, Michel (1977) *Discipline and Punish: The Birth of the Prison*, trans. Alan Sheridan. New York: Vintage.
____ (1997) *Society Must Be Defended: Lectures at the Collège de France, 1975–1976*, trans. David Macey. New York: Picador.
Fountain, Nigel (2004) 'Monkey Business', in David Sterritt and Lucille Rhodes (eds) *Terry Gilliam: Interviews*. Jackson, MS: University of Mississippi Press, 107–12.
Ian Christie and Terry Gilliam (2000) *Gilliam on Gilliam*. London: Faber.
Gordon, Andrew (2004) '*Back to the Future:* Oedipus as Time Traveler', in Sean Redmond (ed.) *Liquid Metal: The Scinece Fiction Film Reader*. New York: Wallflower Press, 116–25.
Jameson, Fredric (1992 [1979]) 'Reification and Utopia in Mass Culture', *Signatures of the Visible*. New York: Routledge.
____ (2005) *Archaeologies of the Future: The Desire Called Utopia and Other Science Fictions*. New York: Verso.

Lashmet, David (2000) 'The Future is History: *12 Monkeys* and the Origin of AIDS', *Mosaic: A Journal for the Interdisciplinary Study of Literature*, 33, 4, 55–72.

McCabe, Bob (2004) 'Chemical Warfare', in David Sterritt and Lucille Rhodes (eds) *Terry Gilliam: Interviews.* Jackson, MS: University Press of Mississippi, 135–40.

Penley, Constance (2004) 'Time Travel, Primal Scene, and the Critical Dystopia', in Sean Redmond (ed.) *Liquid Metal: The Scinece Fiction Film Reader*. New York: Wallflower Press, 126–35.

Suvin, Darko (1979) *Metamorphoses of Science Fiction*. New Haven, CT: Yale University Press.

CHAPTER EIGHT

'It shall be a nation': Terry Gilliam's Exploration of National Identity, Between Rationalism and Imagination

Ofir Haivry

A major theme, perhaps *the* major theme, of Terry Gilliam's films is the tension within the human mind between what is to be perceived as reality and what as fantasy (see Morgan 2004: 41). Since our senses convey to us a great deal of information, much of it contradictory, our mind is constantly attempting to interpret it. One method of interpretation is by rational process – examining all information using deductive logic only – and another by imagination – forming mental images, sensations and concepts, in a moment when they are not perceived through the senses. The different methods often result in diverging interpretations, thus producing in the mind an inner conflict about the true shape of the world around us.

In some Gilliam films, like *The Fisher King* (1991) and *The Imaginarium of Doctor Parnassus* (2009), the aspect of the conflict addressed is principally psychological or spiritual, while in others, like *Brazil* (1985) and *Twelve Monkeys* (1995), moral, social and political aspects are more prominent. However, it is one film in particular, *The Brothers Grimm* (2005), which presents most comprehensively, in terms of both images and ideas, an interpretation of the political dimension. It does so by addressing the significance and the consequences of this conflict, as they relate to national identity – the pattern of values, symbols and memories that individuals identify as being distinctive to their nation (see Smith 2007: 214–15). By this approach, Gilliam also offers what is possibly a way to bridge the tension – national tradition. In this way, he proposes, in effect, that setting the rational and the imaginative within established patterns of a tradition may restrain their excesses.

This chapter looks at *The Brothers Grimm*'s exploration of the interplay of imagination and rationalism with political identity. It proposes that the film inventively outlines

three approaches to political identity, by associating each with a corresponding character who embodies their respective national character. Moreover, it illustrates how, to a great extent, the three approaches outlined by Gilliam dovetail, to a surprising degree, with the three groups of scholarly interpretations concerning national identity (modernist, anti/post-modernist and traditionalist). Finally, this chapter suggests that the film implies that, while neither of the first two identities can supply a stable and decent political identity, it is the third, the traditionalist approach, which may offer such a possibility.

The scholarly debate about modern national identity is wide-ranging, with many different approaches and interpretations on offer. For our purpose these can be divided into three main groups: the first, which we may call 'traditionalist', regards national identity as primarily an effect of a community's long-term cultural developments, and as such, the beneficial expression of cultural self-definition on which the state should be founded. The second group, which we may call 'modernist', views any kind of national identity that is not contingent on the state as a deliberate invention intended to manipulate popular sentiments towards serving petty interests, and, as such, a false and detrimental political element that should be challenged and preferably replaced by a state-identity. The third, which we may call 'anti/post-modernist' includes a number of quite divergent approaches, which nevertheless share the rejection of the central role assigned to the state by both previous groups, preferring instead political and cultural identities that are either sub-national (like tribal or regional ones), or supra-national (like multi-cultural or universalist ones).[1]

Despite their many disagreements, the different approaches concur in assigning to the consequences of the French Revolution a defining role in the debate about modern national identity. Between 1789 and 1814, French armies, first revolutionary and then Napoleonic, occupied most of Europe, ostensibly in the name of Enlightenment ideals. Foremost among these is rationalism, the political version of interpreting the world through rational process – proposing that human society is best ordered according to strict rational principles (thus, the period is also known as the Age of Reason). This invasion shattered the old, unsystematic baroque European political system and erased many existing traditions, laws and loyalties, thus ushering in an era in which the search for identity, including a national one, played a far more prominent role than it had previously.

In the ensuing contest about the preferable principle around which political communities should organise and identify, which to some extent continues to this very day (such as with the ongoing debate about the nature and future of the European Union), two opposing approaches emerged: on the one hand is the approach that rejects rationalism in politics and suggests instead that political identity should be rooted in the heritage of national imagination, such as historical narrative, religious symbols, popular folktales and, first and foremost, the national language(s). On the other hand is the approach that rejects such an 'imagined' heritage as essentially false and proposes instead that society should strive for an order that is as rational as possible emphasising elements like uniformity, centralised planning, and often a belief in the liberating power of technology (see Oakeshott 2010).

Before turning to *The Brothers Grimm*, a brief overview of Gilliam's treatment of imagination and rationalism in previous films will provide the frame for discussion of these themes. The heartless and malevolent nature of political rationalism is a feature of many Gilliam films. An outstanding example is *Brazil*, his most straightforwardly political film, set during a dystopian regime. Beneath a thin, shiny veneer of efficiency and consumerism, a stiflingly rationalist bureaucratic regime is revealed to be spectacularly cruel and inept. Its consecration of mechanistic logic makes it a slave to procedure and incapable of adapting to contingencies. Unable to admit mistakes, it proceeds by crushing everything in its path, impervious to circumstances or to countless lives destroyed in the process. Unable to cope with this harsh reality, the protagonist, a naïve minor bureaucrat, increasingly finds refuge in his fantasy world. Eventually, when the dissonance becomes unbearable, he disconnects completely from reality and loses his mind. Surrendering the political struggle is the only way left for him to escape the cruel grasp of the regime (see Christie & Gilliam 2000: 131, 144).

The same hostility to rationalism is evident in the less overtly political *The Adventures of Baron Munchausen* (1988), the tale of a storyteller left old and weary 'by his battle against the Age of Reason' (McCabe 1999: 131). It opens with the captions, 'Late 18th century. The Age of Reason. Wednesday', followed immediately by a cannon-blast. Soon we learn that an unnamed European city besieged by the Turks is governed by 'the Right-Ordinary Horatio Jackson', who enforces a rule of reason as uniform and passive obeisance to rules. His political creed is epitomised by his response to the latest Turkish proposal for peace: 'No, the Sultan's demands are not yet sufficiently rational. The only lasting peace is one based on reason, and scientific principle.' Later, when guards escort a wounded soldier to Jackson's presence, the following monologue ensues:

> Ah, the officer who risked his life by singlehandedly destroying six enemy cannons, and rescuing ten of our men held captive by the Turks ... the officer about whom we heard so much ... who is taking risks far beyond the call of duty ... have him executed at once! This sort of behavior is demoralizing for the ordinary soldiers and citizens who are trying to lead normal, simple, unexceptional lives. Things difficult enough as it is, without these emotional people rocking the boat.[2]

However Gilliam's evident aversion to political rationalism by no means entails a belief in imagination as panacea. In earlier films, like *Time Bandits* (1981), *Brazil* and *The Adventures of Baron Munchausen*, imagination is the manifest antidote to the evils of extreme rationalism. But later works, like his 'American' trilogy of *The Fisher King*, *Twelve Monkeys* and *Fear and Loathing in Las Vegas* (1998), present a more ambiguous attitude, with imagination facilitating confusion, disintegration and defeat. Gilliam acknowledged this trend explicitly, commenting that, while in early films he clearly identified with the protagonist's point of view, the later 'trilogy' films 'have had split protagonists', and he can identify with both (McCabe 2004: 139).

Although never as completely negative towards imagination as he is towards rationalism, Gilliam increasingly exposes the ambiguous nature of an uncontrolled imagi-

nation with a potential for both salvation and destruction. While in *Brazil* and *The Fisher King*, the imagination that leads to madness is nevertheless a way to escape even worse evils; in *Twelve Monkeys* and *Fear and Loathing in Las Vegas* it has become a prison, even a kind of hell. With the protagonists unable to fashion narrative coherence out of the events they face, imagination becomes the agent of confusion instead of an antidote to rationalism. Without a cohesive story, reality loses meaning and purpose, dissolving into a flux of disconcerting incoherence.

The Brothers Grimm, while reiterating once again Gilliam's unremitting hostility to rationalism in politics, also confronts, more than any previous work, the other side of the coin: the disintegration of all inhibitions when imagination becomes morbid and self-obsessed. Imagination, always the antidote to extreme rationalism in Gilliam films, also carries a sting-in-the-tail: a proximity to, indeed affinity with, insanity. However, the film goes further, presenting a kind of imagination that can be as malevolent (if not more so) than unfeeling rationalism.[3] The film received mixed reviews, with many critics lauding visual aspects while panning plot and direction, such as Roger Ebert (2005) describing it as 'a work of limitless invention, but it is invention without pattern, chasing itself around the screen without finding a plot'. A sizeable minority of critics gave overall praise to the film, such as Jim Fusilli's (2005) comment: '*The Brothers Grimm* is a celebration of the power of stories. Legends and myths, it tells us, should never be mocked or ignored. They may turn out to be real.'

Set in the Germany of 1811, which is under Napoleonic rule, *The Brothers Grimm* – very loosely inspired by the real-life compilers of German lore – tells the story of two brothers, William and Jacob Grimm (Matt Damon and Heath Ledger), who start the movie as con-artists and use Jacob's collection of folktales to orchestrate apparitions of malevolent supernatural creatures of local lore to trick gullible communities into paying them to fight off the spectres. The authorities, represented by the French General Delatombe (Jonathan Pryce) and his Italian henchman Cavaldi (Peter Stormare), apprehend the brothers and offer pardon if they employ their expertise in deception to uncover who is behind the mysterious disappearances of children in a forest adjacent to a Thuringian village. Having accepted the mission, the brothers gradually realise that they are not witnessing another scam but rather the attempt by the 'Thuringian queen' (Monica Bellucci), a long-dormant sorceress inhabiting an ancient tower in the forest, to regain her full powers. A showdown ensues in which French military forces trying to destroy the forest are overpowered and scattered by the queen's magic, and Delatombe himself is killed while attempting to execute the brothers. The Grimms and Cavaldi then cooperate in foiling the queen's bid for rejuvenation, finally breaking her power.

The movie thus unfolds as a conflict between a new French uninhibited rationalism (the general), and a primeval German morbid imagination (the queen). These two evil powers each attempt to gain overall political dominance, while the protagonists (Germans and Italian) struggle with and ultimately succeed in finding an alternative path. The connection of the political dimension of this struggle with the theme of national identity allows important insights into its wider significance, including relevance for the debate about national identity in today's European Union, and beyond.

The characters in the movie are clearly (often comically) identified along national lines, setting Delatombe and his soldiers as French, the brothers and the rest of the local population (including the witch-queen) as Germans, and Cavaldi as Italian. This national characterisation, not peripheral or accidental to the movie, is underscored by visual and plot features, as well as by systematic assignment of stereotypical national accents to all characters.[4] Even more significantly, differences of national identity are associated with different political approaches. Delatombe regards Frenchness as rational, cultured and sophisticated, justified in its political dominance of the superstitious, uncouth and primitive Germans. The Italian Cavaldi starts the movie as an unmitigated acolyte of Delatombe's political vision, unctuously obsequious to his French superiors and brutally contemptuous to his German subordinates. The Germans, including the Grimm brothers, are torn between a politically impotent resentment of the French domination and the allure of a more ancient but also more sinister power represented by the possible reestablishment of the queen's rule.

The national identity conflict emerges early in the movie, when (after a prologue set in 1796) the principal narrative storyline opens with the captions: '15 years later. French-occupied Germany. The town of Karlstadt.' The story then unfolds in the ostensibly independent 'Kingdom of Westphalia' (one of Napoleon's puppet-kingdoms), in fact a thinly disguised French military dominion with the supreme power resting in the hands of General Delatombe. In these circumstances, the daily life of the German population is marred by the conspicuous and heavy-handed presence of French soldiers. The French occupation is not only a harsh military oppression but also an overt attempt to 'Frenchify' the Germans. As the brothers ride into town, the old welcoming sign over the gate is replaced with a new one, bearing the caption 'Bienvenue a Karlstadt'; the flags seen around town are only those of France, never of nominally independent Westphalia, and Karlstadt's mayor sits with an oversize picture of Napoleon looming above him.

Delatombe (whose ruthlessness is represented by his name, translating to 'from the grave') repeatedly makes his mission clear by addressing his German subjects as 'citizens of France'. His goal is most explicitly presented when he welcomes a party of Parisian guests: 'Your shining example illuminates this dark German forest of ignorance and superstition.' An obvious metaphor for the General's vision of his mission – bringing French Enlightenment culture to illuminate the darkness of German superstition – it also encapsulates his eventual attempt to literally extirpate the forest and all it stands for by setting it on fire. But Delatombe's cultural identity is only superficially French, mostly displayed in a comic obsession with cuisine. He repeatedly declares his loathing for German food (even sending a German cook to the guillotine for 'crimes against cuisine'); revels in the extravagantly elaborate dinner he throws for his Parisian guests; mutters after shooting Cavaldi, 'Italian never agrees with me'; and offers as his dying words: 'All I wanted was a little order. A slice of quiche would be nice.' Even from his caricatured obsession, the real character of Delatombe's project surfaces in his dying refrain about wanting 'order': a fanatical attempt to impose procrustean tidiness over an untidy reality and a murderous willingness to extirpate any deviation from this vision of 'progress'.

Thus, Delatombe's identity cannot be said to be French in any meaningful way for his true 'nationality' is effectively some kind of supra-national state in which its inhabitants would subscribe to the ideals of the revolution. That is, rather than identifying with anything inherently French, the general is the patriot of the enlightenment: the universalising, rationalising and organising vision, regarding as the apex of human achievement the contrived construct called the 'Age of Reason'. Such a vision, seeing itself as manifestly superior, requires all to conform to it. While breeding intrinsic hostility to other national, cultural or religious identities, it is an inherently obscurantist and backward-looking opposition to the march of progress and enlightenment (see Vincent 2002: 56–60).

Delatombe embodies the extreme rationalist qualities seen in earlier Gilliam movies: the inept cruelty of the bureaucrat-rulers in *Brazil*, the myopic self-regard of the scientists-rulers in *Twelve Monkeys*, the narrow, stifling vision of the citizen-ruler in *The Adventures of Baron Munchausen*. To be sure, Delatombe is very much a version of the latter film's 'Right-Ordinary' Horatio Jackson (indeed, played by the same actor). Now he is military overlord rather than city-ruler but espouses the same principles of strict rationalism and order at any price with a fanatical willingness to mercilessly impose them. Jackson executes a soldier for heroism beyond the call of duty, Delatombe shoots Cavaldi when no longer useful to him, and both persecute storytellers, regarding their imagination as a threat to the neat rational order they wish to erect. Delatombe represents a political vision seeking reason in uniformity. Regarding the state as the instrument for attaining this goal, as well as the only permitted recipient for the individual's identity, all other agents of identity – tradition, language or religion – are to be erased. Not incidentally, this vision best suits a dictatorial political system. Its goals of reason and order can be fully delivered by an enlightened despot (Napoleon, or in his more circumscribed sphere, Delatombe). Ignoring as immaterial if not downright contemptible the will of his German subjects, the French overlord actively strives to erase their folktales, their gastronomy, even their language, in order to 'illuminate' them, and the essence of this critique is evident even earlier – in Gilliam's depiction of Napoleon in *Time Bandits* (see Klawans 2004: 158).

Delatombe's ideology leads him to regard national identity as the most serious threat to his objective. His greatest worry is that the latent national identity of his German subjects may intensify and grow to become political. This apprehension fuels his hostility to any expression of German culture, but is most obviously displayed in an exchange with the Grimm brothers about the disappearances in the Thuringian forest. When confronted by Delatombe with the demand to rationally explain the forest events or suffer torture and death, the brothers find the only path before them is to play on the general's fears. They suggest that the culprits behind the forest incidents are not a gang of swindlers, but rather a group of armed men – potential competition to French control over the land. The danger from the forest thus becomes no more criminal but political:

> *Jacob*: These are backward people, ignorant peasants. They cling to their folklore, because it gives them strength. The more this goes on, the more Germans will

talk like her [Anjelika, warning that the forest is enchanted], and then arm themselves, and then organize.

William: And then the problem won't just be one forest, any more. It shall be a nation.

Unsurprisingly, the general is immediately convinced of this explanation, catering as it does to his deepest anxieties. Thus Delatombe's goal is exposed as attempting to impose rationalist identity on the subjected population while regarding their developing of national self-awareness as his greatest fear.

At the other extreme from Delatombe's Age of Reason, state-based identity is the ancient witch-queen, representing the resurrection of a primitive, feral, female, self-obsessed power. When the villagers of Marbaden gather in their local church to tell the Grimm brothers of ten children disappearing in strange circumstances, they connect the resurgence of the forest's ancient magic to the simmering but impotent German hostility to the French occupation:

Woman: Our people always knew that the forest was enchanted, but it never turned against us.
Man: Until now.
Old Man: Until the French occupation!

This short exchange establishes that the magical properties of the forest were a long-accepted reality to the villagers, that until recently they went unharmed by these, and that only lately a turn for the worse had occurred – in suspect proximity to the advent of French military presence. The renewed intensity and malicious intent of the forest's magic are soon traced back to an ancient witch-queen, sleeping in a high tower in the midst of the forest. The queen was the wife of a 'Christian king', who centuries ago ruthlessly conquered the surrounding lands from its original pagan inhabitants and felled their sacred forest. His victory was, however, fleeting for within a year he died of a plague, and the forest rapidly grew back. The queen is the true mover behind these events: she tortured the locals (the villagers' ancestors), wresting from them spells controlling magical powers, including one for immortality. Ageing, as a result of having gained eternal life but not eternal youth, she has since lain in waiting, looking for the opportunity to rejuvenate her body and her power. The queen's connection to primeval, pre-Christian powers is indicated by her identification with prominent elements of Teutonic mythology, such as ravens serving as her emissaries and her control of the forest's power.[5] Moreover, while her husband is termed 'Christian king', she is never associated with Christianity and referred to only as 'queen' or 'Thuringian queen'.

Indeed, there are many indications that she is to be regarded as an anti-Christian figure: she displays marked disinterest in her church marriage (the king's hand resting on his chest during the marriage, suggests he, too, might have been spellbound by her, as later others are); the plague arriving on the very day of the wedding implies she was behind it, planning to seize power over the land; and attempts to fend off her evil magic repeatedly feature the use of Christian symbols.[6] Thus, while the village's

evolving tradition and identity has come to include Christianity, the queen and her magic represent an identity that is both pre- and anti-Christian, one that is unchanging and anti-traditional and seeks to obliterate everything that has occurred in the centuries since the queen went to sleep.

Besides the queen's associations with bloodthirsty pagan magic and ancient Teutonic mythology, the full import of her revival is made explicit at least twice. First, when the brothers enter the village, announcing they have come to save the land from enchantments, an old woman answers: 'Too late. The old ways have returned.' Later, the political dimension of the queen's return is highlighted when, while undergoing her process of rejuvenation, she declares: 'When the moon again becomes full, so will I. And your kingdom will once again be mine!' In political terms, the queen symbolises the resurgence of long-lost 'old ways' that are not only opposed to the French rationalistic approach but also to the traditional (and Christian) culture that developed in Germany over the centuries. The queen's reawakening after sleeping for five hundred years represents the revival in Germany of long-dormant, atavistic forces as a direct result of the French destruction of existing traditions, conventions and institutions. Demolishing the traditional framework of German culture and politics sweeps away all the aged but solid devices, which over the centuries had accrued into a complex mass that buried under its weight ancient barbarism.

The revived queen offers Germans an alternative to the rationalistic French oppression but at the price of an even worse moral abyss: the rule of a primitive, uninhibited and self-obsessed power that asserts a sub-national, even tribal, identity, defined only by ties of ancestry and blood. The price for this rejuvenation – the blood and lives of twelve innocents – leaves little doubt about the nature of a power thus resurrected. One does not have to dwell too much on the propensity of Fascism and of Nazism to represent themselves as revivals of an ancient pre-Christian past, Roman or Teutonic, to recognise the parallels in European, and especially German, history.[7] Thus the film connects to the extensive discourse, about the problematic long-term consequences of the French occupation of Germany and the dangerous reactions it produced to the ideals of the revolution. As early as 1791, Edmund Burke, a contemporary adversary of the revolution, warned that, as a result of the attempt to impose on Germans liberties and laws of the French revolutionary 'mode': 'A great revolution is preparing in Germany', one likely to be more decisive for the 'general fate of nations', even than the French Revolution (1989: 348).

In Gilliam's film the German population, primarily represented by the brothers Grimm, finds itself placed between two evils: the general's unfeeling, cold rationalism and the queen's morbid, heated nativism. At first accepting unquestionably, if reluctantly, the seemingly triumphant French rationalism and later lured into the irrational, mesmerising world of the queen, the brothers struggle to find an independent foothold. Convinced by early exposure to a hoax, that all supernatural claims are fraudulent, the brothers attempt for the greater part of the movie to rationalise the strange occurrences they are witnessing, repeating that 'there must be a rational explanation to all of this'. They look for hidden mechanisms and mirrors behind strange creatures, wheels and tracks under moving trees, until finally Jacob realizes the truth:

> I remember the rest of the story ... it's an ancient folk-lore which was passed down ... the tower, the queen's curse story ... you see before the plague, the queen tortured and killed the villager's ancestors, to get her hands on their spells. One of them was a spell for eternal life.

The brothers recognise that the old stories are not simply inventions but real memories, part of their reality, indeed of their identity. By the end of the movie they embrace their role as part of a continuous story, still unfolding in Jacob's words: 'All my life I had been studying these folktales, and now I found one that is real.' This connection with an ongoing tradition that wishes neither to return to the past nor to leap into the future but to continue a story, provides the brothers with a national identity that is culturally as well as politically independent from both the general's imperialistic rationalism and the queen's backward-looking nativism.[8] Effectively, the argument for a balance between rationalism and imagination is developed in *The Brothers Grimm* into a validation of national identity.

However, the most significant exploration of identity in the film is not realised by the titular brothers, but rather by the Italian baroque 'torture artist' Cavaldi. While the brothers start the movie as decent if misguided characters who are restored to their senses, the Italian torturer undergoes a far more extensive process of personal and moral discovery. Perhaps this is because the brothers' role is to represent the viewers' perspective and to further the plot, while the three approaches to identity are elaborated through other main characters, or perhaps because of Gilliam's personal affinity with Italy, Cavaldi is certainly the most complex of the characters, and the one who develops most during the film.[9]

Starting out as a pathetic, cruel and cowardly slavish figure, totally subservient to his French master, it soon emerges that the Italian is not quite what he appears. There are indications from early in the film that Cavaldi is a mercurial, conflicted character, harbouring reservations about his subservience to the French and not as ferocious and cruel as his trade would suggest. Indeed, despite his deference to his overlord, Cavaldi certainly does not regard himself as French, proud as he is of his Italian identity and family heritage, as evident in the way he presents himself: 'I am Mercurio Cavaldi, of the great Cavaldis of Parma.'[10]

As the movie progresses, Cavaldi is confronted with supernatural occurrences that shake his confidence in the General's radical rationalism. For example, his instinctive raising of a crucifix to repel a menacing werewolf (that he is even secretly carrying a crucifix under his shirt is itself important) indicates that he is only outwardly adhering to French revolutionary ideals. Later, confronted by Delatombe with his failure to explain what is happening in the forest, the Italian answers: 'They try to blind Cavaldi, with their fairy tales of devouring trees and flying wolves. But I use my logical brain.' Cavaldi increasingly realises that the French-style abstract 'logical brain' is actually distorting the reality he is witnessing. Eventually, he comes to reject entirely the rationalistic French outlook, its methods and goals. Indeed he is the first to grasp the true nature of the situation and dons the 'magical' armour used by the brothers in their scams as a 'precaution', while they still look for 'rational explanations'. Cavaldi's doubts

about his services to the French mount until Delatombe's attempt to burn the forest. The Italian comes to truly believe the Grimms and their stories and acquiesces to the general's orders out of fear. Finally, when directly ordered by Delatombe to execute the brothers, Cavaldi finds the courage to confront the general and announce his wish to resign from service. For his trouble, he is immediately shot. However, he is saved from the bullet by the 'magical' prop armour that he secretly wears, despite the general's scorn (thus 'magically' saved by the Grimms' false-magic). Freed of his submission to French rationalism, Cavaldi witnesses the full power of the queen's ancient magic. But having discarded one master the Italian is not about to submit to another. No longer cowering before supernatural occurrences, Cavaldi finds his true voice.

Upon discovering that William has apparently been murdered by the queen, instead of escaping when presented with the full force of the ancient dark power, the Italian courageously confronts it and directs at the queen's tottering tower his very own magic, a forceful, heartfelt curse: 'Demon queen, hear me. Swallow my curse, from the dark hearts of my ancestors: *Maledetta! Maledetta!*' ('Damn you! Damn you!'). His words appear to give the tower its *coup de grâce*, and the whole ancient edifice collapses. Cavaldi's restored bond to his national and familial tradition is further emphasised by the restoration of his memory. When viewing Jacob leaning over William's seemingly dead body, the Italian suddenly realises: 'Wait! I know this story, from my childhood. There is still time, Jacob. Look, [points to the moon] the spell can be broken with a kiss of true love.'

Having found the courage to reject both enlightenment rationalism and obscurantist primitivism, Cavaldi presents an alternative version of national identity, one that might be termed 'baroque', stemming as it does from loyalty to continuing familial and national tradition with all their complexities. The Italian accepts his role as part of an ongoing story, neither repudiating the past nor remaining a slave to it. Instead of yielding to or attempting to erase the past's darker features, Cavaldi chooses to recruit them to serve a higher moral purpose, to aid his stand against evil. Thus, national differences have a decisive role in furthering the movie's examination of political identity. The French, and especially Delatombe, represent a view proposing the ideals of the French Revolution and a particularly strict rationalism as the focus for a supranational identity, in effect suggesting the prospect of a uniform and stifling future. The Germans in the movie struggle against the temptation offered by the Thuringian queen (significantly, only Germans ever see her), representing a power-hungry, primitive and self-obsessed identity, its focal point tribal or rather racial, and the consequences of its success too appalling to contemplate. The Italian Cavaldi represents the baroque, a national identity based primarily on culture and memory that can successfully engage with outsiders without losing its own character and can confidently look to the future without severing its connections to the past.

Gilliam explores the moral and practical consequences of cold-hearted rationalism and its counterpart, over-heated imagination, in many of his films. In his own words:

> I like movies that are full of a lot of conflicting and interesting things. I want to make films that inspire people to explore their imagination. We live in a world that is defined

by numbers and calculations – and there is very little room for myth and dreams. I think we need both of those things in our lives, to make life worth living.[11]

The Brothers Grimm carries this examination squarely into the political sphere. Its identification of extreme rationalism with a supra-national even imperial identity and of unbound imagination with a sub-national even tribal identity is instructive, for it intimates that neither of these two principles can provide a stable national identity. It suggests that in their pure form, both rationalism and imagination produce inherently unhealthy and unstable political identities, tending either to extend ever outwards or to collapse inwards into self-obsessive purity. Only something like an independent national idea can deliver durable political identity (see Hazony 2002).

As we have seen, the traditionalist approach stresses the importance of elements like culture, language and customs in sustaining national identity. But in *The Brothers Grimm*, Gilliam assigns the crucial role to another factor: narrative. Story-narratives and their preservation are important in all of Gilliam's movies, especially so in *The Brothers Grimm*. Abstract, a-temporal rationalism, which is inherently anti-narrative, is often set in his films against the continuity-narrative that is the story. However, the opposite of rationalism – imagination – is not necessarily the solution. A degree of imagination is essential to establish a storyline, but in excess it accrues until it overwhelms the narrative, shattering the story into incoherent shards and images – as happens in *Twelve Monkeys* and *Fear and Loathing in Las Vegas*. Thus, the impact of the Baron's tales in *The Adventures of Baron Munchausen*, and the restoration of national self-identity by Cavaldi and the brothers in *The Brothers Grimm*, are explicitly connected to their regaining memories of stories and to their acknowledging themselves as participating in those stories. A story establishes temporal sequence, necessarily tied to the past but also possibly projecting into the future. In this way the individual can intertwine with community – the familial, the regional and eventually the national story. As an American, Gilliam has repeatedly commented that the connection with a continuing story is why he prefers to live in Europe: 'In Europe you get the feeling of belonging to a very, very long history.' This connection, he believes, gives stability which he highlights by pointing out that his houses in England and Italy are hundreds of years old, which for him means that 'I can keep going back to the past' (Costa & Sanchez 2004: 180).

The enduring importance of the debate about the French Revolution and its legacy in European history enables Jordi Costa and Sergi Sanchez (2004) to explore political approaches that are relevant to this day. It reflects the political battle over the European hearts and minds between, on the one side, Delatombe's ideal of the supra-national state, which strives to make Italians and Germans into citizens of the French Revolution, and, on the other, the Thuringian queen's sub-national vision wishes to draw Germans into a native past which is fixated with notions of power and blood so dear to twentieth-century totalitarian ideologies.

Faced with the battle over European identity, waged between enlightenment and obscurantist visions, the film offers a third, baroque alternative. It shows the brothers Grimm and Cavaldi awakening to the true nature of the political struggle around them

and rejecting both malevolent options presented to them in favour of a tentatively hopeful, old/new path of national identity. These three political alternatives differ, first and foremost, about their attitude to the past: the first (rationalism) attempts to erase it, the second (nativism) tries to return to it, and the third (national tradition) proposes to live with it as part of a shared, ongoing story.

Notes

1 The relevant literature is immense. For origins of nationalism and its relationship to the ideas of the French revolution, see Vincent (2002). For the complexities of national identity, and its relationship with the concept of the state, see Roshwald (2006). For some classic examples of the traditionalist view, see Hastings (1997) and Smith (2004). For the modernist view see Anderson (1983) and Hobsbawm (1990). For the anti/post-modern view see Kymlicka (1995) and Archibugi (2003).
2 The same approach is evident in the dying Baron Munchausen's presentation of the cause for his approaching demise (eventually averted) as his apparent redolence: 'Because it's all logic and reason now, science, progress … laws of hydraulics, laws of social dynamics, laws of this, that, and the other. No place for three-legged Cyclops in the South Seas, no place for cucumber trees and oceans of wine. No place for me.'
3 Ehren Kruger is credited for the script of *The Brothers Grimm* due only to the rules of the Writers Guild of America. In his DVD commentary, Gilliam states that he did not like the original Kruger script and that when he agreed to do the movie, he extensively re-wrote it (together with collaborator, Tony Grisoni).
4 In the DVD commentary, Gilliam describes his decision to stress differences of nationality, by intentional and conspicuous (indeed, often comical) use of differing accents: French and Italian characters speak English with their respective accents, while Germans speak with accents from various parts of England.
5 In the voice commentary, Gilliam states: 'The ravens are the messengers of the Queen, I guess going back to Norse mythology.' The sacred forest and Irminsul tree are central elements of pre-Christian Germanic myth.
6 Christian symbols and artifacts are repeatedly placed in opposition to the evil forces of the film: when Karlstadt's mayor is shown sitting under a picture of Napoleon, a crucifix can be seen cast aside near the window, representing the displacement of the old order by the new oppressive regime; and when the villagers gather to tell the brothers about the disappearances, they do so in their local church, hoping its sanctity defends them from the forest's magic. Moreover, throughout the film crucifixes are used to repel evil: when the brothers battle the false witch, William raises a prop-crucifix which ignites into flames; when Cavaldi is threatened by a werewolf, he grasps the crucifix he is carrying about his neck; when Delatombe is about to kill William, the latter raises the igniting prop-crucifix previously used against the false witch (causing the general

to sneer). The bursting flames momentarily blind the Frenchman, allowing the German to kill him. In a deleted scene, when Cavaldi is reluctantly forced by Delatombe to show him the way to the witch's tower, the Italian crosses himself. The comical effect accompanying the use of the cross in these scenes (and the obvious reference to horror film conventions of crucifixes stopping vampires and other monsters) does not deny its effectiveness.

7 Intriguingly, scholars currently most supportive of the fragmentation of national identity into smaller identity groups tend to be those inclined to post-modernism (see Vincent 2002: 51–2).

8 In the introduction to their *Kinder und Hausmärchen* ('Children's and Household Tales') published in 1812, the real Jacob and William Grimm explicitly acknowledge that many of the collected tales were not exclusively German ones, but particular national versions of stories shared for centuries by other European nations, extensively recorded for the first time in Giambattista Basile's *Pentamerone* (1634–1636).

9 Gilliam resides part of the year in his house near the Umbrian town of Montone, where he also helped to establish a yearly film festival.

10 In the DVD commentary, Gilliam describes Cavaldi at the time of his first appearance as a conflicted character: 'Cavaldi, an Italian torture artist, tortured artist', later adding, 'This pathetic creature, Cavaldi, tries to be murderous and has in fact a sweet heart.' Also on the DVD is a deleted scene where Delatombe airs his suspicion of the Italian's true nature: 'Cavaldi, when I scoured Italy in search for a torture artist, they warned me you was [sic] the weakest of all the great Cavaldis. No stomach for it! Sometimes I wonder if you have ever disembowelled any virgin at all.'

11 From the press conference presenting *The Brothers Grimm* at the Venice Film Festival on 4 September 2005.

Works Cited

Anderson, Benedict (1983) *Imagined Communities*. London: Verso.
Archibugi, Daniele (ed.) (2003) *Debating Cosmopolitics*. London: Verso.
Burke, Edmund (1989 [1791]) 'Thoughts on French Affairs', in L. G. Mitchell (ed.) *The Writings and Speeches of Edmund Burke*. Oxford: Clarendon, 348–50.
Christie, Ian and Terry Gilliam (2000) *Gilliam on Gilliam*. London: Faber.
Costa, Jordi and Sergi Sanchez (2004) 'Childhood, Vocation and First Experiences of a Rebel Dreamer', in David Sterritt and Lucille Rhodes (eds) *Terry Gilliam: Interviews*. Jackson, MS: University of Mississippi Press, 170–83.
Ebert, Roger (2005) 'Review of *The Brothers Grimm*', *Chicago Sun-Times*, 26 August. Online. Available at: http://rogerebert.suntimes.com/apps/pbcs.dll/article?AID=/20050825/REVIEWS/50822002 (accessed 5 November 2011).
Fusilli, Jim (2005) 'Inventive Ever After: Review of *The Brothers Grimm*,' *Wall Street Journal*, 26 August. Online. Available at: http://online.wsj.com/article/SB112500448008723407.html (accessed 8 December 2011).

Hastings, Adrian (1997) *The Construction of Nationhood*. Cambridge: Cambridge University Press.

Hazony, Yoram (2002) 'On the National State, Part 1: Empire and Anarchy', *Azure* 12. Online. Available at: http://www.azure.org.il/article.php?id=265 (accessed 5 November 2011).

Hobsbawm, Eric (1990) *Nations and Nationalism since 1870*. Cambridge: Cambridge University Press.

Klawans, Stuart (2004) 'A Dialogue with Terry Gilliam', in *Terry Gilliam: Interviews*, edited by David Sterritt and Lucille Rhodes, 141–169. Jackson: University of Mississippi Press, 2004.

Kymlicka, Will (1995) *Multicultural Citizenship*. Oxford: Oxford University Press.

McCabe, Bob (1999) *Dark Knights and Holy Fools: The Art and Films of Terry Gilliam*. New York: Universe Publishing.

_____ (2004) 'Chemical Warfare', in David Sterritt and Lucille Rhodes (eds) *Terry Gilliam: Interviews*. Jackson, MS: University of Mississippi Press, 135–140.

Morgan, David (2004) 'The Mad Adventures of Terry Gilliam', in David Sterritt and Lucille Rhodes (eds) *Terry Gilliam: Interviews*. Jackson, MS: University of Mississippi Press, 36–46.

Oakeshott, Michael (2010) *Rationalism in Politics and Other Essays*. Indianapolis: Liberty Fund.

Smith, Anthony (2007) 'Nation and Covenant', *Proceedings of the British Academy*, 151, 213–55.

Roshwald, Ariel (2006) *The Endurance of Nationalism*. Cambridge: Cambridge University Press.

Smith, Anthony (2004) *The Antiquity of Nations*. Cambridge: Polity.

Vincent, Andrew (2002) *Nationalism and Particularity*. Cambridge: Cambridge University Press.

CHAPTER NINE

'Won't somebody please think of the children?' The Case for Terry Gilliam's *Tideland*

Kathryn A. Laity

This chapter considers the notion of the monstrous and its relationship to childhood in Terry Gilliam's *Tideland* (2005). There is a small strain of the fantastic that plays upon the powers of horror but skirts the edge of mainstream. Sometimes these films meet with stupendous financial success – as in the case of Guillermo del Toro's *Pan's Labyrinth* (2006) – but more often they turn out to be astounding (critical and/or financial) failures, as in the case of *Tideland*. At the centre of both films is a young girl who confronts all-too-real horrors by delving into a fantasy world that becomes more vivid and sustaining than those daily terrors. While del Toro's film has won awards the world over, Gilliam's film has been dismissed as 'disturbing and misguided' (Rosenblatt 2006) and 'a no-man's land ... between the merely bad and the indefensible' (Scott 2006). Many critics missed Gilliam's skilful exploitation and subversion of horror conventions with which he confronts adults with the shocking reality of childhood innocence.

Despite their many similarities, the two films differ on one key point: sexuality. While there are whiffs of sexual elements in del Toro's film, particularly with the ogre known as the Pale Man who savours the taste of innocents, Gilliam confronts sexuality more frankly and from a child's point of view. The story of Jeliza-Rose (Jodelle Ferland), daughter of two junkies – one of them an ex-rock-star father whose affection borders on the inappropriate – features a child mostly on her own surrounded only by her collection of doll heads and a handful of adults who lack any semblance of responsibility. While there are many horrific moments, in the latter part of the film Gilliam teases his audience into a fury with the suggestion that an unacceptable sexual encounter is about to erupt between Jeliza-Rose and an adult (albeit an adult with developmental disabilities). The contrast of his mature body coupled with her undeveloped shape heightens the difference. The genre of horror still maintains a strong

conservative thrust and the transgressive use of sexuality in *Tideland* unduly disturbs many critics and audience members.

The position of children in twenty-first-century culture is a contested one. French cultural theorist Jean Baudrillard has argued that 'the child is no longer a child' (2002: 103). As technology advances, the child ceases to be a product of its parents and is instead re-invented as 'a technical performance' and a 'mini-extension' of themselves, in short, a clone, not a child. When we hear the raptures of the new parents swooning over their new little echo, we comprehend the narcissism of that self-nurturing. We project the image of the self-less love of the parent for the child, while hiding the helpless and utterly vulnerable love of the child for the parent. The anxious cry – 'Think of the children!' – illuminates the well-known clash between the Puritan heritage of the United States and capitalism's ubiquitous advertising, which attempts to sell a variety of products via the lure of sex.[1] Both the popular and the academic press have made much of this phenomenon with alarmist stories, but the essential tension between the opposing forces seem to have become intractable.

Typically, nanny culture – by definition – looks for macro solutions at the governmental level, absolving the individual of any need to act. Gilliam's film attacks nanny culture at its most tender spot: the seemingly ever-present anxiety over the sexual exploitation of children. While crime statistics demonstrate that children are far more likely to be endangered by family members than anyone else, the sexual endangerment of children has become a seemingly omnipresent fear in the wake of the sexual abuse scandal in the Catholic Church, and the advent of the internet, often seen by alarmists as consisting of little more than a system of doors allowing child-porn predators access to innocent children the world over. While fears for children's safety are understandable enough, terror about sexuality – a natural part of life – has grown from the legacy of Puritan culture to an anxious seesaw between the sexualisation of images of children and the horror at what that sexual provocation might invoke: the child molester.[2] Gilliam confronts this taboo head-on, making use of this terror in the story of Jeliza-Rose and allowing her to become the monstrous one despite our expectations that only the adults will prove monstrous.

Like del Toro, Gilliam realises in his film's heroine the Hobbesian potential of the unsupervised child. Like the gnarled tree that anchors both films, dark horror lurks watchfully over the childish antics of the heroine.[3] The blasted nature of the tree embodies the decrepitude of age, which seeks to abuse the child – a rotting corpse poised over the innocent body of the child in both films (and prefigures del Toro's giant toad and Gilliam's strange brother and sister). This horrific impulse drives the twin narratives of childhood resilience and creativity. Gilliam uses such motifs to assail the viewer and to create fearful expectations as the film unfolds. In doing so, he plays with generic expectations, creating a horror film with recognisable tropes, but one in which they do not lead to expected conclusions. For example, dismembered bodies (like Jeliza-Rose's doll collection) can be playful one moment then exploited as horrific the next. Every trope initially frustrates the horror fan's expectations of blood and gore; then, each undergoes an unexpected transformation to horrify yet still more, if in a generically unexpected way.

For example, the dead body of Jeliza-Rose's father passes from the horror of death to normalcy as part of her 'home' and then back to horror as he undergoes taxidermy. The shifting camera angles, the gruesome images, the foreboding music tell us we are in a horror film, but the monster's identity keeps shifting. Is it horror? In the end, the simplest generic definition still works the best: as Douglas Winter wrote in his introduction to the influential collection *Prime Evil* (1989), 'horror is not a genre, like the mystery or science fiction or the western. It is not a kind of fiction, meant to be confined to the ghetto of a special shelf in libraries or bookstore … Horror is an emotion' (1988: 2). It is the emotion Gilliam seeks to provoke even as he keeps the audience off-balance by veering away from generic conventions.

Gilliam introduces the DVD with a black-and-white sequence that immediately signals its ties to the horror film. It evokes the tacked-on prologue of James Whale's *Frankenstein* (1931), clearly intended as a safety valve, in which the tuxedo-clad Edward van Sloan steps from behind a curtain (as if this were live theatre) and delivers the following 'friendly warning' to the audience:

> Mr Carl Laemmle [the producer] feels it would be a little unkind to present this picture without just a word of friendly warning. We are about to unfold the story of Frankenstein … I think it will *thrill* you. It may *shock* you. It might even *horrify* you. So if any of you feel that you do not care to subject your nerves to such a strain, now's your chance to … uh, well, we warned you.

Gilliam follows a similar tack with his prologue. Rather than the dapper tuxedoed spokesmen, he looks to be speaking from an undisclosed location in a subterranean bunker. Evoking the *Frankenstein* warning, he hectors his audience into thinking that it is their short-comings that will affect their pleasure:

> Hello, I'm Terry Gilliam and I have a confession to make: many of you are not going to like this film … If it's shocking, it's because it is innocent. So, I suggest that you forget everything you learned as an adult … Try to rediscover what it was like to be a child, the sense of wonder and innocence, and don't forget to laugh. Remember, children are strong, they are resilient … I was sixty-four years old when I made this film. I think I finally discovered the child within me. It turned out to be a little girl.

Like Laemmle's preamble, Gilliam's warning serves as both a legitimate 'warning' and a provocative tease. The anticipatory expectation of viewer resistance is couched in a disparagement of that same audience. Just as the *Frankenstein* warning implies a failing of our nerves if we cannot take the strain, Gilliam suggests the largely negative critical reaction comes from a failure to retain what our culture glorifies about childhood: its innocence, and the strange fact that, for all our worship of this special state, we are shocked by its reality. After unbalancing the viewer with the counter-intuitive notion of children as resilient rather than the victims we are accustomed to in media portrayals, Gilliam then sets up an unsettling gender construction: namely, that he has found his inner child to be a little girl. He emphasises his age to increase the disparity

and conjure up the image of the 'dirty old man', playing on our prejudices with practiced ease. Gilliam refuses to sentimentalise the 'girl in dire situation' motif, even as he describes it.

Tideland's power rests on the casting of Jodelle Ferland as Jeliza-Rose. Gilliam details the difficulties in locating a suitable child for the role, complaining that girls of the appropriate age had already been too highly sexualised and jaded by the acting process (and, presumably, by their parents) to be able to portray the innocent young heroine. The character of Jeliza-Rose carries the film, as it must, for not only is she in virtually every scene, but her voice in conversation with her doll heads is our link to the story. Gilliam begins the film with a black screen: we hear a few plaintive notes and then Jeliza-Rose reading from *Alice's Adventures in Wonderland* (1865), the touchstone of both novel and film. While the script by Gilliam and Tony Grisoni closely follows Mitch Cullin's novel (2000) they manage to better locate the horror around the innocence of the child by eliminating much of the unrealistic monologue and instead taking advantage of film's ability to show us things that a novel must merely describe. Jeliza-Rose is a neglected child with no schooling beyond television, and even though much of that TV-time focuses on PBS, the diction of Cullin's heroine never fits. Phrases in the novel like 'inauspicious entryway', 'seared metal' and 'a lemon phosphorescence' pull the reader out of the story in the first two pages. Taking away that first-person narration, Gilliam explains, adds to our fears about what will happen to Jeliza-Rose. This discomfiting feeling of fear permeates the film and, even more so than the novel, exploits horror film conventions.

One of the chief problems, as Gilliam and Grisoni discuss on the commentary, is 'the lack of genre box' for the film. As Linda J. Holland-Toll argues, 'a text which transgresses convenient barriers and resists pigeon-holing creates cultural dis/ease simply because it cannot be easily contained' (2001: 3). But the film draws from traditional and recognisable aspects of horror, even if it does not create a typical or traditional horror film. This slippage proves to be an essential part of the genre, for, as Holland-Toll observes, 'one cannot expand the definition of horror fiction and equate it with any manifestation of cultural dis/ease without rendering generic distinctions meaningless' (2001: 6). Gilliam crosses and re-crosses the boundaries so frequently that the audience may understandably lose the safe comfort of those generic expectations.

Because we have nothing else to hold onto, we navigate our way through the narrative with the help of horror tropes. All the other horror elements – familiar, almost expected conventions of the genre – pave the way for the greatest dis/ease of them all: the spectre of sex associated with a child. Gilliam, despite his disavowals from the introduction onward, knows that this is the taboo that unsettles his audience most of all. Far from shying away from this taboo, Gilliam plays with its limits, especially during the kissing scenes, conscious of flirting with boundaries that must not be crossed. He is well aware of the panic surrounding paedophilia.

After the initial black screen, the film moves dreamily from an apparent underwater scene, which, once the blue light and bubbles fade away, we realise to be the long grass of the prairie location. Although the recitation of Lewis Carroll's words makes clear that we are already down the rabbit hole, the visuals fool us into complacency as

we follow the dreamy golden images of the swaying grass and the leaping grasshopper. There is a slight disjunction with the first shot introducing the doll heads that are Jeliza-Rose's bosom companions. The disconcerting mix of childhood emblem and decapitation adds to the undercurrent of dis/ease, to use Holland-Toll's neologism for 'the disturbing effect and sense of unease' which texts like this generate (2001: 253, n.2). Still, we can set it aside initially because of the happily singing Jeliza-Rose who strides through the golden sea of grass (although, if we listen closely to the words of the song her father has written for her, the sense of dis/ease may return). Even the precipitously overturned wreck of a school bus can be accepted because it mirrors the golden colour of the field. Within its shell, Jeliza-Rose plays with her doll heads, introducing them to the fireflies gathered there, immediately turning the insects into fairies in her imagination.

The sudden roar of a train violently invades the scene. Gilliam prepares us for the horror to come, even though he allows us to hope it is all play, just as Jeliza-Rose screams not in terror but delight. Gilliam does not let that hope live for long. In quick succession, as the credits roll, the camera introduces us to Jeliza-Rose's ageing rock star father and decrepit mother, both junkies. The angled shots around the rock'n'roll club where we see her father perform jump suddenly from a wailing guitar to the red coughing mouth in what Gilliam identifies as his 'favorite cut in the movie'. The first horror is domestic. The loyalty between Jeliza-Rose and her father, Noah, works against her mother, 'Queen Gunnhild' (an almost unrecognisable Jennifer Tilly), and centres around his altar to Jutland, complete with Viking ship. Noah's fascination with the bogmen of Denmark offers a shared context for father and daughter. Jeliza-Rose proudly demonstrates her understanding of Jutland, but the bogmen also fuel a fearful image in the child's mind, as she quickly appropriates the figure of the bogman as her own peculiar boogeyman, first seen as her father's transformed shadow crouching menacingly behind him as he leaves her bedroom.

However, for most of the audience, the true horror is the sight of this young girl cooking heroin for her parents before helping them shoot up. Gilliam and Grisoni discuss at length the power of the scene, disparaging the cachet of heroin and arguing that, had it been alcohol, the effect would be lessened (had it been insulin, no one would complain about a child handling needles at all). Perhaps most disturbing is Jeliza-Rose's practiced efficiency with the whole process. When she later sits on her insensate father's lap reading *Alice* aloud, we see how she dotes on her father despite his frequent and hazy absences, which are at least better than the shrill volley of attacks and subsequent remorse from her mother. Gilliam notes that the story is 'totally about a daughter in love with her father', and that key lies at the root of much of the horror of the rest of the film. A child neglected and abused looks for connections and nurturing wherever she is able.

Yet horror lurks around every corner. When Queen Gunnhild inevitably and messily dies, Noah and Jeliza-Rose flee towards Jutland, making it only as far as his childhood home on the Texas prairie. We first glimpse the monstrous in the child when Jeliza-Rose realises that her mother's death means that she and her father can eat the forbidden chocolate bars jealously guarded by Queen Gunnhild. While she may

not wholly understand the finality of death, as they pile her mother's favourite things on top of her prone body, Jeliza-Rose clearly understands the danger of fire when Noah attempts to light his wife's corpse in a Viking funeral pyre. Gilliam's off-kilter angles and deep shadows enhance the sensation of horror both in the absurdly gruesome scene and during the nightmare bus ride that follows.

When they reach their initial destination, the music swells with anticipation as they cross the golden grass to the home that seems to nestle as a kind of sanctuary in the distance. But as they reach the steps, the music dies away and instead of a 'home' we contemplate a house that conjures up the derelict look of the family home in Tobe Hooper's *The Texas Chain Saw Massacre* (1974). The dust, protruding nails and general dilapidation prepare us for the horror within, first glimpsed on Jeliza-Rose's face as she stares in disbelief through the open door. As graffiti on the living-room wall announces, it is a 'fucking shithole' with visible water damage, broken furniture and the detritus left in the apparent wake of disaster.

As Noah settles down to partake of his habit, Jeliza-Rose explores the upper story where the sense of dis/ease again grows. Despite Gilliam's frequent jokes on the commentary that he has never seen an Alfred Hitchcock film, we expect to find Mrs Bates around every corner of the dilapidated house or in the derelict bed. The narrative veers between Carroll's gentle nonsense and dark horror tropes. Standing in for Carroll's elegant white rabbit in a waistcoat we see a pesky squirrel who leads to the discovery of the attic trapdoor to a hidden room. On the commentary, Gilliam gloats about the horror set up in the creepy attic room, which is somewhat different than the book. While in the novel Jeliza-Rose calls to mind Alice's time in the hallway with the 'Drink Me!' bottle, the film takes us back to *The Texas Chain Saw Massacre* house.

Like the cast of a slasher film, Jeliza-Rose and the doll heads debate whether to enter the dusty cobweb-bestrewn chamber. While the bold sophisticate doll called Mystique favours charging forward, the mostly frightened Sateen Lips expresses Jeliza-Rose's own fears that there is something dangerous lurking in the darkness. Gilliam admits that Sateen Lips is 'the true Jeliza-Rose and that's why I chose her [the doll]'. Presumably, that's why, in one of the eeriest moments of the film, the doll's head – left behind to watch for trouble – rolls to the side and morphs into Jeliza-Rose's head with blinking eyes, just before Gilliam cuts to Jeliza-Rose screaming herself awake. It is a pure moment of dis/ease. Gilliam follows that moment with further horror-tinged visions, which either expand Cullin's text or simply add new elements altogether. While the discovery of her grandmother's old clothes, make-up and feather boa also appear in the book, it is Gilliam's film that reshapes this scene to emphasise the horror ambience of dis/ease.

In Cullin's novel, Jeliza-Rose and her intrepid doll head probe the dusty attic to find 'three cardboard boxes and a large trunk' (2000: 53). A moment of suggestive dis/ease appears upon the opening of the trunk, when Jeliza-Rose spots 'three blond wigs, all tangled in a clump, which frightened' her and cause her to say 'It's a head' while backing away (2000: 54). After reassuring words from her trusty doll head, Jeliza-Rose quickly returns to her exploration of the trunk's contents. In the film, the scene proceeds with a good deal more horrific rhetoric. Approaching the

trunk, Mystique taunts Jeliza-Rose, 'Scared?' The unsettling angles Gilliam employs throughout this sequence set the audience off-kilter, just as the tinkling music adds to the growing tension. The ambience of darkness and shadows creates a sense of dread. Jeliza-Rose attempts to stop Mystique from reaching for the trunk's latch, warning her that it might be 'a dead thing'. As the music swells, the tension heightens. Opening the trunk, Jeliza-Rose screams, as what appears to be a body falls out. It is a good scare moment, one that the director says serves as 'a simple way of shocking us back into reality.' Upon closer inspection, Jeliza-Rose says disdainfully, 'it's just a pile of clothes'. Initially, 'reality' seems to be the world of sense and comfort: what we mistook for a body proves to be innocuous. However, we are also reminded that reality for Jeliza-Rose includes two dead parents and no hope in sight. The horror is far worse than her cavalier search conveys. Gilliam expands the sense of surreal horror by having the inside of the truck stretch elastically, recalling once more Carroll's rabbit hole as well as C. S. Lewis's wardrobe. When the shadow of the squirrel returns, Jeliza-Rose wonders if 'that's what happened, they turned into squirrels', then proceeds to do so herself, chattering with 'paws' held up in front of her. Rather than wonder, the scene provokes the dis/ease of the uncanny.

These dichotomies pull the viewer in opposing directions. Like Gilliam's injunction, 'Don't forget to laugh', our discomfort produces both dis/ease and laughing disbelief. When we see Jeliza-Rose curled up with her father, who is gradually decomposing after a fatal overdose, the situation easily provokes the horror of revulsion. Yet there are also humorous realisations: at last he is spending most of his time with his daughter – her ideal situation. The corpse transforms from abjection into a combination of comfy chair and doll head. He is no less present than he apparently had been for much of her life, providing in death the same low level of comfort as in his normal heroin-induced nod. Just like her doll heads, Noah's limp body offers the same passive comfort and sounding board for Jeliza-Rose's on-going self-revelatory monologue. The multitude of voices she employs suggests slippage into a kind of schizophrenic fugue state, so that it is easy to doubt all her experiences.

The appearance of a mysterious black-clad figure reinforces this doubt about Jeliza-Rose's sanity, as played against the expectations created by the horror conventions. Again the viewer is torn between the common horror trope that Jeliza-Rose herself invokes – 'a ghost!' – and the speculation that none of this is really happening. Her apparent recognition of Dell (Janet McTeer) as the 'ghost' of a dead person clashes with the apparent lack of recognition of her father's death. Gilliam comments that he does not understand the viewers' confusion with Jeliza-Rose's reactions to death, and surmises that they were led astray by genre convention, because 'she just doesn't respond the way children in movies respond', implying that she does respond more naturally as a real child would (and that viewers find the real and perhaps 'innocent' reaction all the more horrifying). Ironically, we feel dis/ease where the child feels none because of our greater experience with death. Jeliza-Rose feels no dis/ease with her dead father's body, but she feels distress, according to her limited experience, at what she perceives to be a ghost. Her father's dead body is familiar, while the living body of the 'ghost' is a stranger. Horror for the girl operates differently than it does for the audience.

Shortly after the first sighting of the 'ghost', Jeliza-Rose plays at being dead when her blood-red lipstick slips and creates a crimson gash across her cheek. 'I'm really dying this time', she tells her constant companion Mystique; 'This is not a vacation,' she says, echoing her father's terminology for his heroin haze. Mystique, who appears to be giant-sized from where she perches above the mirror, tells her, 'Dear, you're already dead, a ghost, a spook!'[4] While the narrative appears to be teetering on the edge of a breakthrough to alleviate dis/ease (has she at last realised the finality of death?), Jeliza-Rose immediately bounces away from the ugly reality of her father's death and of her abandonment to narcissistic enjoyment of her beautiful 'ghost' self. Death becomes not simply acceptable, but perhaps desirable. The sight of Jeliza-Rose appropriating her father's dead body as the latest doll in her collection – putting the blonde wig on his head, rouge on his cheeks and more of the crimson lipstick on his face – brings us back to the uncomfortable tension of laughter and horror signaling dis/ease.

In the book, Jeliza-Rose discovers that there are worse things than death when she encounters Dell's taxidermy shed. The shocking revelation provides a gruesome shift in the narrative, away from death and toward some sense of life and hope. While staring at the ranks of stuffed critters, Jeliza-Rose makes a firm decision:

> This was where Dell kept Death at bay, where she saved silent souls from going into the ground. But I didn't want to end up like those creatures – frozen and on a shelf; I didn't want to be stuck like that forever. Might as well go into the ground, I thought. If you can't run around and yell and cut muffins, you might as well be dead. (2000: 174)

Jeliza-Rose consciously chooses life – and, thus, *real* death. Better death, real death, than that grasping fear of ever letting go. The child recognises the horror inherent in suspending the last step into death that brings comfort to adults like Dell.

Gilliam negotiates this character by taking advantage of a number of horror tropes. In addition to her ghostly appearance and the intercut scenes of her dancing by the burning hives, the film brings us into the taxidermy shed much earlier – and consciously mixes sex and death like any good slasher film would. Gilliam marshals the allusion to *Psycho* (1960) with all its repressed sexuality, introducing Jeliza-Rose to both the suspended death that Dell creates and the forbidden rites of sex. While Cullin has Jeliza-Rose glimpse Dell's exchange with the delivery boy in the bushes beside the house – 'she's a vampire', her doll head informs her – Gilliam moves the scene into the taxidermy workshop to amplify the gruesome connection between sex and death, in turn moving Jeliza-Rose to the position of surreptitious voyeur, *à la* Norman Bates (2000: 117). He also doubles the horrific scene with a second sexual discovery when Jeliza-Rose comes downstairs to find Dell astride her father's corpse.

Gilliam manages the scene with a range of horror touches, from the emphatic shadows to the off-kilter angles, contrasting Jeliza-Rose's delight in company with the dis/ease Dell brings. The two whimpering doll heads offer the usual ignored horror film advice not to go down those stairs, while wondering what Dell can possibly be doing down there. Jeliza-Rose glimpses her astride Noah's body between the balusters. She recoils, but also seems drawn inexorably down the stairs. Gilliam brings us in close

for a tender kiss from Dell as she tells Noah they will never be parted again and that she loves him so, even as she pokes his distended tongue back down his throat. When Dell notices the child haltingly approaching, she brandishes the slasher film's favourite weapon: a large shiny bladed knife. The expected moment of violence is deflected, however, as Dell explains the details of her handiwork, a far more devastating weapon when wielded against the child, as it forces her to acknowledge her father's absence.

The violence is delayed but not avoided as Dell sinks the blade's point into Noah's chest. The delayed horror trope appears, but instead of death, the knife's penetration reads to both Dell and Jeliza-Rose as a healing, making Noah 'all better'. For Dell, healing means that he will never leave her again; for Jeliza-Rose, healing means something more complex. In the novel, she finally cries, giving in to grief even if Dell refuses to comfort her. In the film, however, Gilliam does not quite allow the tears to well, robbing the audience of some relief from the horror. Instead, he inserts a house-cleaning scene that provokes an incredible level of dis/ease through its appropriation of the happy singing-and-dancing montage popular in romantic comedy films. The cheerful scenes of the misbegotten threesome whitewashing the wreckage of the miserable house provokes laughter at its absurdity as well as a continuing sense of dis/ease at their inability to alleviate the horror beneath the thin veneer of white.

Most of the sexual horror connects to the figure of Dickens (Brendan Fletcher), whose name conjures up both the nineteenth-century novelist and his string of tragic children (perhaps also to the nurturing Dickon of Frances Burnett's *Secret Garden*, 1910–11), as the film hinges on a sexual scene between him and Jeliza-Rose. Gilliam knows the sight of an adult male actor performing an explicit scene with a real child would be a taboo for the audience. He mentions that he cautioned the cast and crew that they needed to be 'innocent' while shooting the film. Gilliam manipulates the emotional scales minutely. In the first scene, the playfulness of the two characters is quite captivating as Jeliza-Rose makes Dickens 'pretty' with the blonde wig and the lipstick. The camera pulls out from a close-up and back for a long shot which, co-writer Grisoni notes, increases the tension. We see how alone these two mismatched figures are, and we are reminded that Dickens may have a child's mind but an adult's body. Returning to a close-up suffused with white light, Dickens relates with pleasure the paedophilic encounters with Jeliza-Rose's grandmother and his distress at her death. In the midst of this comes their first kiss. Gilliam shifts the centre of power between the two, keeping the audience off balance. Jeliza-Rose reacts with a childish laugh while wiping away the 'silly kiss', yet returns for a second one. Gilliam allows the audience's tension to grow, fearful that things will go too far, before literally blowing them away with an explosion from the nearby strip mine. While the explosion has the effect of the monster jumping out of the shadows, the initial fright is quickly replaced by relief that the scene is over.

'It's in the world of horror films but it's never going where they go', Gilliam says in preparation for the final gruesome mixture of romance and horror. Jeliza-Rose, convinced that her growling stomach means that their kisses have made a baby, returns to Dell's house to see her 'husband'. She wears an impromptu wedding dress made from her dead mother's nightgown and ample make-up. The wailing winds, spooky

shadows, crazy camera angles and mute gazes of the stuffed creatures combine to create an atmosphere rife with dis/ease. Jeliza-Rose's discovery of Dickens in the taxidermy shed lacks the force of the sudden revelation of Dell's terrible power to keep death at bay. Instead Gilliam uses the black shadows, red light and *Psycho*-esque ambience to drench the scene with dread. We see Dickens from below, with menacing angles and shadows to suggest to the viewer that something sinister is about to occur. The caged squirrel warns Jeliza-Rose to 'get out, get out while you can', and its anxiety transfers to the audience with the *The Texas Chain Saw Massacre* setting as a background. Dickens' violent reaction to Jeliza-Rose's surprise appearance once more tilts the mood toward danger, as he reacts with a startlingly intense anger, though the reversal becomes clear quickly: he has been frightened by her.

They enter the house for the final time while watched by the camera from within, as if it mirrors another Norman Bates lying in wait for his victims. The off-kilter angles and flickering lights present a typical horror setting, enhanced by the whistling wind, dead animals and labyrinthine corridors. Dickens has promised to show Jeliza-Rose his 'secret'. While this mystery turns out to be dynamite, the audience clearly expects a sexual encounter. As Jeliza-Rose lies down on Dickens' bed, the tension grows. Gilliam makes use of the audience's horror to lead up to – and just as quickly turn away from – the feared moment of contact. While the scene ends less explicitly than the novel's version, it might shock the audience even more because the uncomfortable sexual scene has been shrouded in horror motifs. The red and blue lighting, mirroring Jeliza-Rose's lipstick and Dickens' deep sea adventures, also add weight to the scene's tension as Dickens moves above Jeliza-Rose (duplicating Dell's previous position). Gilliam takes us up to the edge of unacceptable contact and then whisks us away for a truly (recognisably) horrific sight: the real bogman, Dell and Dickens' mother, preserved by Dell's imperfect art. While her peaty and crooked appearance should be horrific, it comes as a relief: here, at last, is a real horror moment and not the feared sexual encounter.

Gilliam is not content to leave it at that, however. The whirlwind return of Dell leads to the violence long awaited, and the small room erupts in noise and fury, finally resulting in Dell crushing Glitter Girl, an act mirrored by Jeliza-Rose when she gets tossed across the room to smash her foot audibly into their mother's preserved face. The sudden onset of silence hits with a shock: at last a horrifying moment. Yet it is as likely to provoke the laughter of release as the squirm of dis/ease.

The sheer weight of horror motifs leaves the audience wanting an appropriate horror resolution, to recognise the monster. Dell identifies Jeliza-Rose as the true monster. It is she who unnerves Dickens, who injures mama, who throws away Dell's protective boyhood. On the commentary, Gilliam and Grisoni joke about Jeliza-Rose being a serial killer, noting that everyone around her seems to die, but leaving her mostly untouched by the carnage. While Cullin's final paragraph allows a kind of amnesia to begin setting in, Gilliam's film leaves both Jeliza-Rose and the audience in a more ambiguous state. The fireflies reflected in her eyes meld with the night sky in an unsettling image of eyes without a face. Has she been rescued – or will the monster claim more victims? Gilliam gives us no easy reconciliation.

We tend to want children to be helpless victims, in part because it means that we must protect them. Wrapping our lives around them is supposed to be an accomplishment in itself, and not just a sign of our selfishness in desiring dependent admirers. In the end, del Toro's suffering victim, Ofelia (Ivana Baquero), we can accept; the triumphant monster, Jeliza-Rose, however, we cannot forgive: her resilience, her fearlessness, and her sexuality give the lie to the need for parental protection. Her innocent monstrousness highlights the schism between our idealised child and our recognition of the ruthlessness that survival in this world requires.

Notes

1 'Won't somebody please think of the children!' All *Simpsons* fans will recognise the catchphrase of gossipy minister's wife Helen Lovejoy. While a humourous exaggeration, Lovejoy's panicky catchphrase has touched a nerve with those who would like to see the end of the so-called 'nanny culture', where even adults have been reduced to the status of children who must be protected. The phrase perhaps comes from dialogue in the opening of Disney's *Mary Poppins* (1964). In the film, Mrs Banks – the erstwhile suffragette and mother of the recalcitrant children – is reduced to pleading with her departing nanny with a heartfelt, 'Think of the children!' So universal has the phrase become in this fictional universe that the cry gets picked up by even the unlikeliest of characters (such as the unscrupulous and homicidally vindictive bartender Moe Szyslak in 'Natural Born Kissers', season 9, episode 25) whenever a moment of crisis appears – regardless of its relevance to that crisis. The term 'nanny culture' was first popularised in Britain to characterise government control of the media as well as a range of laws to protect people from their own stupidity (see Wells 2000) and the tendency in the United States to include small print warnings such as 'these are professional stuntmen, don't try this at home' in advertisements.
2 On the commentary track of the *Tideland* DVD, Gilliam recalls with frustration how his twelve-year-old son would not leave the house to go to the nearby shops because he perceived even their relatively affluent neighborhood to be a dangerous place. Many link this to the so-called 'CNN Effect', which posits that the 24-hour news channels play up threatening and emotionally volatile topics to increase the number of their viewers; see Robinson (2002: 25–45).
3 On the commentary track of the DVD, Gilliam and Tony Grisoni joke that they sold their tree to del Toro for his film.
4 Gilliam admits they cheated with a larger doll head for the shot.

Works Cited

Baudrillard, Jean (2002) *Screened Out*. New York: Verso.
Cullin, Mitch (2000) *Tideland*. Chester Springs, PA: Dufour Editions.

Foucault, Michel (199) *The History of Sexuality: An Introduction*. New York: Vintage Books.
Holland-Toll, Linda J. (2001) *As American as Mom, Baseball, and Apple Pie: Constructing Community in Contemporary American Horror Fiction*. Bowling Green, OH: Bowling Green State University Popular Press.
Rosenblatt, Josh (2006) '*Tideland*', *The Austin Chronicle* (October 27). Online. Available at: http://www.austinchronicle.com/gyrobase/Calendar/Film?Film=oid%3A413780 (accessed 12 October 2009).
Robinson, Piers (2002) *The CNN Effect: The Myth of News, Foreign Policy and Intervention*. London: Routledge.
Scott, A. O. (2006) '*Tideland*: A Girl Endures a No-Man's Land by Dwelling in the Make-Believe', *The New York Times* (October 13). Online. Available at: http://movies.nytimes.com/2006/10/13/movies/13tide.html (accessed 12 October 2007).
Wells, Matt (200) 'Great White Hope', *The Guardian* (November 20). Online. Available at: http://www.guardian.co.uk/media/2000/nov/20/broadcasting.mondaymediasection (accessed 29 October 2009).
Winter, Douglas E. (ed.) (1988) *Prime Evil*. New York: New American Library.

CHAPTER TEN

Divorced from Reality: Time Bandits in Search of Fulfilment

Jeff Birkenstein

> The imagination of a boy is healthy, and the mature imagination of a man is healthy; but there is a space of life between, in which the soul is in a ferment, the character undecided, the way of life uncertain, the ambition thick-sighted: thence proceeds mawkishness, and all the thousand bitters which those men I speak of must necessarily taste…
>
> <div align="right">John Keats, in his preface to Endymion (1818: 60)</div>

It was just a coincidence, but around the time of my parents' divorce, I watched Terry Gilliam's *Time Bandits* (1981) dozens of times on HBO. Enthralled at twelve or thirteen, I never sensed that critics might call it 'a lot of frippery' (Rea 2004: 51). It was about a boy I recognised, Kevin (Craig Warnock), who was about my age, with a rich, imaginative fantasy life, a world of books and head-bound adventure. I admired him immensely. And even though I had no idea then who Terry Gilliam was, I now know why Gilliam also identifies with Kevin (see McCabe 2004: 139).

Gilliam's film frames Kevin's fantasy life and his encroaching transition to adulthood amidst the architecture of inattentive middle-class parents (played by David Darker and Sheila Fearn) and suburban ennui. Kevin's rather simple search for a family interested in him also reveals acutely the fissures that real-world problems relating to questions of good and evil, parental roles, mind-dulling capitalism and (un)fulfilling employment reveal. Kevin is so immersed in his fantasy life that he is unaware – indeed, unable – to fully understand, let alone articulate, the weight of the world from which he comes and to which he is (probably) going. Part of this immaturity expresses itself in Kevin's uncritical perspective regarding his beloved heroes, many of whom he meets during the course of the film. This phenomenon is akin to what Patricia A. Matthew

and Jonathan Greenberg believe happens with Children's Literature students, many of whom have beloved and critically uncomplicated childhood memories of classic children's stories. Like Kevin, and myself before the divorce, these students 'encounter … children's texts during the very time of life when they are unconsciously absorbing ideological codes [so] their emotional investment in the ideological legitimacy of such texts is high – so high that these texts appear, ironically, to be uniquely *free* of ideology' (2009: 218). Of course, nothing is free of ideology, regardless of the level at which someone is reading (or not) a text. The question Gilliam then poses is whether Kevin's adventures will direct him down the path of lifelong inquisitiveness and childlike excitement, even as he matures and begins to see cracks in the system, or whether he is doomed to suffer the same fate as his trapped parents.

Despite the omnipresent child-like gaze through which much of the film can, on one level, be viewed, Gilliam – an adult ever suspicious of the world adults have created – seems most interested in the light this gaze casts on the myriad adults around Kevin. Similar to Karen Lury, who watches children in film in order to ascertain 'the way in which [they] manage not *their* apparent strangeness, but how they can reveal the strangeness of the world in which they live' (2010: 14), I am interested in the warped social milieu which adults have created for Kevin. Likewise, Gilliam uses Kevin's initially uncritical and innocent eye to revisit fairy tales and ancient heroes, because the modern adult world no longer allows (and/or encourages) substantive heroes or meaningful dreaming. In turn, these fairy tales come to life and do what fairy tales are supposed to do: they allow the child 'to learn language and master the linguistic conventions that allow adults to do things with words, to produce effects that are achieved by saying something … Fairy tales help children move from that disempowered state to a condition that may not be emancipation but that marks the beginning of some form of agency' (Tatar 2010: 6). *Time Bandits*, then, is about this process of maturation through stories. But what happens when the adults Kevin has in his life do not say anything of substance? For what purpose is Kevin maturing? Will he be able to choose a different path? What stories from his own life will he learn to emulate? Will he become his parents?

Ian Christie, citing Tzvetan Todorov, argues that Gilliam's narratives operate in the realm of fantasy, of hyper-reality, where the rational still applies, but the irrational seems, at times, even more persuasive: 'Gilliam's heroes … innocents all … are engaged in quests, which lead them into perilous worlds of illusion, poetry and nonsense … latter-day descendents of the heroes of the Grail legend' (2000: viii).[1] Within the context of the film, another word for this fantasy world might be 'suburbia'. It is precisely these early framing scenes of exaggerated reality (in Kevin's house) that situate *Time Bandits* as, at its heart, a wholly 'suburban' film. Gilliam announces as much in the opening frames when the camera focuses on a celestial map of some kind (which we will later see is key to the plot) before zooming through it, plunging through outer space and down to earth through the clouds, and then landing on a suburban housing tract (the film ends in almost the opposite manner – the camera withdrawing from earth much the same way it arrived – with the addition of disembodied hands folding up the map).

Gilliam critiques suburbia at the expense of, to use Keats' term above, immature adults who, alienated from their own existence, are unable to imagine a life of substance, so incapable of living their own lives apart from coveting the material goods held aloft by distant marketing gods. But Gilliam offers hope for the next generation. It is only through Kevin's eyes, even if he himself is not fully aware of what he is seeing, that this film offers any hope. Peter Marks argues that children, for Gilliam, work 'as protagonists or as critical observers of the actions and failings of adults ... [and, thus] Kevin's youthfulness [is] social satire' (2010: 66, 68). Gilliam chronicles the experiences of little people (both Kevin, still a child, and his band of time travellers, who are not taken seriously by almost anyone, including their Godhead employer) who still dare to dream, and argues that all anyone wants is to have both something meaningful to do and a supportive family. Gilliam savages the latter twentieth-century's fetishised adult and parental construct of the world, the Disneyfied, consumerist version of reality.

Time Bandits explores this disconnect between parent and child. Here it is not the child demanding the latest consumerist fad; rather, the child yearns for an idealised, idolised and mythologised past of love, adventure, community and, ultimately, of family. Put simply, Kevin still dreams of a life of endless possibility, unconstrained by his suburban walls, because he has not yet learned to view them as either barriers or a false security. His parents, meanwhile, repeat only what they are told they want by the 'idiot box' in their 'living' room, having turned their dreams over to the higher wisdom of game shows and commercials. It is the parents who seem to equate parental duty and love with providing the latest in material excess for their home. Kevin, however, wants only a family to be interested in his interests and is thus forced to light out for his own territory of dreams.

In so doing, Kevin follows a long line of (stereotypically) boyish, imaginative adventures. Like Huck Finn before him, youth is not only not a hindrance but a boon, because of the open-mindedness and adaptability that comes with a still undeveloped sense of cynicism. As in all quests, Kevin doesn't remain on his own for long, but is joined by a loveable, rather disgusting cast of diminutive adults, his merry band of little men. Kevin joins, as Gilliam calls them, a community of 'dwarfs' (Thompson 2004: 5), who at first seem to be on the same quest as his parents: to accumulate things.[2] Joseph Campbell tell us that Kevin's adventure begins in timeless fashion, for all it takes for a hero is, usually, '[a] blunder – apparently the merest chance – [which] reveals an unsuspecting world, and the individual is drawn into a relationship with forces that are not rightly understood' (1973: 51). I saw in Kevin's journey, and his contention with large and powerful forces beyond his control, my own experience. Here was a young person who lived largely on his own, which, though for different reasons, is what divorce did to me. Kevin is unaware of his coming fall into adulthood and does not realise the fears ahead of him, even as Gilliam's narrative subtly highlights them for an adult audience.

Because most film critics see *Time Bandits* as a children's film, analysis of its cogent critique of suburbia has been lacking. Though neither the US nor the international trailer make the claim, critics mutually agreed that *Time Bandits* is a family film, often

because they do not know how else to classify it. Vincent Canby writes that the film 'means to appeal as much to very young moviegoers as to their parents, and that's a problem. These dual objectives result in a film that lands somewhere in between' (1981). Stanley Kauffmann admits that, initially, he 'didn't know *Time Bandits* was a children's picture' (1981: 25). Roger Ebert muses, 'perhaps *Time Bandits* does work best as just simply a movie for kids … I'm not sure that's what Gilliam had in mind' (1981). But if it is primarily a children's film, critics note there are some problems; that is, what might be non-threatening to a child in a Disney-type movie is shot in Gilliam's realistic, if exaggerated, manner and perhaps not really aimed at children. For instance, David Sterritt notes some 'gross' moments, like 'a hungry hero gnawing on a rat' (2004: 17). Additionally, the film contains such non-kid-friendly elements as Napoleon's firing squads, Evil Genius's (David Warner) exploding minions, an arm ripped off in an arm-wrestling contest, the trademark Gilliam rabble that is dirty, ignorant and helpless, as well as a general atmosphere that is so dark it's a wonder anyone could think it was a kid's movie. Perhaps thanks to these and other reviews, *Time Bandits* became 'a surprise hit in US theaters, suddenly making [Gilliam] a bankable director' (Lyman 2004: 27); that is, parents went with their children to see the film. And even Gilliam admits to wanting to 'do a kid's film, and all these things came out … I wanted to work at a kid's level through the whole thing, and the kid would be the main character' (Thompson 2004: 5). But shooting at a kid's level is not the same as making a kid's film.

Kevin is the heart of the film, but he is, in his just-prepubescent state, unable to appreciate that which a discerning audience can: namely, that the adult world ahead, comprised of unappreciated work and imaginations controlled by television, is an existence he has little hope of escaping. But, there is hope. The quest at the centre of *Time Bandits* is simple enough. Kevin, a boy who lives in his own head and among the legends and heroes about which he reads endlessly, goes on a journey. Not knowing if he is dreaming or awake (there are clues suggesting both possibilities at once, a common plot device in films as diverse as *The Wizard of Oz* (1939) and *Hot Tub Time Machine* (2010)), he gets sucked up into his own myth-making. One night, there appears in his bedroom a group of small men who have emerged from a time travelling door conveniently located in his wardrobe. Kevin follows them and, after a series of adventures through and beyond time, confronts, finally, the embodiments of both good and evil during a bizarre, quasi-humorous, cataclysmic battle.

Gilliam explains his film: 'Fantasy/Reality. Lies and truth is an extension of that, and it's about age and youth. Also death, birth, all those things … a boy going through space and time and history, and never knowing whether it was real or a dream' (Morgan 2004: 41). *Time Bandits* is something of an anti-fairy tale, one that deconstructs the fairy tale promise of latter-twentieth-century middle-class suburban existence. 'Certain fairy tales', Jack Zipes explains, 'have become almost second nature to us and not simply because they have become part of an approved hegemonic canon that reinforces specific preferred values and comportment in a patriarchal culture – something that they indeed do – but rather because they reveal important factors about our mind, memes, and human behavior' (2008: 110). Just as my own parents' divorce caused

If not quality, Kevin and his parents do spend time together

me to challenge the stereotypical myths of suburbia as providing default answers to elusive questions, *Time Bandits* critiques multiple common mythologies. And though Kevin may never quite understand the border between fantasy and reality, the film leaves no doubt that Kevin cannot escape the everyday-world of harsh reality.

When we first meet Kevin, we see him sitting at the kitchen bar counter, back to the camera. He is poring over an at-first unidentified book while his parents watch television. This scene – short but important – is a reverse angle from the perspective of the television, which commands a complete view of the family tableau before it. Though not a pretty picture, this is appropriate, as the television directs the family's (in-)action. The father is dressed in a blue tracksuit of some kind (ostensibly suggesting he has exercised after work, but more probably just being what he wears during leisure time) while the mother is in pink loungewear. Seemingly middle-class, work now done, they relax, uncritically enjoying the pitfalls of their station: ennui disguised as choice, inadequate purchasing power disguised as potential upward mobility, and co-habitation disguised as family bonding.

Like medieval barons seated on their thrones – a couch and recliner, they sit in their gendered-appropriate places, á la *All in the Family* (1968–79) – they are lord and lady of their manor. And yet their apparent peace cannot last, for, as Daniel Thomas Cook argues, 'conceptually, leisure and consumption appear to be at odds with one another [because] leisure, often conceptualized by theorists and practitioners as an escape from the vicissitudes of productive life, can itself hardly escape the pull of capital' (2007: 304). This clash of titanic ideas is certainly present here, for the relaxing parents discuss only topics related to material possessions and their sense of inadequacy before this altar. With mail-order catalogues, petty conversation about the neighbours, television and substantive parental duties ignored, they are multi-tasking two decades before the phrase came into vogue.

This scene contains three conversations, a classic suburban palimpsest: Kevin speaking excitedly to his unheeding parents about the ancient world, mother with father and television with parents. Gilliam, with his American roots, well knows the original promotion of the television as being central to the middle-class home. Many early shows representing suburbia on television, especially in 1950s/60s America, 'created an imaginative vision of a landscape devoid of social competition and striving, a place altogether free from any outside connection to the social and economic concerns of the world "outside"' (Beuka 2004: 72). And while such programming – the safe and the

scripted – may gloss over substantive investigation into real world concerns in favour of a world where father knows best (and, what's more, can prove it in 23 minutes!), commercials have long represented the crack in the façade. Relentlessly pushing material inadequacy in the service of capitalism, commercials corral viewers, even getting louder so they can still be heard during a trip to the kitchen or toilet. In the world of Kevin's parents, the programmes themselves are extended commercials, exploiting insecurities and promising false hope. In the show the parents are watching – a game show called 'Your Money or Your Life' – the non-winning 'winning' options indicate the invisible barrier confronting the middle-class: there is no winning.

Kevin glances up periodically to throw out facts about the ancient Greeks and their fighting ways. 'Dad', Kevin asks of the air and, sadly, probably not really of his father, 'did you know that ancient Greek warriors had to learn 44 ways of unarmed combat? Did you know the ancient Greeks could kill people 26 different ways! … And this king, Agamemnon, he once fought…' Kevin isn't so much competing with the television as ignoring it. For how could Kevin compete with the allure of a new kitchen? Though the house's kitchen is, the screenplay tells us, a 'modern, fully gadgeted kitchen', it cannot compare with the space-age graphics of the kitchen on the television. The mother engages the television's omniscient voice that, like a vampire and with more or less the same intentions, she has unwisely invited into her home, as seen in the screenplay:

> *Voiceover on TV*: Yes, folks … Moderna Designs present the latest in kitchen luxury. The Moderna Wonder Major All Automatic Convenience Center-ette. Gives you all the time in the world to do the things you really want to do! … A washing machine that cleans, dries and tells you the time in three major international cities! A toaster with a range of fifty yards! And an infrared freezer/oven complex that can make you a meal from packet to plate in 15½ seconds.

Attempting to mask her insecurity, the mother shrugs her shoulders at this positively amazing information. While it is obvious they do not have such a kitchen – a Center-ette, no less – the mother tries to re-exert her superiority over the inferiority-inducing television kitchen by, oddly, claiming that the *neighbours* have an even *better* kitchen: 'The Morrisons have got one that can do that in 8 seconds … Block of ice to Boeuf Bourguignon in 8 seconds … [with feeling] lucky things.' In her Jungian study of food, Eve Jackson argues that hunting and gathering are part of what make us human; according to the Greeks, the sacrifice of another being (meat eating) defined 'the conscious as opposed to the instinctual' (1996: 46–57, 61). But what of a society where hunting and gathering means going to the grocery store and where kitchens prepare our food without us? Are we still fully human? The answer purports to be yes, but only if we can combat this challenge to our humanity in other ways, as the father meekly tries to do: 'Well, at least we've got a two-speed hedge cutter.' If there is hope for Kevin, it doesn't appear to be on this path.

The suburban frame of the film set, Kevin's adventure begins in his bedroom, that sphere of false respite from parents' control. This scene is, suggests Owen Gleiberman,

classic Gilliam: 'I think of the archetypal Terry Gilliam image – it's there in both *Brazil* and *Time Bandits* – as a peaceful, tranquil setting suddenly disrupted by a force of great violence' (2004: 34). This great violence is a medieval knight, in full battle regalia, emerging from Kevin's wardrobe before galloping off into the forest. Kevin pulls the blankets over his head and his room returns, the knight gone even as the night endures. Investigating, he finds a picture of the same knight in the same forest on his wall. But just as he is about to write it off as a dream, his father bursts in and demands to know what all the noise is about. So, the next night, after Kevin has waited for his microwaved food and blended pink drink to 'go down' (a prerequisite, his parents argue, of being able to go to bed), he is ready with flashlight and Polaroid camera. But nothing happens; he falls asleep.

When the wardrobe again opens on the second night, it is not a knight, but a band of small, strange men. Kevin shines his torch on them and they panic, scattering like cockroaches. Kevin does not know it yet, but this group will become like a family to him. Suddenly, a giant glowing head appears and chases the dwarfs and Kevin down a corridor that appears out of nowhere. This giant head belongs to Supreme Being (Ralph Richardson), who intones deeply (godhead voiced by Tony Jay): 'Return what you have stolen from me. Return the map. It will bring you great dangers. Stop now.' At this point in his young life, Kevin understands little of his parents' everyday experience. That is, suburbia is designed to reduce anxiety, danger and the need to depend on a map for life's direction. But the result of this Frankensteinian way of living – which was thought by some to be the culmination of all the best parts of a community – has often been the opposite of that which was intended. In post-World War II suburbia the formerly external, large-scale fears of invasion and the need to defend one's family against all enemies foreign and domestic are meant to be, but never can be, confined behind closed doors. If our homes are our castles, then the often isolating effects of suburbia mask the dangers which, as Supreme Being accidentally suggests, have always come with risk and a purpose to life. A map represents life outside one's front door, and there is no doubt such a pursuit brings with it great dangers. Kevin's parents retreat each night to their castle, keen in their desire to avoid the dangers that Supreme Being lays out, thinking that they have vanquished such threats from without. Still innocent, however, Kevin is not ready to acquiescence.

The conflicts detailed above are seen in every one of Kevin's escapades, beginning in 1796, at the Battle of Castiglione in northern Italy, a 'reality' which Kevin embraces immediately. Finally away from his stultifying suburban life, he is ecstatic to see history come alive in such a way. True to his child-like nature, he takes no empathetic notice of the death and suffering around him. Sneaking into the embattled city, Kevin and the Time Bandits meet Napoleon (Ian Holm), who watches puppets beat each other on stage with much amusement. This whole episode is predicated on Napoleon's size and how his perceived inadequacy is the cause of him trying to do his best at his chosen line of employment, that is, as conqueror of Europe: 'Five foot one and conqueror of Italy,' he says; 'Not bad, huh?'[3] Despite causing fear and death throughout the continent, or perhaps because of this, Gilliam suggests that Napoleon's conquests are merely to prove his mettle as a (still small) man. Kevin, however, sees only the 'great' Napoleon.

Planning theft, the Time Bandits perform an impromptu, ridiculous act for the emperor, which degenerates into them hitting and slapping each other. Terrified that he has failed in his job to amuse the Little Corporal, the theatre owner (Charles McKeown) looks to commit suicide, but Napoleon is thrilled to find people even smaller than himself and intervenes. He tells Kevin: 'Young man, you stick with these boys, you have a great future.' Napoleon then dismisses his generals, appoints his new little friends to his staff, and, at dinner, gets drunker and drunker, while contemplating famous short people of history. Meanwhile, Randall (David Rappaport) and the others, looking ridiculous in their too-big uniforms with their too-big hats, at a too-big table with piles of looted gold and treasure, look nervously on, checking their pocket watches, like a certain famous White Rabbit. Everyone in this scene is just a worker (or sees himself as such) wanting to be appreciated, from the theatre owner to the generals, to Napoleon, to the Time Bandits ('We're international criminals. We do robberies!' says Fidgit [Kenny Baker] proudly), and all are loaded with grievances. Though perhaps less spectacular in the suburbs, this sense of needing respect and appreciation for one's daily output, and often not getting it, is a common source of family breakdown, one that perfect lawns and wide streets cannot assuage.

Next stop: Sherwood Forest. Again, Kevin meets a hero and is bewitched by him, though Gilliam paints Robin Hood (John Cleese) as not the beloved quasi-historical figure in which we so desperately want to believe (and the fact that Hollywood continues to return to this myth shows its endurance), but as a benevolent dictator, something of a forest dandy. Cleese's Robin Hood is just trying to be successful at his day job of thievery, and in his desire to get ahead observes no honour among his colleagues. He marvels at the Time Bandits' haul. 'It was a good day, Mr Hood', Randall replies, as if discussing cleaning out the inbox on his desk with his boss. Only when Robin Hood thanks them for the contribution to the poor does Randall understand that there is no getting ahead in this world, no rising above one's station. In fact, even the poor must suffer in return for the Time Bandits' unwitting beneficence. Gilliam's trademark rabble stand in line for a handout, where each recipient is promptly hit in the face – men and women alike – by one of Hood's men. Is this necessary, Robin Hood wonders? Yes, he is assured by his henchmen, it is. There is no free lunch. Hood's parting gesture is to ask the Time Bandits to stay: 'There's still so much wealth to redistribute.' Kevin, however, sees only a potential family unit, and would like to stay, but he's pulled away mid-sentence by Randall and the boys.

Kevin then meets Agamemnon (Sean Connery), who credits the boy, an apparent gift from the gods, with helping to slay the Minotaur. The king takes Kevin home, but something is not right in the Agamemnon household. His wife (Juliette James) is unhappy that he returns alive from his travelling for work, it being his responsibility as king to kill the threat from the Minotaur (and, if this is the same Agamemnon from *The Odyssey*, we know he will later be murdered by his wife and/or her lover). 'The enemy of the people is dead!' bellows Agamemnon, as he beckons Kevin to his side. Back in the office, Agamemnon blithely condemns three nobles to death and tells his courtiers to 'remind the queen that I still rule the city'. Kevin catches none of this, as he occupies himself sketching out great battle scenes, thinking perhaps that

this latest potential father is merely busy at work. Though Kevin wants Agamemnon to teach him swordfighting and killing, the king wants to teach him tricks and to use his wits. For the king also wants to be a father, and he has now found a willing son. Kevin says, 'You know, I never, ever want to go back.' Young Kevin sees his emasculated suburban father and pines instead for children's fairy tales where killing others is exciting and romantic. Gilliam the director knows the fantasies of young people even as his Agamemnon knows the weight of everyday headaches, king or not.

Having been spirited away from ancient Greece by his fellow Time Bandits at the moment he was to become Agamemnon's son and heir, Kevin and company next escape into and out of the dinner pot of a hard-working ogre with back problems. They then wander a desert before running into, like so many people trying to get ahead, an invisible wall, which is broken by the bones – literally – of those who have come before. It is shattered by a skull Randall throws in a fight in order to retain leadership of a group that has agreed to be leaderless. Fairy tales, Maria Tatar argues, can be transformative for their readers and, further, 'function as shape-shifters, morphing into new versions of themselves as they are retold and as they migrate into other media' (2010: 56). This lesson of hope and struggling ever onward despite the odds, however, is not a lesson that Kevin learns at home. Instead, he learns it from his new companions who, unlike his parents, have not given up on whatever fairy tale dreams they had as children.

Stepping through the formerly invisible barrier, the Time Bandits arrive at their goal: the fortress of Evil Genius, a boss who, true to his moniker, is merciless to his idiotic sycophants. He believes he needs only the stolen map in order to set himself up as the rightful ruler of the universe. And why does he qualify for this job advancement? Because, he says, he has 'understanding'. Of what, a minion asks? 'Digital watches', he begins:

> And soon I shall have understanding of videocassette recorders and car telephones. When I have understanding of them, I shall have understanding of computers. When I have understanding of computers *I* shall be the Supreme Being. God isn't interested in technology. He knows nothing of the potential of the microchip. Silicon revolution. Look how he spends his time: forty-three species of parrots; nipples for men.

This is an argument Kevin's parents know well; essentially, it is the same argument used for the modern kitchens they see on their television. Evil Genius knows what humans want and knows what they will sacrifice (peace, family, self-dominion and so on) to get it. In fact, he has tricked the Time Bandits into coming to his lair by putting words in the mouth of the dumbest bandit: the 'greatest thing man could want: the goal of everybody's hopes and dreams … the most fabulous object in the world'. In a significant line that shows Kevin moving toward both maturity and understanding by challenging the model his parents have bequeathed to him, he asks, sceptically, about this modern-day Grail: 'do you always have to go after money?'

Ignoring Kevin, they run pell mell through a labyrinth and toward an apparent gameshow, a trick by Evil Genius. Studio lights flash, the darkness is illuminated; cheesy game-show music plays; the promises of a beautiful, gleaming Moderna

Designs kitchen looms ahead. A sleazy, well-dressed game show host descends the stairs, intoning 'And here they are, the winners of the most Fabulous Object in the World'. Kevin warns them not to go; he knows through much personal experience that such an Object is but an illusion. Even when Evil Genius produces likenesses of Kevin's parents, dressed in showbusiness glitter, he is not convinced: 'It's a trap!' he yells. And it is, for the game show host is Evil Genius and Kevin's parents his minions, now dressed in the same plastic as his living-room furniture, indicating that they have given up all subjectivity for the love of the commercial object.

For the final confrontation, Evil Genius steals the map from Kevin in order to 'remake man in our own image'. His use of the possessive pronoun is interesting here, as he appears to be referring to himself and his minions. Consequently, he means that he wants man (and woman) to be but a sycophant, ready to do his bidding and not the apparently free-thinking individuals who have long frustrated and elated philosophers and mass manufacturers of all stripes. The film posits, then, that he will not have much work to do with the adults in the world, for he knows how to lure them: shiny objects of technology (and this was before the internet; he didn't know how right he was). But Kevin, still a child, presents the real problem; Evil Genius knows he 'is stronger than the rest ... a very troublesome little fellow'. Only children (Kevin) and their toys appear to have a chance to defeat Evil Genius. On a Sherman tank, Randall rides to the rescue; other Time Bandits bring to the fight (through time portals) knights, ancient Greek archers, Old West cowboys with six-shooters, and even a small spaceship. But these are no longer children's toys but real weapons of war and violence, and thus doomed to failure. Gilliam explains this scene as being shot from a kid's approach to evil: 'There was a kid, he's got to go to battle with evil with all these toys you have, your cowboys, your Indians, your knights, that's what it's all about. I wanted the messiness of a kid's playroom' (Klawans 2004: 152). However, Evil Genius defeats them all, killing Fidgit in the melee. All seems lost.

Gilliam knows how to fill a scene with well-placed, meaningful items which, taken in sum, further his arguments. For example, we see the moment just after Evil Genius turns into coal-like stone and explodes in a cloud of flame and smoke. In walks Supreme Being, dapper in a grey suit, a proper elderly British gentleman. A father. Or, a boss. Supreme Being, despite creating the world, abhors a mess and he demands that every piece of Evil Genius be cleaned up (his coal-hand outstretched in the lower right of the frame, in one more attempt to beckon the Time Bandits toward evil). Supreme

Time to clean up the playroom

Being also hates time wasted, so he re-animates Fidgit, if only because being dead is 'no excuse for laying off work'. The independent contracting jig (theft across time) now up, Randall returns to his supplicating, worker-bee ways. These are unfortunate lessons that Kevin has been taught in his own suburban home, and if he has any chance, he must reject them. But Supreme Being, Randall's boss, is not having any of it: 'Of course you didn't mean to steal [the map]. I gave it to you, you silly man ... Do you really think I didn't know? I had to have some way of testing my handiwork. I think it turned out rather well, don't you? [Randall looks at him incredulously.] Evil, turned out rather well.' Order. The system. All is restored and work can resume, which is what Supreme Being desires as proof that he is in charge. Kevin then comes face to face with the ultimate hero: the deity. And, Gilliam suggests, Kevin finds him lacking, for Supreme Being employs dubious explanations and deceitful practices similar in nature to his suburban parents, all in the name of expressions of power and desire for order.

Like many employers, Supreme Being is unconcerned when his logic falls apart. Despite claiming to have intentionally set the Time Bandits' actions in motion, he then demotes the Time Bandits, before taking credit for being a benevolent employer:

> Ah, you certainly were appallingly bad robbers. I should do something very extrovert and vengeful with you. Honestly, I'm too tired. I think I'll just transfer you to the undergrowth department, bracken, small shrubs, that sort of thing. With a 19 per cent cut in salary, backdated to the beginning of time. [Randall and others bow and thank Supreme Being.] Well, I am the nice one ... Come on then, back to Creation. They'll think I've lost control again and put it all down to Evolution.

But if the Time Bandits are chastened and accept the order of the powerful and the powerless, Kevin does not know enough to withhold his questions, so he challenges Supreme Being about the nature and importance of Evil in the world:

> *Kevin*: You mean you let all those people die just to test your creation?
> *Supreme Being*: Yes. You really are a clever boy.
> *Kevin*: Why did they have to die?
> *Supreme Being*: You may as well say why do we have to have Evil?
> *Randall*: [Stepping in front of Kevin] Oh, we wouldn't dream of asking a question like that, sir.
> *Kevin*: Yes, why do we have to have Evil?
> *Supreme Being*: Ah... [Walks away behind a column before suddenly returning] I think it's something to do with Free Will.

Supreme Being is not used to being questioned in such a manner and, although he seems to agree with his own answer, it also appears after all these millions of years of creation, he just threw out a term humans have been using against themselves for a long time. But why eschew free will, as Kevin's parents have? The joke, it seems, is on those of us who would go along with the very mythologies we have created to explain our modern world, with its curious mix of business and torpor. Perhaps, the film

argues, adults are not so different from how, according to Matthew and Greenberg (2009), children also accept uncritically their own childhood stories.

The fortress of Evil Genius now tidied up, only one of the Time Bandits shows any concern for Kevin (and it is not Randall), but is told by Supreme Being that, no, Kevin cannot come along and join their 'family'. In a cloud of smoke, they are gone; in this same smoke we return to Kevin's bedroom where he is being rescued by firemen. 'Someone' left something burning in the toaster and it has now burned down the house, which might signal a warning to the parents: next time, purchase the deluxe new kitchen or suffer the consequences. While Kevin is being hustled out by a fireman, his parents, already safe, are worrying about the kitchen equipment. The mother wants to go back in to save the appliances: 'Let go. I've got to save it … I'm going in for the toaster! … Honestly, Trevor, if you'd been half a man you'd'a gone in there after the blender.' Contrary to how it was sold to him, suburban consumerism has destroyed the father's last vestiges of masculinity.

And then the final twist, which David Sterritt claims 'is downright bizarre for a children's film – an unexpected and unsettling twist that may disconcert young moviegoers' (2004: 17). Several things happen at once: one of the firemen is Agamemnon/Sean Connery; Kevin looks through his Polaroids confirming that his dream was a reality (or, is his reality a dream?); and, he sees an overlooked chunk of Evil Genius – which caused the fire – in the just-recovered toaster. Kevin warns his parents: 'Mom. Dad. It's evil. Don't touch it!' Naturally, they do not listen to their child and immediately both put a hand on the 'concentrated evil', their last act of marital solidarity. They promptly explode, Kevin and neighbours in bathrobes looking on, the fire crew driving away. Gilliam says that '*Munchausen* had a happy ending, so did *Time Bandits*. *Brazil* has an ending that was right for that piece' (Wardle 2004: 91).[4] Yet this 'happy ending' leaves Kevin alone in the world, suddenly orphaned. Gilliam expands:

> I think it's a reaction against American films where the learning experience is easy and things work out well … The line that I've always liked is when Fidget says, 'Can he come with us?' and the Supreme Being goes, 'No, he's got to stay here and carry on the fight.' Now that's an incredible thing to say in a kids' movie like that, that it is a battle, that it is a fight, and it doesn't mean that good wins and bad loses. (McCabe 1999: 98–9)

Kevin's father is of no help and his alternate father figure, Agamemnon, is now reduced to a kindly fireman, one who probably winks at all the children of burned down houses and who does not even know he is supposed to be a father figure. Kevin now realises consciously for the first time that he is largely on his own (whether or not his parents are actually dead), and, though tragic, this awareness will hopefully aid him going forward. Perhaps the ending, then, is not so much happy as hopeful, as Kevin has moved to maturity and demonstrated that he will not passively accept the suburban inertia, which for so long has been his only model.

* * *

Randall Jarrell writes that 'a story may present fantasy as fact, as the sin or hubris that the fact of things punishes, or as a reality superior to fact' (1994: 6). Looking back, I see that before my parents' divorce I viewed the world in much the same way that Kevin does up until the film's conclusion. Blending history with the present, confusing mythology and fairy tales with facts, Kevin and I were, as children, unconcerned with adulthood and unable to critique our own fantasies outside of our small worlds. And even though Kevin is presented with the idea, again and again, that his heroes are not all that heroic after all, he is not able to *see* this at first. The reality that Kevin learns when he watches his parents explode is similar to what I learned all those years ago through the divorce. And yet while Kevin's parents may be far from perfect, the prospect stretches before him that neither are the 'real' heroes he met along his journey and, for now, his solipsistic, materialistic, overwhelmed and alienated parents (or, the memory of them at least) are all he has.[5] Kevin and I learned together what young store clerk Sammy learned, through a sudden life-changing decision, in John Updike's short story, 'A&P': 'and my stomach kind of fell as I felt how hard the world was going to be to me hereafter' (2004: 601).

Notes

1. For more on Todorov and Gilliam, see Marks (2010: 54, 72–4). Regarding Gilliam and the Quest for the Holy Grail, see Tony Hood's chapter in this volume.
2. Gilliam argues, 'But a kid isn't going to sustain a film, so he's surrounded with a gang of interesting characters, but they've got to be the same height as the kid, so we're talking about dwarfs, folks' (Thompson 2004: 5). This immediately recalls other famous dwarfs in movie history, including Disney's *Snow White and the Seven Dwarfs* (1937), who are diamond miners. A key difference is that the Time Bandits want to steal wealth, not work for it, as millennia of unsatisfying work for Supreme Being is what prompts them to try larceny. Further, Gilliam's dwarfs are not as sweet and cuddly as the munchkins Dorothy meets in *The Wizard of Oz* (1939); and, though devious, the Time Bandits do not willingly work for 'the Man' as do the Oompa Loompas in *Willy Wonka & The Chocolate Factory* (1971) and *Charlie and the Chocolate Factory* (2005). Nevertheless, there exists a little bit of all these characters in the Time Bandits.
3. Of course, theatre within theatre within theatre is a common theme for Gilliam the Python. Interestingly, Gilliam claims not to have realised that he has similar theatre scenes set in besieged cities in both *Time Bandits* and *The Adventures of Baron Munchausen* (1988) until a reporter pointed it out to him. Then, considering this semi-coincidence, he says: 'I think it's me, just making a statement about what is important in life. It's about how the theatre and entertainment and art, no matter how dire the world is, has to be kept alive' (Klawans 2004: 158).
4. Here Gilliam refers not to the studio-generated 'Love Conquers All' version of *Brazil*, but his own preferred ending. This classic Hollywood battle is discussed in greater depth elsewhere in this volume.

5 I shared this with Kevin, I believe, even though my own parents were quite different from his, perhaps only qualifying on this list of issues as being, at times, overwhelmed. For their lifelong love and support, this chapter is dedicated to them.

Works Cited

Beuka, Robert (2004) *SuburbiaNation: Reading Suburban Landscape in Twentieth-Century American Fiction and Film*. New York: Palgrave Macmillan.
Campbell, Joseph (1973) *The Hero with a Thousand Faces*. Princeton, NJ: Princeton University Press.
Canby, Vincent (1981) 'Time Bandits', A Lark Through the Ages', *The New York Times*, 6 November. Online. Available at: <http://movies.nytimes.com/movie/review?res=9800E1DA113BF935A35752C1A967948260&partner=Rotten%20Tomatoes> (accessed 19 March 2010).
Christie, Ian (2000) 'Preface', in Ian Christie and Terry Gilliam, *Gilliam on Gilliam*. London: Faber.
Cook, Daniel Thomas (2007) 'Leisure and Consumption', in Chris Rojek, Susan M. Shaw, and A. J. Veal (eds) *A Handbook of Leisure Studies*. New York: Palgrave Macmillan.
Ebert, Roger (1981) '*Time Bandits*', *Chicago Sun-Times*, 1 January. Online. Available at: <http://rogerebert.suntimes.com/apps/pbcs.dll/article?AID=/19810101/REVIEWS/101010374/1023> (accessed 1 June 2011).
Gleiberman, Owen (2004) 'The Life of Terry', in David Sterritt and Lucille Rhodes (eds) *Terry Gilliam: Interviews*. Jackson, MS: University Press of Mississippi, 30–5.
Jackson, Eve (1996) *Food and Transformation: Imagery and Symbolism of Eating*. Toronto: Inner City Books.
Jarrell, Randall (1994) 'Stories', in Charles E. May (ed.) *The New Short Stories Theories*. Athens, OH: Ohio University Press.
Kauffman, Stanley (1981) 'Stanley Kauffmann on Films', *The New Republic*, 11 November, 25.
Keats, John (2009 [1818]), Elizabeth Cook (ed.) *John Keats: The Major Works: Including Endymion, the Odes and Selected Letters*. Oxford: Oxford University Press.
Klawans, Stuart (2004) 'A Dialogue with Terry Gilliam', in David Sterritt and Lucille Rhodes (eds) *Terry Gilliam: Interviews*. Jackson, MS: University Press of Mississippi, 141–69.
Lury, Karen (2010) *The Child in Film: Tears, Fears and Fairytales*. New Brunswick, NJ: Rutgers University Press.
Lyman, Rick (2004) 'A Zany Guy Has a Serious Rave Movie,' in David Sterritt and Lucille Rhodes (eds) *Terry Gilliam: Interviews*. Jackson, MS: University Press of Mississippi, 26–9.
Marks, Peter (2010) *Terry Gilliam*. Manchester: Manchester University Press.

Matthew, Patricia A. and Jonathan Greenberg (2009) 'The Ideology of the Mermaid: Children's Literature in the Intro to Theory Course', *Pedagogy: Critical Approaches to Teaching Literature, Language, Composition, and Culture*, 9, 2, 217–33.

McCabe, Bob (1999) *Dark Knights and Holy Fools: The Art and Films of Terry Gilliam*. New York: Universe.

____ (2004) 'Chemical Warfare', in David Sterritt and Lucille Rhodes (eds) *Terry Gilliam: Interviews*. Jackson, MS: University Press of Mississippi, 135–40.

Morgan, David (2004) 'The Mad Adventures of Terry Gilliam', in David Sterritt and Lucille Rhodes (eds) *Terry Gilliam: Interviews*. Jackson, MS: University Press of Mississippi, 36–46.

Rea, Steven (2004) 'Birth of *Baron* Was Tough on Gilliam', in David Sterritt and Lucille Rhodes (eds) *Terry Gilliam: Interviews*. Jackson, MS: University Press of Mississippi, 47–51.

Sterritt, David (2004) 'Laughs and Deep Themes', in David Sterritt and Lucille Rhodes (eds) *Terry Gilliam: Interviews*. Jackson, MS: University Press of Mississippi, 16–29.

Tatar, Maria (2010) 'Why Fairy Tales Matter: The Performative and the Transformative', *Western Folklore*, 69, 1, 55–64.

Thompson, Anne (2004) 'Bandit', in David Sterritt and Lucille Rhodes (eds) *Terry Gilliam: Interviews*. Jackson, MS: University Press of Mississippi, 3–15.

Updike, John (2004) *The Early Stories: 1953–1975*. New York: Ballantine Books.

Wardle, Paul (2004) 'Terry Gilliam', in David Sterritt and Lucille Rhodes (eds) *Terry Gilliam: Interviews*. Jackson, MS: University Press of Mississippi 65–106.

Zipes, Jack (2008) 'What Makes a Repulsive Frog So Appealing: Memetics and Fairy Tales', *Journal of Folklore Research*, 45, 2, 109–43.

CHAPTER ELEVEN

Celebrity Trauma: The Death of Heath Ledger and The Imaginarium of Doctor Parnassus

Karen Randell

'I'd cut carrots and serve the catering on a Gilliam film ... I really love the guy.'
Heath Ledger (DVD commentary 2010)

'It was awful shooting after Heath died ... It was madness ... Each day, it was really hard to keep going. It was: What are we doing? At times it felt like we were just going through the motions, because we just had to keep moving forward, looking to see where it went, hoping it would shape itself.'
Terry Gilliam (Biskard 2009: 135)

Our first view of Heath Ledger in *The Imaginarium of Doctor Parnassus* (2009) is a shocking sight, as his character, Tony Liar, wearing a brilliant white suit and lit with an angelic glow in the midnight gloom of a stormy London sky, hangs from the rafters of Blackfriars Bridge with a rope around his neck. This image is one of daring distaste – the now-dead star plays the potentially dead Tony Liar. As Peter Biskard comments, 'in the light of his [Ledger's] subsequent death, it takes your breath away' (2009: 86).[1] With his head tipped back and his mouth hanging open, this uncanny figure places the audience in the uncomfortable position of being able to 'see' the image of death as portrayed by Ledger, a scene too uncomfortably near the truth. Rain falls as Anton (Andrew Garfield), wearing his mercury wings and proving that his mythical incarnation can indeed reach into the underworld, albeit of London, pulls Ledger over the bridge. A wet and bedraggled Doctor Parnassus (Christopher Plummer) shouts from the roof of his neo-Victorian carriage, 'why are you fishing dead people out the river? ... for the love of God, he's dead!' This line not only announces the character of Tony

and shows Parnassus to be the cantankerous old man that he is but also alerts the audience to the reality of Ledger's demise outside of the film.

Thus the relationship between star and character is established and explored within the film's fragmented narrative, which places Ledger as Tony in front of the mirror in the 'real time' of twenty-first-century London and his three co-stars as Tony behind the mirror in the unconstructed time of fantasy. As Anton pulls Tony to the pavement and hits him in the chest, a brass rod shoots out of his mouth and the prone body heaves forward and breathes: a wish-fulfilment moment for the audience and a poignant reminder of the real loss of Ledger. From this moment on the character of Tony acts as a *doppelgänger* for Ledger and an embodiment of the life returning to a now-dead star whose loss, the audience will know, left a real and narrative gap to be filled in order for the film to continue its shooting schedule.

The death of Heath Ledger on 22 January 2008 placed the production of *The Imaginarium of Doctor Parnassus* in turmoil. This tragic setback left Gilliam with the rather unpalatable dilemma of cancelling the movie or shooting with another actor. In this chapter I consider the narrative structure of the movie, given Gilliam's decision to continue to shoot with the addition of three well-known actors to replace Ledger: Johnny Depp, Jude Law and Colin Farrell. Notions of fantasy and trauma are explored to unravel the complexity of a plot, which asks its audience to enter the imaginary world of Parnassus and to accept what one sees there as a truth, to, as Gilliam puts it, 'look at the world in a slightly different way' (2008: 5). I also take up this concept of a world askew in considering the reception of the film and the ways in which the image of Heath Ledger functions as a central focus in the discourse around the film's promotion and exhibition. Thus, I analyse the film within the context of a cultural and narrative trauma associated with loss, celebrity and performance. Ledger's 'stand-ins' not only play homage to his acting prowess but also problematise the tragic truth of his disappearance from the film, because when his character enters the other side of the mirror, Ledger is truly not there.

The film is a 'fantastical morality tale set in the present day' (Gillam 2008: 2). It tells the story of an Imaginarium, a travelling show in which the ancient Doctor Parnassus guides members of the audience to enjoy an 'irresistible opportunity to choose between light and joy or darkness and gloom' (ibid.). The film is set a few days before the sixteenth birthday of Parnassus's daughter, Valentina (Lily Cole). Unbeknownst to her, centuries before, Parnassus made a deal with the Devil (Mr Nick, played by Tom Waits) when he traded his immortality for her life. When Mr Nick returns to claim his prize Parnassus secures a new deal: whoever first seduces five souls will win her. In his desire to keep his daughter safe, Parnassus promises her hand in marriage to any man who can help him win. This film's tale of the foolishness of men takes its audience behind the mirror into the whimsical world of the imagination of the Imaginarium's paying audience where the surreal goings-on propel a story that is both amusing and chilling. Its fantasy landscape, though, is always undercut by the off-screen trauma and reality of the death of Heath Ledger.

In 'Traumatic Memories', Bessell A. Van der Kolk states that 'clinical experience teaches us that traumatized individuals often suffer from a combination of

vivid recall for some elements of the trauma, and amnesia for others' (1997: 248). The structure of *The Imaginarium of Doctor Parnassus* relies on memory – the audience needs to remember not only *what* has gone before in terms of plot progression but also *who* has gone before in terms of the performance of Tony. The return from Ledger to his stand-ins produces a neurotic return to a memory of death, the constant memory of the loss of Ledger. Yet this return also makes him a constant presence in the film, regardless of who is playing homage to him behind the mirror: the narrative form asks us to have selective amnesia about the actor playing Tony. While we are required to remember the narrative thread in order to understand the emerging plot, we are encouraged through the artifice of the mirror to re-imagine the face of the actor as Ledger.

However, every time Ledger as Tony enters the mirror he takes on a different face – Depp as Tony/Law as Tony/Farrell as Tony – which produces a twisted version of the once whole man. Ledger's reappearance in front of the mirror again functions as a neurotic memory for the audience, a repeated motif in the film of the returning (dead) man. For the audience, this acts as wish fulfilment might, which according to Freud in 'The Interpretation of Dreams', works by taking a subconscious trigger and distorting it to engage with the unconscious impulses that drive our hopes and dreams. So the complete body of Heath Ledger is returned again and again to the twenty-first century. However, Freud's argument fails to take into account the importance of recent conflicts in the waking life of the patient. As W. H. R. Rivers points out in his work on the subconscious, dreams are 'attempts to solve in sleep conflicts which are disturbing in real life' (1923: v). The neurotic return of a memory or dream is suggestive of the difficulty of assimilation, a traumatic image that cannot be fully understood. In *The Imaginarium of Doctor Parnassus* the structure of the film engages its audience in just such an unassimilated trauma, thus creating a neurotic loop in its insistent reproduction of the distorted image of Tony behind the mirror only to return him whole as Heath Ledger in front of it again.

The film has another layer to its fantasy narrative, too. Although the film is set in the present, Gilliam locates its *mise-en-scène* in the late nineteenth century so that it is 'more like Dickens' than Gordon Brown's version of London (Biskard 2009: 85). He produces, through the construction of the Imaginarium wagon and pop-up theatre, yet another steampunk version of the modern world, a recurring motif for Gilliam as Anna Froula notes in chapter one of this volume. The film's satirical view of the need for an archaic entertainment and escape from the realities of twenty-first-century Britain positions the film – made during Gordon's Brown's lacklustre time as Prime Minister – as a commentary on the suffering economy, rising unemployment figures and the general anomie of the population. As Allan Hunter comments, Gilliam's London is 'a despairing old man's vision of a world that needs a little magic and hope more than ever' (2009). Even the wealthy middle class, as epitomised by the women who enter the Imaginarium in the gilded shopping mall, are in need of emotional and spiritual sustenance not found in their *couture* clothes and expensive jewellery. *The Imaginarium of Doctor Parnassus*, then, takes its audience on a somewhat melancholy journey constructed by aesthetic and philosophical bricolage.

Melancholia is a loss that cannot be assimilated into consciousness. It is an emotional lacuna associated with something lost. Unlike mourning, which is an active, painful and cathartic outpouring of grief, melancholia presents itself as an immovable longing for something to be restored. In 'Mourning and Melancholia', Sigmund Freud remarks that

> melancholia ... borrows some of its features from mourning ... It is on one hand, like mourning, a reaction to the real loss of a loved object; but over and above this, it is marked by a determinant which is absent in normal mourning, or which, if it is present, transforms the latter into pathological mourning. (1995: 587)

This pathology presents itself as a constant longing for normality to be restored and can be interpreted within the fractured narrative form and plot-line of the film – from the loss of faith in oneself for Parnassus to the transformation (and loss) of Tony/Ledger's image behind the mirror and his re-emergence in front of it. *The Imaginarium of Doctor Parnassus* never quite succeeds as film-as-mourning because the anxiety around the disappearance of the actor's body is never truly resolved.

As Biskard notes, the film's preoccupations move to and fro between the artistic and self-referential to the sardonic and political:

> Stuffed with ... satire, philosophical musings, puns and jokes, throwaway allusions both mundane and arcane, fleeting references to Gilliam's previous pictures as well as classics such as *The Seventh Seal* and *La Strada*, not to mention a handful of Big Ideas – including the nature of narrative, the relation of the artist to the audience, artifice to truth – all of which get turned over and ruminated upon. (2009: 85)

Like all of Gilliam's films we are not in one landscape for very long. The film moves between worlds, real and imagined, and between narratives of philosophy – in particular the hubris of men – and the function of charity, celebrity and fame in the twenty-first century. It is no accident that the name of entrepreneur (charity) crook Tony Liar bears a striking resemblance to the British ex-Prime Minister, Tony Blair. Gilliam admits that 'both [writer Charles McKeown] and I were obsessed with Tony Blair at the time, and that's why he's called Tony. It's all about the hypocrisy that's out there' (Biskard 2009: 87). Satire here takes on a second traumatic turn here as the character of Tony Liar stands in for all the disappointments and unpopular decisions made by Blair, particularly for loyal supporters of the Labour Party.[2] In particular the third incarnation of Tony by Colin Farrell is a dark, celebrity critique that suggests the worlds created by publicity and hubris are shallow, transient and ultimately corrupt.

It is somewhat disconcerting to consider the film's production (2007–8) and release (2009) and to view the imaginary, constructed, glitzy world of paparazzi and fame that Liar has built and that literally comes crashing down around his ears in light of Tony Blair's activities after he resigned as Prime Minister in 2007. His career as a consultant for Tony Blair Associates saw him 'tour the world', while he also offered his services to the academic lecture circuit in the United States, became a rumoured potential First

President of the European Council, and actively promoted the work of his three charities: the Tony Blair Sports Foundation, the Tony Blair Faith Foundation and the Tony Blair Africa Governance Initiative. In aligning Tony Liar with Tony Blair, Gilliam crafts a character assassination – around celebrity status and political power – that suggests his fantasy worlds ought to be taken very seriously indeed.

The film premiered at Cannes on 22 May 2009, to a standing ovation, but reviews were mixed. The film received much negative criticism, perhaps the most severe from Ramin Setoodeh, who suggests that 'an unfinished work is much more fraught, especially when it's a total stinker' (2009). He comments more abruptly:

> That's not completely true of *The Imaginarium of Doctor Parnassus*, also known as The Film Heath Ledger Was Making When He Died. Still, watching it, you feel like a dinner guest who has to pretend to like his best friend's bland cooking ... But the best way to honour the dead may be to allow their last work to stay just as they left it – unfinished. (2009)

Commenting on Ledger's performance in the film, Anthony Lane suggests that it 'should not be mistaken for his [Heath Ledger's] finest hour: we see his larking, but not the undertones of frailty that tugged at *Brokeback Mountain*' (2009). These reviews suggest, though, that there is an awkward respect around the reception of this film for Ledger as an actor, but not for the film or even Gilliam.

Those who liked it focused on the director as creator of yet another fantasy world. Kenneth Turan of the *Los Angeles Times* said the film is 'a work as exceptional and unusual as its title ... the director's best, most entertaining film for years' (quoted in Biskard 2009: 135). Charles McGrath enthusiastically exclaims *The Imaginarium of Doctor Parnasuss* to be 'Gilliam's first wholly original project since the [sic] *Time Bandits*' and that his 'phantasmagorical world ... is a cinematic representation of the inside of Terry Gilliam's teeming brain' (2009). The majority of the reviews focused on the presence and absence of Heath Ledger; for instance Manohla Dargis states the film is 'a weird ... not entirely successful experiment. Mr Ledger's death understandably haunts the movie, shadowing its every gaudy and hyperventilated scene to alternatively distracting and depressing effect' (2009). Stuart Klawans commented that 'the trick [of having three actors] does nothing to diminish the film's exuberance – but it does lend gravity to the supernaturalism. *Dr. Parnassus* is one fantasy that's been visibly marked by death' (2009). Thus the reviews echo the melancholy of the film; the once bright star, Ledger, is lost and although his image can be (re-)viewed over and over his wholeness can never be restored.

This pathology of loss can also be identified in the 'story' of Ledger's death. Tabloid headlines and magazine articles directly after his death charted his ambivalent relationship to drugs and 'partying' while at the same time heralding his immense love for his daughter, Matilda, and his despair at the break-up of his relationship with Michelle Williams (see Anon. 2008a; Anon. 2008b; Anon. 2008c). Never missing from the reports or articles is the mention of the loss of such a promising and hard-working young actor. *People*'s leading article on 4 February 2008 – just two weeks after his

death – ran for a full eight pages, and included photographs of all his major film roles and Academy Award-winning appearances as well as images of Ledger the family man (see Tresniowski et al. 2008). The article focuses on the loss to his family ('Michelle is devastated'), and Hollywood's loss of a rising star; it also included detailed information and speculation about Ledger's growing levels of anxiety caused by his impending divorce and the strain of work. This line, for instance – 'an intense, restless man known for his partying and wild streak as for his sweetness and sensitivity, Ledger had been having problems sleeping' – suggests the accidental circumstances of his death and the pressures leading to it. This example of the article's rhetoric is typical of the discourse around his death of confusion, loss, anxiety and disappointment.

The mourning for Ledger directly after his death includes an extraordinary lament for the lack of hindsight of everyone around him, including the press themselves. *People* includes in its article eleven examples of prophetic commentary on his lifestyle and state of mind and health in the weeks before his death, including his disclosure to a *Los Angeles Times* reporter that 'Ambien barely worked for him'. Ledger had said, 'last week I probably slept an average of two hours a night ... I couldn't stop thinking. My body was exhausted and my mind was still going' (2008: 58). There is an overwhelming tone of regret and loss at Ledger's death, as if, perhaps, someone could have done something. Gilliam, too, in an interview with *Vanity Fair* tries to make sense of his loss when he says, 'I wish I had the answer. It really bothers me that I can't make sense out of it. There was nothing grand or dramatic about it. It just happened. It's still a big mystery' (Biskard 2009: 132). Commenting on Ledger's health during the last weeks of the shoot, he describes how the actor worked through what was clearly a difficult time for him after the break-up of his relationship:

> One day, he showed up with a terrible cough, shivering. He was clearly bloody sick ... We called a doctor, who said, 'This is the beginning of pneumonia. You need antibiotics. Go home and rest.' He said, 'No way. I'm not going to go home, because I can't sleep ... I'd rather stay here and work ... He looked awful, because of lack of sleep and just the shit he was going through with the lawyers.' (Ibid.)

Here Gilliam suggests – in an attempt to understand – that Ledger himself was suffering from a loss that he was trying to compensate for with his craft. The actor was shooting in London, Matilda was in Sweden with her mother (where she was working), and, according to Gilliam, Ledger 'put [everything] into the work, because that was the joy; what he loved to do. The words were just pouring out. It was like he was channelling' (ibid.). What these reports and articles do is construct a sense of melancholy around his loss. These are not obituaries; instead, they read as records of confusion, self-blame and affection from an industry and fan-base that fails to assimilate the trauma of its loss.[3]

Ledger's absence from the production necessitated what Gilliam describes as the 'rescue' of the film by 'three heroes, Johnny Depp, Jude Law and Colin Farrell', whose 'incredible act of generosity and love' was a 'beautiful and rare moment in our industry' (Gilliam 2008: 19). The involvement of the three actors enabled a more defined sepa-

ration of character and performance both in front of and behind the mirror. Gilliam states that the narrative of the Imaginarium lent itself to creating new worlds and so 'every time Tony ... goes through the mirror, he becomes a different aspect of himself' (2008: 19). These three actors bring different aspects of performance and intertextuality, too, of course. In 2008 Johnny Depp was most well-known for playing eccentric, fantasy figures – Jack Sparrow (2003, 2006, 2007), Willie Wonka (2005) and Sweeney Todd (2007) – but in 1998 he had made *Fear and Loathing in Las Vegas* with Gilliam and was so committed to working with him again that he worked his one-and-a-half day break from playing John Dillinger in Michael Mann's *Public Enemy* (2009) in order to enable the first incarnation of Tony behind the mirror.

Jude Law had played a variety of British cads and romantic leads and had starred in the first completely green screen, live-action fantasy, *Sky Captain and the World of Tomorrow* (2004), and Colin Farrell was hot from his role as a traumatised hit man, Ray, in Martin McDonagh's unique gangster film *In Bruges* (2008). It is hard to resist reading these past performance traits into their performances of Tony as the storyline becomes darker and more sinister. The pre-advertising for the film and the publicity around the death of Ledger ensure that the audience is clear about the necessary change of actors and their identities, and thus it contains no surprises for the audience once Tony goes through the mirror. The issue, though, is whether the audience is ready to lose Ledger yet. Will he come back? The first transition to Tony-behind-the-mirror happens after he has been rescued from the bridge and wants to help the theatre troupe make money.

The notion of the freak show is writ large as Tony re-aligns the troupe to appeal to the masses (an early clue to his exploitative tendencies not yet realised). He is dressed in his white suit, gold paint on his face, with a re-dressed stage, including a reclining Anton dressed in drag (reminiscent of Mrs Gumby in *Monty Python's Flying Circus*), a fan-carrying dwarf Percy (Verne Troyer) in turban and black face, and a practically naked Valentina. Placing the Imaginarium in a glittering Victorian mall, Tony asks the shopping women, 'Do you dream? Or more importantly, what price would you put on your dreams?' Here he evokes the notion that to dream and to enter the mirror are similar exercises in fantasy and wish fulfilment. He is wearing a theatrical bird mask – but it is clearly Ledger. The mask complicates the image for the audience – we are asked to consider his body, his performance style, his hairline and his voice to ascertain whether this is *still* Ledger. The effect of this is to elevate the performance of Ledger to spectacle. All narrative is lost in the moment of recognition as the audience concentrates their efforts on ascertaining whether this is actually the lost star – and this has real currency as we are never sure when the last view of him will be. This creates a fractured viewing position for the audience who must disrupt the flow of narrative continuity to interpret who is the actor behind the mask.

When Tony succeeds in tantalising the first wealthy woman behind the mirror with promises of inner happiness, he follows after her not understanding the rules of the Imaginarium (one soul at a time). Here we see a fantasy land fit for Carrie Bradshaw, shoes as far as the eye can see. The woman runs from shoe to shoe, ecstatic with her fantasy world whose *mise-en-scène* is also reminiscent of the colourful world

of Tim Burton's chocolate factory (*Charlie and the Chocolate Factory*, 2005). She asks Tony, 'Who are you dear?' It is a simple question and one that answers to the truth of the metadiegetic absence of Ledger. As she lifts the bird mask we see that the actor is now Johnny Depp – he stares at his face in the mirror, staring through it directly at us, a key moment of recognition and confusion for the character and the audience. He dances her around in a Valentino-styled tango on tall lily pads as they rise up above the ground. Here the audience experiences an uncanny moment as the figure of Tony rises above the camera and in long shot, his figure, hairline, pony tail and white suit show Depp to be deceptively like Ledger in physique, thus playing to audience confusion and toying with the experience of loss.

Tony guides her towards a small river and a waiting gondola. As he does so, toy boats sail past displaying pictures of Rudolph Valentino (reviving the motif of the tango), James Dean and Princess Diana; the woman gasps, 'All these people, they're all dead', to which Tony replies, 'Yes, but immortal, nevertheless; they won't get old, or fat, they won't get sick or feeble, they are beyond fear, because they are forever young, they're gods, and you can join them.' Here Gilliam plays with the deceit within the narrative that enables the character to change faces behind the mirror and quadruples the film-as-mourning potential for the audience, whilst also playing homage to both Ledger and other young legends whose short lives made them style icons and mourned celebrities. This self-referentiality breaks the illusion of fantasy and reminds the audience of the importance of memory in their construction of the narrative.

This melancholic tribute moment is undercut as Gilliam's sense of the ridiculous comes into play when an animated Cobra complete with Mr Nick's devil's head rises up to threaten the soul of the woman. Tony/Depp leaves her (and us) with one comment: 'remember, nothing's permanent, not even death', and he is catapulted backward out of the mirror onto the stage. Ledger appears again in a crumpled heap onstage on the 'real-life' side of the mirror – death is not a permanent state, so far, for the on-screen Ledger. In terms of loss and mourning, this continues a vacillating emotional journey for the audience.

The next transition of Ledger happens after a farcical chase between Russian gangsters and Tony from the shopping mall back into the mirror. Here, the audience begins to understand that Tony may have a dark past, and, as he enters into the mirror first – to escape this history – *his* fantasy begins to play out. A woman's voice can be heard saying, 'You, too, can be rich and famous', as front pages of *Fortune Magazine* and *USA Today* – with cover images of Jude Law as Tony – flash past the audience, who first sees the new Tony mediated through the image of the tabloid press. This is the first suggestion of Tony as celebrity, but the link to the tabloid obsession with Hollywood – including to these four central actors – places this second Tony-behind-the-mirror story within the realms of social commentary as the narrative takes a slide into the world of the self-promoting charity celebrity.

The landscape is one of picture-book paradise, like a Grant Wood painting of pastel field and sky with enormous ladders that reach beyond the clouds. There is joyfulness about the surreal nature of this dream-like landscape as Tony starts to climb one of the ladders, and the voice-over asserts, 'It will be you; it can be you; it is you', thus

playing on the actor's identity as well as alluding to the self-help assertiveness training that endorses positive thinking for positive results.[4] As Tony climbs higher he removes the bird mask – in close-up – revealing the second stand-in for Ledger, Jude Law. All the positive thinking in the world can't bring Ledger back. Again, it is the audience who is invited to look first at this new incarnation. Like the horror of the unmasking of the phantom of the opera in Lon Chaney's characterisation in 1925, the audience is witness to the artifice of make-up and performance. Tony grins as he leaps across the landscape on the two uprights of the ladder, as if on giant stilts, and the ludicrousness of the situation is highlighted by his manic laugh at foiling his Russian enemies, but Law isn't foiling us. The landscape begins to crumble and dark clouds loom ahead. The *mise-en-scène* transforms into a Salvador Dali-esque nightmare landscape as Tony falls from the broken ladder, suggesting that this duplicity cannot be kept up forever.

Upon landing, he is captured and held forcefully by the gangsters who stare at his face; one says, 'that's not him, I told you, that's not him!' But they wipe off the gold face paint to reveal red markings on his forehead that identify him as Tony. They prepare to hang him (again). This cry of 'that's not him' echoes the loss of Ledger; it is indeed 'not him'. After a moment of Gilliam's Pythonesque madness (a giant animated head of a policeman appears from beneath the earth, a spoof performance of the Secret Policeman's Ball, and an exploding Russian mother), Anton appears in the desolate landscape still dressed as a woman and carrying tabloid newspapers containing accusations of Tony as a charity fraud.[5] He asks angrily, 'Who are you?' Like the moment of change from Ledger to Depp ('Who are you, dear?'), the character of Tony as Law needs to be re-dedicated once more. This repetition ensures that audiences are not lured into feeling secure about the incarnations of Tony, and, indeed, Ledger's final performance is close.

A distressed Anton continues to shout, 'You stole their money!', and we start to understand the back-story of Tony: his status as hero and 'saviour of Tibet' and his charity work with children. He reduces Anton to tears as he convincingly argues for his innocence and describes how the Russian gangsters laundered money through the charity. There is something 'believable' in the performance of Law here as the lovable English rogue, an echo of cockney scoundrel Alfie (2004) for the audience, but Anton does not believe him, and there is a challenge to any notion that Tony is a good character. The dark set begins to crumble as Anton's fantasy challenges that of Tony's, and he disappears again through the mirror back to the 'real world', still shouting, 'I needed the money!' This line bleeds into the next scene, and over the image of Ledger this edit collapses the two actors into one Tony for the briefest of moments as sound and image coalesce. The spiralling downfall of Tony is enhanced by the changing actor as the different facets of his personality are exposed. Could we really imagine the weirdly Willy Wonka-esaque Depp as a charity swindler? Jude Law provides a step towards uncovering the trickster Tony. Is this darker than we want to remember Ledger?

With the transition of Tony to Colin Farrell, we see a very different version of the larky lad that Ledger gave us in the shopping mall or the sweet, tango-dancing Depp. Here he is dark and brooding, predatory and manipulative, as he seduces a very willing Valentina (he takes her into his fantasy) in the gondola and smirks, 'You're a

very naughty girl.' Ignoring Mr Nick's ploy to take both of their souls, Tony's fantasy continues as he stands at the top of a red-carpeted staircase, surrounded by paparazzi. He has Valentina join him, glamorous in high heels and a bright red figure-hugging dress. It is a familiar scene from any celebrity or political event. Instructing her to 'smile for the camera, sweetheart', he has an orphaned child on his hip as they pose before the flashing lights below. Tony announces sadly that there is 'so much suffering … it's been a big year for the foundation'. The sardonic overtones here provide social commentary about the fragility of celebrity as the images change more rapidly within the Imaginarium and Tony struggles to keep the illusion alive. He appears on a stage in a glittering ballroom packed with guests. Anton appears as a small child and can be heard calling, 'You're disgraced!' and 'Arrested last week selling organs of third world children!' Tony's world literally begins to crumble around him as his fraudulent life is exposed: staircases fall, glass shatters and Valentina can be seen running to escape through exploding glass, recalling Scotty's (James Stewart) dream in Hitchcock's *Vertigo* (1958) where petals of Carlotta's bouquet explode outward in psychedelic spirals.

This evocation of *Vertigo*'s traumatic dream sequence disrupts the narrative and, in so doing, begs the question, whose trauma is this now? In whose fantasy are we caught up? Valentina appears in Tony's fantasy but the Imaginarium can only be accessed if Doctor Parnassus is in a trance. Here, we view Parnassus's nightmare as the devil, Mr Nick, appears and starts to tango with Valentina, spinning her through the glass until he presents her with two mirrors from which to choose her escape. She is dangerously close to becoming the fifth soul, and Parnassus will lose his child forever. This is a significant move from one fantasy to the other because Tony loses control of his destiny from this point. He now is pursued by the mob and hung – for the third and final time – from the dark and looming tree at the top of a giant staircase. Parnassus regains control of his mind and the fantasy (and the Imaginarium) as he tricks Tony into using the wrong tube and watches as the man drops to his death. Parnassus displays here an angry drive for retribution that has not been evident in the narrative before. The threat of the loss of his child is more than he can bear and Tony must be punished for the threat that he posed to her survival.

Driven by melancholia – a loss that cannot be assimilated into consciousness – Parnassus becomes (self-)destructive and focused as he looks for meaning and tries to make sense of his early life decisions, his consequent life, and the consequences that follow. In 'The Ego and the Id' Freud reminds us that in melancholia, 'we find that the excessively strong super-ego … rages against the ego with merciless violence' (1995: 654). In re-gaining control of the fantasy within the Imaginarium, Parnassus 'defends against the tyrant' that threatens his ego. The death of Tony signifies a moment of action for Parnassus but it does not regain his lost child. At the end of the film, Parnassus is seen with Percy selling paper theatre versions of the Imaginarium. A small boy asks Parnassus, 'Does it have a happy ending?' He looks forlornly at Percy who says, 'Sorry, we can't guarantee that.' This line underscores the melancholia of loss, the realities of life, the conceit of Hollywood and the failure of celebrity to bridge the gap; the lack of a catharsis leaves the audience in a melancholic frame of mind and still searching for understanding.

Another reason, perhaps, why Gilliam films require another viewing, as Mark Kermode suggests in his Radio 5 Live review of the film, is that, 'Frankly, Gilliam is one of the only directors making cinema [who's] innovative [and] working in a way that encourages audiences to view the film again'. Re-viewing *The Imaginarium of Doctor Parnassus* enables an unravelling of the complex narrative, but it also increases the sense of melancholia for a viewer or fan feeling the loss of Heath Ledger. Gilliam's film places the star central to the narrative even with his actual loss from the set because of the three star actors' referential relationship to Ledger. Their acting styles remain idiosyncratically their own, but make-up and costume allude to the lost star even as his character moves further and further away from the Ledger performance. When Farrell-as-Tony is finally hung, we are left wondering if he did not just get punished for not being Ledger-as-Tony. Can there be resolution in such retribution?

Heath Ledger's status as a rising star of significant potential is clearly demarcated then by his replacement within *The Imaginarium of Doctor Parnassus* by not one but three A-list actors and whose presence is felt within the performances of those actors as they play out the multiple personalities of one man, as character and actor. Gilliam comments in his production notes for the film, 'Heath seemed to be with us the whole way … his energy, his brilliance, his ideas … are the reasons that this is truly a film from Heath Ledger and friends' (2009: 20). The film's pre-promotion, implicit through the articles around Ledger's death and explicit through its pre-advertising, reviews and Gilliam's interviews produce an over-awareness of the death of Heath Ledger and add a burden to the film of memorial and mourning that was not originally intended. Such pre-promotion also foregrounds the anxious life of the star, his divorce and his prescription drug habit that would not have been at the forefront of publicity had he survived the shoot and appeared at the premiere. Writing about stardom, Richard deCordova suggests that there is a fascination with revealing 'a concealed truth … that resided behind or beyond' the surface of the star so that 'transgression, betrayal, restlessness and loss entered the dramatic framework' of the star persona (1990: 140). This, as Sean Redmond and Su Holmes suggest, offers the reader and follower of stars and celebrities to understand that 'the glory of public visibility can leave its subjects wanting' (2006: 289). However, as Ledger-as-Tony wryly reminds us in his last delivered line of the film: 'Don't believe what you read in the newspapers; especially the mirror.'[6]

Notes

1 Gilliam is referencing the mysterious demise of Roberto Calvi, 'God's Banker', a figure at the centre of the Vatican bank scandal of 1982 – alluded to in *The Godfather, Part III* (1990) – who was found hanging from the same bridge.
2 For instance, introducing and then raising University tuition fees, the slow but pervasive privatisation of the British health care system and, not least of all, the invasion of Iraq, the war in Afghanistan, and the collusion in the incarceration and torture of prisoners at Abu Ghraib and Guantánamo.

3 For the record, the circumstances of Ledger's death are confirmed as an accidental overdose of a mixture of painkillers, anti-anxiety medication and sleeping pills. *Vanity Fair* quotes a spokeswoman from the New York City medical examiner saying, 'It's the combination of the drugs that caused the problem, not necessarily too much of any particular drug' (quoted in Biskard 2009: 132).
4 This presents another Tony – Tony Robbins – who promotes self-assertion techniques and life coaching (see www.tonyrobbins.com).
5 *The Secret Policeman's Ball* was a live comedy charity performance for Amnesty International, played in the UK and originating in 1976. Including the Monty Python team and other leading British comedians, it included a scene of transvestite policemen singing and dancing. The charity event spawned many spin-offs using the original title until 2008.
6 There is an intended pun by Gilliam here, as *The Daily Mirror* – coined 'The Mirror' in the UK – is a popular tabloid newspaper.

Works Cited

Anon. (2008a) 'Truly Tragic end to a promising career', *Variety*, 23 January (from Heath Ledger clipping file, by kind permission of the Academy of Motion Picture Arts and Sciences Library, Beverly Hills, CA.).

____ (2008b) 'Too-brief career filled with risk', *Hollywood Reporter*, 23 January (from Heath Ledger clipping file, by kind permission of the Academy of Motion Picture Arts and Sciences Library, Beverly Hills, CA.).

____ (2008c) 'Parnassus is shut down', *Hollywood Reporter*, 25 January (from Heath Ledger clipping file, by kind permission of the Academy of Motion Picture Arts and Sciences Library, Beverly Hills, CA.).

Biskard, Peter (2009) 'The Last', *Vanity Fair*, 588, August, 82–135.

Dargis, Manohla (2009) '*The Imaginarium of Dr. Parnasuss*', *New York Times*, 25 December (from Heath Ledger clipping file, by kind permission of the Academy of Motion Picture Arts and Sciences Library, Beverly Hills, CA.).

deCordova, Richard (1990) *Picture Personalities: The Emergence of the Star System in America*. Urbana, IL: University of Illinois Press.

Freud, Sigmund (1995a [1897]) 'The Interpretation of Dreams', in Peter Gay (ed.) *The Freud Reader*, London: Vintage, 129–42.

____ (1995b [1917]) 'Melancholia and Mourning', in Peter Gay (ed.) *The Freud Reader*, London: Vintage, 584–89.

____ (1995c [1923]) 'The Ego and the Id', in Peter Gay (ed.) *The Freud Reader*, London: Vintage, 628–58.

Gilliam, Terry (2008) *The Imaginarium of Dr. Parnassus Production Notes*. Academy of Motion Picture Arts and Sciences Library, Beverley Hills.

Hunter, Allan (2009) '*The Imaginarium of Dr. Parnassus*', *Screen International*, June 12.

Klawans, Stuart (2009) '*The Imaginarium of Dr. Parnassus*', *The Nation*, 25 January (from Heath Ledger clipping file, by kind permission of the Academy of Motion Picture Arts and Sciences Library, Beverly Hills, CA.).

Lane, Anthony (2009) '*The Imaginarium of Dr. Parnasus*', *New Yorker*, 21 December (from Heath Ledger clipping file, by kind permission of the Academy of Motion Picture Arts and Sciences Library, Beverly Hills, CA).Klawans, Stuart (2009) *The Nation*. 25 January.

McGrath, Charles (2009) 'Seeking Harmony with the Gods of Cinema', in *New York Times*, 13 December. Online. Available at: http://topics.nytimes.com/topics/reference/timestopics/people/g/terry_gilliam/index.html (accessed 8 December 2011).

Redmond, Sean and Su Holmes (eds) (2006) *Framing Celebrity: New Directions in Celebrity Culture*. London, Routledge.

Rivers, W. H. R. (1923) 'Introduction', *Conflict and Dream*. London: Kegan Paul, Trench, Trubner, i–v.

Setoodeh, Ramin (2009) '*The Imaginarium of Dr. Parnasuss*', *Newsweek*, 14 December (from Heath Ledger clipping file, by kind permission of the Academy of Motion Picture Arts and Sciences Library, Beverly Hills, CA).

Tresniowski, Alex et al. (2008) 'A Life Cut Short', *People*, 4 February. Online. Available at: http://www.people.com/people/archive/article/0,,20174285,00.html (accessed 3 December 2011).

Van der Kolk, Bessell A. (1997) 'Traumatic Memories', in Paul S. Appelbaum, Lisa A. Uyehara and Mark R. Elin (eds) *Trauma and Memory: Clinical and Legal Controversies*. Oxford: Oxford University Press, 248–60.

FILMOGRAPHY

Storytime (1968, UK)
Director: Terry Gilliam
Screenplay: Terry Gilliam
Producer: Terry Gilliam
Director of Photography: Terry Gilliam
Editor: Terry Gilliam
Art Director: Terry Gilliam
Sound Editor: Terry Gilliam
Length: 9 min.
Lead Cast: Terry Gilliam

The Miracle of Flight (1974, UK)
Director: Terry Gilliam
Screenplay: Terry Gilliam
Producer: Terry Gilliam
Director of Photography: Terry Gilliam
Editor: Terry Gilliam
Art Director: Terry Gilliam
Sound Editor: Terry Gilliam
Length: 5 minutes
Lead Cast: Terry Gilliam

Monty Python and the Holy Grail (1974, UK)
Director: Terry Gilliam and Terry Jones
Screenplay: Graham Chapman, John Cleese, Eric Idle, Terry Gilliam, Terry Jones, and Michael Palin
Production Company: Michael White Productions, National Film Trustee Company, and Python (Monty) Pictures
Executive Producer: John Goldstone
Producers: Mark Forstater and Michael White
Director of Photography: Terry Bedford
Editor: John Hackney
Art Director: Philip Cowlam
Sound Editors: Jean-Raphaël Dedieu, Campbell Askew, and Nicholas Gaster
Length: 91 minutes
Lead Cast: Graham Chapman (King Arthur, Voice of God, Middle Head, Hiccoughing Guard), John Cleese (Second Swallow-Savvy Guard, The Black Knight, Peasant 3, Sir Lancelot the Brave, Taunting French Guard, Tim the Enchanter), Eric Idle (Dead Collector, Peasant 1, Sir Robin the Not-Quite-So-Brave-as-Sir Lancelot, First Swamp Castle Guard, Concorde, Roger the Shrubber, Brother Maynard), Terry Gilliam (Patsy, Green Knight, Old Man from Scene 24 [Bridgekeeper], Sir Bors, Animator, Gorilla Hand), Terry Jones (Dennis's Mother, Sir Bedevere, Left Head, Cartoon Scribe, Prince Herbert), and Michael Palin (First Swallow-Savvy Guard, Dennis, Peasant 2, Right Head, Sir Galahad the Pure, Narrator, King of Swamp Castle, Brother Maynard's Brother, Leader of the Knights Who Say Ni!)

Jabberwocky (1977, UK)
Director: Terry Gilliam
Screenplay: Terry Gilliam, Charles Alverson, and Sanford Lieberson
Production Company: Python Films and Umbrella Films
Executive Producer: John Goldstone
Producers: Sanford Lieberson and Julian Doyle (associate)
Director of Photography: Terry Bedford
Editor: Michael Bradsell
Associate Editors: Michael John Bateman and Roy Burge
Art Director: Millie Burns
Sound Editor: Alan Bell
Length: 105 minutes
Lead Cast: Michael Palin (Dennis Cooper), Harry H. Corbett (The Squire), John Le Mesurier (The Chamberlain), Warren Mitchell (Mr. Fishfinger), and Max Wall (King Bruno the Questionable)

Time Bandits (1981, UK)
Director: Terry Gilliam
Screenplay: Michael Palin and Terry Gilliam
Production Company: HandMade Films
Executive Producers: George Harrison and Denis O'Brien
Producer: Terry Gilliam
Director of Photography: Peter Biziou
Editor: Julian Doyle
Art Director: Norman Garwood
Music composer: Mike Moran
Sound Editors: Dino Di Campo, Stanley Fiferman, and Mike Hopkins
Length: 116 minutes
Lead Cast: John Cleese (Robin Hood), Sean Connery (King Agamemnon, Fireman), Shelley Duvall (Dame Pansy), Katherine Helmond (Mrs. Ogre), Ian Holm (Napoleon), Michael Palin (Vincent), Ralph Richardson (Supreme Being), Peter Vaughan (Winston the Ogre), David Warner (Evil Genius), David Rappaport (Randall), Kenny Baker (Fidgit), Malcolm Dixon (Strutter), Mike Edmonds (Og), Jack Purvis (Wally), Tiny Ross (Vermin), and Craig Warnock (Kevin)

The Crimson Permanent Assurance (1983, USA)
Director: Terry Gilliam
Screenplay: Terry Gilliam
Production Company: Universal Pictures, Celandine Films, and The Monty Python Partnership
Director of Photography: Roger Pratt
Editor: Julian Doyle
Art Director: John Beard
Music composer: John Du Prez
Sound Editor: Debbie Kaplan
Length: 16 minutes
Lead Cast: Michael Palin (Workman), Graham Chapman (Clerk), Terry Gilliam (Workman), Terry Jones (Clerk), Sydney Arnold, Guy Bertrand, and Andrew Bicknell

Brazil (1985, USA)
Director: Terry Gilliam
Screenplay: Terry Gilliam, Tom Stoppard, Charles McKeown
Production Company: Embassy International Pictures,
Producer: Arnon Milchan
Co-Producer: Patrick Cassavetti
Director of Photography: Roger Pratt
Editor: Julian Doyle
Art Director: John Beard, Keith Pain
Music composer: Michael Kamen
Sound Editor: Rodney Glenn
Length: 132 minutes
Lead Cast: Jonathan Pruce (Sam Lowry), Robert De Niro (Archibald 'Harry' Tuttle), Katherine Helmond (Mrs. Ida Lowry), Michael Palin (Jack Lint), Kim Greist (Jill Layton)

The Adventures of Baron Munchausen **(1988, USA)**
Director: Terry Gilliam
Screenplay: Charles McKeown, Terry Gilliam,
Production Company: Columbia Pictures, Prominent Features, Laura Film, Allied Filmakers
Executive Producer: Jake Eberts
Producer: Thomas Schühly
Director of Photography: Giuseppe Rotunno
Editor: Peter Hollywood
Art Director: Maria-Teresa Barbasso
Music composer: Michael Kamen
Sound Editor: Rusty Coppleman
Length: 126 minutes
Lead Cast: John Neville (Hieronymus Karl Frederick Baron von Munchausen), Eric Idle (Desmond/Berthold), Sarah Polley (Sally Salt), Jonathan Pryce (The Right Ordinary Horatio Jackson), Uma Thurman (Venus/Rose)

The Fisher King **(1991, USA)**
Director: Terry Gilliam
Screenplay: Richard LaGravenese
Production Company: Columbia Pictures:
Producer: Debra Hill, Lynda Obst
Associate Producer: Tony Mark, Stacey Sher
Director of Photography: Roger Pratt
Editor: Lesley Walker
Art Director: P. Michael Johnston
Music composer: George Fenton
Sound Editor: Peter Pennell
Length: 137 minutes
Lead Cast: Jeff Bridges (Jack), Mercedes Ruehl (Anne), Robin Williams (Parry), Amanda Plummer (Lydia)

Twelve Monkeys **(1995, USA)**
Director: Terry Gilliam
Screenplay: Chris Marker, David Webb Peoples, Janet Peoples
Production Company: Universal Pictures, Atlas Entertainment, Classico
Executive Producer: Robert, Cavallo, Mark Egerton, Robert Kosberg, Gary Levinsohn
Producer: Charles Roven
Director of Photography: Roger Pratt
Editor: Mark Audsley
Art Director: William Ladd Skinner
Music composer: Paul Buckmaster
Sound Editor: Imogen Pollard
Length: 129 minutes
Lead Cast: Bruce Willis (James Cole), Madeleine Stowe (Kathryn Railly), Brad Pitt (Jeffrey Goines)

Fear and Loathing in Las Vegas **(1998, USA)**
Director: Terry Gilliam
Screenplay: Terry Gilliam, Tony Grisoni, Tod Davies, Alex Cox
Production Company: Fear and Loathing LLC, Rhino Films, Shark Productions, Summit Entertainment, Universal Pictures
Executive Producer: Harold Bronson, Richard Foos
Producer: Patrick Cassavetti, Laila Nabulsi, Stephen Nemeth
Director of Photography: Nicola Pecorini
Editor: Lesley Walker
Art Director: Chris Gorak
Music composer: Ray Cooper
Sound Editor: Peter Pennell
Length: 118 minutes
Lead Cast: Johnny Depp (Raoul Duke), Benicio Del Toro (Dr Gonzo), Ellen Barkin (Waitress), Gary Busey (Highway Patrolman)

The Brothers Grimm **(2005, USA)**
Director: Terry Gilliam
Screenplay: Ehren Kruger
Production Company: Dimension Films, Metro-Goldwyn-Mayer, Mosaic

Media Group, Reforma Films, Atlas Entertainment
Executive Producer: Jonathan Gordon, Chris McGurk, Andrew Rona, John D. Schofield, Bob Weinstein, Harvey Weinstein
Producer: Daniel Bobker, Charles Roven
Director of Photography: Newton Thomas Sigel
Editor: Lesley Walker
Art Director: Keith Pain, Jirí Sternwald, Andy Thompson, Frank Walsh
Music composer: Dario Marianelli
Sound Editor: Ian Wilson
Length: 118 minutes
Lead Cast: Matt Damon (Wilhelm Grimm), Heath Ledger (Jacob Grimm), Jonathan Pryce (Delatombe), Monica Bellucci (Mirror Queen)

Tidelands (2005)
Director: Terry Gilliam
Screenplay: Tony Grisoni, Terry Gilliam
Production Company: Recorded Picture Company, Telefilm Canada, HanWay Films
Executive Producer: Paul Brett, Peter Watson
Producer: Gabriella Martinelli, Jeremy Thomas,
Director of Photography: Nicola Pecorini
Editor: Lesley Walker
Art Director: Anastasia Masaro
Music Composer: Jeff Dana, Mychaèl Dana
Sound Editor: Nick Lowe
Length: 120 minutes
Lead Cast: Jodelle Ferland (Jeliza-Rose), Jeff Bridges (Noah), Jennifer Tilley (Queen Gunhilda), Brendan Fletcher (Dickens)

The Imaginarium of Doctor Parnasuss (2009)
Director: Terry Gilliam
Screenplay: Terry Gilliam, Charles McKeown
Production Company: Infinity Features Entertainment, Poo Poo Pictures, Parnasuss Productions, Davis-Films, Téléfilm Canada,
Executive Producer: Victor Hadida, Patrice Theroux, David Valleau
Producer: Amy Gilliam, Terry Gilliam, Samual Hadida, William Vince
Director of Photography: Nicola Pecorini
Editor: Mick Audsley
Art Director: Dan Hermansen (Vancouver), Denis Schnegg (London)
Music composer: Jeff Dana, Mychaèl Dana
Sound Editor: Nick Baldock
Length: 123 minutes
Lead Cast: Andrew Garfield (Anton), Christopher Plummer (Doctor Parnasuss), Lily Cole (Valentina), Verne Troyer (Percy), Tom Waits (Mr. Nick), Heath Ledger (Tony), Johnny Depp (Imaginarium Tony #1), Jude Law (Imaginarium Tony #2), Colin Farrell (Imaginarium Tony #3)

The Legend of Hallowdega (2010) short
Director: Terry Gilliam
Screenplay: Aaron Bergeron
Production Company: Amp Energy Juice, Radical Media
Executive Producer: Frank Cooper, George Cox, Bob Friedman, Megan Hughes, Jon Kamen, Erica Pergament
Producer: Justin Wilkes, Samantha Storr,
Director of Photography: Luke McCoubrey
Editor: Alex Horwitz
Art Director: Andrew Clark
Music composer: Human, Bill Sherman
Sound Editor/Sound Mixer: William Martel Jnr.
Length: 15 minutes
Lead Cast: David Arquette (Kiyash Monsef), Justin Kirk (Host),

The Wholly Family (2011) short
Director: Terry Gilliam
Screenplay: Terry Gilliam
Production Company: Blue Door Soc. Coop, Pastifico Garafola
Producer: Amy Gilliam, Gabrielle Oricchio,
Director of Photography: Nicola Pecorini
Editor: Mick Audsley
Art Director: Elio Maiello
Music composer: Daniele Sepp
Sound Editor: Andre Jacquemin
Length: 15 minutes
Lead Cast: Pietro Botte (Pulcinella 2), Christiana Capotondi (Madre), Nico Cirasola (Doll repairman), Nicolas Connelly (Jack)

BIBLIOGRAPHY

Adams, Sam (2010) 'Interview: Terry Gilliam'. Online. Available at: http://www.avclub.com/articles/terry-gilliam,37194 (accessed 14 May 2011).
Agamben, Giorgio (1995) *Homo Sacer,* trans. Daniel Heller-Roazen. Stanford: Stanford University Press.
____ (2005) *State of Exception*, trans. Kevin Attell. Chicago: University of Chicago Press.
Anderson, Benedict (1983) *Imagined Communities.* London: Verso.
Anon. (1998) 'Summer movies; On Filming a Gonzo Vision: A Gonzo Dialogue', *New York Times*, 3 May. Online. Available at: http://www.nytimes.com/1998/05/03/movies/summer-movies-on-filming-a-gonzo-vision-a-gonzo-dialogue.html?pagewanted=6&src=pm (accessed 17 May 2011).
____ (2008a) 'Truly Tragic end to a promising career', *Variety*, 23 January (from Heath Ledger clipping file, by kind permission of the Academy of Motion Picture Arts and Sciences Library, Beverly Hills, CA.).
____ (2008b) 'Too-brief career filled with risk', *Hollywood Reporter*, 23 January (from Heath Ledger clipping file, by kind permission of the Academy of Motion Picture Arts and Sciences Library, Beverly Hills, CA.).
____ (2008c) 'Parnassus is shut down', *Hollywood Reporter*, 25 January (from Heath Ledger clipping file, by kind permission of the Academy of Motion Picture Arts and Sciences Library, Beverly Hills, CA.).
Archibugi, Daniele (ed.) (2003) *Debating Cosmopolitics*. London: Verso.
Barber, Richard (2002) *King Arthur in Music*. Woodbridge: Boyehill and Brewer.
Barthes, Roland (1975) *S/Z: An Essay*, trans. Richard Miller. New York: Hill and Wang.
Baudrillard, Jean (2002) *Screened Out*. New York: Verso.
Behar, Henri (1995) 'A Chat with Terry Gilliam on (or around) *Twelve Monkeys*', *Film Scouts*. Online. Available at: http://www.filmscouts.com/scripts/interview.cfm?File=ter-gil (accessed 15 May 2011).

Beuka, Robert (2004) *SuburbiaNation: Reading Suburban Landscape in Twentieth-Century American Fiction and Film*. New York: Palgrave Macmillan.
Birkenstein, Jeff, Anna Froula and Karen Randell (eds.) (2010) *Reframing 9/11: Film, Popular Culture, and the 'War on Terror'*. New York: Continuum.
Biskard, Peter (2009) 'The Last', *Vanity Fair*, 588, August, 82–135.Bodel, Jean (1989 [c1200]) *La Chaison de Saisnes*, 2 vols. Annette Brasseu (ed.). Geneva: Druz.
Bowser, Rachel and Brian Coxall (2009) 'Material History: The Textures, Timing and Things of Steampunk'. Paper presented at the annual convention of the South Atlantic Modern Language Association, Atlanta, Georgia, 6 November.
____ (2010) 'Introduction: Industrial Evolution', *Neo-Victorian Studies*, 3, 1, 1–45.
Bradley, Marion Zimmer (1982) *The Mists of Avalon*. New York: Ballantine.
Burke, Edmund (1989 [1791]) 'Thoughts on French Affairs', in L. G. Mitchell (ed.) *The Writings and Speeches of Edmund Burke*. Oxford: Clarendon, 348–50.
Burnett, Frances Hodgson (1911) *The Secret Garden*. New York: Frederick A. Stokes.
Campbell, Joseph (1973) *The Hero with a Thousand Faces*. Princeton, NJ: Princeton University Press.
Canby, Vincent (1977) '*Jabberwocky:* Monster Film with Heart', *New York Times*, 16 April. Online. Available at: http://movies.nytimes.com/movie/review?res=9D03EFDE1E3BE334BC4E52DFB266838C669EDE (accessed 15 May 2011).
____ (1981) '*Time Bandits*, A Lark Through the Ages', *The New York Times*, 6 November. Online. Available at: <http://movies.nytimes.com/movie/review?res=9800E1DA113BF935A35752C1A967948260&partner=Rotten%20Tomatoes> (accessed 19 March 2010).
Carroll, Lewis (1865) *Alice's Adventures in Wonderland*. London: Macmillan.
Charles-Edwards, Thomas (1991) 'The Arthur of History', in Rachel Bromwich, A. O. H. Jarman and Brynley F. Roberts (eds) *The Arthur of the Welsh: Arthurian Legend in Mediaeval Welsh Literature*. Cardiff: University of Wales Press, 15–32.
Christiansen, Rupert (2011) '*The Damnation of Faust*, ENO, London Coliseum–Review', *The Telegraph*, 9 May. Online. Available at: http://www.telegraph.co.uk/culture/music/opera/8502174/The-Damnation-of-Faust-ENO-Coliseum-review.html (accessed 28 May 2011).
Christie, Ian and Terry Gilliam (2000) *Gilliam on Gilliam*. London: Faber.
Clute, John (1999) 'Instauration Fantasy', in John Clute and John Grant (eds) *The Encyclopedia of Fantasy*. London: Orbit, 500–2.
Cook, Daniel Thomas (2007) 'Leisure and Consumption', in Chris Rojek, Susan M. Shaw, and A. J. Veal (eds) *A Handbook of Leisure Studies*. New York: Palgrave Macmillan.
Cornwell, Bernard (1997) *Enemy of God: A Novel of Arthur*. New York: St. Martins.
____ (1998) *Excalibur: A Novel of Arthur*. New York: St. Martins.
Costa, Jordi and Sergi Sanchez (2004) 'Childhood, Vocation and First Experiences of a Rebel Dreamer', in David Sterritt and Lucille Rhodes (eds) *Terry Gilliam: Interviews*. Jackson, MS: University of Mississippi Press, 170–83.
Crossley, Dave (1965) 'Christopher's Punctured Romance', *Help!*, May, 15–21.
Cullin, Mitch (2000a) *Tideland*. Chester Springs, PA: Dufour Editions.

_____ (2000b) 'The Metaphorical Sperm Donor Masturbates', *Dreams: The Terry Gilliam Fanzine*. Online. Available at: http://www.smart.co.uk/dreams/tidecul2.htm (accessed 27 May 2011).

Dargis, Manohla (2009) '*The Imaginarium of Dr. Parnasuss*', *New York Times*, 25 December (from Heath Ledger clipping file, by kind permission of the Academy of Motion Picture Arts and Sciences Library, Beverly Hills, CA.).

deCordova, Richard (1990) *Picture Personalities: The Emergence of the Star System in America*. Urbana, IL: University of Illinois Press.

Dening, Penelope (1998). 'Devious Devices', *Dreams: The Terry Gilliam Fanzine: Devious Devices*, 25 January. Online. Available at: <http://www.smart.co.uk/dreams/automata.htm> (accessed 10 May 2011).

de Troys, Chrétien (1991 [c1180]) *Arthurian Romances*. William Kibler and Carelton Corrall (eds.) London: Penguin Books.

Di Filippo, Paul (2010) 'The Remarkable Resilience of Steampunk'. Online. Available at: http://www.salon.com/books/feature/2010/04/22/steampunk_appeal (accessed 14 May 2011).

Drucker, Elizabeth (1991) '*The Fisher King*: Terry Gilliam Melds the Modern and the Mythical', *American Film*, 16, 50–1.

Dumville, David N. (2002) *Anneles Cambriae* A.D.682-954: Texts A-C in Parallel. Cambridge: University of Cambridge, Department of Anglo Saxon, Norse, and Celtic.

Ebert, Roger (1981) '*Time Bandits*', *Chicago Sun-Times*, 1 January. Online. Available at: <http://rogerebert.suntimes.com/apps/pbcs.dll/article?AID=/19810101/REVIEWS/101010374/1023> (accessed 1 June 2011).

_____ (1998) '*Fear and Loathing in Las Vegas*', *Chicago Sun-Times,* 22 May. Online. Available at: http://rogerebert.suntimes.com/apps/pbcs.dll/article?AID=/19980522/REVIEWS/805220303 (accessed 17 May 2011).

_____ (2005) 'Review of *The Brothers Grimm*', *Chicago Sun-Times*, 26 August. Online. Available at: http://rogerebert.suntimes.com/apps/pbcs.dll/article?AID=/20050825/REVIEWS/50822002 (accessed 5 November 2011).

Elfman, Doug (2008) 'John Cleese Loves *Spamalot*, Doesn't Know It's Closing, Also He Declares, "It's Not a Fortune to be God"', 5 May. Online. Available at: http://www.lvrj.com/blogs/elfman/John_Cleese_Loves_Spamalot_Doesnt_Know_Its_Closing_Also_He_Declares_Its_Not_a_Fortune_to_be_God.html (accessed 6 November 2011).

Eliade, Mircea (1963) *Myth and Reality,* trans. W. R. Trask. New York: Harper and Row.

Field, J. C. (1998) *Malory: Texts and Sources*. Cambridge: Brewer.

Fitting, Peter (1998) 'The Concept of Utopia in the Work of Fredric Jameson', *Utopian Studies* 9, 2, 8-17.

Flanagan, Caitlin (2005) 'Becoming Mary Poppins: L. Travers, Walt Disney and the Making of a Myth', *The New Yorker,* 81, 41, 40-6.

Forlini, Stephania (2010) 'Technology and Morality: The Stuff of Steampunk', *Neo-Victorian Studies*, 3, 1, 72–98.

Foucault, Michel (1977) *Discipline and Punish: The Birth of the Prison*, trans. Alan Sheridan. New York: Vintage.

____ (1997) *Society Must Be Defended: Lectures at the Collège de France, 1975–1976*, trans. David Macey. New York: Picador.

Fountain, Nigel (2004) 'Monkey Business', in David Sterritt and Lucille Rhodes (eds) *Terry Gilliam: Interviews*. Jackson: University of Mississippi Press, 107–12.

Freud, Sigmund (1993a [1924]) 'The Loss of Reality in Neurosis and Psychosis', Alan Tyson and James Strachey (eds and trans.) *On Psychopathology: Inhibitions, Symptoms, and Anxiety and Other Works, vol. 10*, Harmondsworth: Penguin, 219–6.

____ (1993b [1923]) 'Neurosis and Psychosis', in *On Psychopathology: Inhibitions, Symptoms, and Anxiety and Other Works, vol. 10*, trans. and eds. Alan Tyson and James Strachey. Harmondsworth: Penguin Books, 213–8.

____ (1995a [1897]) 'The Interpretation of Dreams', in Peter Gay (ed.) *The Freud Reader*, London: Vintage, 129–42.

____ (1995b [1917]) 'Melancholia and Mourning', in Peter Gay (ed.) *The Freud Reader*, London: Vintage, 584–89.

____ (1995c [1923]) 'The Ego and the Id', in Peter Gay (ed.) *The Freud Reader*, London: Vintage, 628–58.

Frucci, Adam (2007) 'Exclusive Interview: Steampunk Virtuoso Datamancer, aka Rich Nagy, Shows Us His "Tesla Cane"'. Online. Available at: http://gizmodo.com/#!322687/exclusive-interview-steampunk-virtuoso-datamancer-aka-rich-nagy-shows-us-his-tesla-cane (accessed 22 April 2011).

Fusilli, Jim (2005) 'Inventive Ever After: Review of *The Brothers Grimm*,' *Wall Street Journal*, 26 August. Online. Available at: http://online.wsj.com/article/SB112500448008723407.html (accessed 8 December 2011).

Ganley, Doug (2009) 'Monty Python's 40 Years of Silliness', *CNN*, 24 October. Online. Available at: http://articles.cnn.com/2009-10-24/entertainment/monty.python.40_1_ifc-documentary-silliness-bbc?s=PM:SHOWBIZ (accessed 6 November 2011).

Geoffrey of Monmouth (1996 [c1138]) *The History of the Kings of Britain*, Lewis Thorpe (ed.) Harmondsworth: Penguin Books.

Gilliam, Terry (1999) 'Director's Commentary', *Monty Python and the Holy Grail* (1975). Directed by Terry Jones and Terry Gilliam. Culver City: Sony Pictures.

____ (2005) *The Imaginarium of Doctor Parnassus*. Production Notes, Academy of Motion Picture Arts and Sciences Library, Beverley Hills, LA.

____ (2006) 'Special Features: Terry Gilliam's Featurette: Episode Four', *Monty Python's Flying Circus: Terry Gilliam's Personal Best*. DVD. Directed by Terry Gilliam. New York: A&E Home Video.

Gilliam, Terry and Michael Palin (2001) 'Special Commentary', *Jabberwocky* (1977). DVD. Directed by Terry Gilliam. Culver City: Sony Pictures.

Glass, Fred (1986) '*Brazil*', *Film Quarterly*, 39, 4, 22–8.

Gleiberman, Owen (1998) 'Fear and Loathing in Las Vegas,' *EW*, 29 May. Online. Available at: http://www.ew.com/ew/article/0,,283406,00.html (accessed 17 May 2011).

____ (2004) 'The Life of Terry', in David Sterritt and Lucille Rhodes (eds) *Terry Gilliam: Interviews*. Jackson, MS: University Press of Mississippi, 30–5.

Gordon, Andrew (2004) '*Back to the Future:* Oedipus as Time Traveler', in Sean Redmond (ed.) *Liquid Metal*. New York: Wallflower Press, 116-25.

Grant, John (1999) 'The Fisher King', in John Clute and John Grant (eds) *The Encyclopedia of Fantasy*. London: Orbit, 354.

Gross, Cory (2008) 'A History of Steampunk: Part III: The Birth of Steampunk', *Voyages Extraordinaires*, 28 August. Online. Available at: http://voyagesextraordinaires.blogspot.com/2008/08/history-of-steampunk.html (accessed 25 October 2009).

Hamel, Keith James (2004) 'Modernity and Mise-en-scène: Terry Gilliam and Brazil', *Images: A Journal of Film and Popular Culture*, 6. Online. Available at: http://www.imagesjournal.com/issue06/features/brazil.htm (accessed 4 November 2011).

Hardy, Kevin J. (1991) *Cinema Arthuriana*. New York: Garland.

Hastings, Adrian (1997) *The Construction of Nationhood*. Cambridge: Cambridge University Press.

Hazony, Yoram (2002) 'On the National State, Part 1: Empire and Anarchy', *Azure* 12. Online. Available at: http://www.azure.org.il/article.php?id=265 (accessed 5 November 2011).

Hobsbawm, Eric (1990) *Nations and Nationalism since 1870*. Cambridge: Cambridge University Press.

Holden, Stephen (1998) 'A Devotedly Drug-Addled Rampage Through a 1971 Vision of Las Vegas', *The New York Times*, 22 May. Online. Available at: http://movies.nytimes.com/movie/review?res=9800E7DF1039F931A15756C0A96E958260&scp=3&sq=fear%20and%20loathing%20in%20las%20vegas&st=cse (accessed 17 May 2011).

Holland-Toll, Linda J. (2001) *As American as Mom, Baseball, and Apple Pie: Constructing Community in Contemporary American Horror Fiction*. Bowling Green, OH: Bowling Green State University Popular Press.

Hollinger, Robert (1994) *Postmodernism and the Social Sciences: A Thematic Approach*. Thousand Oaks, CA: Sage.

Holmes, Su & Sean Redmond (eds.) (2006) *Framing Celebrity: New Directions in Celebrity Culture*. London, Routledge.

Hopewell, John and Elsa Keslassy (2010) 'Gilliam to Godfather *1884*', *Variety*, 16 December. Available at: http://www.variety.com/article/VR1118029166?refCatId=13 (accessed 29 April 2011).

Housel, Rebecca (2006) 'Monty Python and the Holy Grail: Philosophy, Gender, and Society', in Gary Hardcastle and George A. Reisch (eds) *Monty Python and Philosophy: Nudge Nudge, Think Think!* Chicago: Open Court, 82–92.

Hunter, Allan (2009) '*The Imaginarium of Dr. Parnassus*', *Screen International*, June 12.

Jackson, Eve (1996) *Food and Transformation: Imagery and Symbolism of Eating*. Toronto: Inner City Books.

Jameson, Fredric (1971) *Marxism and Form: Twentieth Century Dialectical Theories of Literature*. Princeton, NJ: Princeton University Press.

_____ (1982) 'Progress Versus Utopia; Or, Can We Imagine the Future?', *Science Fiction Studies*, 9, 2, 147–58.

_____ (1992) 'Reification and Utopia in Mass Culture' in *Signatures of the Visible*. New York: Routledge.

_____ (2005) *Archaeologies of the Future: The Desire Called Utopia and Other Science Fictions*. New York: Verso.

Jarrell, Randall (1994) 'Stories', in Charles E. May (ed.) *The New Short Stories Theories*. Athens, OH: Ohio University Press.

Jones, Jason B. (2010) 'Betrayed by Time: Steampunk & the Neo-Victorian in Alan Moore's *Lost Girls* and *The League of Extraordinary Gentlemen*', *Neo-Victorian Studies*, 3, 1, 99–126.

Kael, Pauline (1989) 'Too Hip by Half', *The New Yorker*, 3 April, 103–5.

Kauffman, Stanley (1981) 'Stanley Kauffmann on Films', *The New Republic*, 11 November, 25.

Klawans, Stuart (2004) 'A Dialogue with Terry Gilliam', in David Sterritt and Lucille Rhodes (eds) *Terry Gilliam: Interviews*. Jackson, MS: University Press of Mississippi, 141–69.

_____ (2009) '*The Imaginarium of Dr. Parnassus*', *The Nation*, 25 January (from Heath Ledger clipping file, by kind permission of the Academy of Motion Picture Arts and Sciences Library, Beverly Hills, CA.).

Kymlicka, Will (1995) *Multicultural Citizenship*. Oxford: Oxford University Press.

Lafrance, J. D. (n.d.) '*Twelve Monkeys*: Dangerous Visions'. *Dreams: The Terry Gilliam Fanzine*. Online. Available at: http://www.smart.co.uk/dreams/home.htm (accessed 7 April 2011).

LaGravenese, Richard (1991) *The Fisher King: The Book of the Film*. New York: Applause.

Landy, Marcia (2002) *Monty Pythons' Flying Circus*. Detroit: Wayne State University Press.

Lane, Anthony (2009) '*The Imaginarium of Dr. Parnasuss*', *New Yorker*, 21 December (from Heath Ledger clipping file, by kind permission of the Academy of Motion Picture Arts and Sciences Library, Beverly Hills, CA).

Langer, Lawrence (1980) 'The Dilemma of Choice in the Death Camps', *Centerpoint: A Journal of Interdisciplinary Studies* 4.1, 53-59.

Lashmet, David (2000) 'The Future is History: *12 Monkeys* and the Origin of AIDS', *Mosaic: A Journal for the Interdisciplinary Study of Literature*, 33, 4, 55–72.

Lerner, Alan Jay and Frederick Lowe. *Camelot*. Directed by Moss Hart. Play. 1960.

Lewis, C. S. (1950) *The Lion, the Witch and the Wardrobe*. London: Geoffrey Bles.

Lury, Karen (2010) *The Child in Film: Tears, Fears and Fairytales*. New Brunswick, NJ: Rutgers University Press.

Lyman, Rick (2004) 'A Zany Guy Has a Serious Rave Movie,' in David Sterritt and Lucille Rhodes (eds) *Terry Gilliam: Interviews*. Jackson, MS: University Press of Mississippi, 26–9.

Mallory, Thomas (2001 [1485]) *Le Morte D'Arthur*, trans. and ed. Keith Baines. New York: Penguin.

Marks, Peter (2010) *Terry Gilliam*. Manchester: Manchester University Press.

Mathews, Jack (1998) *The Battle of Brazil: Terry Gilliam v Universal Studies*. New York: Applause.
Matthew, Patricia A. and Jonathan Greenberg (2009) 'The Ideology of the Mermaid: Children's Literature in the Intro to Theory Course', *Pedagogy: Critical Approaches to Teaching Literature, Language, Composition, and Culture*, 9, 2, 217–33.
Matthews, John (1985) *The Grail: Quest for the Eternal*. London: Thames & Hudson.
McCabe, Bob (1999) *Dark Knights and Holy Fools: The Art and Films of Terry Gilliam*. New York: Universe.
____ (2004) 'Chemical Warfare', in David Sterritt and Lucille Rhodes (eds) *Terry Gilliam: Interviews*. Jackson: University of Mississippi Press, 135-140.
____ (2006) *Dreams and Nightmares: Terry Gilliam, The Brothers Grimm & Other Cautionary Tales of Hollywood*. London: HarperCollins.
McCarthy, Todd (1998) '*Fear and Loathing in Las Vegas*', *Variety*, May 16. Online. Available at: http://www.variety.com/review/VE1117477489?refcatid=31 (accessed 17 May 2011).
McGrath, Charles (2009) 'Seeking Harmony with the Gods of Cinema', in *New York Times*, 13 December. Online. Available at: http://topics.nytimes.com/topics/reference/timestopics/people/g/terry_gilliam/index.html (accessed 8 December 2011).
Monty Python (1999) *Monty Python's Big Red Book*. London: Meuthen.
____ (2006) *The Very Best of Monty Python*. London: Meuthen
____ (2007) *The Brand New 'Monty Python' Papperbok*. London: Meuthen.
Monty Python and Bob McCabe (2005) *The Python's Autobiography*. London: Orien.
Morgan, David (1988) 'The Mad Adventures of Terry Gilliam', *Sight and Sound*, 57, 4, 238–42.
____ (1991) 'Interviews with Terry Gilliam', in Richard LaGravenese (ed.) *The Fisher King: The Book of the Film*. New York: Applause, 153–71.
____ (2004a) 'The Mad Adventures of Terry Gilliam', in David Sterritt and Lucille Rhodes (eds) *Terry Gilliam: Interviews*. Jackson, MS: University Press of Mississippi, 36–46.
____ (2004b) 'Gilliam, Gothan, God', David Sterritt and Lucille Rhodes (eds) *Terry Gilliam: Interviews*. Jackson, MS: University of Mississippi Press, 52–64.
Nennius (1948 [c800]) '*Historia Brittonum*' in J. A. Giles (ed.) *Six English Chronicles*. London: Henry G. Bohn, 1-15.
Nevins, Jess (2008) 'Introduction: The 19th-Century Roots of Steampunk', in Ann VanderMeer and Jeff VanderMeer (eds) *Steampunk*. San Francisco: Tachyon, 3–11.
Nietzsche, Friedrich (2006 [1892]) *Thus Spoke Zarathrustra*, Adrian Del Caro and Robert Pippin (eds. and trans.). Cambridge: Cambridge University Press.
Oakeshott, Michael (2010) *Rationalism in Politics and Other Essays*. Indianapolis: Liberty Fund.
O'Connell, John (2006) 'Michael Palin: Interview', *Time Out*, 31 October. Online. Available at: http://www.timeout.com./london/books/features/2202/3.html (accessed 17 December 2010).
Orr, John (1993) *Cinema and Modernity*. Cambridge: Polity Press.

Pagliassotti, Dru (2009) 'Does Steampunk Have Politics?', *The Mark of Ashen Wings*. 11 February. Online. Available at: http://ashenwings.com/marks/2009/02/11/does-steampunk-have-politics (accessed 25 October 2009).

Palin, Michael (2006) *Diaries 1969-1979: The Python Years*. New York: Thomas Dunne.

Penley, Constance (2004) 'Time Travel, Primal Scene, and the Critical Dystopia', in Sean Redmond (ed.) *Liquid Metal: The Scinece Fiction Film Reader*. New York: Wallflower Press, 126–35.

Perschon, Mike (2009) 'Steampunk as Pastiche', *Steampunk Scholar*. 15 June. Online. Available at: http://steampunkscholar.blogspot.com/2009/06/steampunk-as-pastiche.html (accessed 15 May 2011).

Pizzello, Stephen (1998) '"*Twelve Monkeys*": A Dystopian Trip Through Time', *American Cinematographer*, 77, 36–44.

Plume, Ken (2005) 'Interview with Terry Gilliam'. Online. Available at: http://www.asitecalledfred.com/2006/08/08/quickcast-interview-terry-gilliam-part-8/ (accessed 6 November 2011).

Price, David (2010) 'Governing Fear in the Iron Cage of Rationalism: Terry Gilliam's *Brazil* through the 9/11 Looking Glass', in Jeff Birkenstein, Anna Froula and Karen Randell (eds) *Reframing 9/11: Film, Popular Culture, and the 'War on Terror'*. New York: Continuum, 167–82.

Project Bravo (2006) 'Bravo's List of 100 Best Movies is Laughable', 2 June. Online. Available at: http://www.projectbravo.com/?m=200606&paged=2 (accessed 27 May 2011).

Redmond, Sean and Su Holmes (eds) (2006) *Framing Celebrity: New Directions in Celebrity Culture*. London, Routledge.

Remy, J. E. (2007) 'The "Punk" Subgenre', *Die Wachen*. 26 July. Online. Available at: http://diewachen.com/2007/07/punk-subgenre.html (accessed 25 October 2009).

Rivers, W. H. R. (1923) 'Introduction', *Conflict and Dream*. London: Kegan Paul, Trench, Trubner, i–v.Robinson, Piers (2002) *The CNN Effect: The Myth of News, Foreign Policy and Intervention*. London: Routledge.

Robley, Les Paul and Paul Wardle (1996) 'Hollywood Maverick: Terry Gilliam, A Career Profile of One of the Cinema's Premier Fantasists', *Cinefantastique*, 27, 6, 24–37.

Rosen, Elizabeth (2008) *Apocalyptic Transformation: Apocalypse and the Postmodern Imagination*. Lanham, MD: Lexington Books.

Rosenblatt, Josh (2006) '*Tideland*', *The Austin Chronicle* (October 27). Online. Available at: http://www.austinchronicle.com/gyrobase/Calendar/Film?Film=oid%3A413780 (accessed 12 October 2009).

Roshwald, Ariel (2006) *The Endurance of Nationalism*. Cambridge: Cambridge University Press.

Rushdie, Salman (1985) 'The location of *Brazil*', *American Film*, 10, 50–3.

Schulte-Sasse, Jochen (1987) 'Imagination and Modernity: Or the Taming of the Human Mind', *Cultural Critique*, 5, 23–48.

Scott, A. O. (2006) '*Tideland*: A Girl Endures a No-Man's Land by Dwelling in the Make-Believe', *The New York Times* (October 13). Online. Available at: http://movies.nytimes.com/2006/10/13/movies/13tide.html (accessed 12 October 2007).

Seckerson, Edward (2011) 'A Mischievous Showman', *The Damnation of Faust* [programme]. London: English National Opera, 8–13.

Setoodeh, Ramin (2009) '*The Imaginarium of Dr. Parnasuss*', *Newsweek*, 14 December (from Heath Ledger clipping file, by kind permission of the Academy of Motion Picture Arts and Sciences Library, Beverly Hills, CA).

Smith, Anthony (2004) *The Antiquity of Nations*. Cambridge: Polity.

____ (2007) 'Nation and Covenant', *Proceedings of the British Academy*, 151, 213–55.

Smith, Giles (1998) 'War Games: Terry Gilliam Goes Gonzo With *Fear and Loathing in Las Vegas*', *The New Yorker*, 74, 74–9.

Solman, Gregory (2004) 'Fear and Loathing in America: Gilliam on the Artist's Fight or Flight Instinct', in David Sterritt and Lucille Rhodes (eds) *Terry Gilliam: Interviews*. Jackson, MS: University Press of Mississippi, 184–207.

Steffen-Fluhr, Nancy (1994) 'Terry Gilliam', in Gary Crowdus (ed.) *A Political Companion to American Film*. Chicago: Lakeview Press, 185–9.

Sternberg, Doug (1994) 'Tom's a-cold: Transformation and Redemption in *King Lear* and *The Fisher King*', *Literature/Film Quarterly*, 22, 3, 160–9.

Sterritt, David (2004) 'Laughs and Deep Themes', in David Sterritt and Lucille Rhodes (eds) *Terry Gilliam: Interviews*. Jackson, MS: University Press of Mississippi, 16–29.

Sterritt, David and Lucille Rhodes (eds) (2004) *Terry Gilliam: Interviews*. Jackson, MS: University of Mississippi Press.

Stewart, Mary (1970) *The Crystal Cave*. New York: William Morrow.

____ (1973) *The Hollow Hills*. London: Hodder and Stoughton.

____ (1979) *The Last Enchantment*. Boston: G. K. Hall.

Suvin, Darko (1979) *Metamorphoses of Science Fiction*. New Haven, CT: Yale University Press.

Tapper, Michael (2006) 'Beyond the Banal Surface of Reality: Terry Gilliam Interview', *Film International*, 4, 1, 60–9.

Tatar, Maria (2010) 'Why Fairy Tales Matter: The Performative and the Transformative', *Western Folklore*, 69, 1, 55–64.

Taylor, Beverly and Elizabeth Brewer (1983) *The Return of King Arthur: British and American Arthurian Literature Since 1800*. Cambridge: Brewer.

Tennyson, Alfred (1996 [1859]) *The Idylls of the King*, J. M. Gray (ed.). New York: Penguin Books.

Thompson, Anne (2004) 'Bandit', in David Sterritt and Lucille Rhodes (eds) *Terry Gilliam: Interviews*. Jackson, MS: University Press of Mississippi, 3–15.

Thompson, R. H. (1996) 'English, American Literature in (Modern)', in Norris J. Lacy (ed.) *The New Arthurian Encyclopedia*. New York: Garland.

Tobias, Scott (2011) 'The New Cult Canon: *Fear and Loathing in Las Vegas*', *The A.V. Club*, February 24. Online. Available at: http://www.avclub.com/articles/fear-and-loathing-in-las-vegas,52308/ (accessed 17 May 2011).

Todorov, Tzvetan (1975) *The Fantastic: A Structural Approach to a Literary Genre*. Ithaca, NY: Cornell University Press.
Tolkien, J. R. R. (1966) 'On Fairy-stories', in *The Tolkien Reader*. New York: Random House, 33–99.
Travers, Peter (1991) '*The Fisher King*', *Rolling Stone*, 20 September. Online. Available at: http://www.rollingstone.com/movies/reviews/the-fisher-king-19910920 (accessed 5 June 2011).
Tresniowski, Alex et al. (2008) 'A Life Cut Short', *People*, 4 February. Online. Available at: http://www.people.com/people/archive/article/0,,20174285,00.html (accessed 3 December 2011).
Twain, Mark (2002 [1889]) *A Connecticut Yankee in King Arthur's Court*. Berkeley, CA: University of California Press.
Van der Kolk, Bessell A. (1997) 'Traumatic Memories', in Paul S. Appelbaum, Lisa A. Uyehara and Mark R. Elin (eds) *Trauma and Memory: Clinical and Legal Controversies*. Oxford: Oxford University Press, 248–60.
Vincent, Andrew (2002) *Nationalism and Particularity*. Cambridge: Cambridge University Press.
Wardle, Paul (1996) 'Terry Gilliam', *The Comics Journal*, 182. 15 November. Online. Available at: http://archives.tcj.com/index.php?option=com_content&task=view&id=36&Itemid=48 (accessed 15 May 2011).
____ (2004) 'Terry Gilliam', in David Sterritt and Lucille Rhodes (eds) *Terry Gilliam: Interviews*. Jackson, MS: University Press of Mississippi 65–106.
Wells, Matt (200) 'Great White Hope', *The Guardian* (November 20). Online. Available at: http://www.guardian.co.uk/media/2000/nov/20/broadcasting.mondaymediasection (accessed 29 October 2009).
Wells, Paul (2004) "On Being an Impish God." in David Sterritt and Lucille Rhodes (eds.) *Terry Gilliam: Interviews*. Jackson: University of Mississippi Press, 124-134.
Weston, Jessie Laidlay (1920) *From Ritual to Romance: History of the Holy Grail Legend*. Cambridge: Cambridge University Press. Online. Available at: http://books.google.co.uk/books?id=bvdU05-zgF8C&dq=from+ritual+to+romance&source=gbs_navlinks_s (accessed 3 March 11).
White, T. H. (1986 [1958]) *The Once and Future King*. New York: Ace.
Winter, Douglas E. (ed.) (1988) *Prime Evil*. New York: New American Library.
Woerner, Meredith (2010) 'Terry Gilliam's Next Project Takes You Into the Steampunk Britain of 1884'. *io9*. 21 December. Online. Available at: http://io9.com/#!5715735/terry-gilliams-next-project-takes-you-into-the-steampunk-britain-of-1884 (accessed 29 April 2011).
Wollen, Peter (1996) 'Terry Gilliam', in Philip Dodd and Ian Christie (eds) *Spellbound: Art and Film*. London: British Film Institute and Hayward Gallery, 61–6.
Yule, Andrew (1991) *Losing the Light: Terry Gilliam & The Munchausen Saga*. New York: Applause.
Zipes, Jack (2008) 'What Makes a Repulsive Frog So Appealing: Memetics and Fairy Tales', *Journal of Folklore Research*, 45, 2, 109–43.

INDEX

Adventures of Baron Munchausen, The (1988) 1, 5, 10, 18, 25, 29, 54–64, 81, 89, 106, 109, 114–15, 141–2
Agamben, Giorgio 96, 101–2
And Now for Something Completely Different 5, 42, 46
Anderson, Benedict 115
Archibugi, Daniele 115

Back to the Future 98–9
Badland, Annette 25
Barthes, Roland 21
Bergman, Ingmar 47
Birkenstein, Jeff 6, 9, 130
Boorman, John 27, 45
Bosch, Hieronymus 16, 26, 29
Bowser, Rachel 17, 21
Bradley, Marion 44
Brazil (1985) 3–5, 9, 11–13, 23–5, 28–9, 34–5, 38, 66–77, 79, 81, 88, 101, 104, 106–9, 136, 141–2
Brokeback Mountain (2005) 149
Bronzino, Agnolo 21–4
Bruegel, Peiter 26, 29

Camelot (1960) 44
Camelot (1967) 45
Canby, Vincent 26, 133
Casablanca (1942) 68
Chaney, Lon 153

Chapman, Graham 25, 45, 50
Charlie and the Chocolate Factory (2005) 142, 152
Christie, Ian 2, 13, 33, 131
Cleese, John 29, 45, 47–9, 51, 137
Cleveland, Carol 48
Clute, John 89–90
Connecticut Yankee in King Arthur's Court (1949) 44–5, 52
Cornwall. Bernard 44
Cortese, Valentina 56
Costa, Jordi 114
Coxall, Brian 17
Crimson Permanent Assurance, The (1983) 23
Crosby, Bing 45
Cullin, Mitch 121, 123, 125, 127

Damon, Matt 107
de Niro, Robert 88
Depp, Johnny 2, 6, 34, 146–7, 150–3
Di Filippo, Paul 18, 22
Drucker, Elizabeth 61

Ebert, Roger 107, 133
Edwards, Blake 27
Emerson, Jim 54
Excalibur (1981) 27, 45

Farrell, Colin 6, 146–8, 150–5

Fear and Loathing in Las Vegas (1998) 2–3, 13, 29, 34–5, 106–7, 114, 151
Fisher King, The (1991) 3, 10, 29, 32–3, 35, 39, 54, 61–3, 79–80, 88–9, 104, 106–7
Fletcher, Brendan 39, 126
Florence, Carol 94
Foucault, Michel 92–3, 95–8, 102

Gardner, Ava 45
Garrison, Michael 29
Gibson, William 11, 18
Gleiberman, Owen 135
Grisoni, Tony 115, 121, 126–8

Harris, Richard 45
Harryhausen, Ray 16
Hastings, Adrian 115
Hitchcock, Alfred 16, 38, 40, 123, 154
Hobsbawm, Eric 115
Hooper, Tobe 123

Idle, Eric 19–20, 23, 45, 47–8, 55

Jabberwocky (1977) 2, 5, 16–17, 23, 25–9, 45, 89
Jameson, Fredric 68, 76–7, 93, 101
Jaws (1975) 26
Jeffrey, Peter 56

Kermode, Mark 155
Klawans, Stuart 149
Knights of the Round Table (1953) 45
Kruger, Ehren 115
Kubrick, Stanley 19
Kurtzman, Harvey 20, 29, 72

Langer, Lawrence 72
Lashmet, David 94
Law, Jude 6, 146, 150–3
Le Mesurier, John 26

Ledger, Heath 6, 107, 145–55
Lovejoy, Helen 128

Marks, Peter 3, 17, 80, 132
Mathews, Jack 3, 66, 77
McCabe, Bob 2–3, 61, 70
McKeown, Charles 55, 73, 137, 148
McTeer, Janet 124
Mirren, Helen 45
Monkey Business (1931) 72
Monty Python and the Holy Grail (1975) 5, 17, 33, 42–5, 48–52
Monty Python's Flying Circus (1969–74) 19–22, 24, 46, 49, 151
Monty Python's Flying Circus: Terry Gilliam's Personal Best (2006) 21
Monty Python's The Meaning of Life (1983) 4, 19, 22–4
Morgan, David 64, 73, 87

Nero, Franco 45

Ollive, Tim 24, 28–9
Orwell, George 19, 22, 28

Pagliassotti, Dru 18–19
Palin, Michael 20, 25, 27, 45–9, 51, 71
Peckinpah, Sam 26
Penley, Constance 99
Perschon, Mike 25
Plummer, Amanda 37, 61, 80
Polley, Sarah 54
Ponnelle, Jean-Pierre 27
Poussin, Nicolas 21
Price, David 12
Public Enemy (2009) 151
Purvis, Jack 55

Randell, Karen 6, 9, 145
Redgrave, Vanessa 45
Rhodes, Lucille 2
Ruehl, Mercedes 61, 80
Rushdie, Salman 40

Sanchez, Sergi 114
Schneider, Marcel 64
Schulte-Sasse, Jochen 64
Seventh Seal, The (1957) 47, 148
Sheinberg, Sid 54, 66–7
Siegel, Joel 54
Spielberg, Stephen 29
Sterritt, David 2, 133, 141
Stewart, James 154
Stewart, Mary 44
Stormare, Peter 107
Stowe, Madeleine 92
Sword in the Stone (1963) 44–5

Taylor, Robert 45
Terminator (1984) 99
Texas Chainsaw Massacre, The (1974) 123, 127
Thompson, Hunter S. 2, 7, 38
Thurman, Uma 56
Tideland (2005) 6, 12, 18, 32, 39, 81, 118–28
Tilly, Jennifer 122
Time Bandits (1981) 3, 6, 9, 18, 32–3, 40–1, 54, 65, 106, 130–42
Todorov, Tzvetan 5, 54, 57–60, 62–4, 131, 142
Twain, Mark 44–5
Twelve Monkeys (1995) 3, 5, 11, 19–22, 32, 34–8, 63, 72, 79, 90, 92–100, 104, 109, 114

Van Der Beek, Stan 16

Wagner, Richard 44
Waits, Tom 4, 63, 146
Wall, Max 26
Wardle, Paul 67
Wells, H. G. 18
Whale, James 120
Williamson, Nicol 45
Willis, Bruce 19, 34, 81, 92
Wood, Grant 152

Young, Jimmy 16